IMAGO MUNDI

I

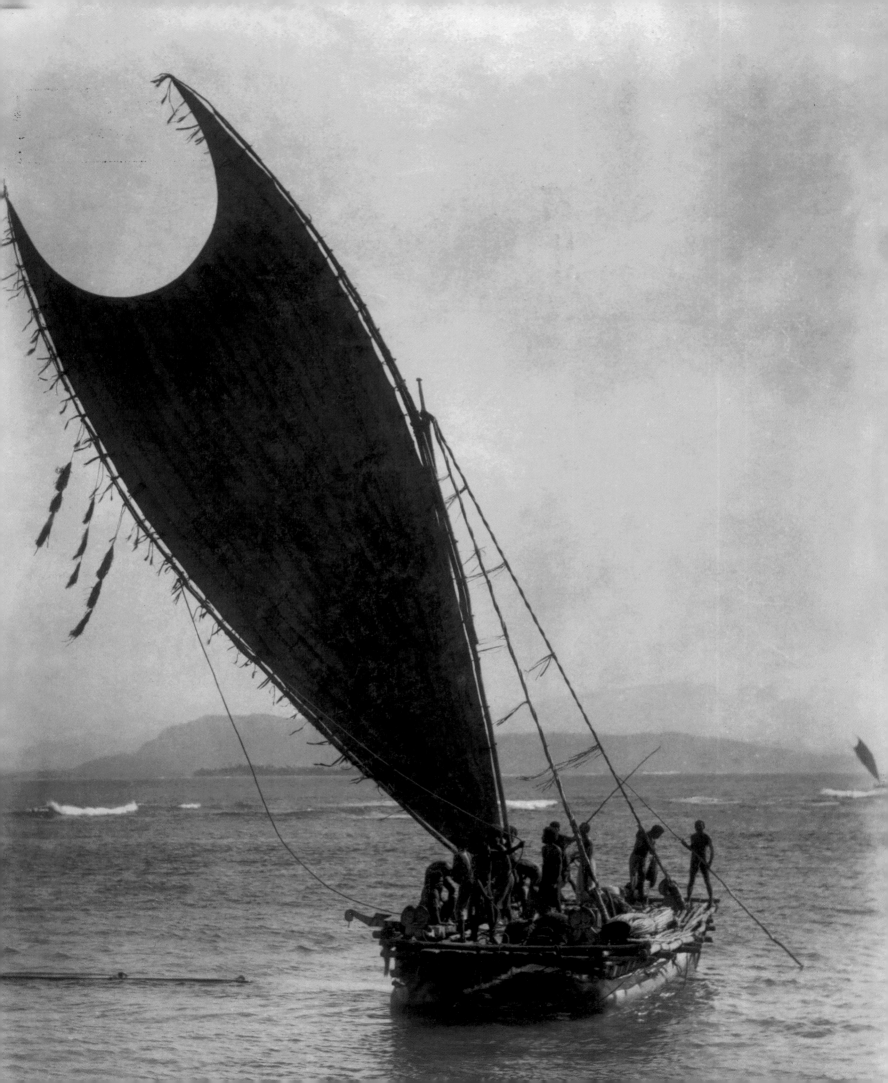

BERNATZIK

South Pacific

by *Kevin Conru*

with an introduction by
A. D. Coleman

Photographs
Hugo A. Bernatzik

5
CONTINENTS

Frontispiece
X3359. An intercoastal trading canoe (*lakatoi*).
Mailu Island. Papua New Guinea.

Front cover
X3182. Male Motu dancers
with kundu drums.
Mailu Island, Papua New Guinea.

Back cover
X653. A replica of a sacred bonito
canoe used as a personal feast bowl.
Owa Riki Island, Solomon Islands.

Editing
Annie M. Van Assche

Art director
Fayçal Zaouali

Layout
Maria Letizia Lo Bosco

© 2002 by 5 Continents Editions srl, Milan
info@5continentseditions.com

ISBN 88-7439-002-5

Table of Contents

Acknowledgements

I had always known the work of Hugo Bernatzik through two small books, both difficult to find and long out of print. I found *Südsee* in English, but the rarer (until Internet search engines dredged the world's bookstores giving split-second results) *Owa Raha*, long remained elusive, and as it was only printed in German, was not easy to read. Written word aside, I was most struck by the grainy black and white photographs that liberally abound in the two books. In my gray and rainy London rooms, they conjured up vividly the vision of a South Pacific, exotic, romantic, seductive, yet very real, and I felt as if the images were inviting me to go there.

Much later, when I had the opportunity to explore Bernatzik's entire photographic *oeuvre* more deeply, I was struck by his very systematic approach to his work. That which had taken my fancy as impressions of extraordinary people, beautifully photographed, was only enhanced by the respect that grew when I could see his larger picture. Page after page of the Wiener Werkstätte bound albums were filled with images, any one or sequence of which, could have been used to illustrate his narrative texts. I was smitten, and I am very grateful that Bernatzik had the special ability to carry me along with him.

I wish to thank foremost my dear friend Paul Asenbaum, who has shared so many aspects of this project with me. Without his very sensible Viennese advice and counsel, and his love of these photographs, this whole venture would never have been possible. I would also like to acknowledge Hugo Bernatzik's daughter, Doris Byer, who lovingly looked after Bernatzik's archive, documented it in a suitably serious manner and compiled so much disparate information. Her work has made my work easier. I would like to thank my brother, Andrew, and my good friend, Don Ellis, who both offered advise and support in their very practical style. To Pierre Loos, a big credit must go for breaking the ground with his fine book on Zagourski. It opened the door and gave Eric Ghysels and Marco Jellinek an extra impetus to do this book. I thank Eric and Marco for spending the time and effort to do a truly beautiful book, and for believing that there would be enough people in the world out there who would respond to these images as strongly as I did (I never had my doubts). A kind word of thanks must be said for Christina Thomas and David F. Rosenthal for their work in translating the more difficult parts of the original documents, and to Elena Cecchinato, who helped organise my manuscripts and is still no doubt typing away someplace upstairs. I am greatly indebted to Annie Van Assche for her tireless work on editing the sections of the text and for digging up all the many, difficult-to-find Bernatzik titles. Shining light into dark corners is her specialty. Finally, I wish to dedicate this book to Loed van Bussel, who in addition to taking me on my first trip to the islands of Melanesia, has probably forgotten more about the Pacific than most people, myself included, would ever know.

Kevin Conru
Brussels, 3 July, 2002

Hugo A. Bernatzik
The South Seas, an Introduction

by *A. D. Coleman*

Photography has unusual appeal to displaced persons—think of all the refugees, emigrés, and persistent, footloose wanderers among the medium's practitioners. But photography has also generated its own form of displacement—what Martha Chahroudi identified as "the time-displaced photograph."[1] The life and work of Hugo A. Bernatzik represent excellent cases in point on both counts.

Self-defined as a travel journalist, yet nursing ambitions that moved him well beyond the parameters of that job description, Hugo Bernatzik (1897–1953) spent several decades of his life immersing himself in cultures not his own, and bringing back detailed reports on the ways that other peoples lived. In some cases, he was the first European to observe and document the tribes he studied. He visited Spain, Albania, Central and North Africa, Morocco, the Solomon Islands, Papua New Guinea, Bali, Siam, and other countries, generating images that have been reproduced in countless periodicals and books up through the present day, to illustrate texts by himself and other writers.

He also authored fourteen books of his own, many of them translated from the German into numerous languages and published in multiple editions through the 1960s. In the 1930s and 1940s, he gave over eighty-five slide lectures at universities, museums, and other public venues across Europe, presentations that were widely reported in the popular press. His work was exhibited during his lifetime, and collected by museums of anthropology and natural history. Yet, at the onset of the new century, he enjoys no acknowledged position in any of the fields on which his life's work touches.

From a present-day standpoint, Hugo Bernatzik's extensive *oeuvre* demands consideration within two different but not unrelated disciplines: visual anthropology and documentary photography. Yet, weighing it by present-day guidelines proves not only retroactive but also anachronistic. Both of those now-intersecting disciplines had only begun to formulate their separate core understandings, principles and methodologies at the time Bernatzik produced the work before you, drawn from his account, in images and texts, of his time spent in the South Seas between the years 1932 and 1933.[2] While we have some exemplary projects and bodies of work in each of those two disciplines from that period, no clear or agreed-upon standard existed then, to which we can now hold up Bernatzik's investigations.[3]

Bernatzik would have known this about ethnography, a field in whose nascent version he had some formal grounding. In 1930, he decided to make a profession out of his love of travel. Enrolled in the philosophy department of the Wein Universität [University of Vienna], he took courses in ethnology given by Pater Wilhelm Knoppers, while also studying psychology, philosophy, Indian philosophy, anthropology and geography. Due to his extensive experience as a world traveller and his eight already-published books, he was granted his doctorate in 1932.

In achieving this, Bernatzik seemed to have coordinated all of his interests, and he found his true calling at last. Restless and rootless from childhood on, he had manifested an early interest in nature, apprenticing with a forest warden at the age of ten, and engaging in serious informal studies of zoology and botany in his teens. (Some of his first photography and writing concerned the subject of ornithology.) In 1915, at the age of eighteen, he volunteered to fight in the Great War, and served in Albania. Upon his return at the end of that conflict, he tried his hand at business, found it inhospitable to his temperament, and enrolled as a medical student at the University of Vienna, where his most distinguished professor specialized in anatomy. In 1920, he abandoned that venture too, and began a life of travel and adventure. In letters to friends then and thereafter, he spoke repeatedly of his wanderlust, and his horror of staying tied to any one place.

Both before and after his phase of formal study, Bernatzik's projects as a travel journalist, photographer, and ethnographer, not surprisingly, seem to have sprung from an idiosyncratic mix of professional and personal impulses.[4] As a photographer, Bernatzik was largely self-taught. He attended no schools or private courses offering formal instruction in photography, and no evidence suggests even that he used the then-widespread network of camera clubs as a source of informal tutelage for himself. Instead, he appears to have obtained whatever training he felt he needed directly from the various camera manufacturers whose equipment he used: K.u.K Hof Manufaktur in Vienna, Firma Voigtländer in Braunschweig, and the British company William Nesbit (which proved especially helpful with his flash photography).

Clearly, he chose his equipment carefully and well, knew it intimately (he had to perform all his own repairs in the field), and prepared thoroughly for each trip. On his 1927 voyage to the Sudan, for instance, he took along two Type E teakwood view cameras made by the Krupp-Ernemann Company in Dresden, with five different lenses (manufactured by Leica, Leitz and Voigtländer), as well as six Caminda single-lens reflex cameras; automatic flash equipment; two cases of magnesium torches; 1000 photographic plates (for the view cameras); and 10,000 metres of roll film for the SLRs. Hardly the outfit of even the most serious amateur.[5]

To the extent possible, Bernatzik had his toolkit adapted to the tropical climate, and in his writings often describes the painstaking protective measures (including heavy rubber bags) he used to ensure that equipment, unexposed film, and exposed negatives survived the extremely high temperature, humidity, and other perils of his journeys. Because he did not do his own film developing in the field, but commissioned the Felix Leutner Company to handle that (and to store his negatives) upon his completion of any expedition,[6] any malfunction could go undetected for months and result in the ruination of large numbers of exposures. His consistent return from difficult working conditions with scores of expertly made and undamaged negatives in itself represents a technical triumph of no small measure.

Not that this would have mattered much had his images proved inept or humdrum. But that is far from the case. However he acquired it, Bernatzik's craft expertise was placed at the service of a vision that had as its ultimate goal the empathetic rendering of ways of life not his own. Some of his imagery seems primarily evidentiary, recordative of quotidian activities. But other pictures demonstrably seek to evoke the ethos of the cultures they describe, to convey something of the feeling-tone of the individual and the collective lives they limn. The best of these—and they are many—can stand alongside the finest classic documentary photographs of that era.

Yet, despite all the obvious efforts he put into making his photographs, it appears unlikely that Bernatzik would ever have thought of himself as a photographer, per se. In his own view, he oscillated between the role of daring, eccentric travel writer—a Bruce Chatwin or Tobias Schneebaum—and that of freelance ethnographer. Indeed, looking at a book such as his *Owa Raha* (1936), with its photo-

graphs of South Seas island life, its numerous drawings of tools and other artifacts, its extensive discussions of mythology, social organization, language, and related matters, the analogue that springs most readily to mind is that of Edward Sheriff Curtis, whose immense survey of the Native American tribes had just recently been resolved, when Bernatzik published this book and its companion volume on the South Seas. Some commonalities between them are as follows:

Bernatzik's projects were largely self-defined and self-sponsored,[7] involving no supervisory committees or other authorizing agencies.

His polished photographic style incorporated elements of pictorialism—most notably the use of selective focus to eliminate distracting background elements. Structurally, many of his images correlate closely to Curtis's.

Bernatzik, too, made an unsuccessful attempt at producing a documentary film.

His interest in the peoples he visited extended far beyond what would then have been considered their "picturesque" aspects; he concerned themselves with how they lived, what they believed, and why they did what they did. Hence the larger projects in which he imbedded his photographs contain extensive annotation of diverse aspects of these cultures, and are as notable and rich in their written aspects as in their photographic components.

Bernatzik saw these peoples as "disappearing" races, already contaminated or soon to be overtaken by western civilization—and mourned what he anticipated would be their inevitable passing, because he admired the integrity of their cultures. For that reason, he was determined to record as much of what he called their "material culture" as he could, along with their legends and history.

He maintained an uneasy relationship with the field of ethnography—from which he sought recognition and acceptance and learned much, and to which he surely contributed in his way, but which viewed him as a mere popularizer.

What can we make of this set of parallels? Did Bernatzik himself know of Curtis's work, or feel the influence of any of the competing photographic tendencies of his own era? Impossible to say, or even to guess, at this juncture (though copies of the Curtis *magnum opus*, *The North American Indian*, were surely available to him through the libraries of various institutions to which he had access). No evidence so far suggests a connection with, involvement in, or even awareness of any of the prominent movements in photography of his time (Bauhaus, Neue Sachlichkeit), although, for a literate intellectual, it would have been hard to avoid some knowledge of a medium then in ferment. For all intents and purposes, we can consider Bernatzik as existing outside the history of photography until the appearance of the present volume.

From extant documents, including his surviving correspondence, we learn that, in addition to his studies, he had other links to the field of ethnography. From his teens on, he had a strong connection to the Naturhistorisches Museum [Museum of Natural History], Wein, and the Museum für Tierkinde [Museum for Zoology], Dresden. A 1927 meeting in Sudan with the British ethnologist, Dr. E. E. Evans-Pritchard apparently had a profound impact on him, and such figures as Fritz Krause, Director of the Museum für Völkerkunde [Museum for Ethnology], Leipzig, and Dr. Bernhard Struck at the Landesmuseum für Archäologie und Vorgeschichte, Dresden [Museum for Anthropology and Prehistory, Dresden], supported his work. (Regardless of his lack of formal training in photography, his pictures were unparalleled in terms of their technical quality and subject matter.) Yet he does not appear to have served as a reference point in ethnography or visual anthropology in his own day, nor has he become one since. There, too, he is an anomaly, a wild card—a member of no school, a follower of no particular tendency, a professor at no university, an independent and unaffiliated scholar in a discipline that was assiduously academicizing itself.

Which is to say that Hugo Bernatzik appears to have made a lifelong habit of not fitting in— a

form of self-willed displacement. As previously mentioned, Martha Chahroudi introduced the concept of "time displacement" some decades ago to identify a phenomenon peculiar to photography: that of an individual photograph or even an entire body of work that, for any of a number of reasons, does not register itself within the medium's field of ideas at the time of its initial production or public presentation, but instead first coming to our attention and evaluation decades after its creation. Apparently, though it is much less frequent, this can also happen even in a field of social study such as ethnography.

Positioning such work within the history of photography (or visual anthropology) so long after the fact of its original making necessarily involves generating an unverifiable hypothesis: What might this work have meant to its maker's contemporaries in the field and those who came after, had they known of it? And how might it have affected the audience's perception of the medium in its own time? Those crucial questions go to the very heart of the critical tradition, which the late Hugh Kenner defined as "a continuum of understanding, early commenced."[8] Further scholarship may recover for us some long-buried information about how documentary photographers and ethnographers saw Bernatzik in his own day, but his work dropped off the radar screen of visual anthropology long ago, and only now finds itself introduced for the first time to the international audience for photography. So, in neither case can we reconstitute anything resembling "a continuum of understanding." In place of that, as Kenner suggests, we will have to reinvent Bernatzik and his work.

This monograph, the first in a series, represents a beginning. Bernatzik's now-rare books are still eminently readable; perhaps someone will see fit to reprint them. They may seem dated to some, but that adds a certain charm to them for the lay reader. They may also be found by today's researchers to contain important information available nowhere else. Certainly his remarkable and durable photographs do. The best of Bernatzik's images, like the best of Curtis's, stand by themselves, autonomous and iconic, speaking to us across time about people who lived less than a century ago, yet came from ancient cultures that have changed irrevocably in a mere seventy years—telling us of them in the distinctive voice of an inquisitive and highly observant man who thought it would prove useful for us to have his first-hand account of what we were all about to lose.

Notes

1 Martha Chahroudi, "Contemporary Bias and the Time-Displaced Photograph," *Afterimage,* May-June 1977, pp. 39-40.

2 He published two books based on that exploration: *Südsee: Travels in the South Seas*, (London: Constable & Co., 1935) and *South Seas* (New York: Henry Holt, 1935), an engaging narrative of the entire trip aimed at a general readership (published in German in 1934) and *Owa Raha* (Wein: Bernina-Verlag, 1936), a much more formally structured and ethnographically oriented work that concentrates on the Solomon Islands.

3 For more on this subject, see the essay, "Edward S. Curtis: The Photographer as Ethnologist," in A. D. Coleman, *Depth of Field: Essays on Photography, Mass Media and Lens Culture* (Albuquerque: University of New Mexico Press, 1998), pp. 133-58.

4 The details of Bernatzik's life mentioned in this essay are drawn from the book *Der Fall Hugo A. Bernatzik* (Köln: Böhlau Verlag, 1999) by Doris Byer; I am indebted to Christina Thomas for an English translation of passages therefrom.

5 After 1927 he added Leicas to his array of instrumentation.

6 This collaboration extended eventually to the company's fulfilling orders for prints, an arrangement that lasted well after Bernatzik's death in 1953.

7 Bernatzik married a wealthy woman, which freed him financially to pursue his own interests, and also enjoyed what we nowadays might call sponsorship from various photo-industry sources, such as Leica, William Nesbit, and Voigtländer, who supplied him with test equipment for use in the field.

8 "Precisely because William Blake's contemporaries did not know what to make of him," Kenner elaborated, "we do not know either, though critic after critic appeases our sense of obligation to his genius by reinventing him. . . . In the 1920s, on the other hand, *something* was immediately made of *Ulysses* and *The Waste Land*, and our comfort with both works after 50 years, including our ease at allowing for their age, seems derivable from the fact that they have never been ignored." See Hugh Kenner, *The Pound Era* (Berkeley and Los Angeles: University of California Press, 1971), p. 415.

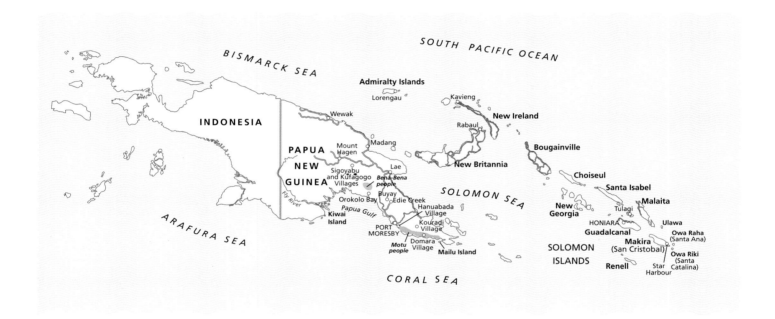

SOUTH PACIFIC OCEAN

BISMARCK SEA

Admiralty Islands
Lorengau

Kavieng
New Ireland

Rabaul
Wewak

INDONESIA

Madang

PAPUA
Mount
Hagen

NEW Lae
Sigoyabu Bena-Bena
and Kufagogo people
GUINEA Villages

New Britannia

Buyay

Orokolo Bay Edie Creek
Hanuabada
Village
Papua Gulf Kouradi
Village
Kiwai
Island

PORT
MORESBY
Motu Domara
people Village Mailu Island

ARAFURA SEA

Fly River

SOLOMON SEA

Bougainville

Choiseul

Santa Isabel
New Malaita
Georgia Tulagi

HONIARA Ulawa

Guadalcanal Owa Raha
(Santa Ana)
SOLOMON Makira
ISLANDS (San Cristobal) Owa Riki
(Santa
Renell Star Catalina)
Harbour

CORAL SEA

An Historical Perspective of Early Melanesian Photography: Hugo A. Bernatzik in the South Pacific

Kevin Conru

"An enormous sea turtle felt herself pregnant. To make a home for her young she built a little island to the south-east of the Solomon group, called by the natives today Owa Riki. Here the turtle bore two children, a boy and a girl, and named them Woikareniparisu and Kapwaronaru. As the children grew up, they became discontented with their home. 'Mother, take us to another place,' they said. 'Our island is too hot and too small. Barely enough coconuts grow here to satisfy our hunger.' The turtle did not answer, but the children saw that she went off in her canoe to the east. Then they asked her, 'Mother what do you do out on the open sea'? Again the turtle made no answer, but still sailed the way every day to a certain spot out at sea. And every time she had her canoe filled to overflowing with coconuts, bananas, yams, taro, legumes, and *nali* nuts, and without a word she sunk these precious things to the bottom of the sea.

One day the turtle took her two children with her and told them to cut hooks out of her massive shell. To these hooks she fastened long, tough lines made of palm fibres and got her offspring to cast them. At once the children felt a stubborn resistance and began to pull with all their might. There was a jerk and the empty hooks came to the surface. They cast the lines into the water again and this time they were lucky—the hooks held fast. But however hard they pulled and tugged, they could not bring their heavy, invisible catch to the surface. Then the old turtle came to their aid and with her prodigious strength she hauled the line in, and behold! On the water appeared a new island, much bigger and more beautiful than their despised home. The seeds of the trees, plants and field crops had struck root in the bed of the sea, and so the island covered with verdure and planted with delicacies, presented itself to the astonished eyes of the children.

Here at last the turtle children felt happy and here it was that a girl Kapwaronaru gave birth to the first human beings.

Men called the island Owa Raha, and just as it had once enchanted the turtle children with its luxuriance, so it lay before me, green and dazzling, as I landed one morning on its beach."

<div align="right">Hugo A. Bernatzik, Südsee, 1935[1]</div>

The first third of the twentieth century saw a marked change in the way the camera was used in Melanesian field studies. Many anthropologists and ethnographers used the camera to document people in a more scientific way than what was used in the heyday of the postcard/stereo vision period, when the emphasis was on posed exoticism for the tourist and travelogue market. Among the very first to incorporate photographs as a tool to help visually define his narrative texts was the Reverend George Brown. He resided in Samoa between 1860 and 1874, and in New Britain between 1875 and 1880. He often visited, in the course of his missionary work, the Solomon Islands, Papua New Guinea, and many of the other Pacific island groups. His early photographs reflect the nineteenth-century penchant for formally posed beauties and staged exotic warriors, taken either in studio settings, or in artificially arranged backgrounds. Later in Melanesia, his subjects were mostly photographed in their own domestic environments, though still mainly in formal group arrangements, or in static single portraits. Invariably, they were shown with identifying regalia and costumes, or in the case of most men, posed with the accoutrements of battle. Similarly,

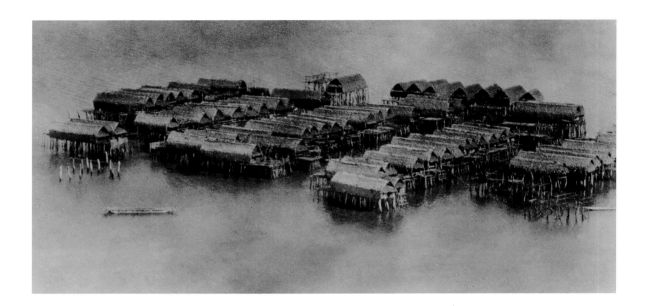

Richard Parkinson, in his *Thirty Years in the South Seas*, made extensive use of photography to help document the people of the Bismarck Archipelago. His published illustrations are almost exclusively that of groups of inhabitants, forward facing, either sitting, squatting or standing, and though while not necessarily posed or arranged, the viewer senses that the subjects were gathered together for each individual image. As in Brown's work, there is no real sense of action or movement, the author's emphasis being on the ethnographic detail of the subject, the costume, the ornamentation, or the manner of bearing. This singular attention to ethnographic detail as a prescribed method of vision was followed in the works of the important British anthropologists, A. C. Haddon, C. G. Seligmann and Robert W. Williamson.

A. B. Lewis, anthropologist for The Field Museum of Chicago, undertook between the years 1909 and 1913, probably the last large 'expedition period' exploration of Melanesia, making regional anthropological surveys and collecting vast numbers of artifacts. His field photographs, while strictly documenting the material culture and ethnography of the people he encountered, also began to break away from the more formal visual arrangements of his predecessors. Many of his illustrations, while not visually arresting (for he was not a trained photographer), began to allow his subjects the space in which to perform domestic activities without the camera interrupting the flow of action. Lewis's camera begins to be a more anonymous witness to the lives of the people he encountered, and the viewer senses Lewis's desire to show his subjects as they really were. These photographs were innovative in that they showed dancers as they really moved, artisans at ease with their creative work, and with ensemble images that have a much looser and more natural feel to the composition.

Malinowski, who again was not a trained photographer, but who studied his subjects assiduously and dispassionately, allowed his camera to perform the same silently observant role as his notes. He attempted, and sometimes succeeded, in capturing images of the ordinary, though, all too often, a sense of structural formality creeps in. This is reflected overall in the stern countenances and stiff postures that are a pervasive thread linking much of the interaction between the anthropologist-photographers and their subjects.

It was not until Frank Hurley, who was first and foremost a photographer, made two trips to

the Gulf of Papua between 1920 and 1923, that the camera played a central role in documenting the people, their environment and their customs. Hurley, now famous for accompanying Edward Schackleton on his ill-fated voyage to the South Pole and for taking a series of extraordinary images in the most adverse conditions, wanted to not only take still photographs in New Guinea, but also to make a full length feature film. The Purari Delta region provided him with the spectacular, large men's houses and fantastic mask forms that he required for his film—Hurley with an eye for flair was always looking for the most dramatic images. As a photographer, Hurley excelled at portraiture, capturing through his lens a very direct contact between his subject and himself. The viewer feels that his subjects are not reacting to the camera as a completely foreign artefact, but are indeed interacting with Hurley himself. Also, Hurley made exceptional use of natural lighting, creating depth to the images, which up until this time was lacking in field photography. Perhaps because of his cinematographic bent, and partly because Hurley's overriding interest was not strictly ethnographic, his images have a certain stage quality; this is especially so in the group pictures, as they are ordered in a way that seems totally authentic yet artfully, artificially arranged.

Hurley's film, *Pearls and Savages*, was a great success, running from October, 1924, for three months, three times a day at the Polytechnic Cinema Theatre on Regent Street in London. His book by the same title was equally well-received, and was also translated into German and Braille.

Finally, there remains the fieldwork and photographs of the Papua administration anthropologist, F. E. Williams. Williams, another Australian (as was Hurley) and Oxford educated, worked in Papua between the years 1922 and 1939. In contrast to Malinowski's aloofness and marked formal distance to his subjects, Williams was abundantly at ease with the people he encountered, and he had a desire to probe the personality of a sitter that was completely lacking in Malinowski's *oeuvre*. He found it useful, from an ethnographic perspective, and necessary, from the technical limitations of his cameras, to oftentimes reconstruct scenes of autochthonous life. While it is impossible to know exactly how much arranging of the subjects Williams had to do, his photographs also show a high degree of spontaneity and alertness that allowed him to overcome methodological hindrances.

It is certain that Hugo Bernatzik had a reference knowledge of all of these anthropologists' works, as they were widely published before Bernatzik embarked for the Pacific. One possible exception to this was, perhaps that of Lewis, who after completing his tour of Melanesia, returned to provincial Chicago, where he published two pamphlets on decorative arts of the region and later a guide to the museum. (His notes, diaries and photographs have only just recently been published.) As well, although it is impossible to say what specific influences Bernatzik drew from these sources, he no doubt knew what had been achieved both from literal anthropological interpretations, as well as what had been accomplished visually. He felt that while there were many fine studies conducted by British anthropologists on the southern coast of New Guinea—in fact, the modern school of British anthropology was formulated here—they had concentrated on the social and intellectual side of the indigenous cultures at the expense of material studies. In his mind, he hoped to offer a balance to that perspective.

By the time Bernatzik left for the Pacific in 1932, he had ten years of exhaustive experience in photographing several remote parts of Europe and Africa, and had written seven related books. Also in 1929, he made a photo-study of birds from the Neusiedlersee, a document which indirectly would have a profound bearing on how he approached his subjects later.

Bernatzik, above and beyond all previous Pacific photographers, managed to set himself aside completely, removing the photographer from the image and presenting the image in a so-called 'real time' experience. He seemingly made no demands on his subjects other than to let them completely

involve themselves in their own activities, and he managed to instill, almost immediately, a complete absence of self consciousness in his subjects. Bernatzik's images are without stiffness, sullenness or artificiality—a woman mourning is a woman mourning, a child crying is a child crying, a girl laughing is a girl laughing. Bernatzik also had a tremendous ability to frame his subjects, again without artifice, in a way which naturally allowed single people, couples or large gatherings to exist. He had a fantastic eye for movement, and an innate ability to capture movement that seems completely spontaneous. This ability, and the desire to seek out images which up until then were almost impossible to photograph—walking, running and dancing—was probably perfected by his training for bird and wildlife photography, when following a flighty subject and photographing it 'on the wing' was a very necessary skill. While never losing sight of the ethnographic meaning of an image, and being aware of presenting an anthropologically correct view, his paramount aim was always to allow the

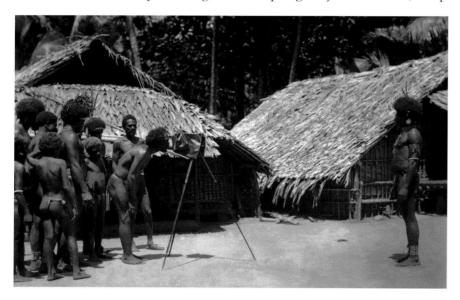

human quality of the image through. While approaching this in a direct, almost journalistic way, he particularly liked to document the interactions of his subjects between themselves. Subjects like children playing, musicians and dancers, amorous couples, fishermen, sailors and warriors, all needed the flawless, invisible execution of the photographer to capture and retain the immediacy of the image. Interestingly, a sense of lightness also comes through his images, both in texture and composition. Whether this comes from the truly natural expressions of the subjects, the overall sense of movement, or whether by a pattern of technique, this mood strongly contrasts with the pervading heaviness which so often characterised prior photographic works.

Hugo Bernatzik first planned his trip to the South Pacific with the knowledge that there was a fellow German-speaking resident on one of the remote outer islands of the Solomon group. It turned out that the man, a former ship's officer, had lived there since before the First World War, in the Star Harbour region of Makira (San Cristobal) and later on Owa Raha (Santa Ana). Henry Küper had married into a high-ranking family, and in time, became a chiefly individual himself. Küper's reputation, even in far away Austria, was that of a recluse who, to the best of his ability, attempted to keep external influences, such as Chinese traders and missionaries, away from his home island. This information intrigued Bernatzik because he needed, as an ethnographer, to work amongst people who had not only not lost track of their traditional ways, but even possibly were encouraged to keep their customary structures intact. Küper, for his part, not only kept traders and missionaries at bay, but also did not welcome visiting Europeans outside of the colonial government's officials.

Fortuitously for Bernatzik, upon his arrival at Owa Raha, Küper and his wife, Kafagamurirongo, were both taken ill, and the medicines that Bernatzik brought with him evinced a quick recovery for both of them. Küper showed his gratitude by allowing Bernatzik to stay in his village and more

importantly, by introducing him to the islanders as a fellow clansman. This proved invaluable, as Küper's introduction put the relationship between Bernatzik and the inhabitants immediately at ease, and this allowed Bernatzik access to not only public customs and ceremonies, but it also gave him the chance, with Küper's translations, to delve more intimately into the information which was held by the island's elders and priests.

After becoming settled on Owa Raha, and after conducting field work in the vicinity of Küper's residence, Bernatzik moved to the village of Natagera, in order to work more closely with the residents without any interference or guidance. He had befriended Natagera's *Mwana Apuna*, or chief priest, and knew that he would help him win the villagers' confidence. Throughout his stay in Melanesia, Bernatzik was constantly aware of the people around him and the need to integrate socially. He made a point of listening to the older men, regardless of whether it was about a deeply

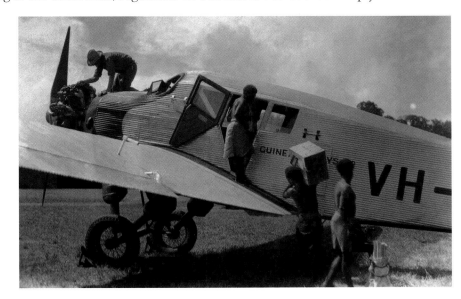

spiritual matter or a simple mundane discussion. He won the confidence of the women by admiring their children, and by playing their games. He wrote:

"It was delightful to watch the children on the beach, where they enjoy themselves at all hours of the day, and to see them ride the crest of the waves on narrow planks and then, laughing all the while, shake the glistening water from their elegant dark bodies. The tiny tot is hardly weaned before the group of children on the beach take him up. The boys built castles and hunt for shells and sea creatures; often there is a wild scrimmage—they are playing war. Divided into clans, the youngsters charge down upon each other and prisoners are taken and carried away, strung up on a long pole like pigs. They are to be eaten. Curiously enough, the older ones take care that no one is hurt. How easily can such a game go too far! Yet during the whole of my stay I only once saw a child start to cry." [2]

While in Natagera, Bernatzik documented many aspects of the islanders lives and environment. The most sacred buildings on Owa Raha and the adjacent islands were the canoe houses. These buildings were the focal point for the entire community, serving not only as structures that housed the sacred bonito and war canoes, but also as the repository for the bones and skulls of the ancestors, ritual centres of worship for the tutelary and protective deities, and more prosaically, a place for meeting and spending time with one's friends and companions, the equivalent of a Papuan men's house. The buildings were quite large—about sixty feet long and twenty five feet wide. The gabled roof was supported by five rows of posts, the height of the central row being about fourteen to fifteen feet tall. These posts were carved as guardian deities, often as sharks, surmounted by human figures. On Owa Raha (but not on Owa Riki), the rafters of the canoe houses held carved wooden caskets that contained the bones and skulls of the honoured dead. Bernatzik took many photographs of these bonito-shaped reliquaries and noted:

" . . . after about three months the bones of important men are dug up by night, cleaned, wrapped in tree fibre and laid on the middle stand of the sacred house. Then a pig is slaughtered to pacify the spirits' anger over the exhumation. The priest of the clan to which the dead man belonged cut a piece of meat from the neck of the pig and roasted [it] on the sacred stone in the middle of the Aofa, (canoe house) so that the smell of the food fills the whole house. The fragrant smoke must play round the great wooden fishes in which the skulls of the departed are kept. Then the ancestors will know that they are remembered and their spirits will watch over the people.

In the course of the next month a large wooden fish is carved by the best artist of the village and inlaid with shells. If the dead man belonged to the shark clan—that is, if he believed that he was descended from the shark—the wooden fish has that shape. Otherwise it is generally a wooden tuna.

After another six months, if possible at the time of full harvest, a great feast is held and the dead man's bones are finally given their appointed place in the Aofa, which they again leave. The skull and jawbones are placed in the fish and hung up on the stand in the Aofa."[3]

Most importantly, the houses held the sacred bonito canoes. The bonito, a type of tuna, most often appears in large schools. These schools are seen irregularly, only during one season of the year, when the fish they feed upon also school. Not only are the bonito attracted by the schools of small fish, but so are large numbers of several species of fishing birds, gulls and frigate birds among them, that feed on the same bait. Around the fringes of the schools lurk hundreds of sharks which feed upon the bonito. The combination of bait, bonito, birds and sharks produces a phenomenon that the islanders regard as an awesome manifestation of their powerful tutelary deities. According to their pagan religion, the bonito are believed to be under the absolute control of some of these deities. Bonito, too, is considered to be the most delectable of all fish, and the appearance of a school is a valuable gift to humans. But schools of bonito are as unpredictable in their occurrence as they are nervous, when a fishing canoe is in their midst. They appear without advance notice, they disperse suddenly without warning, and always with them are the most vicious of sea creatures—sharks. The bonito school, thus, has three salient characteristics: it contains one of the most valued of all seafoods in vast quantities; it is unpredictable and subject to quick change; and it attracts animals that can kill or maim humans. These three characteristics, generosity, fickleness and danger, seemed to be the same features of temperament ascribed to the tutelary deities. The bonito schools reflect these, since they are a manifestation of the deities. The appearance of schools of bonito have still another significance. If they appeared regularly, then relations between the deities who control them and mankind, are amicable; if they do not appear regularly, then relations between the societies and its tutelary deities are strained. The bonito school is a kind of barometer that indicates the state of the relationship between societies and the supernatural.[4]

On Owa Raha, Bernatzik noted a very powerful spiritual vision of the priest in relationship to the bonito. After many seasons when the bonito school failed to materialise, an especially respected and beloved chief died. When his skull was ritually placed in the *aofa*, the priest of the clan decided to appeal to the deceased spirit, and to ask for assistance in a successful hunt. The priest fell into a trance, and through the dead chiefs words, said "Towards dawn, sail out to sea. On the third day, in the early morning, you will see plenty of *waiau* (bonitos)."[5]

As it was monsoon season, and the heavy skies and seas announced the impending arrival of a typhoon, the islanders normally on no account would venture out, especially in the extremely fragile bonito canoes. But at the priest's urging, they raced out of the canoe house with the lightly-built boats, and put them into the heavy swells. The first day passed without a sighting, as did the second.

On the third day, shortly after sunrise, the fishermen came upon a vast school of bonito fish, and they returned safely to Owa Raha with their boats full to overflowing.

Bernatzik was very fortunate to have been on Owa Raha at this time, because the young boys' initiation ceremony, which was not held annually, was going to take place. Amongst the most important events in the life of the community, each boy must go through a long initiation that introduces him to the mystic milieu of the bonito. The initiation commences when a group of young boys meet the sacred canoes coming in from a successful catch. Each boy is taken into a canoe, where he embraces one of the fish and comes ashore with that bonito as if he had caught it. The supernatural forces within the bonito are transferred to the boys by a ritual drinking of a few drops of bonito blood. Then for a period of six months, the boys must live in the sacred canoe house, isolated from women and the ordinary activities of community life. Their return to community life is marked by a large celebration in which the boys, decked in adult finery, are paraded up onto a platform where they are briefly shown off to the receiving villagers. The platform itself is a major artistic effort, upon which many weeks of labour have been expended. Following their debut, the initiates are ritually desacralised, a feast is given to celebrate their re-entry into the community, and they resume their lives in a spiritually transformed state.

Bernatzik eloquently captured the women's dance, celebrating the return of the bonito canoes, and took portraits of many of the participants in their finest jewellery. This jewellery, consisting of beaded belts, gorgets, arm and leg bands, and head, nose and ear ornaments, was made from *tridacna* and nautilus shells, cowries and dog's teeth. They were important heirloom items, passed down from generation to generation, and they conferred on the wearer great wealth and status. The *tridacna* shell nose ornament, in particular, was a sign of high rank, and could only be worn by individuals of chiefly families.

Bernatzik's extended stay on Owa Raha also allowed him the time to record the interaction of peoples from outside the confines of local clans and village members. Islanders had close, yet often difficult relationships with their neighbours and always, even in the early twentieth century, had to be alert for adversarial situations. On Owa Raha, he witnessed the arrival of a war canoe sent from a nearby island on its maiden voyage.

"One morning the strange war canoe appeared on the horizon. Since the natives did not know at first sight whether to expect a friendly visit or an attack, they blew their conch shell trumpets and alarmed the whole island. The warriors hastened from all sides and took the precaution of arming themselves for battle. They carried their weapons with them and painted their dusky bodies with white war paint. The war chief took command and [on] his order they hid themselves behind palms at the beach.

Slowly the strange canoe drew near. At the paddles sat young warriors, at the prow the chief and the priest. The priest sat with his back to the bow, facing the paddlers to encourage them, while

the chief had his back to the priest to face the enemy, for he was responsible for the success of the voyage. Before the canoe touched the shore, the crew lowered their paddles and the Mwane Apuna offered betel nut. The boat then began to rock, the sign that no ambush threatened ashore and they might venture to land.

Wasia, the chief of the warriors hidden on the beach, now stepped forward to the boat. He had long since recognised that this was no attack but a friendly visit, and he held out four strings of shell money as a gift of welcome to the arrivals. At that moment, the warriors rushed out of their hiding to intimidate their guests with a show of attack. They had little success, however, because the gift of shell money had meant permission to the warriors of the strange canoe to land. They took no notice of the attack, sprang overboard and with shouts lifted the heavy plank-built boat out of the water. They then held it above their heads, hurled it several times into the air to show their strength, and finally pulled it onto the beach."[6]

After completing his work on Owa Raha, Bernatzik visited the nearby island of Owa Riki (Santa Catalina). Smaller than Owa Raha, and difficult to reach except by the smallest of canoes—Owa Riki is surrounded by difficult reefs and heavy swells— Owa Riki was spared the predations of foreign traders and civilising influences of missionaries, thus allowing for the preservation of ancestral custom. It is an island with little cultivable land, and therefore a tradition of trade and barter developed between it and the people of Makira. Upon their return to their home island, the men were welcomed with general rejoicing and by various dances of celebration. In addition to the sexually-charged maiden's dance, the dance of the frigate birds and sharks was also performed. It is a dance steeped in spiritual tradition, and was taught by the ancestors to their old priest. Bernatzik watched this dance and noted:

"About sixty magnificently decorated young fellows appeared. One of them had a broad mask made of strips of coconut leaves, bound round his forehead. He stooped forward and with bent elbows imitated the dorsal fin of a shark. His whole body twitched this way and that, like a fish that has strayed into shallow water. The others played the frigate birds and circled around their prey. They knew it could not escape them. More and more frantic grew the birds' movements, closer and closer drew the circle.

To one side stood four men singing a monotonous chant. It represented the sound of the eternal breakers in strict, repeating rhythm, the streaming backwards and forwards of the water, and the dash of the hissing, incoming waves. No better accompaniment for the dance of the frigate birds could be imagined. The shark struggled with all its strength to escape, but in vain. The bloodthirsty birds encircled it ever closer till, after many exhaustive attempts, it lay dying on the ground in the centre of the victorious, whirling brigands.

So exactly did these nimble youths imitate all the characteristic movements of the frigate birds, that I could scarcely believe I was watching human beings. But these were people of faith, who entirely forgot themselves, so absorbed were they in the dance their priest had given them."[7]

Bernatzik also travelled to Makira Island, where he photographed, under difficult technical conditions, a green sea turtle hunt off the coast of Funukuma village. He followed the fast-moving chase on land, on sea, and then back on land, when at the conclusion, he took the famous dance-of-victory photo. Also in Funukuma, he photographed a young boy being ritually tattooed in the manner of his specific clan. The tattooing was performed by a ritual specialist, the complicated pattern etched into his skin with a sharpened bird's bone. While it must have been extremely painful, with the cuts

oozing blood, the boy—in an effort to become a worthy clan member—made no sound whatsoever.

After several months of living in the southeastern Solomon Islands, Bernatzik decided to visit the supposedly untouched island of Choiseul. Choisel lies to the northwest of Makira, and is one of the largest islands in the archipelago. His information, from the government station at Tulagi and from knowledgeable independent traders, all confirmed that the island had never been explored, and that virtually nothing was known about its inhabitants. He was, therefore, greatly taken aback when after navigating with extreme caution through the uncharted reefs that lay off the island, he arrived at a very European-looking village complete with well-dressed English-speaking greeters. He was readily informed that all the villagers were now devout Christians, belonging to an American religious church (most probably Seventh Day Adventist or Mormon), and that there were no people left in the interior, as they all had either died from imported diseases, or had been relocated to the coast. Although disheartened, Bernatzik did explore the interior in the hope that he may encounter at least the vestiges of pre-contact life. He became even more despondent when all he could find were numerous abandoned villages with crumbling stone walls and overgrown gardens. With the help of one of the last remaining elders acquainted with the past, he did, however, uncover beneath the undergrowth, a number of remarkable stone burial urns that even the elder could not date. (The example that Bernatzik collected is now in the Museum für Völkerkunde, Basel.)

Weakened with malaria and framboesia, Bernatzik decided to leave the Solomons for Australia, where he planned to recuperate and plan the next portion of his voyage. While in Sydney, he learned that gold prospectors had recently encountered unknown people in the interior of New Guinea. That, and the knowledge of the many interesting inhabitants along the southern coast, prompted Bernatzik to book his passage to Port Moresby, the administrative capital. Gold was discovered only two years earlier, though by 1933, the field at Edie Creek was the largest in the world. Remarkably, the people in the interior of the island had little contact with the coastal dwellers for centuries, and none with the outside world. Bernatzik was the very first ethnographer to visit this region, arriving three years before the territory's own ethnographer, Williams, did in 1936. It does seem unusual that, after forty years of extensive field studies conducted by the greatest minds in British anthropology along the whole of the southern coast of New Guinea, only fifty kilometres inland there were over half a million unknown people, living in cultural conditions that greatly predated anything discovered up until then. While the words "stone age" may, in some cases, have been too loosely applied, the inhabitants in the interior had no metal-making traditions, marking people of the bronze and iron periods. They worked exclusively with stone head axes and weapons, and had larger celts for ceremonial purposes.

It is often commented on how a whole civilisation could exist not only undetected, but to have evolved in such dramatic isolation from nearby cultural currents. While the answer is complex, a few points are self evident. Papua New Guinea has a varied population that speaks over 700 different languages, languages as distinct as English and Hungarian. This figure, considering the geography, is enormous. In the remote interior, only a few neighbouring villages and clans spoke the same language, so there was a large mosaic of language groups—each culturally related, but unable to communicate with each other. Out of this isolation stemmed a constant friction between people, meaning that many groups were in some form of open hostility, or even war, with each other. This was so deeply embedded in the psyche that the whole method of combat and killing became ritualised and was perpetuated. As the extreme fertility of the land and climate made for a high degree of agrarian self-sufficiency, the pastoralist's need for movement was absent. The inhabitants had no need to move beyond the safety of their very small worlds, and to do so

would invite death, as every stranger was an enemy, and enemies were to be killed. Trade, therefore, was highly restricted and like all other intergroup relations, became ritualised. Goods to be exchanged were often placed on neutral ground, to be replaced with the desired goods by the pre-arranged trading partner. Goods passed along from village to village this way, with groups in the centre of this nexus unable to trade with the residents on the external borders. Most of the population had never seen the ocean nor had any idea that it existed.

Bernatzik, like Williams and other later European visitors, was amazed that in this supposedly empty region, there were so many well-ordered villages, all built along the steppes of the mountains, and stretching as far as the eye could see. He also noted the extensive, well-cultivated gardens that spread between the villages with a wide variety of crops, vegetables and flowers. The first place Bernatzik visited was Sigoyabu village in the upper reaches of the Purari River, near Mount Hagen. Here he encountered the Bena-Bena people who had never seen a white person, and he was mobbed by the inhabitants who all wanted to touch his skin and clothes. After inspecting the village, Bernatzik began taking pictures, and the process amused rather than startled the villagers. Carelessly, he threw the papers that separated the films on the ground, where they were eagerly sought as hair ornaments. Not wishing to create advertising for Agfa, he stuffed the papers in his pocket, until he passed a fire where he disposed of them. A scream went up, and a villager dashed to the fire to pluck out the papers. Apparently, they thought that Bernatzik, after imposing their pictures on the paper, was trying to harm them by some form of magic, by throwing their images in the fire. Realising his mistake, and the danger it put him and his companions in, he immediately thought to offer an antidote to the perceived magic, by making them believe that they had won back power over him. He tore out a tuft of hair and offered it to the group of angry-looking warriors. After a disconcerting moment, the chief warrior grinned, realising what was being offered, took it, and told the rest of the assembled company to do likewise. Bernatzik wound up sore but alive, and with the trust of these people.[8]

While the episode does sound a bit like a 'boys own' adventure tale, it illustrates clearly the incredible barriers to communication, not only in language, but also in every facet of life.

In Sigoyabu, Bernatzik noticed that the warriors wore strangely twisted flexible cords around their necks, so he asked what they were for:

"Several of them moistened their cane with saliva and began to swallow it with strangled, gulping movements. They started in the middle, so that they held the two ends of the cane in their hands all the time. They swallowed and gulped, and seemed to be keeping down a hardly repressible impulse to vomit, while their eyes bulged out of their sockets. At last, the bent cane had reached the stomach. The two strained and quivering ends pulled the half-open mouth to hideous grimace. I was thus witness to one of the forms of self-torture, through which the young warrior proves his self-mastery and thereby his worthiness to be received into his clan."[9]

Bernatzik also photographed a woman in the dress of mourning, in the neighbouring village of Kufagogo. After the funeral, and for a period of several months, the widow shaves her head, and smears her body with ritual clay, or in some instances, black ash. In this area of the Bena-Bena, the widow keeps her deceased husband's skull in her woven-fibre net bag. In other regions, the widow (or widower) must exit her (or his) dwelling by a back or secondary exit, and remain completely covered beneath a bast-fibre hood. There are prescribed foods for the period, and all of the restrictions are not fully lifted until a final commemorative feast is held.

An aspect of the Highlands society, which was evident everywhere Bernatzik looked and which

remained a problem for successive generations, was that the numerous clans and villages were almost always in a state of war. On his short trip, he passed several villages which had recently been burned down, and had been scavenged by the victor's women and children. Often he had to skirt around these blood feuds, and he regularly encountered groups of armed warriors on their way to, or from, a skirmish. Bernatzik noted that, in the ranks, there were not only boys of eight or ten years old fully painted for war, but also that some of the warriors were carrying sons as young as two or three. Williams also noticed the prime importance of the father-son relationship in Kutuba society. Young boys pass into the care of their fathers from about the age of two, and for the rest of their boyhood, until the rites of adulthood are undertaken, they are inseparable.[10]

After returning to Port Moresby, Bernatzik decided to visit East Papua and photograph the Motu people who lived along the coast. He first visited the island of Mailu, which lies about twenty kilometres off the mainland, and he photographed the islander's singular houses with their narrow gables and decorative roof finials. He also documented domestic activities, and in particular, the making of pottery vessels, the Mailu people's most renowned craft and trade item. Most importantly, Bernatzik hired one of the island's large ocean-going trade canoes, called *lakatoi* (or *ouro*), for the 250 kilometre return voyage, a trip that would allow him to stop and record at will. Because of the limited agricultural resources on Mailu, the inhabitants devised a system of trade, which due to their superior navigational skills, grew into a large intercostal enterprise. They not only traded their beautifully made clay vessels, used throughout the coast for cooking and storage of foodstuffs, but they also traded a variety of commodities between many ethnic groups all along the coast— from the Trobriand Islands in the east through to the extreme west of Papua along the Fly River. The annual trading season began in July and August, and the Mailu traded betel nut for pottery in the area of Aroma. Later, they traded sago bundles, shells and animals, always using the surplus as leverage for the next deal. Williams noted the procedures for the exchange of goods from the viewpoint of the Purari people, some 500 kilometres away from Mailu:

"When word is brought that the *Lakatoi* are on their way up the river, the villagers sally out in their canoes to meet them, come aboard, and help at the oars, thus conducting each particular craft to its correct destination. Upon reaching the village, the *Lakatoi* anchors opposite the Ravi, or men's house, and the members of the crew make presents of knives, axes, arm-shells, boars' tusks, and the like, to the villagers, who kill pigs in return. That night there is great feasting among the Motuans.

Probably the next morning swarms of villagers come alongside in their canoes, and the pots are delivered. The Motuans, in order to make themselves comfortable for a long stay, now proceed to sink piles in the river-bed, make their craft thoroughly secure, and build a roof over the whole of it.

Meanwhile the villagers have gone up into the bush to remain a considerable time preparing the large tree-trunks, which are to serve for dug-outs (Motu: *asi*). When these have been floated down they are hollowed out by the *Lakatoi* men themselves while the villagers take a spell.

The hollowing of the logs having been completed, almost the whole of the village—men and women—migrates into the bush in order to prepare the great quantities of sago which are to pay for the Hanuabada pots and pans. The visitors meanwhile are left to lash together the newly made *asi* and to rig the *Lakatoi*.

When some Purari man coming into the village, perhaps with food for his friend, observes that the mast is already erected, he carries this news back to those in the bush, and they will gather their sago together and return. The lots of sago are handed over by the villagers to their respective friends in return for the pots they have received.

Tallies (*kai*; Motu: *kahi*) are made on the occasion of first accepting the pots. These are merely small pieces of the mid-rib of a palm leaflet, and they are broken off in duplicate, so that for every pot received there are two pieces of equal length, one of which remains in the hand of the *Lakatoi* man, the other in the hands of his Purari friend. These tallies are less in the nature of a receipt than of an aid to memory. The native in the bush can possibly neither recollect nor even count the number of pots he took over, and he must know how many lots of sago are owing. There is, one is told, nothing but straight dealing in these transactions. The packages of sago having been satisfactory compared with the tally are now packed into the *Lakatoi*. Numerous gifts of banana, taro, betel nut, &c. [*sic*], are made to the visitors; and when all is ready they take their departure, accompanied to the 'big water' by the villagers in their canoes. That night they probably accept further presents of cooked food, and in the morning set sail for Hanuabada.

In all the *Lakatoi* may remain as long as five months. During that time the visitors sleep on their vessel, and on the whole keep rather to themselves; they are said to have no intercourse with Purari women."[11]

Bernatzik was greatly taken by the stateliness of these crafts, with the single crab-claw sail and double dug-outs bound by a platform. In spite of their apparent fragility, the entire construction was made without metal tools, using only indigenous materials, and the great *lakatoi* could attain the speed of a steamer and weather even the most violent of squalls.

Bernatzik interrupted his coastal journey to explore the interior region around the government station of Abau. He landed at Domara village, fifteen kilometres further west and began to trek into the interior. Passing through the coastal plain, he ascended into the Owen Stanley Mountains, changing bearers as he entered and left different language groups, until he arrived at the largest village in the area, Kouradi. This village, and the rest it offered, gave Bernatzik a chance to make some interesting observations regarding kinship, funeral customs, dress, and ubiquitously, inter-tribal warfare. He was beginning to return to the coast, and the rainy season had begun in earnest. He feared being cut off on his return by the flooding rivers, when he was told that an important feast was to be held shortly, and that the inhabitants of other related villages would attend to take part. It was a rare occurrence, so he decided to stay and risk the chance, not only for good photographs, but for the safety of his return. He wrote:

"The day of the feast arrived and for the first time since I set foot on the bushmen's land my tent was not surrounded by an inquisitive crowd, for they were all busy decorating themselves for the feast. In the morning the guests from the neighbouring villages arrived. With bag and baggage they rolled up, the women heavily laden with provisions. Their large carrying nets formed great balls, on the top of which sat enthroned the children, puppies and piglets they did not want to leave behind. The men carried drums and weapons.

The festal ornaments that now met my gaze surpassed the wildest fancies. The wide-spreading headgear which hung down below the waist was made of bird-of-paradise tails, hornbills' skulls and finely carved pieces of wood and shells. Coloured strips of opossum skin decorated the body and shining breast ornaments of strange fruits completed the wonderful picture.

The dances started with imitations of animals. I at once recognised the pairing of the paradise birds [*sic*] by the measured, swaying steps. Then to the rhythm of the drums, hunters with drawn spears stole upon their quarry. And was not this animal that rose up, then with great bounds took cover behind a tree and sat on his haunches, a kangaroo? Only the long tail was missing; the movements were perfectly represented.

Now followed a war dance. With raised spears two warriors danced around each other with threatening gestures that were effectively emphasised by the beat of the drums. Just then came for me what was the pleasantest point of the day. For a moment the sky cleared and with my Tessar lenses I was able to take a number of excellent photos."[12]

Bernatzik finished his stay in the Pacific by continuing on up the coast. He made a brief stop in Kerepuna, where he photographed an unusual death dance which commemorated the victims of a very recent, violent epidemic. He also stopped at Gaili village, where the Motu women and girls were renowned for their exquisite tattooing. After staying a few days in Port Moresby, he boarded a Dutch steamer heading for the Indonesian island of Bali.

In total, Bernatzik took about 3,500 photographs in Melanesia, a phenomenal sum considering his relatively short time there, and given the physical restraints of working in a tropical environment. He wrote two books chronicling his work there, both of which included many of his best photographs. The first, *Südsee*, was originally published in the German language in Leipzig in 1934. It was subsequently published again in Germane in the years 1944, 1949 and 1960. It was also translated into Swedish, English, Polish, French, Norwegian, Spanish, Dutch and Hungarian, making it perhaps his most widely-read book. The second book, *Owa Raha*, was published in Vienna and Leipzig in 1936. It is an in-depth ethnography of the inhabitants of the southeastern Solomon Islands, and it remains one of the most important books on the subject. Both books were designed by pupils of Josef Hoffmann, and reflect the Wiener Werkstätte tradition, to which Bernatzik ascribed.

[1] Hugo A. Bernatzik, *Südsee: Travel in the South Seas* (London: Constable & Co., London, 1935), p. 4.
[2] Ibid., p. 22.
[3] Ibid., p. 33.
[4] William E. Davenport and Mason J. Alden, "Expedition" vol. 10, no. 2 (Philadelphia: University Museum of the University of Pennsylvania, 1968), p. 23.
[5] *Südsee* (1935), p. 38.
[6] Ibid., p. 43.
[7] Ibid., p. 46.
[8] Ibid., p. 98.
[9] Ibid., p. 101.
[10] Michael W. Young and Julia Clark, *An Anthropologist in Papua: the Photography of F. E. Williams 1922-39* (Adelaide: Crawford House Publishing, 2001), p. 244.
[11] Francis E. Williams "The Natives of the Purari Delta," in *Territory of Papuan Anthropology* (Port Moresby: Government Printer, 1924), Report No. 5, pp. 125-126.
[12] *Südsee* (1935), pp. 139-140.

Bibliography

Annear, Judy, ed. *Portraits of Oceania*. Exh. catalogue. Sidney: The Art Gallery of New South Wales, 1997.

Bernatzik, Hugo A. *Owa Raha*. Wien/Leipzig/Olten: Bernina-Verlag, 1936.

Bernatzik Hugo A. *Südsee: Travels in the South Seas*. London: Constable & Co., 1935.

Brown, George. *Melanesians and Polynesians*. London: MacMillan & Co., 1910.

Byer, Doris. *Die Große Insel*. Wien: Böhlau Verlag, 1996.

———. *Der Fall Hugo A. Bernatzik*. Köln: Böhlau Verlag, 1999.

———. *Fremde Frauen, Photographien des Ethnographen Hugo A. Bernatzik 1925–1938*. Wien/München: Verlag Christian Brändstatter, 1985.

Coiffer, Christian. *Le Voyage de la Korrigane dans les Mers du Sud*. Exh. catalogue. Musée National d'Histoire Naturelle, Musée de l'Homme. Paris: Editions Hazan, 2001.

Craig, Barry, Bernie Kernot, and Christopher Anderson, eds. *Art and Performance in Oceania*. Honolulu: University of Hawai'i Press, 1999.

Davenport, W., and Mason J. Alden. *Expedition*. vol. 10, no. 2. Philadelphia: University Museum of the University of Pennsylvania, 1968.

Edwards, Elizabeth, ed. *Anthropology and Photography: 1860–1920*. London-New Haven: Yale University Press, 1992.

Geary, Christrand M., and Virginia L. Webb. *Delivering Views: Distant Cultures in Early Postcards*. Washington D.C.: Smithsonian Institution Press, 1998.

Guppy, Henry B. *The Solomon Islands and Their Natives*. London: Swan Sonnenschein Lawrey & Co., 1887.

Haddon, Alfred C. *Reports of the Cambridge Anthropological Expedition to Torres Straits*. 6 vols. Cambridge: University Press, 1901 .

Haddon, Alfred C., and James Hornell. *Canoes of Oceania*. Honolulu: Bishop Museum Press, 1975.

Hurley, Frank. *Perlen und Wilde*. Leipzig: F. A Brockhaus, 1926.

Landtman, Gunnar. *The Kiwai Papuans of British New Guinea*. London: MacMillan & Co., 1927.

Mead, Sydney M., *Material Culture and Art in the Star Harbour Region, Eastern Solomon Islands*. Toronto: Royal Ontario Museum; University of Toronto Press, 1973.

Parkinson, Richard H. *Dreissig Jahre in der Südsee*. Stuttgart: Streder & Schröder, 1926.

———.*Thirty Years in the South Seas*. Bathurst, N.S.W: Crawford House Publishing, 1999.

Seligmann, Charles G. *The Melanesians of British New Guinea*. Cambridge: University Press, 1910.

Specht, Jim and John Field. *Frank Hurley in Papua: Photographs of the 1920–1923 Expeditions*. Bathurst, N.S.W: Brown and Associates, in association with The Australian Museum Trust, 1984.

Stephen, Ann, ed. *Pirating the Pacific: Images of Travel, Trade and Tourism*. Haymarket, N.S.W.: Powerhouse Publishing, 1993.

Theye, Thomas. *Der geraubte Schatten*. München: C. J. Bucher, 1989.

Welsch, Robert L. *An American Anthropologist in Melanesia: A. B. Lewis and the Joseph N. Field South Pacific Expedition 1909–1913*. Honolulu: University of Hawai'i Press, 1998.

Williams, Francis E. "The Natives of the Purari Delta." In *Territory of Papuan Anthropology*, Report no. 5. Port Moresby: Government Printer, 1924.

Williamson, Robert W. *The Mafulu Mountain People of British New Guinea*. London: MacMillan & Co., 1912.

Young, Michael W., and Julia Clark. *An Anthropologist in Papua: The Photography of F. E. Williams 1922-39*. Adelaide: Crawford House Publishing, 2001.

Hugo A. Bernatzik
1897–1953, Vienna

After abandoning his medical studies at Wein Universität (Vienna), Hugo Adolf Bernatzik became a sales agent in 1923, and later travelled to Spain and northwest Africa. On his journey, which he helped finance through journalism and by selling his photos, he became interested in the peoples and cultures that he encountered. Returning to Vienna, he re-entered the university to continue his studies in the areas of ethnology, psychology and anthropology. On his first expedition, to Portuguese Guinea and the Bissagoes Islands in 1925, he was joined by Professor Bernhard Struck of Jena. From his field work, he developed and presented a monograph on the Kassanga for his doctoral thesis (1932). He later conducted research in Sudan (1927), the Solomon Islands, Papua New Guinea and Bali (1932–1933), Southeast Asia (1936–1937) and Morocco (1949–1950), as well as travelling to Albania, Rumania, and Swedish Lapland. In 1935, he was offered a job as lecturer at the Universität Graz (Austria), and he received an associated tenure there in 1939.

Bernatzik is considered a co-founder of the Applied Ethnology methodology which, as a field of research, looked for bases for interaction with foreign cultures. This field sought to arrest the pervading and inexorable influences of Western civilisation, while trying to align indigenous peoples with the industrial states. This method was greatly admired by Sir Hubert Murray, Lieutenant Governor of Papua New Guinea, who employed its tenets.

Among his most important scientific activities were the publication of the three-volume general study, *Die Große Völkerkunde*, in 1939 (co-authored with seven colleagues), and *Afrika, Handbuch der angewandten Völkerkunde*, a two-volume work, which he published in cooperation with thirty-two anthropologists in 1947. He also wrote twenty-eight other books related to his travels and studies, many of which were translated into different languages. One of the most successful was *Südsee* (South Seas); first published in German in 1934, it was subsequently translated into eight foreign languages and republished several times, from 1935 to 1962.

Bernatzik fell ill on his last trip to Morocco, and died from a tropical disease, at the age of fifty-six.

Appendix: The Published Works of Hugo A. Bernatzik

Hugo A. Bernatzik kept contact prints of all his European, Pacific, Asian and African [excluding Moroccan] works in a total of forty-seven albums. Arranged chronologically and by geographic area, most were bound in decorative cloth at the Weiner Werkstätte school, under the direction of Josef Hoffmann. Two hundred ninety-four of the early volume prints (relating to Spain and Egypt) were formatted to 26 centimetres by 20 centimetres (10 in. by 8 in.), the rest being are 12 centimetres by 9 centimetres (4 $^3/_4$ in. by 3 $^1/_2$ in.) in size. The albums have detailed annotations, written in Bernatzik's script, regarding each photograph, and each photograph is numbered and includes its publication history. On many of his photographs, Bernatzik included cropping marks (for publication); this is mainly the case with his portraitures.

There are approximately 16,000 individual images in Bernatzik's albums. The original negatives of these photographs were destroyed in the war. Bernatzik also produced a number of large format prints. The size of these prints was 13 centimetres by 19 centimeters (5 in. by 7 $^1/_2$in.). These were made for his own books, as well as for journalistic purposes. With most of these prints, the reverse side is noted with publication information, and all bear the Bernatzik copyright. A handful of period exhibition prints survive; as well, there are about twenty extant photographic workbooks specifically relating to his book projects.

1927

Typen und Tiere im Sudan. Leipzig: F. A. Brockhaus (170 pp., 160 ph.); Leipzig: Kohler & Voigtländer, 1942; Gütersloh: Bertelsmann, 1951 (with new title hereafter, *Jagd am Blauen Nil: Typen und Tiere im Sudan*, 197 pp., 107 ph.); Berlin: Deutsche Buch-Gemeinschaft, 1952; Berlin: Verlag Ullstein, 1956 (157 pp., 25 ph.).

1929

Zwischen Weissem Nil und Belgisch-Kongo. Contributions by Otto Reche, Bernhard Struck, and Helmut Antonius. 139 pp., 204 ph. by Hugo Bernatzik, and 70-page text by Otto Reche and Bernhard Struck. Wien: L. W. Seidel & Sohn; Wien: Anton Schroll, 1943 (*Zwischen Weissem Nil und Kongo: Ethnographische Bilddokumente einiger Völker am Oberen Nil*, 70 pp., 170 ph.).

1929

Ein Vogelparadies an der Donau. Bilder aus Rumänien. Berlin-Zurich: Wasmuth (96 pp., 142 ph.).

1930

Europas vergessenes Land. Wien: L. W. Seidel & Sohn (62 pp., 105 ph.).

1930

Albanien. Das Land der Schkipetaren. Wien: Anton Schroll (96 pp., 93 ph.).

1930

Der dunkle Erdteil, Afrika, Landschaft/Volksleben. Berlin: Atlantis-Verlag (45 pp., 256 ph.); London: "The Studio" Ltd., 1931 (*The Dark Continent. Africa: the Landscape and the People*; 15 pp., 256 ph.); New York: B. Westermann, 1931 (*The Dark Continent. Africa: the Landscape and the People*).

1930

Gari-Gari: Leben und Abenteuer bei den Negern am Oberen Nil. Wien: L. W. Seidel & Sohn (200 pp., 106 ph.); Berlin: Deutsche Buch-Gemeinschaft, 1930 (*Gari-Gari: Leben und Abenteuer bei den Negern zwischen Nil und Kongo*, 203 pp. 116 ph.); Wien: L. W. Seidel & Sohn, 1935/1936/1938/1941 (144 pp., 156 ph.); London: Constable & Co., 1936 (*Gari-Gari: The Call of the African Wilderness*, 138 pp.); New York: H. Holt & Co., 1936 (*The Call of the African Wilderness*, 146 pp.); Wien: Anton Schroll, 1941/1943; Innsbruck:

Schlüsselverlag, 1948; Bern: Aare-Verlag, 1948; Den Haag: Stols, 1948 (*Gari-Gari. Leven en avonturen bij de negers an de Boven-Nijl*, 165 pp.); Barcelona: Labor, 1950/1953/1956 (*Gari-Gari. Vida y costumbres de los negros del Alto Nilo*); Frankfurt a. M.: Verlag Kommentator, 1951 (197 pp., 107 ph.); Budapest: Gondolat, 1958/1961/1966 (*Gari Gari. Életem és kalandjaim Felsö-Nilus négerei között*); Gütersloh: Bertelsmann, 1961.

1930

Gari-Gari, der Ruf der afrikanischen Wildnis. Wien: L. W. Seidel & Sohn (144 pp., 160 ph.).

1930

Riesenpelikane und ihre Kinder. With contributions by Adolf Heilborn and Hans Weiss. Wien: L. W. Seidel & Sohn (54 pp., 33 ph.).

1932

Monographie der Kassanga. Ph.D. dissertation, Wien Universität, Wien.

1933

Geheimnisvolle Inseln Tropen-Afrikas: Frauenstaat und Mutterrecht der Bidyogo. Ein Forschungsbericht. Berlin: Deutsche Buch-Gemeinschaft (220 pp., 189 ph.); Wien-Leipzig-Olten: Bernina-Verlag, 1936 (*Im Reich der Bidyogo: Geheimnisvolle Inseln in Westafrika*); Leipzig: Kohler & Voigtländer, 1944 (200 pp.). Innsbruck: Alpha-Verlag, 1946 (unaltered Austrian ed.); Alfed-Leine: Alpha-Verlag, 1950?, (*Im Reich der Bidyogo. Geheimnisvolle Inseln Westafrika*; 236 pp. 189 ph); München: F. Bruckmann, 1951; 1956 (Dutch ed.); Barcelona: Labor (*En el reino de los Bidyogo*, 208 pp.); Gütersloh: Bertelsmann, 1960; Berlin: Verlag Ullstein, 1960 (157 pp., 25 ph).

1933

Äthiopen des Westens: Forschungsreisen in Portugiesisch-Guinea. With essay by Bernhard Struck: "Anthropologische Ergebnisse aus Portugiesisch-Guinea." Wien: L. W. Seidel & Sohn (German and Portuguese, 2 vols., 290 pp., 378 ph.).

1934

Südsee. Leipzig: Bibliographisches Institut, ag. (125 pp., 103 ph.); Berlin: Deutsche Buch-Gemeinschaft, 1934; Söderström: Natur och Kultur, 1935 (*Resa i söderhavet. Salomonöarna, Nya Guinea och Bali*); London: Constable & Co., 1935 (*Südsee: Travels in the South Seas*; 158 pp.); New York: H. Holt and Co., 1935 (*The South Seas*; 167 pages, photos); 1935 (Polish ed.); Wien: L. W. Seidel & Sohn, 1939; Wien: Anton Schroll, 1941/1943/1944; Bern, Aare-Verlag, 1949 (*Südsee, ein Reisebuch*; 203 pp.); Innsbruck: Schlüsselverlag 1949 (203 pp., 114 ph.); Frankfurt a. M.: Verlag Kommentator, 1951 (203 pp., 114 ph.); München: F. Bruckmann, 1951; Paris: Société Nouvelle de Editions Self, 1952 (*Canaques et Papous*); 1952 (Norwegian ed.); Barcelona: Destino, 1953 (*Mares del sur*); 1953 (Dutch ed.), Zurich: Schweizer Druck- und Verlagshaus, 1960; Budapest: Gondolat, 1962 (*Óceánia nepei között*).

1935

"Über die Ursachen des Aussterbens der Melanesia auf den britischen Salomon Inseln." In: *Zietsch für Rassenkunde*, vol. 1, 3, Stuttgart.

1935

Lappland. Leipzig: Bibliographisches Institut (131 pp. 90 ph.); 1936/1943 (Czech eds.); London: Constable & Co./Travel Book Club 1938 (*Lapland*, 136 pp., 90 ph.); New York: R. M. McBride & Co., 1938 (*Overland with the Nomad Lapps*, 136 pp., 90 ph.); Leipzig: Kohler & Voigtländer, 1942; Frankfurt a. M.: Verlag Kommentator, 1951 (116 pp.; 142 ph.).

1935

Vogelparadies: Vogelwelt und Menschen in europäischen Rückzugsgebieten. Wien: L. W. Seidel & Sohn (119 pp. 142 ph.). Leipzig: Kohler & Voigtländer, 1941; Innsbruck: Schlüsselverlag, 1947.

1936

Owa Raha. Wien-Leipzig-Olten: Bernina-

Verlag (295 pp., 600 ph.); Wien-Zurich-Prag/ Büchergilde Gutenberg.

1936

Afrikafahrt; ein Frau bei den Negern Westafrikas. In collaboration with Emmy Winkler Bernatzik. Wien: L. W. Seidel & Sohn (240 pp.).

1938

Die Geister der Gelben Blätter. Forschungreisen in Hinterindien. In collaboration with Emmy Winkler Bernatzik. München: F. Bruckmann (240 pp., 106 ph.); 1936/1943 (Czech eds.); Leipzig: Koehler & Voigtländer, 1941; Söderström: Natur och Kultur, 1942 (*De Gule bladens andar. Forskiningresor i Bortre Indien*); 's-Gravenhage: Holle, & Co, 1944/1947 (*De geesten van de gele bladeren*); 1945/1958/1965 (Spanish eds.); Gütersloh: Bertelsmann, 1951/1961 (205 pages, 39 ph.); Paris: Plon, 1955 (adaptation by George Condominas. *Les esprit des feuilles jaunes.* 267 pp., 51 ph.); 1956 (Dutch ed.); London: R. Hale, 1958 (*The Spirits of the Yellow Leaves*); Tokyo: Heibonsha, 1968 (*Kiiroi ha no seirei: Indoshina sangaku minzokushi*).

1938

"Vorläufige Ergebnisse meiner Hinterindien-expedition." In: *Forschung & Fortschritt*, Berlin.

1938

Historisches Tanzspiel auf den Salomon Inseln. Zurich: Atlantis (332 pp.).

1939

Die große Völkerkunde. Sitten, Gebräuche und Wesen fremder Völker. Chief editor and co-author. In collaboration with 7 ethnographers. 3 vols. (vol. I: *Europa, Afrika*; vol. II: *Asien*; vol. III: *Australien, Amerika*), 1138 pp., 700 illustrations (with color-mounted plates); Leipzig: Bibliographisches Institut; Tokyo, 1943 (partial Japanese edition, 349 pp.).

1939

Kolonisation primitiver Völker unter besonderer Berücksichtigung des Moken-Problems. München: J. F. Lehmann. (Printed in commemoration of Otto Reche's 60th birthday.).

1940

Akha und Meau. Probleme der angewandten

Völkerkunde in Thailand. Berlin: Reimer.

1940

Die Begegnung der Natuervölker mit der Zivilisation. Heinz Zeiss and Karl Pintschovious, eds. München: J. F. Lehmann.

1947

Afrika, Handbuch der angewandten Völkerkunde. Chief editor and co-author, 2 vols. Innsbruck: Schlüsselverlag, Wagner'sche Universitäts-Buchdruckerei (1429 pp., 202 ph.); München: F. Bruckmann, 1951.

1947

Akha und Meau, Probleme der angewandten Völkerkunde in Hinterindien. 2 vols. Innsbruck: Wagner'sche Universitäts-Buchdruckerei (566 pp., 108 ph.); 1957 (reprint edition); New Haven: Human Relations Area Files, 1970 (*Akha and Miao: Problems of Applied Ethnology in Farther India*, 772 pp.).

1952

"Die Buschmannzeichnungen und die Entwicklung der zeichnerischen Begabung an Beispielen farbiger Völker." In: *Actes du IVᵉ Congrès international des sciences anthropologiques et ethnologiques*, vol. II, Wien.

1953

"Untersuchungen der zeichnerischen Bagabung von Fremdvölkern farbiger Rasse." In: *Archiv für Völkerkunde*, vol. VIII.

1954

Die neue große Völkerkunde. Völker und Kulturen der Erde in Wort und Bild. Chief editor and co-author, with revisions on the 1939 edition, *Die große Völkerkunde. Sitten, Gebräuche und Wesen fremder Völker.* 3 vols. Frankfurt/Main: Herkul (1552 pp., 1280 ph.); Köln: Buch und Zeit, Hansen, 1958 (1 vol.); Roma: Le Maschere, 1958 (3 vols. *Popoli e razze*); Gütersloh: Bertelsmann Lesering, 1962 (1 vol., 976 pp., 347 ph.); Barcelona: Ave, 1966 (3 vols., Spanish ed.).

Note to the Reader

The publisher has done everything possible to include herein an accurate and complete list of all known publications by Hugo A. Bernatzik.

SOLOMON ISLANDS

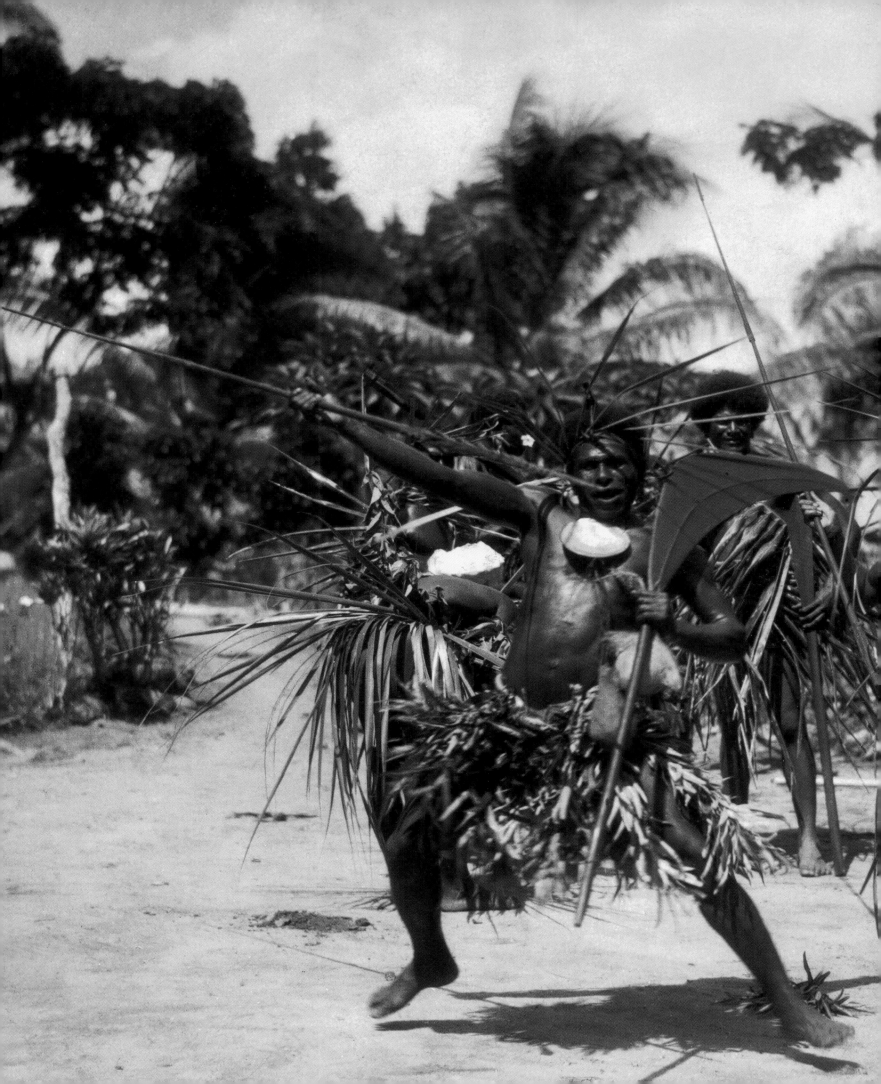

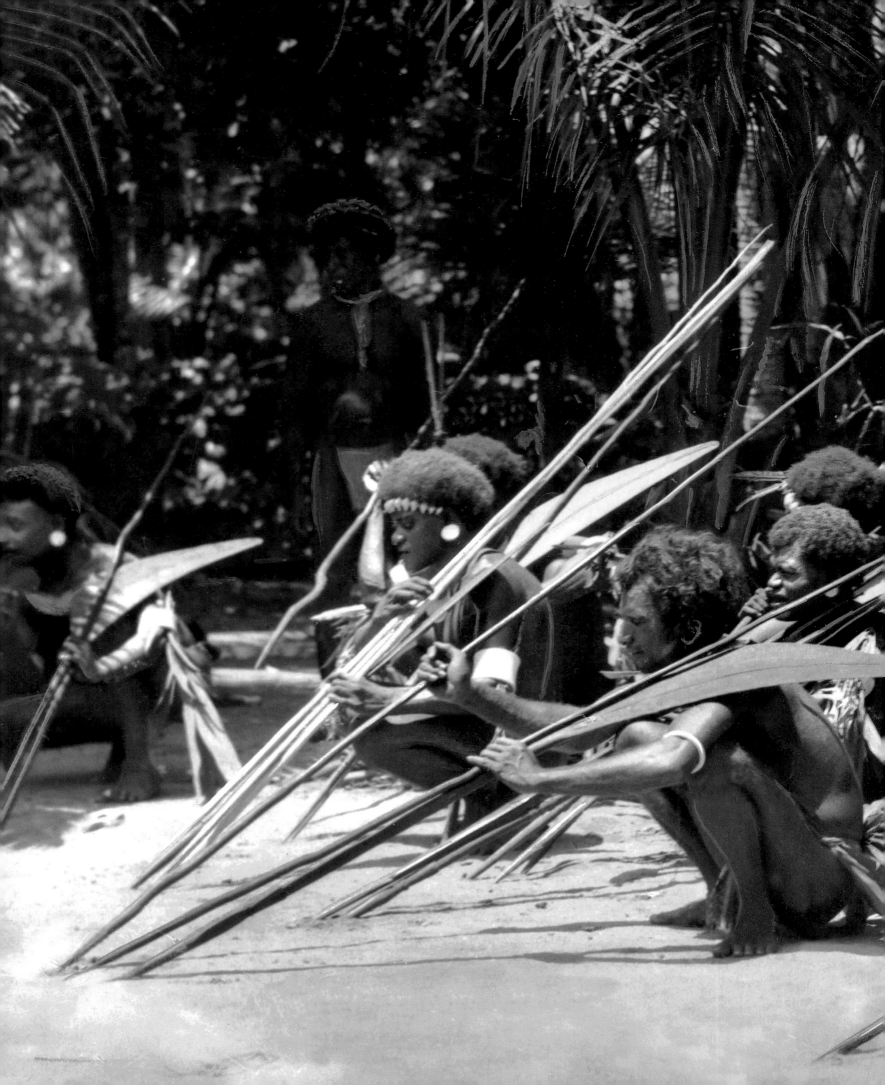

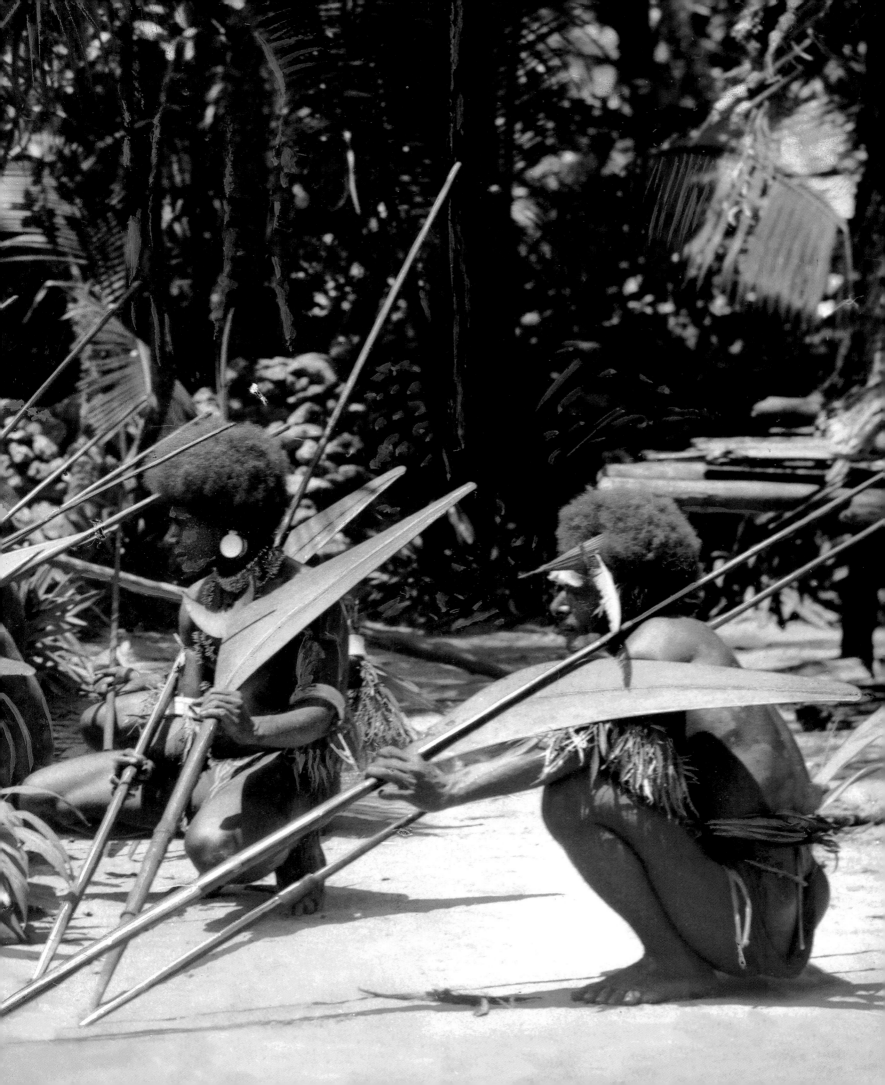

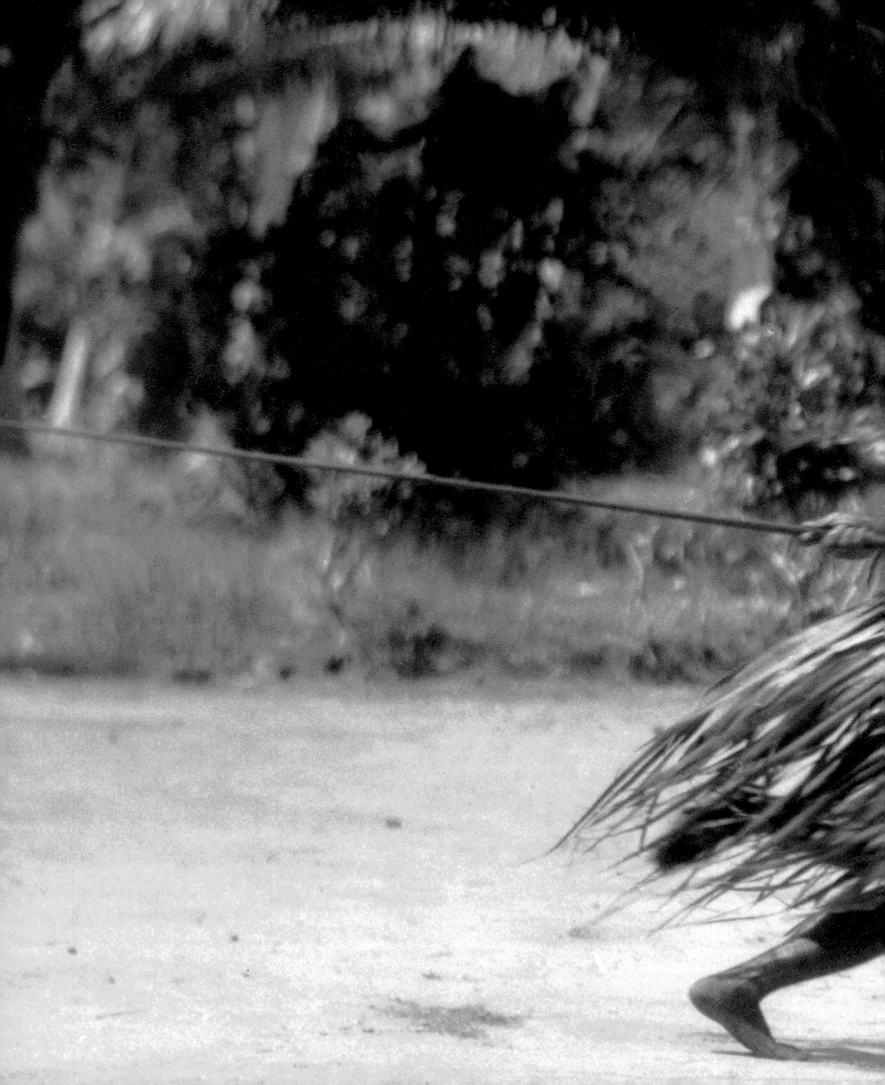

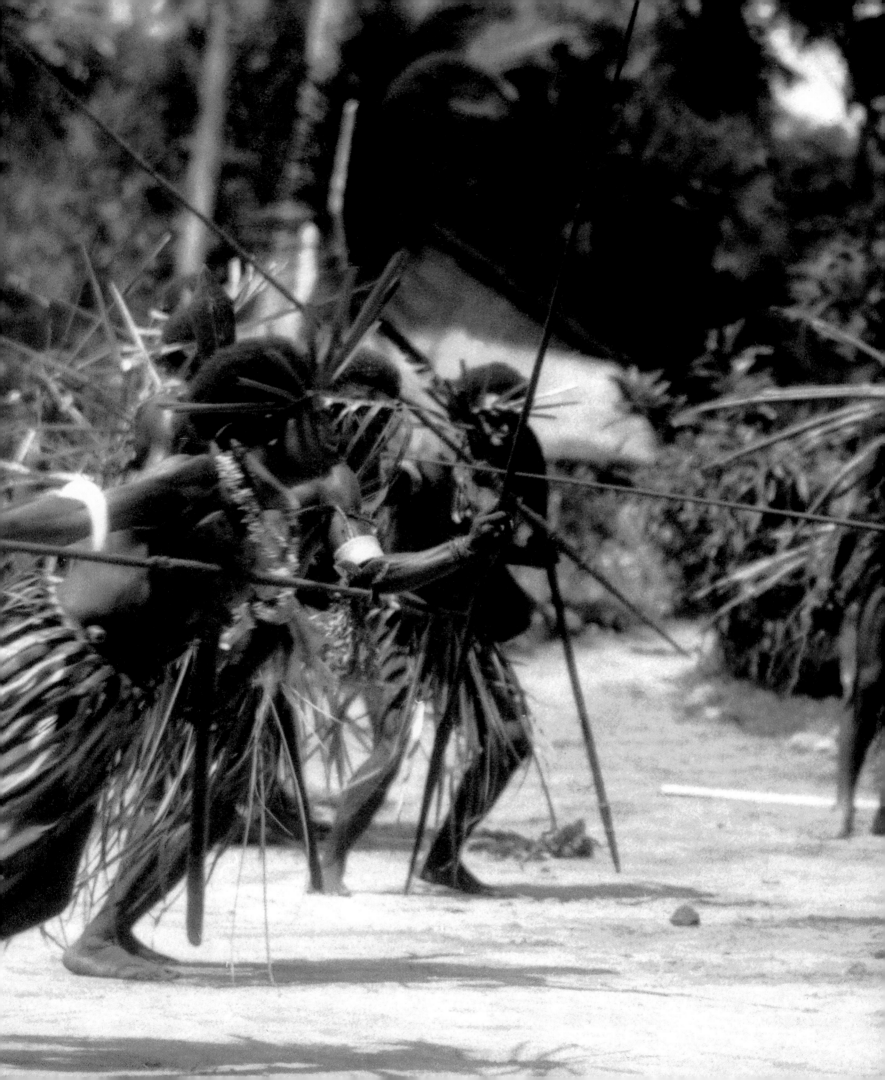

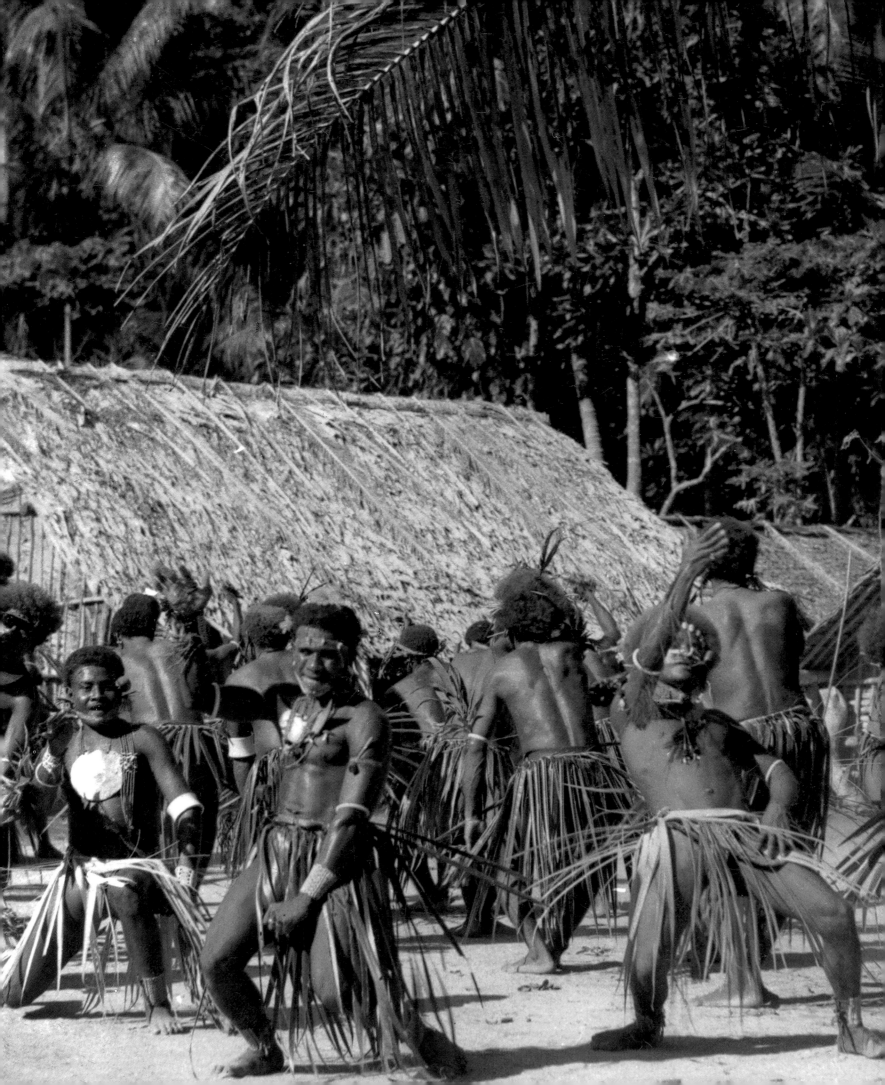

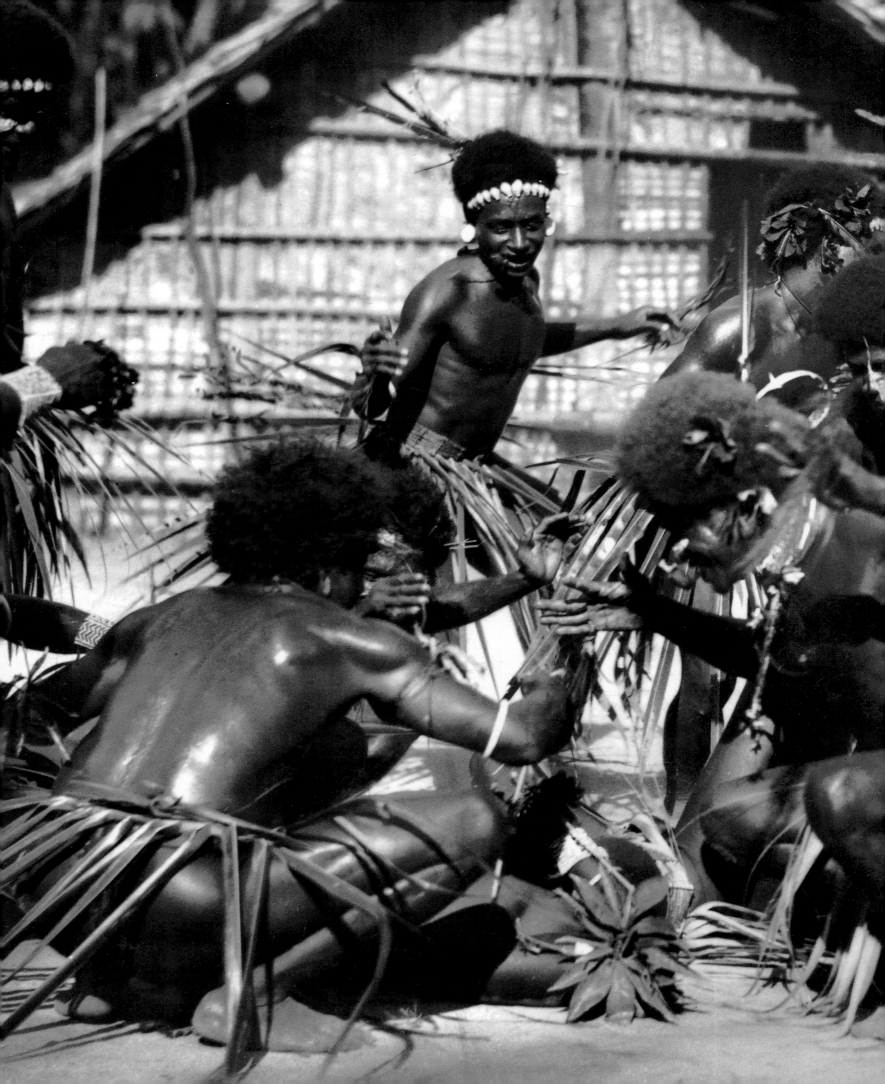

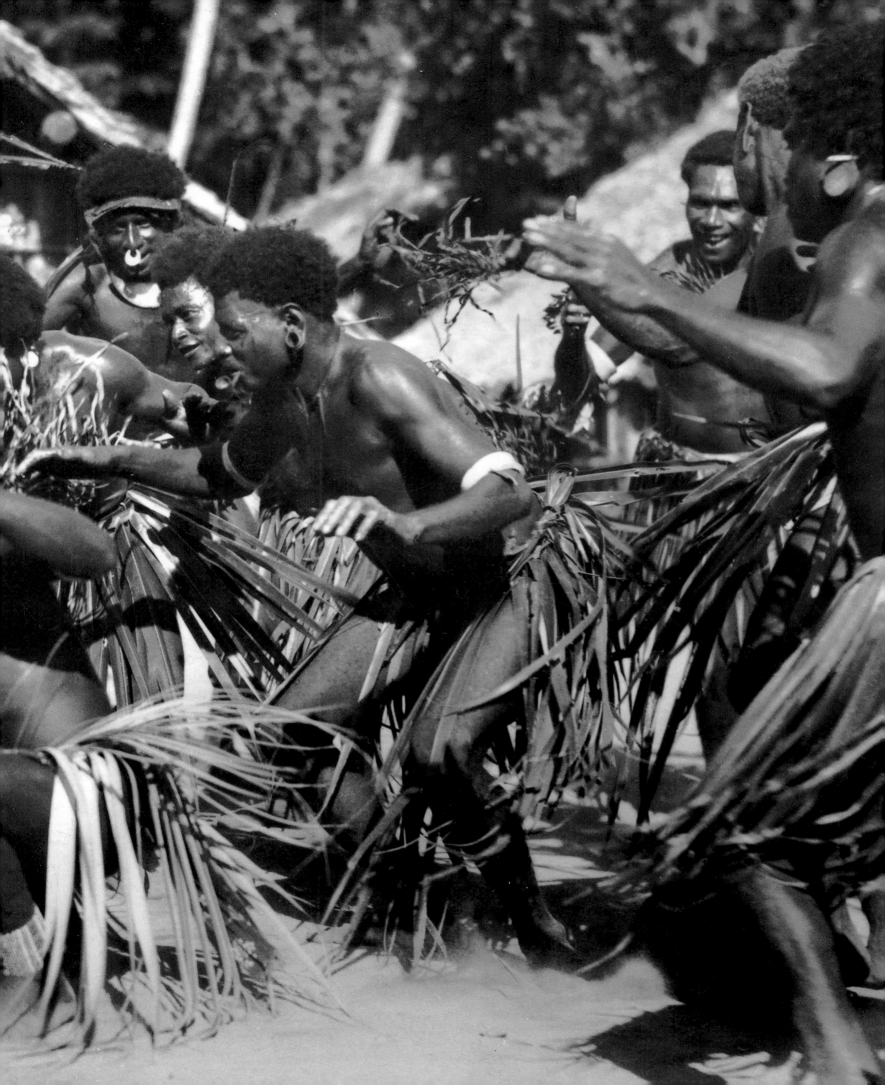

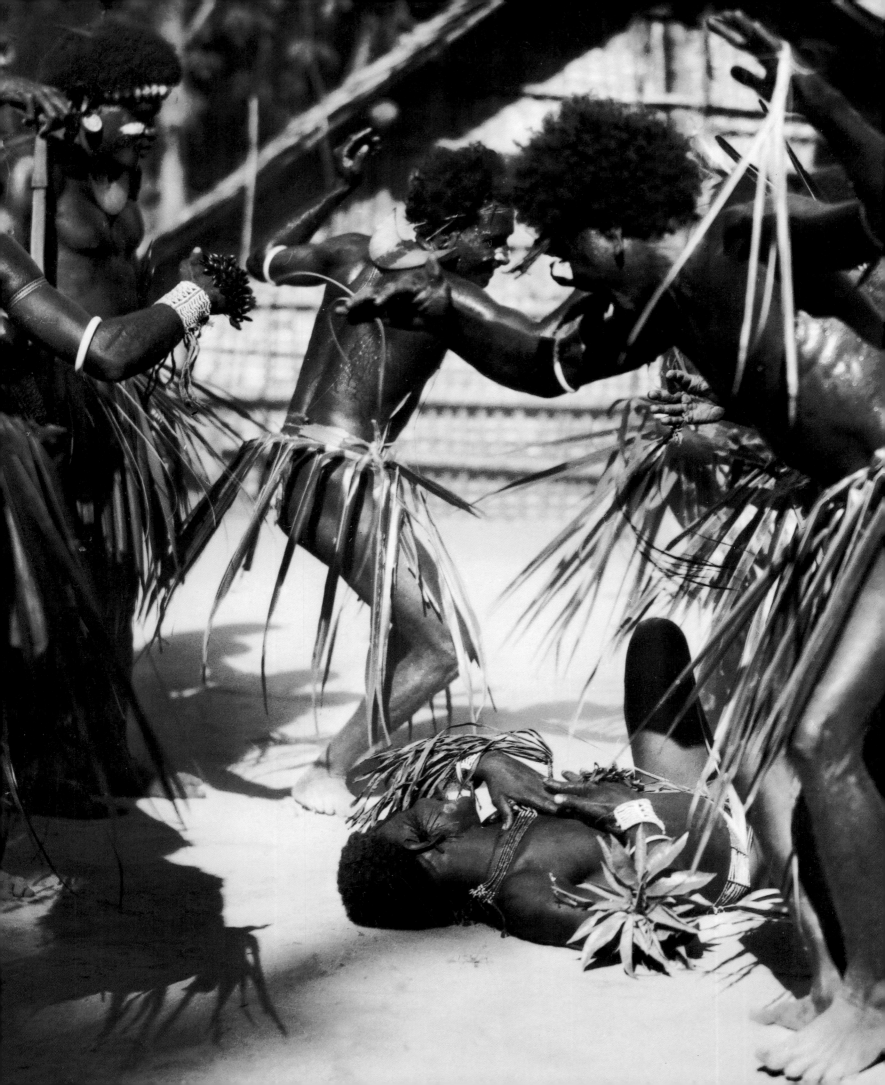

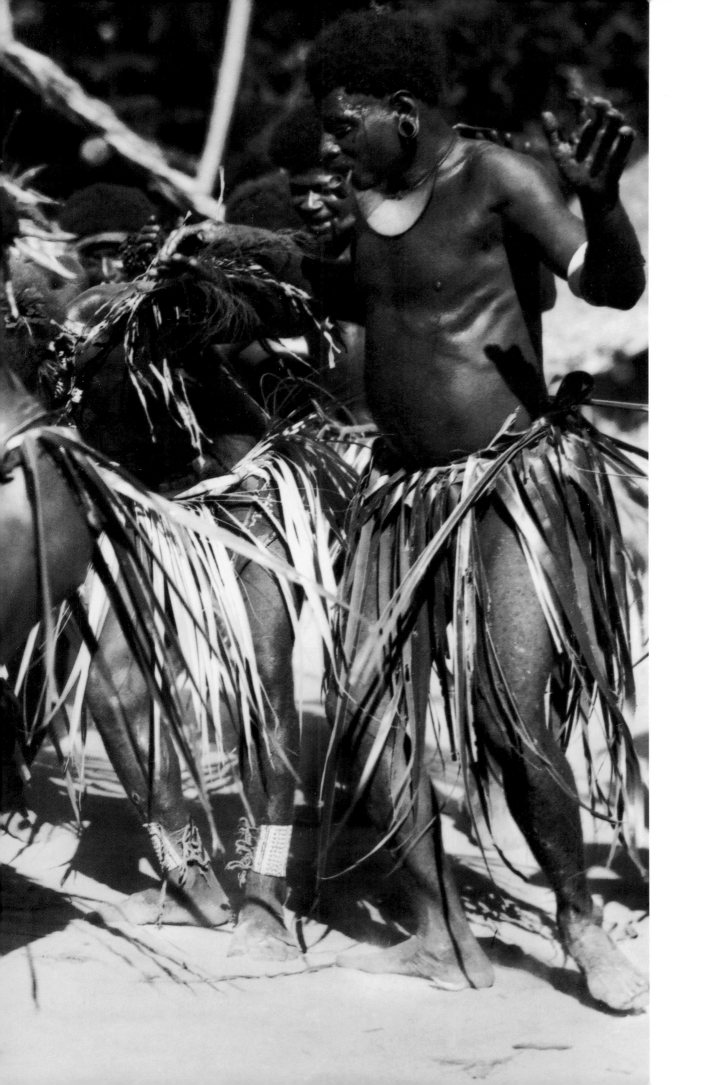

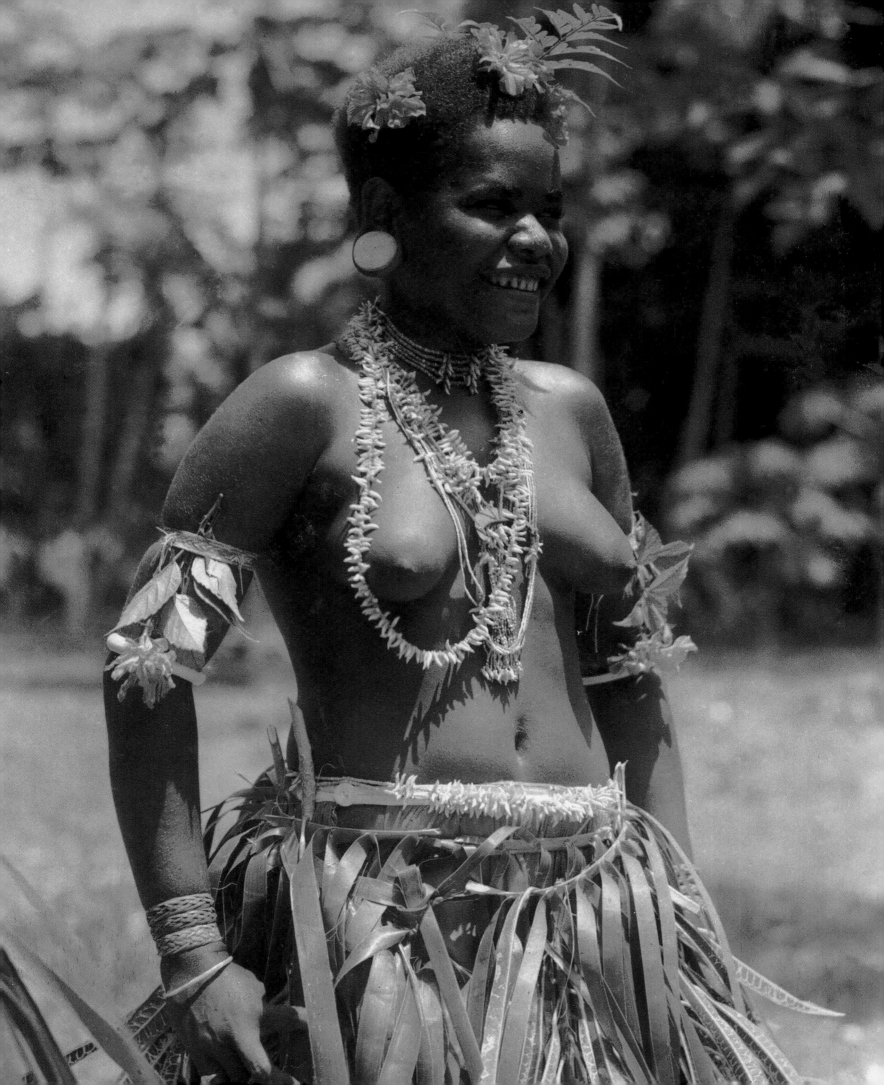

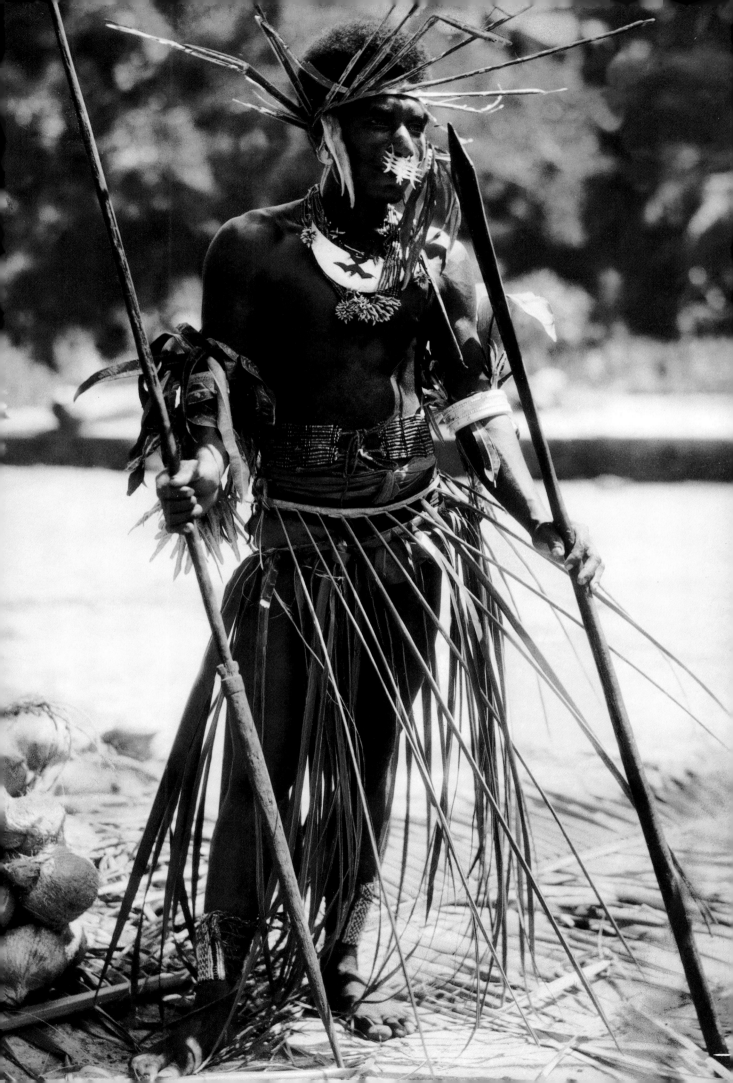

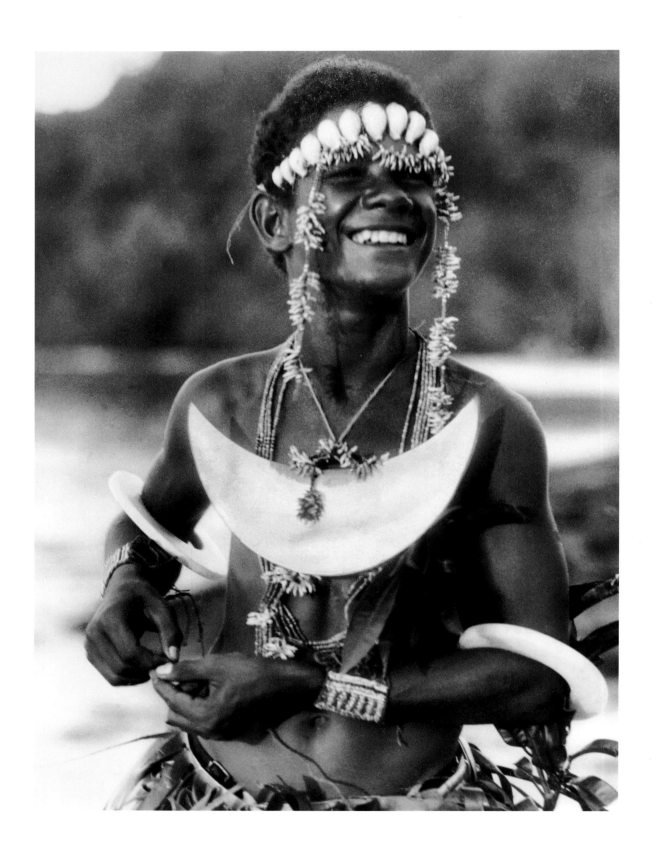

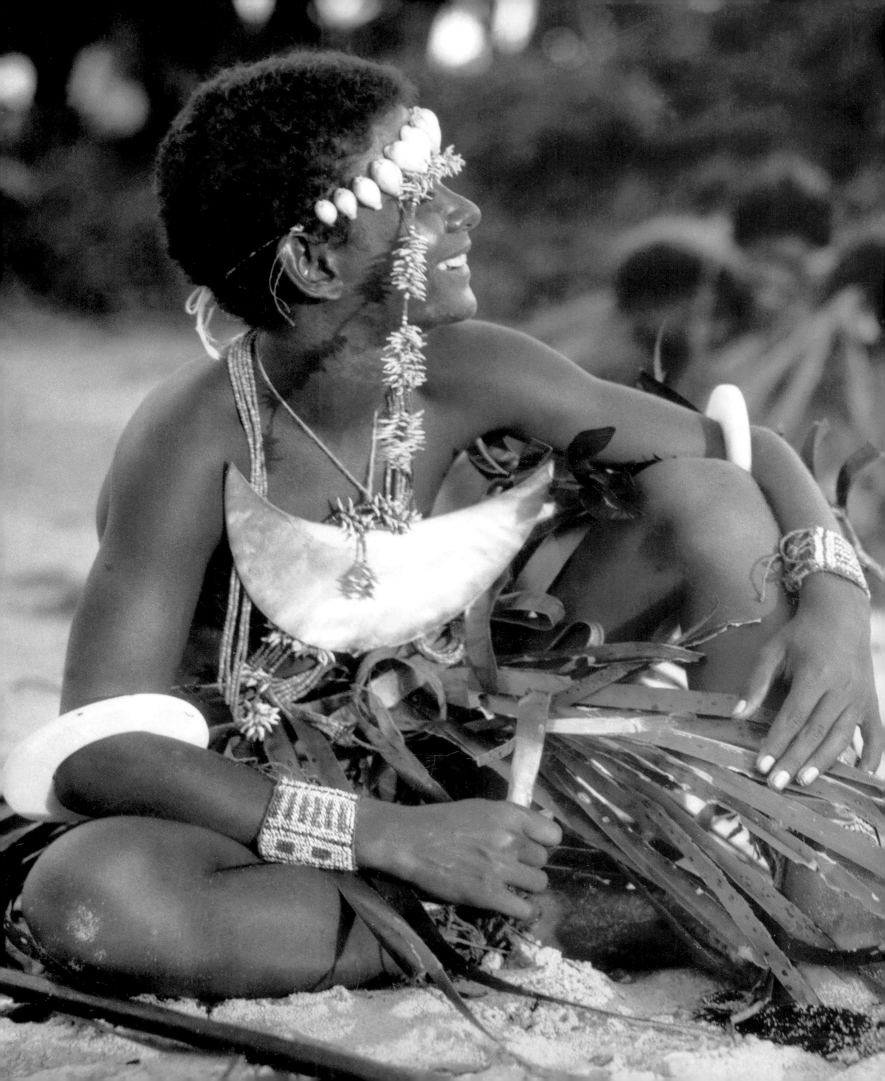

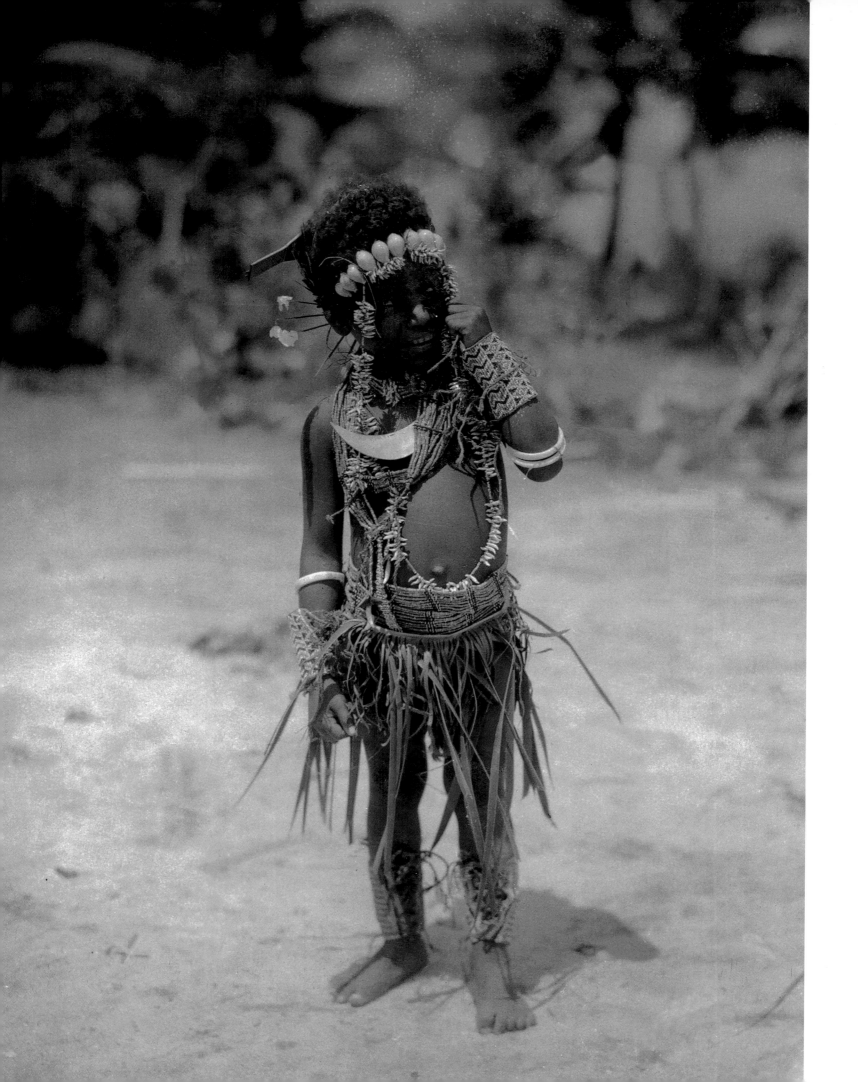

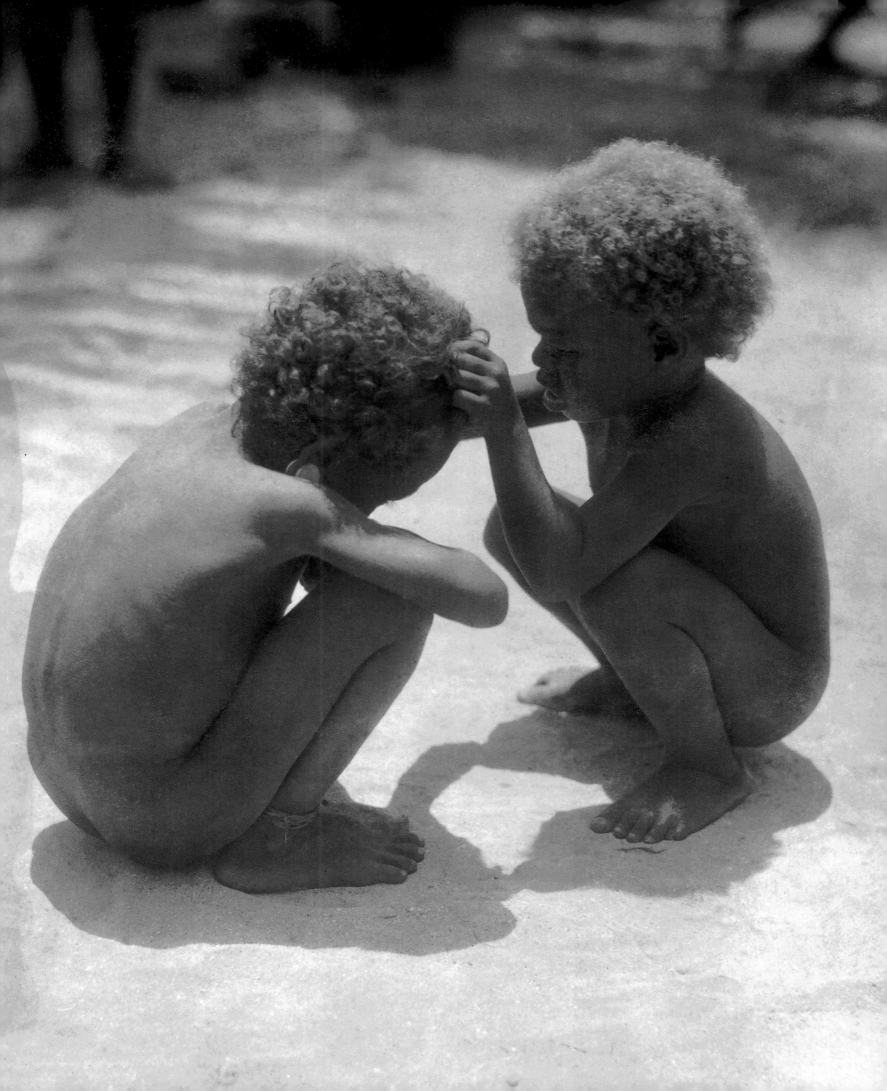

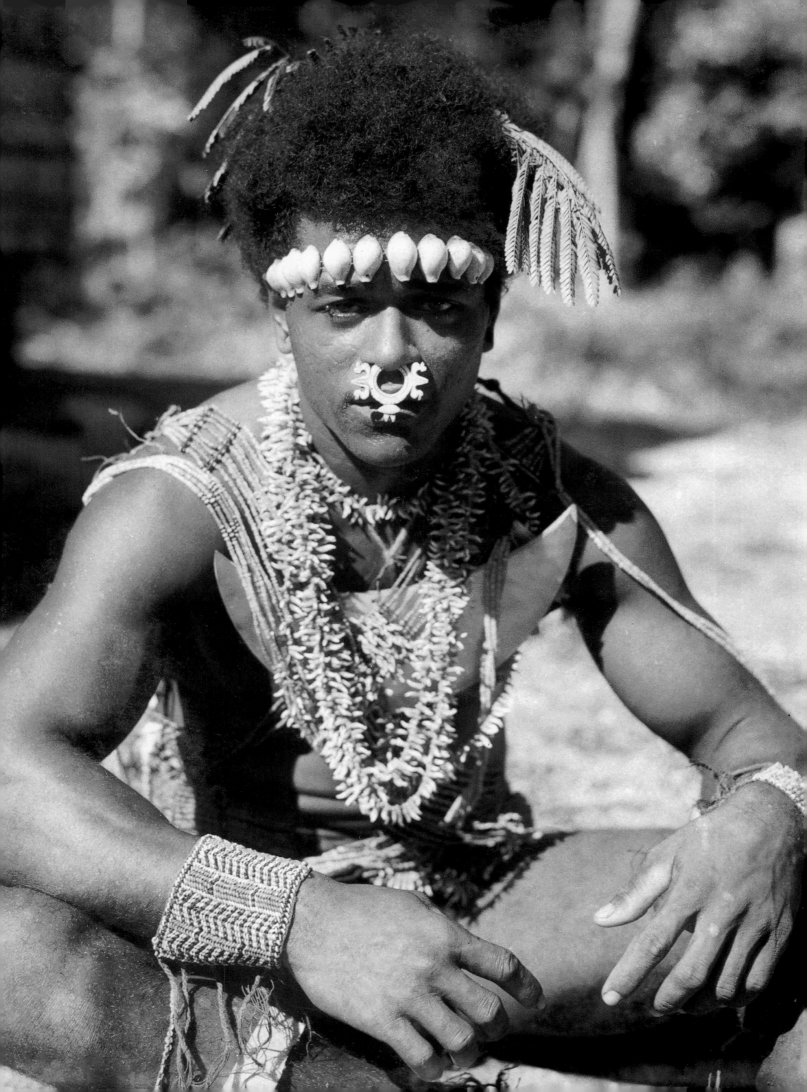

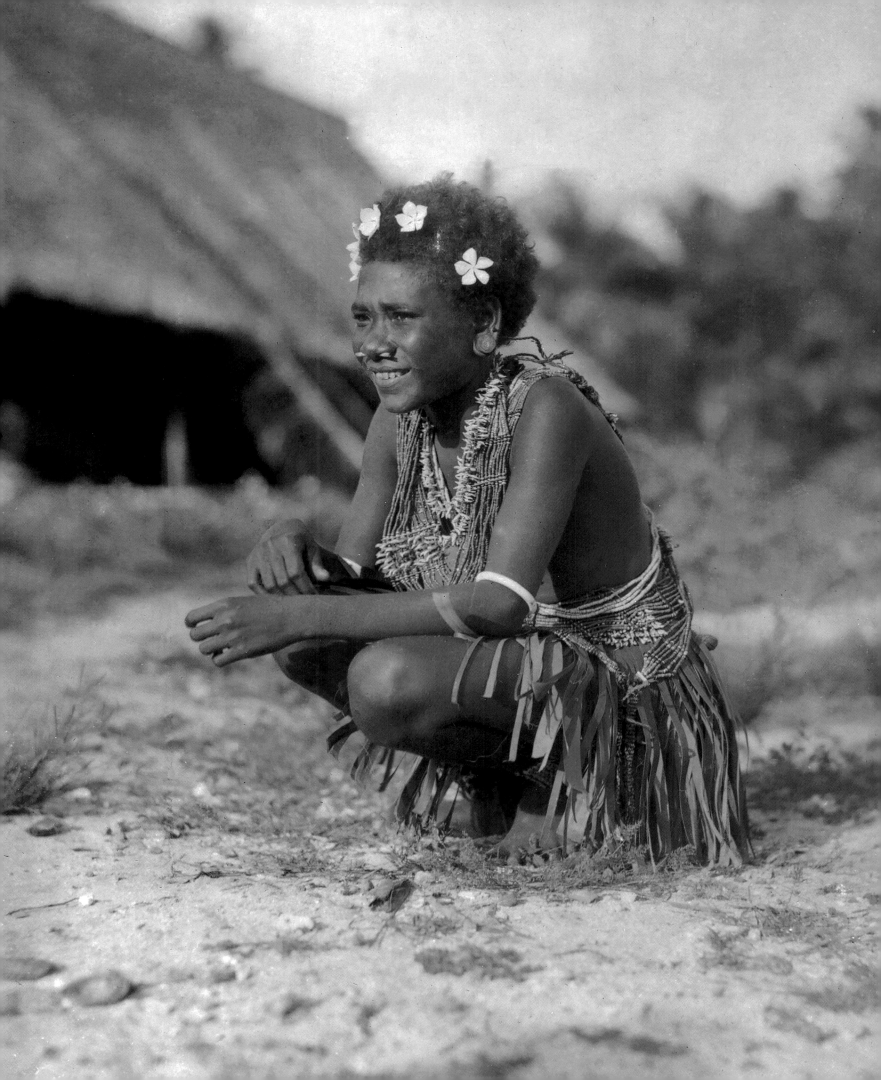

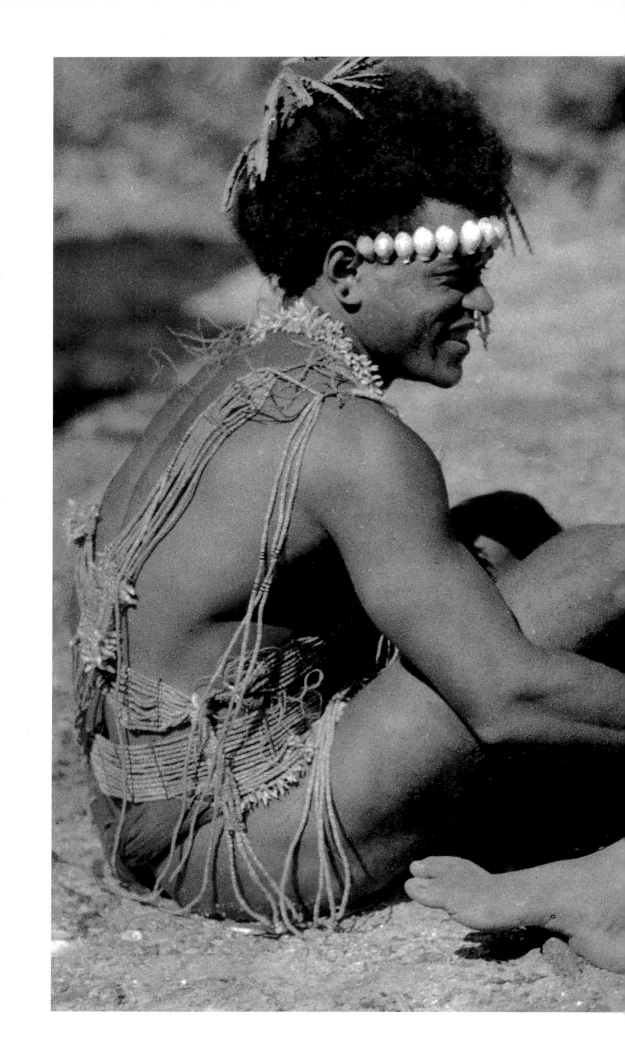

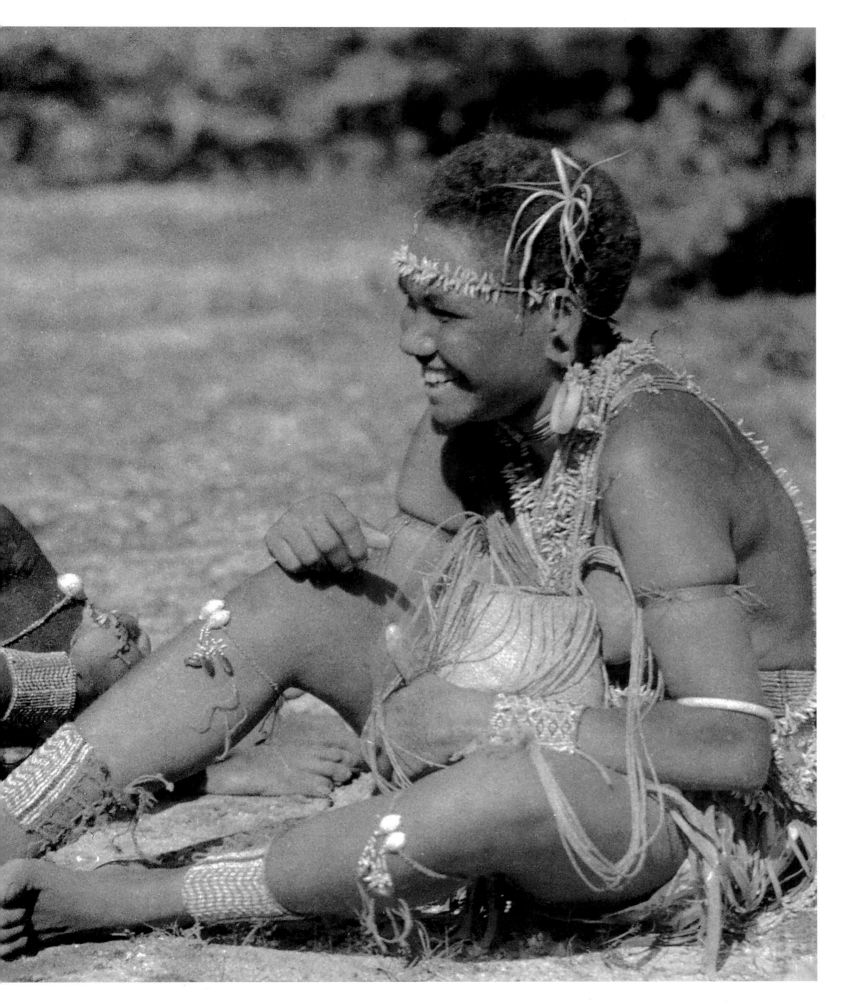

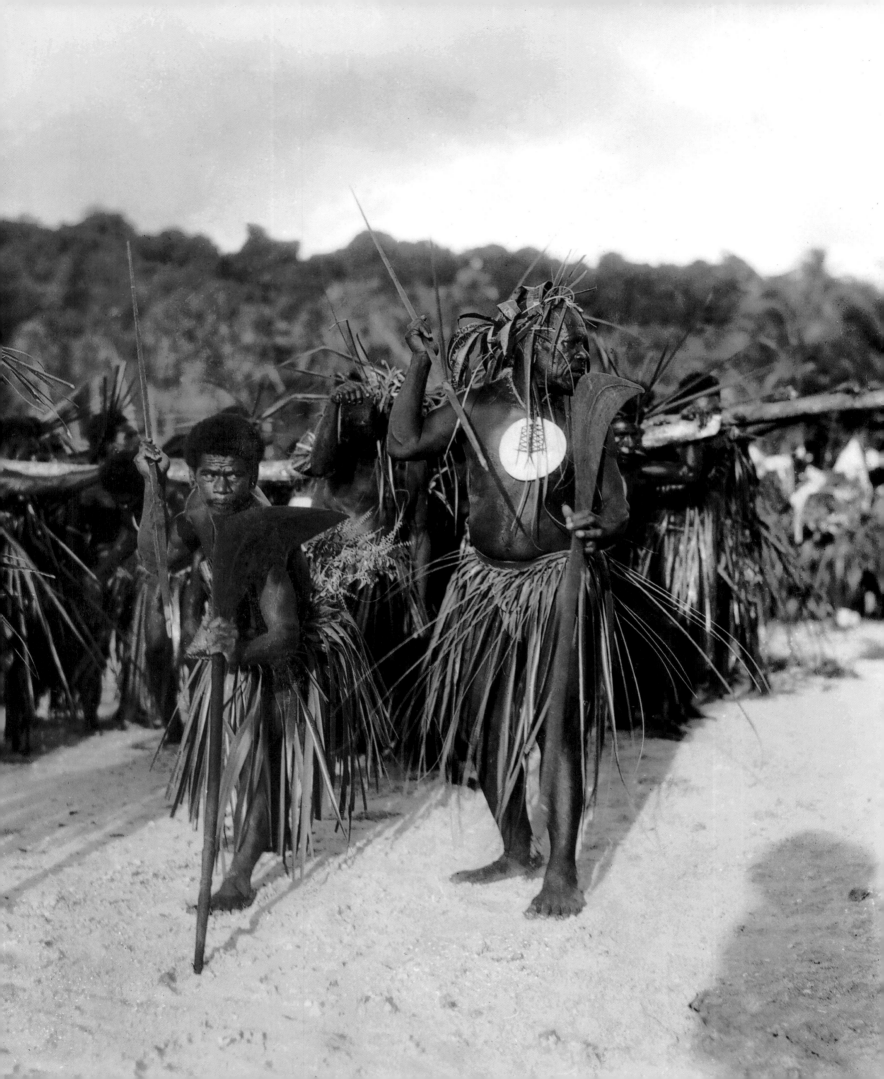

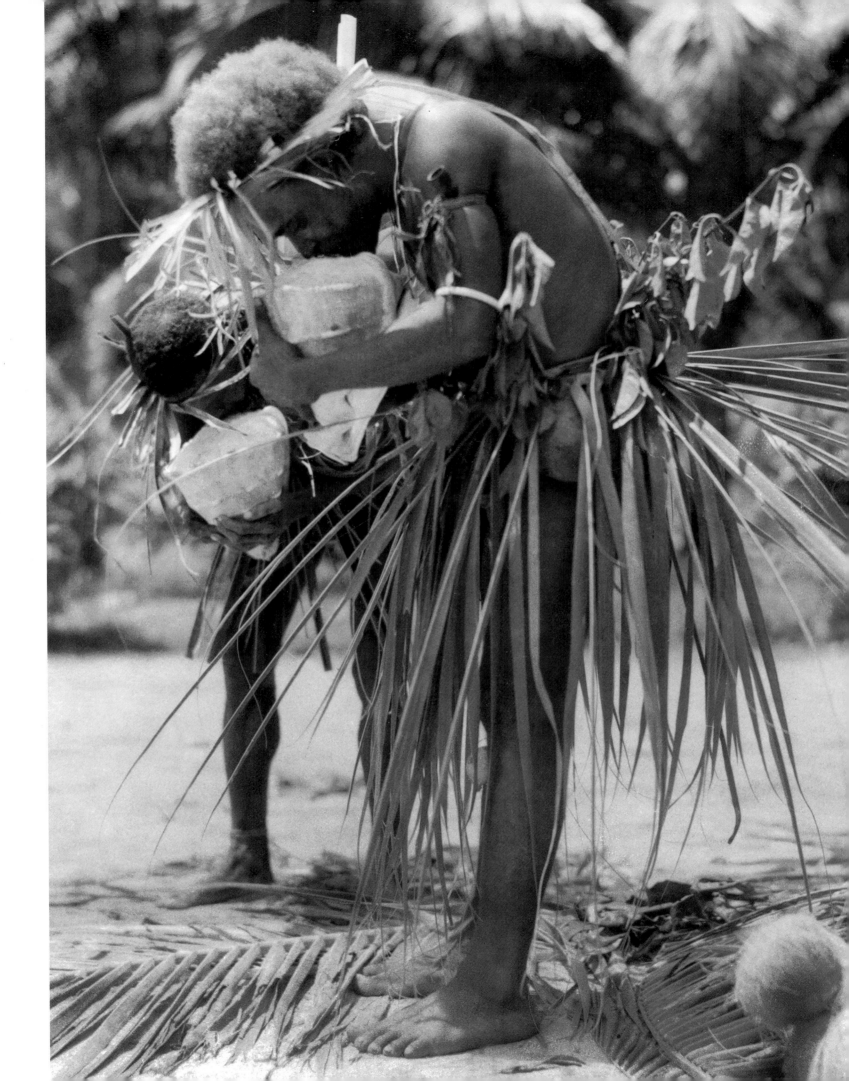

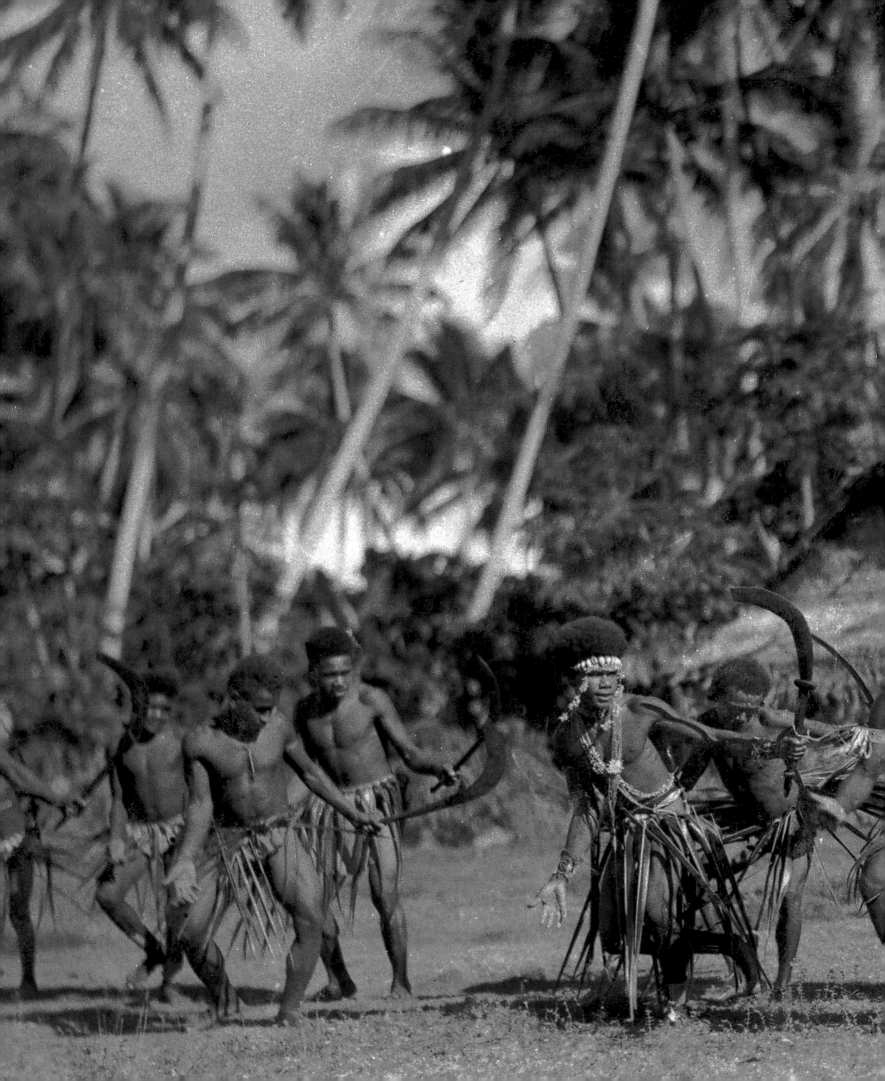

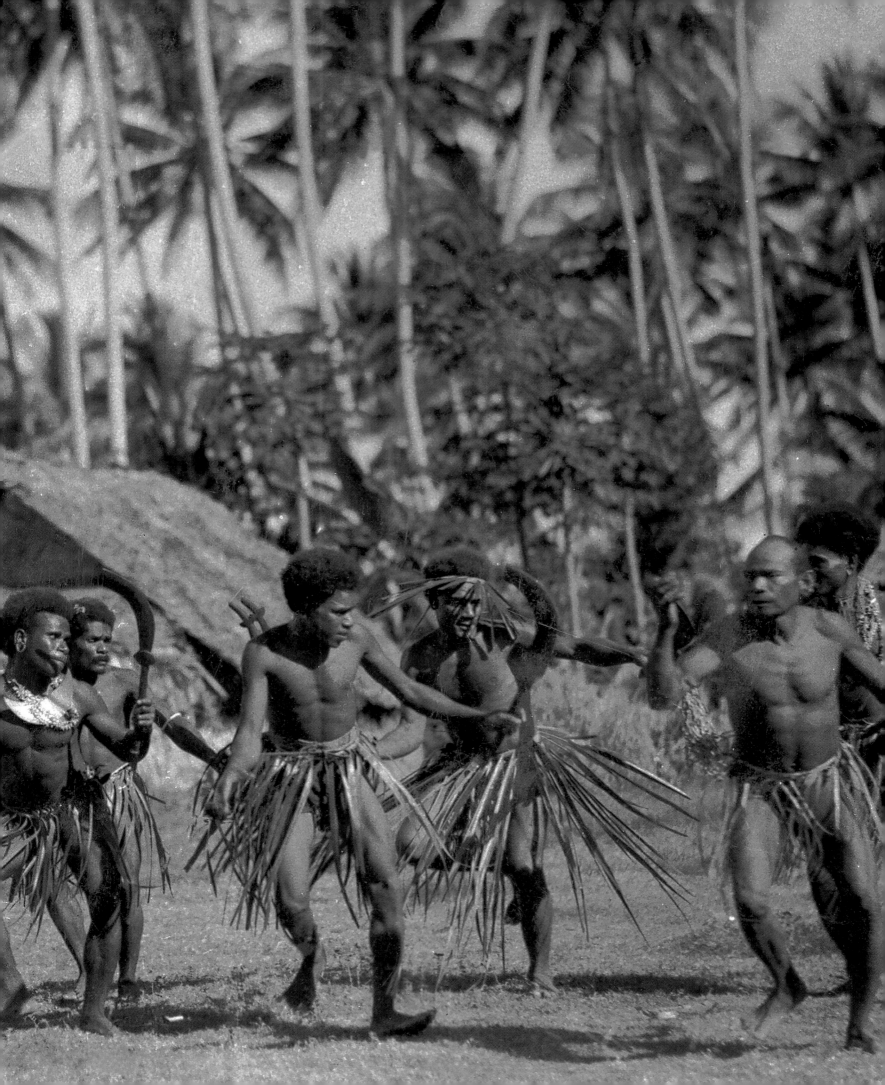

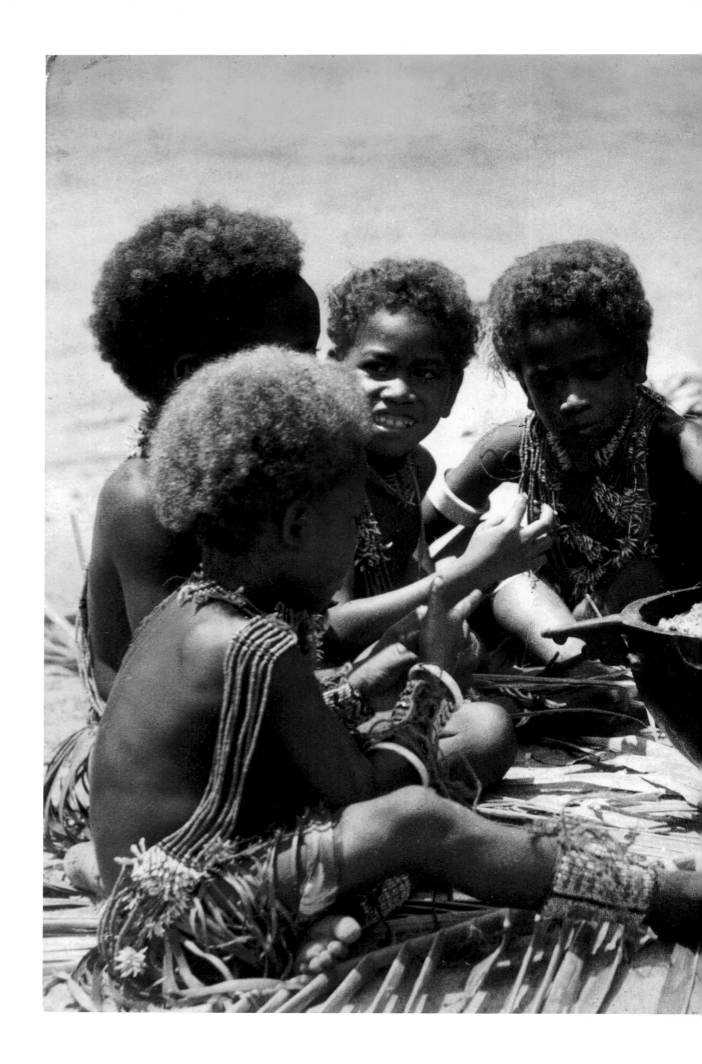

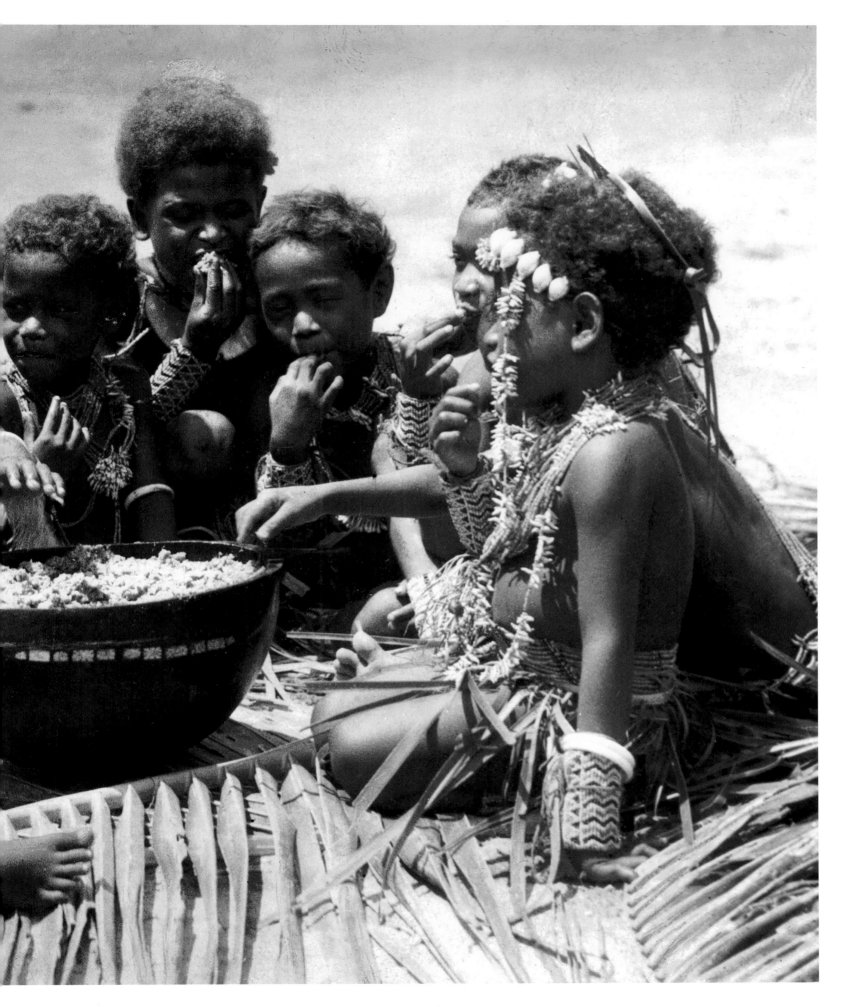

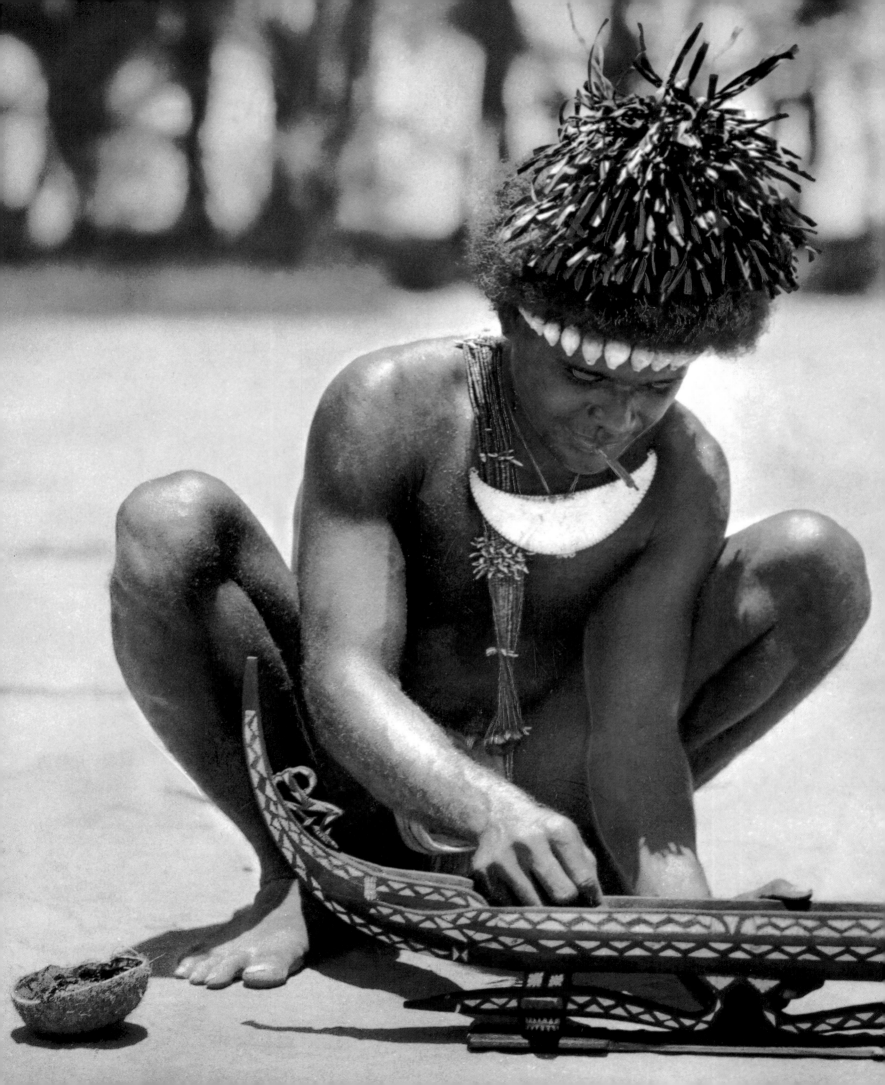

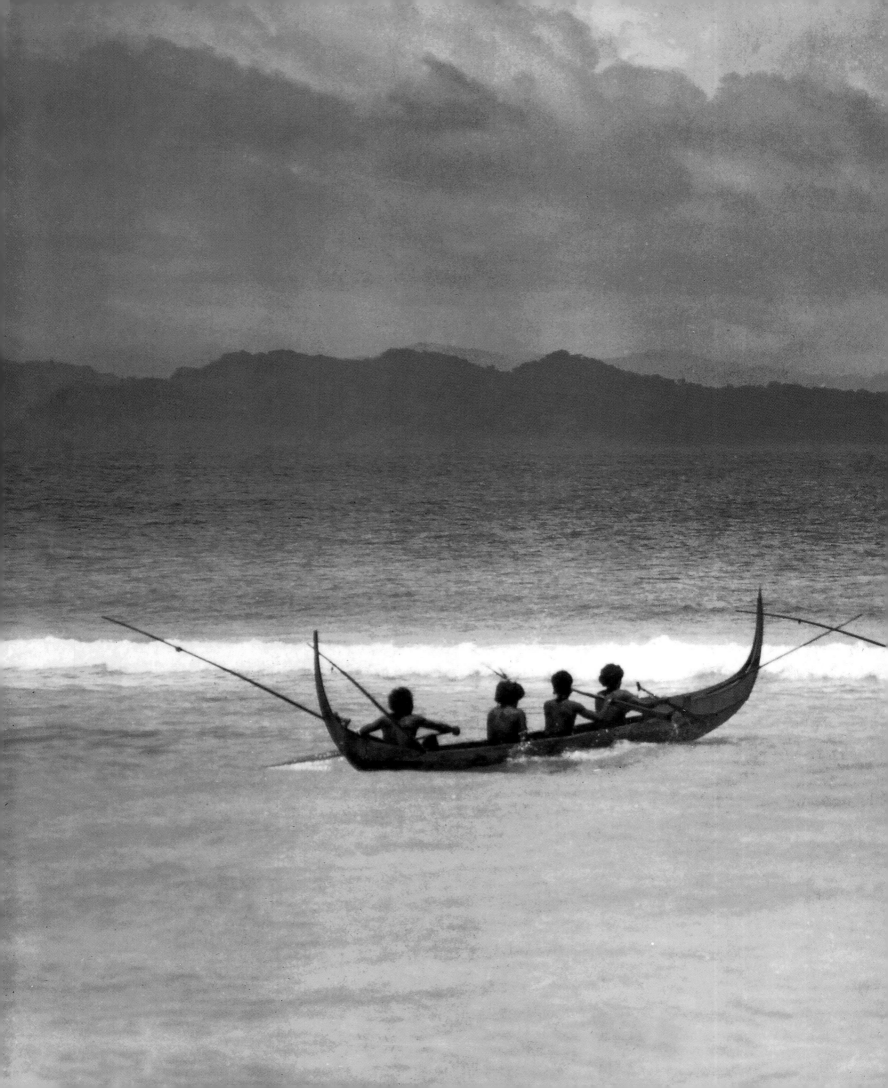

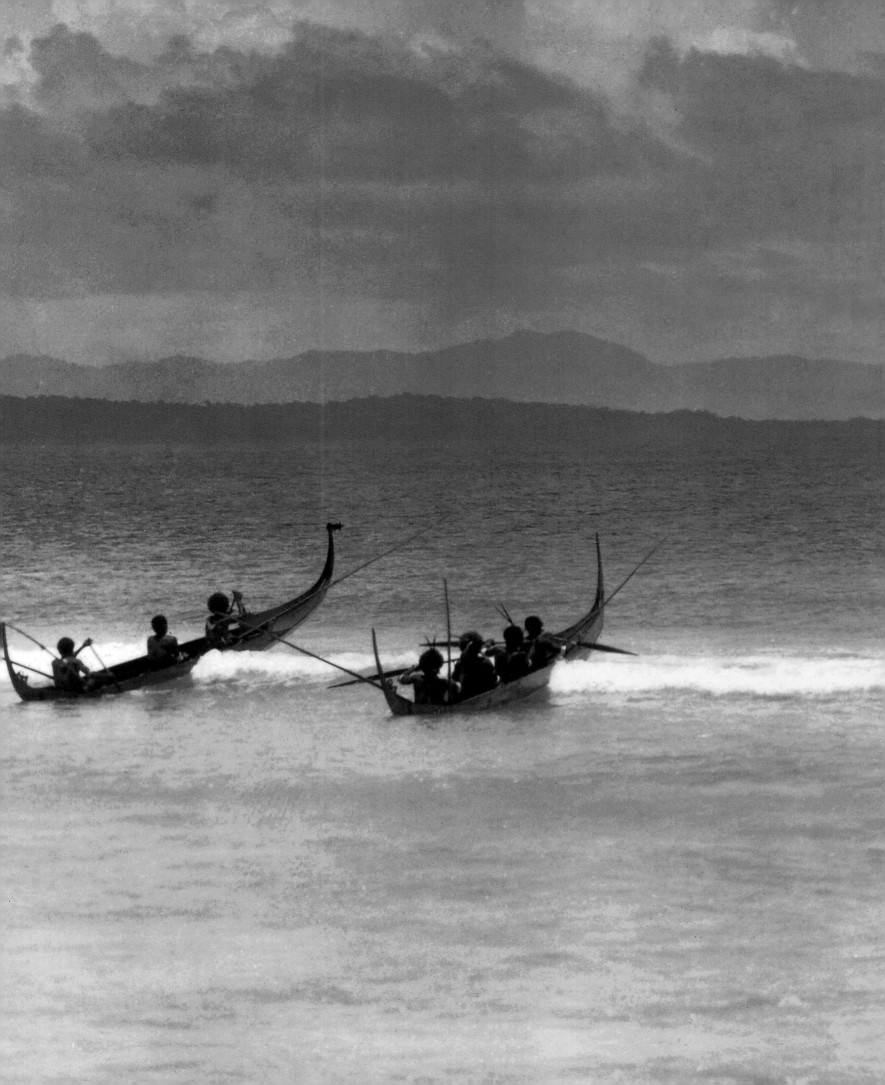

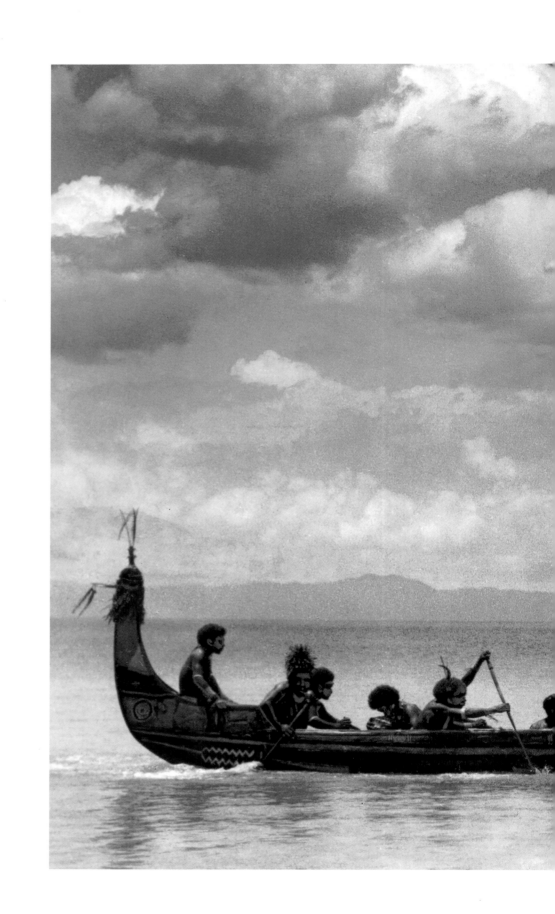

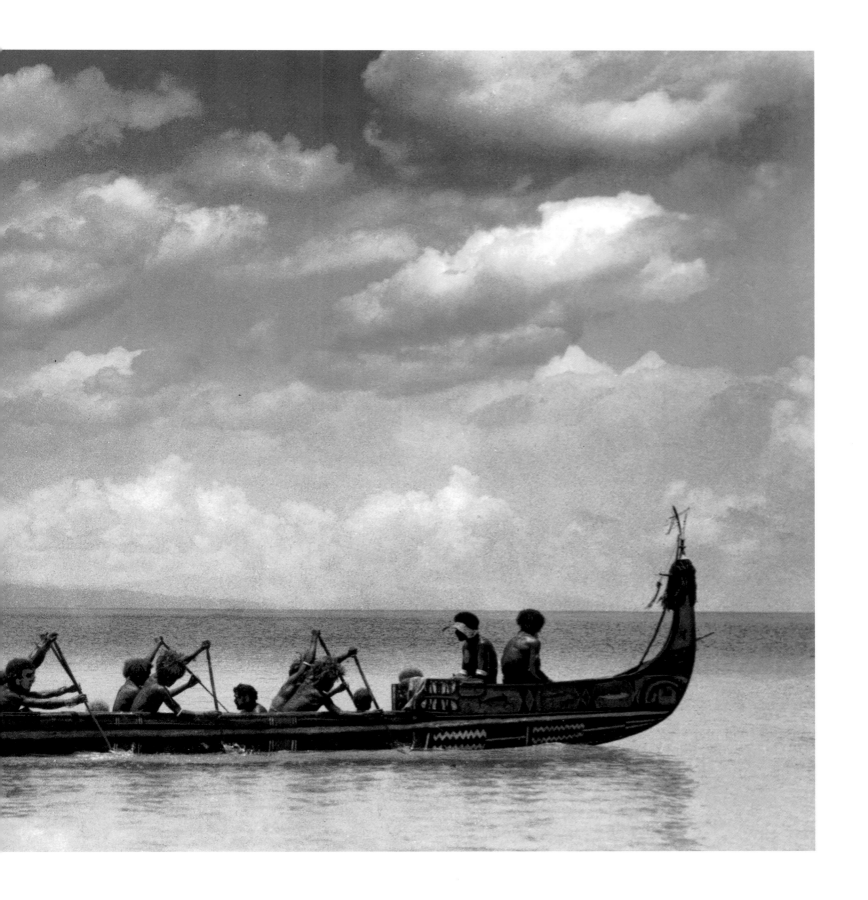

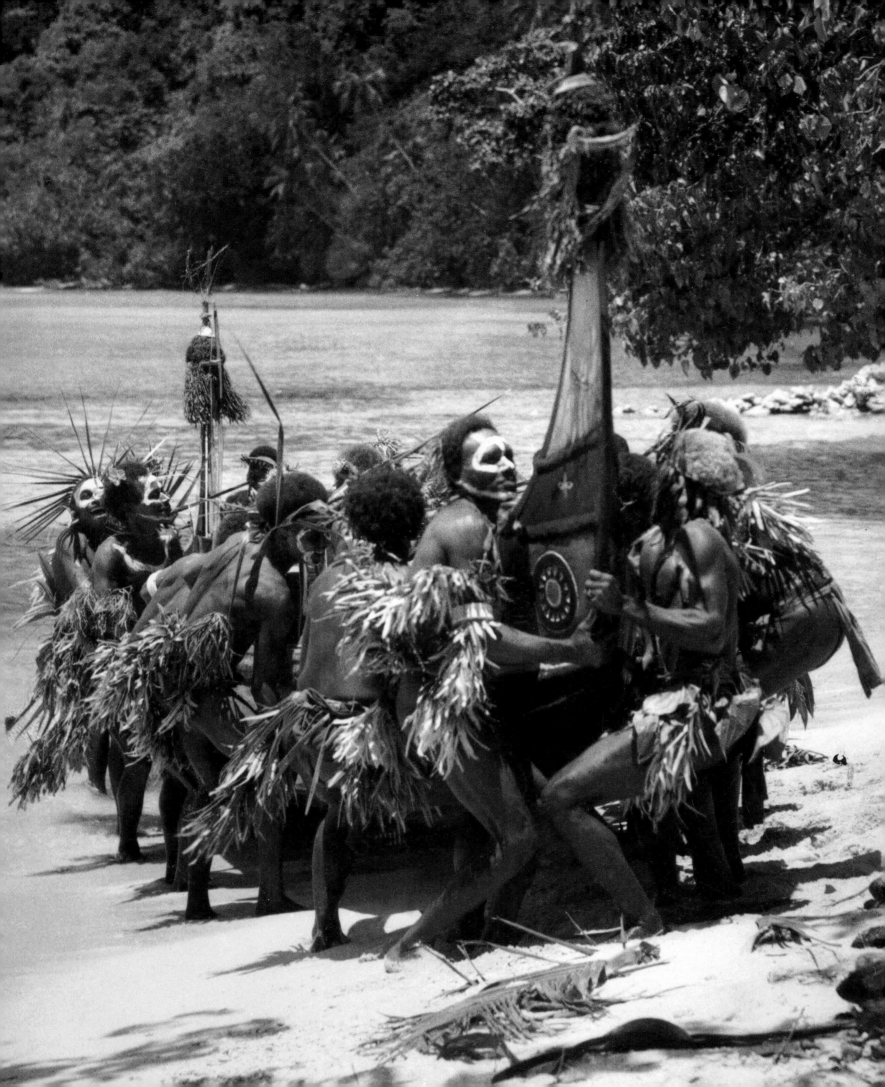

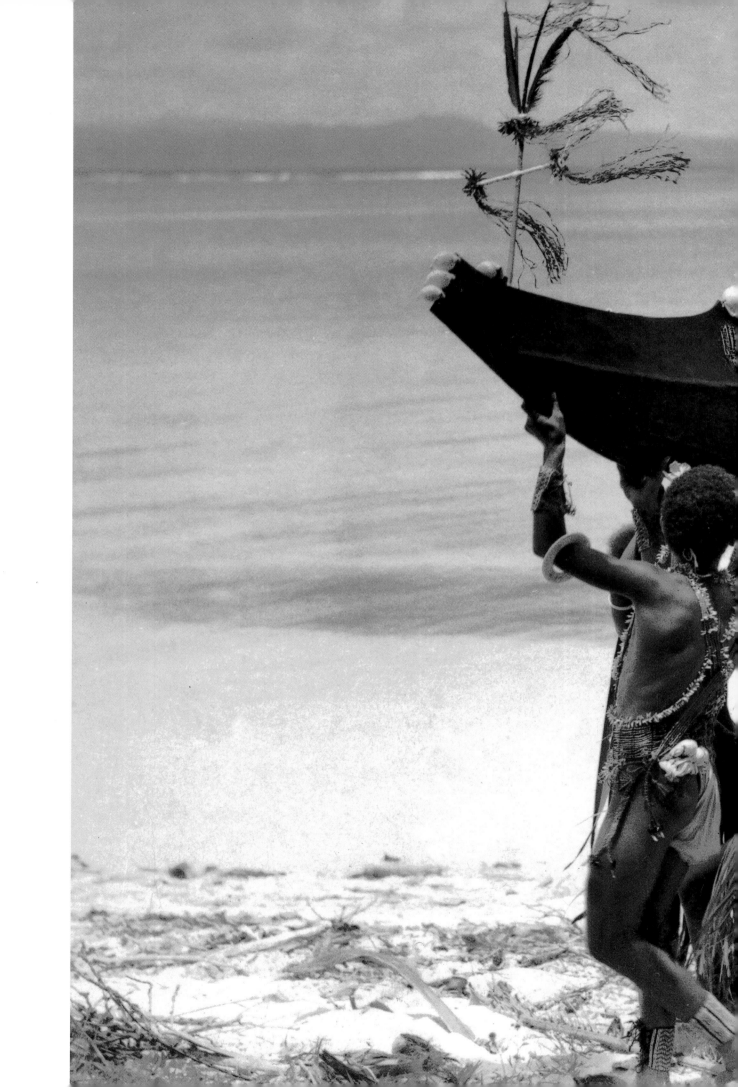

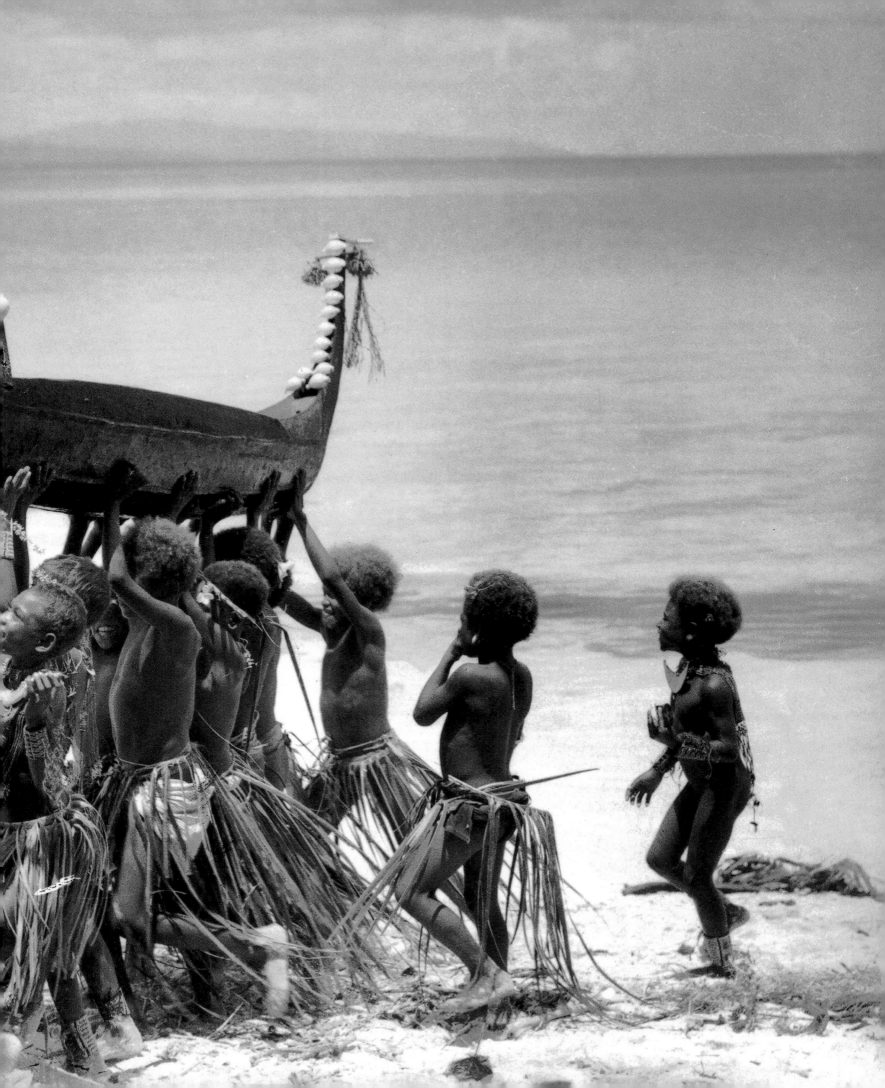

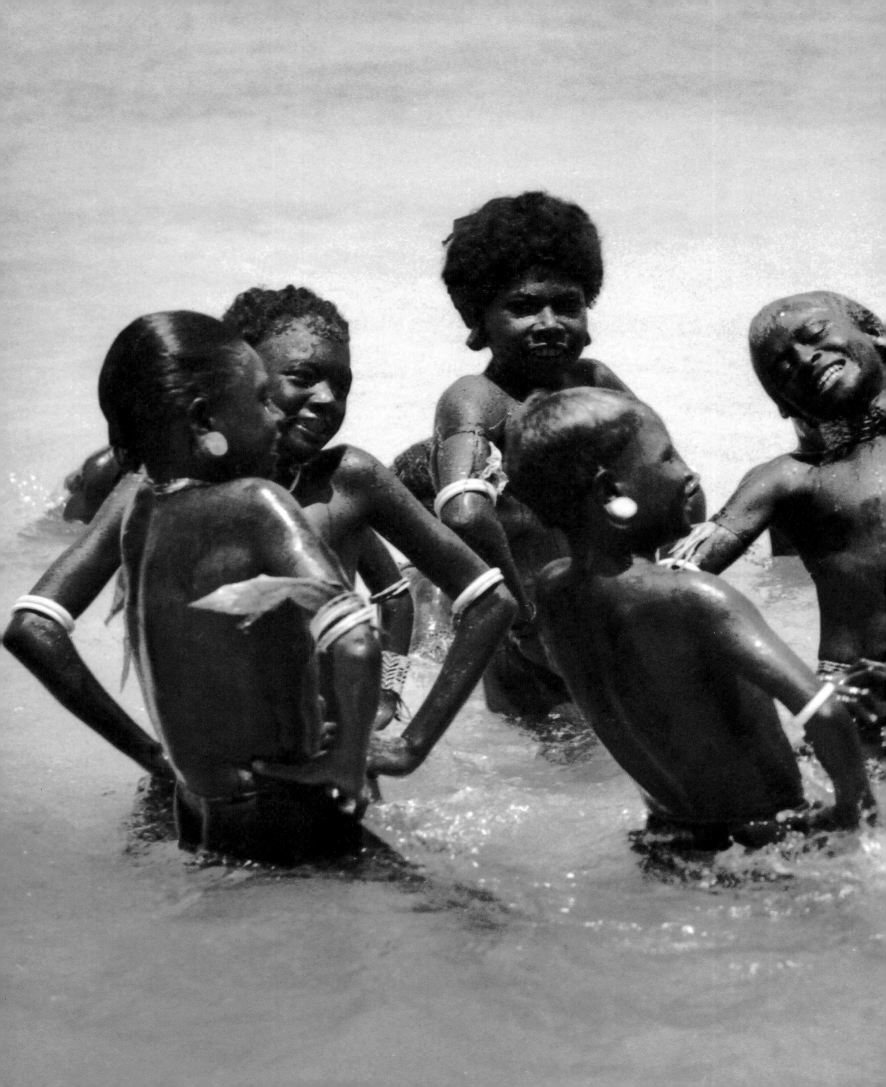

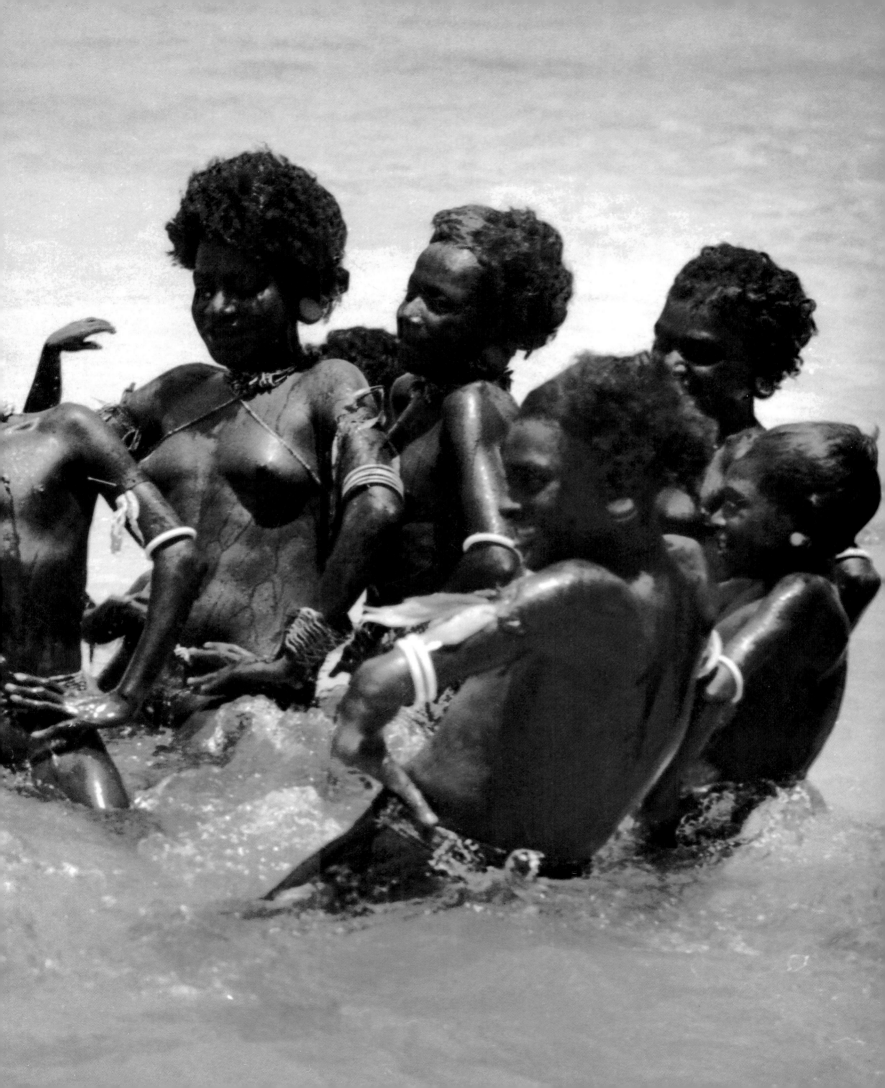

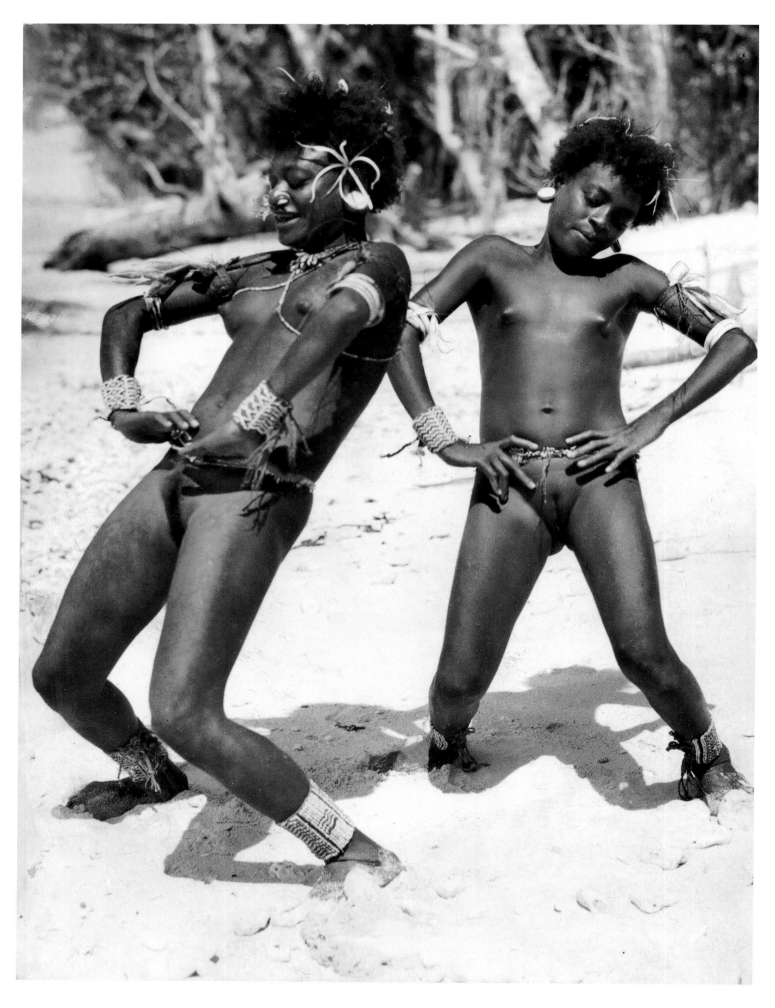

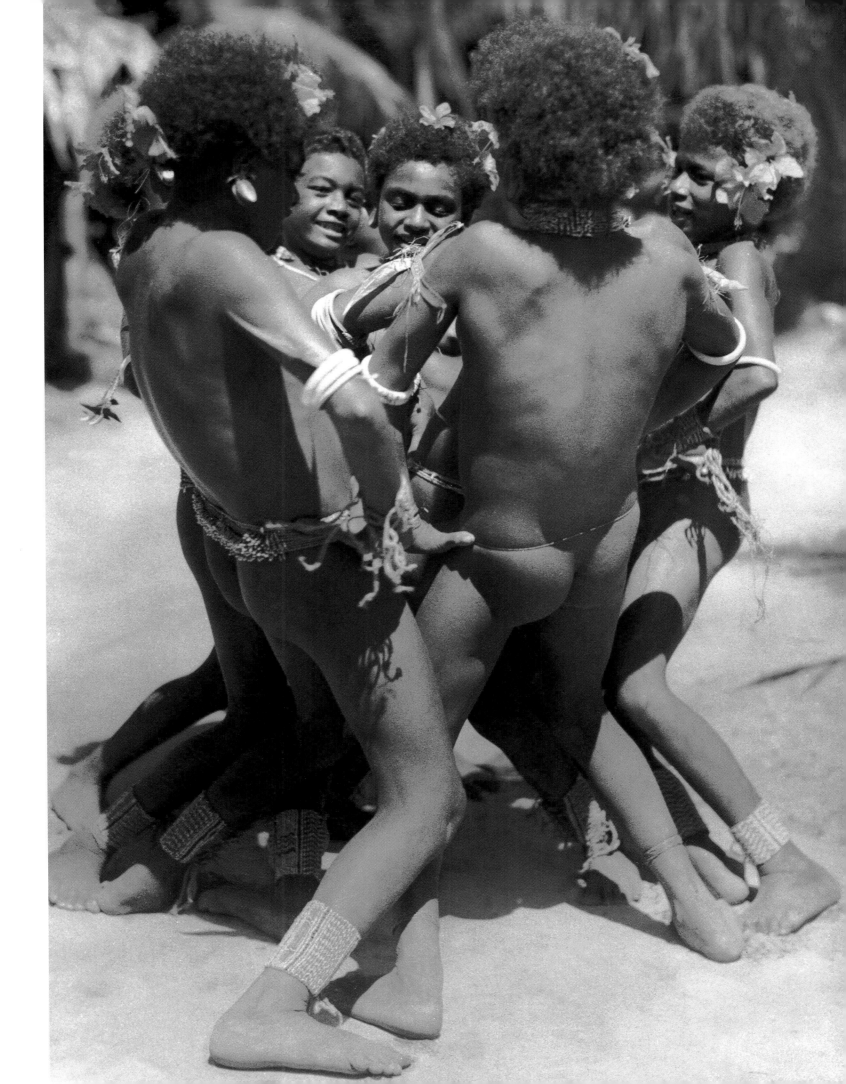

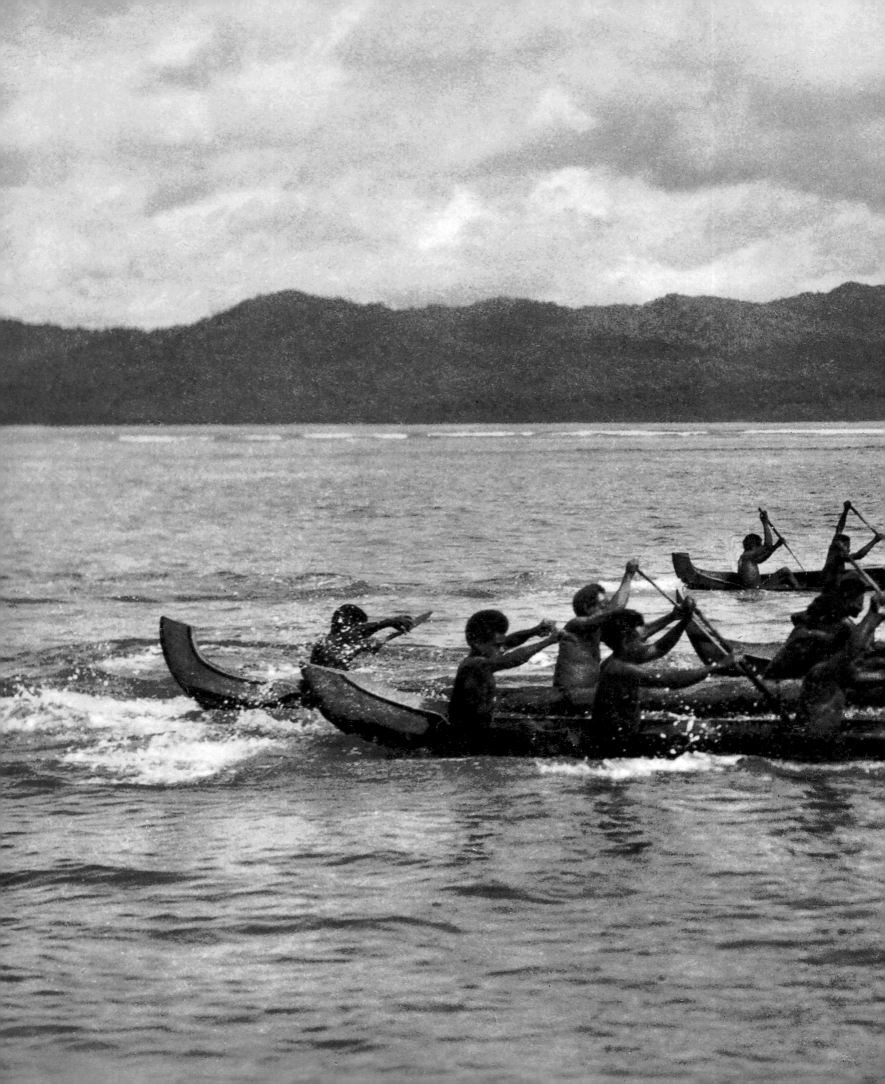

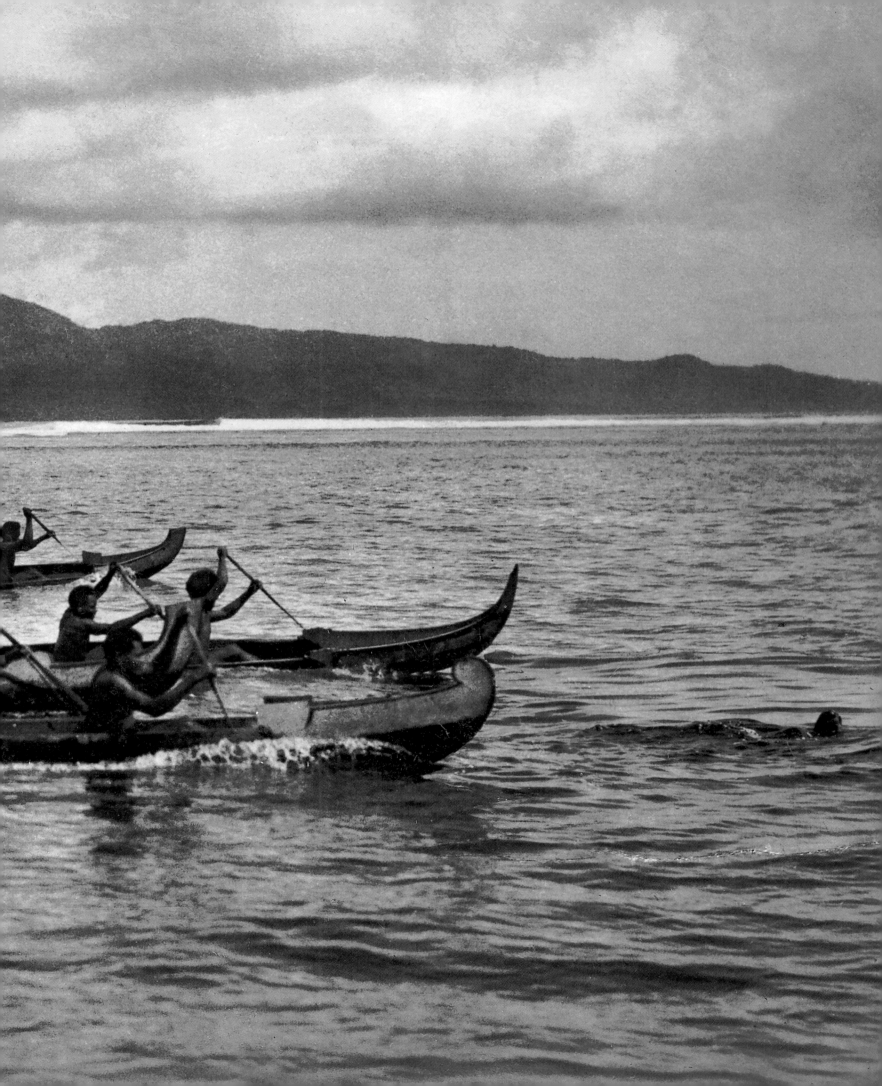

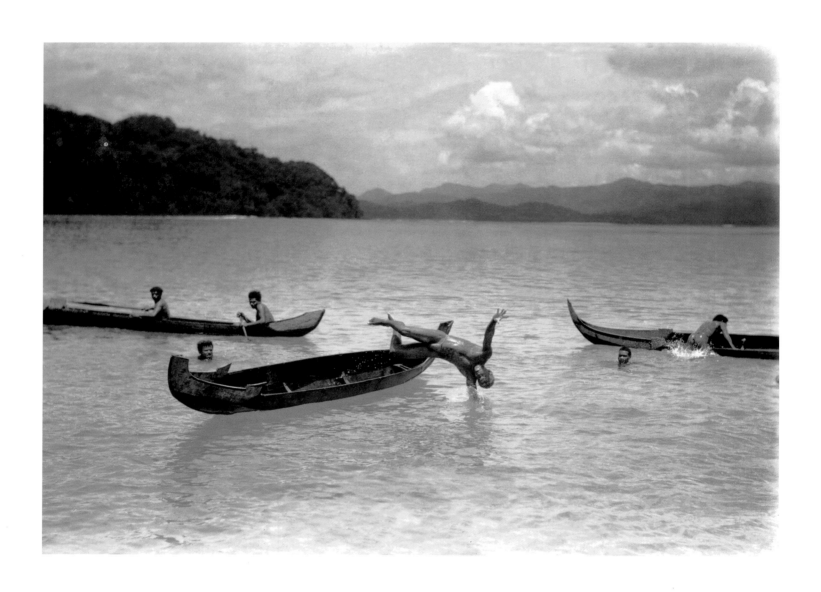

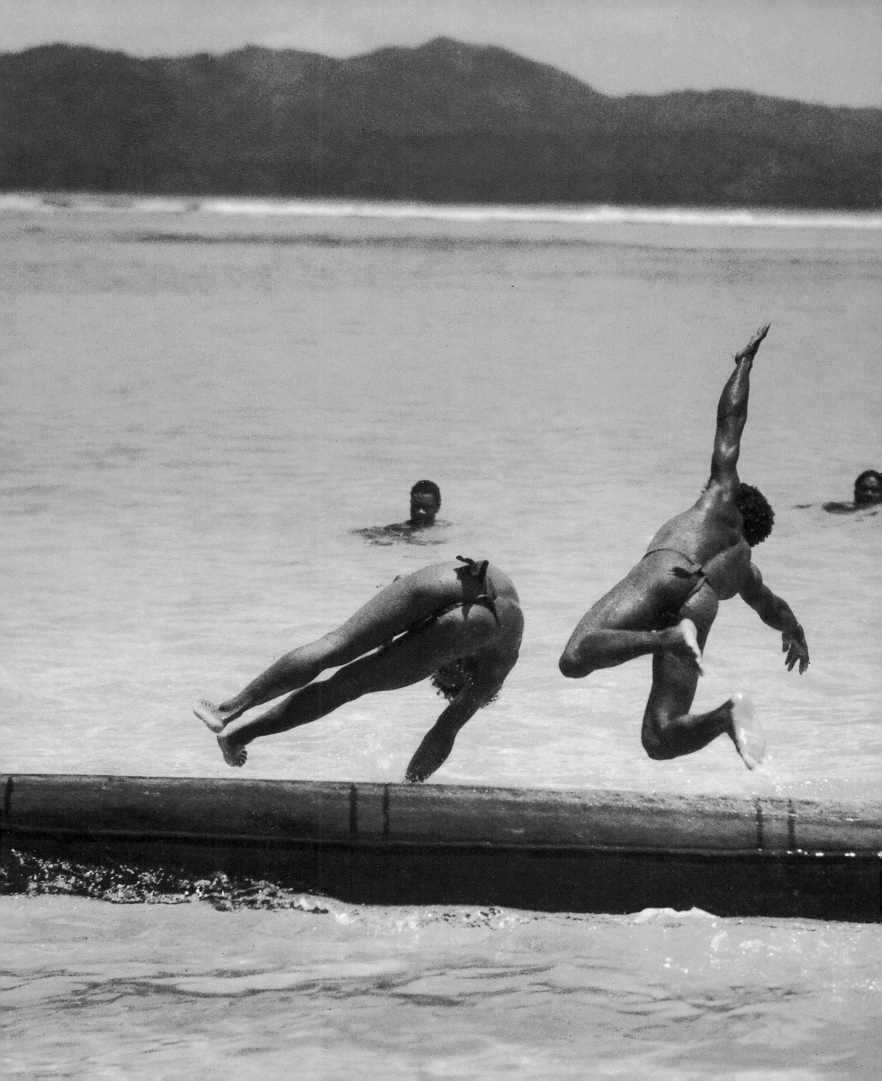

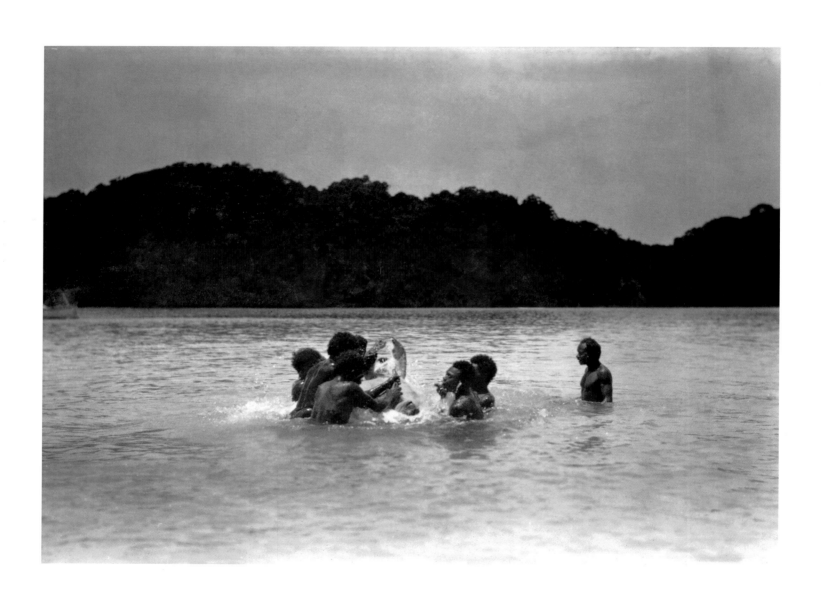

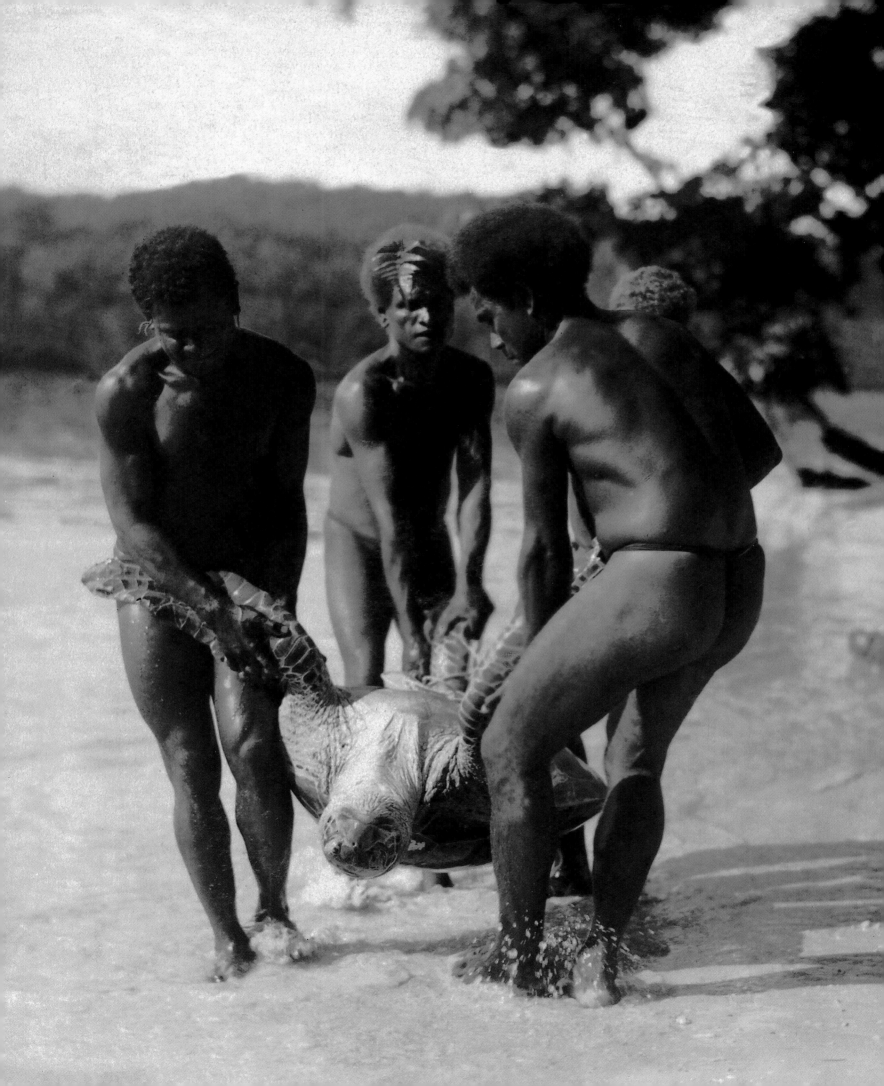

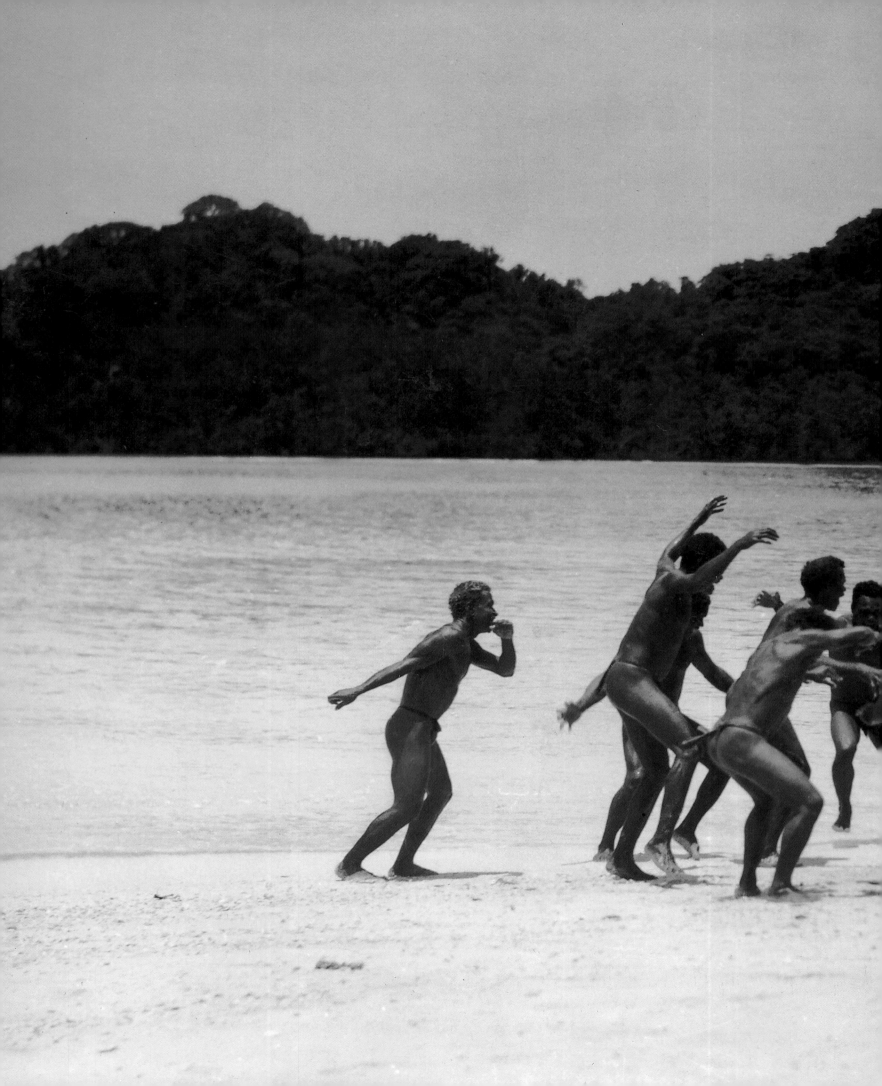

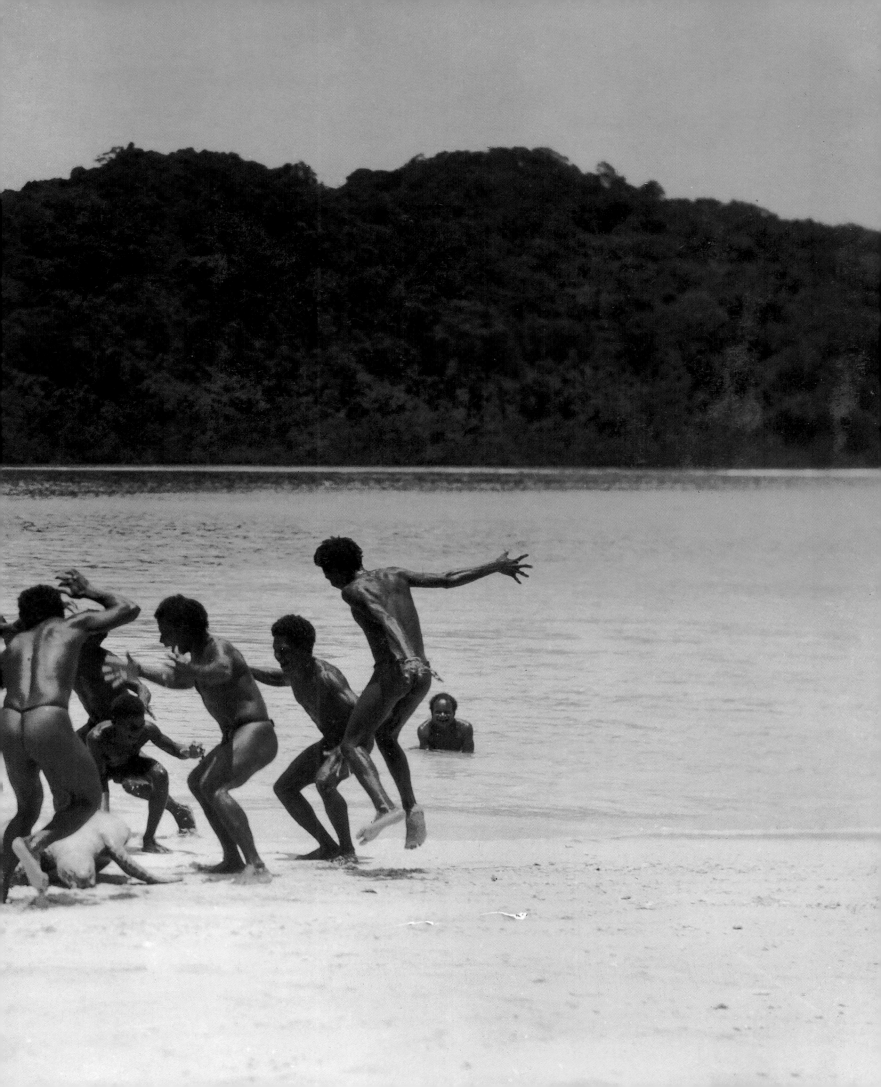

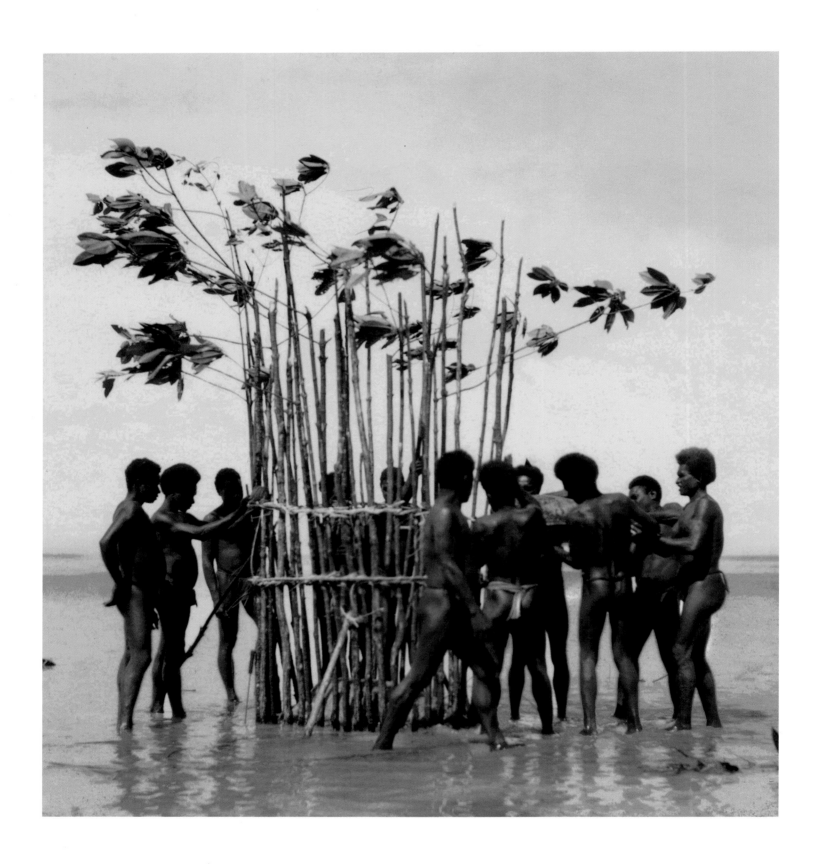

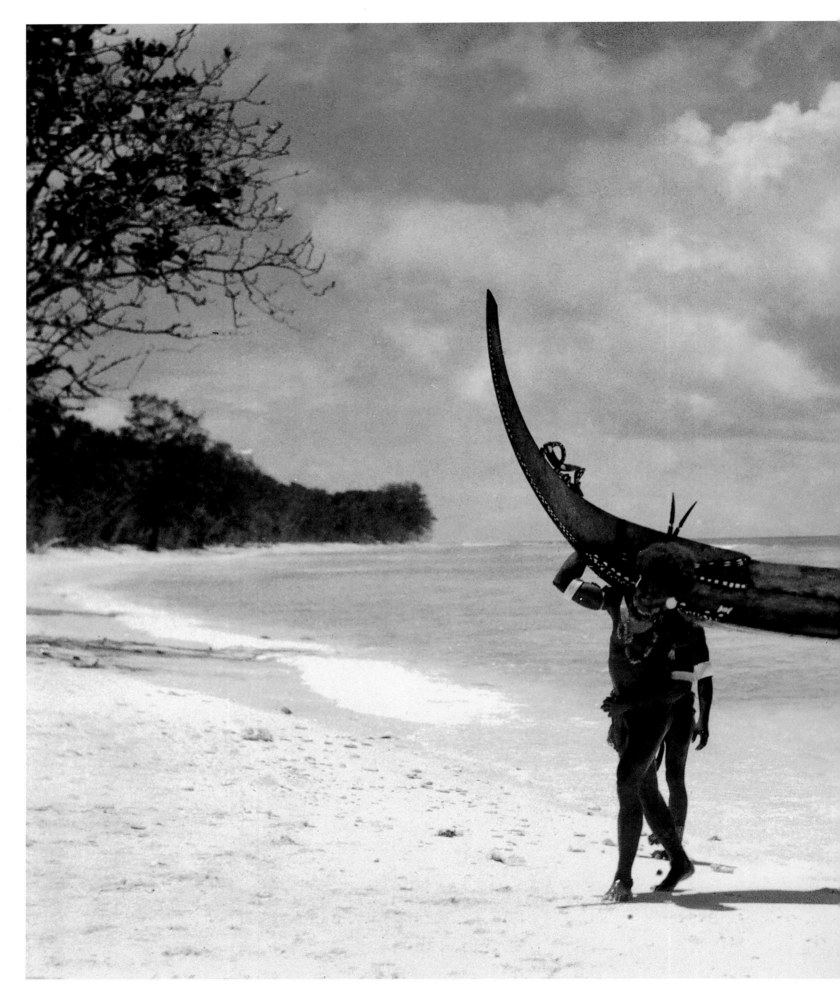

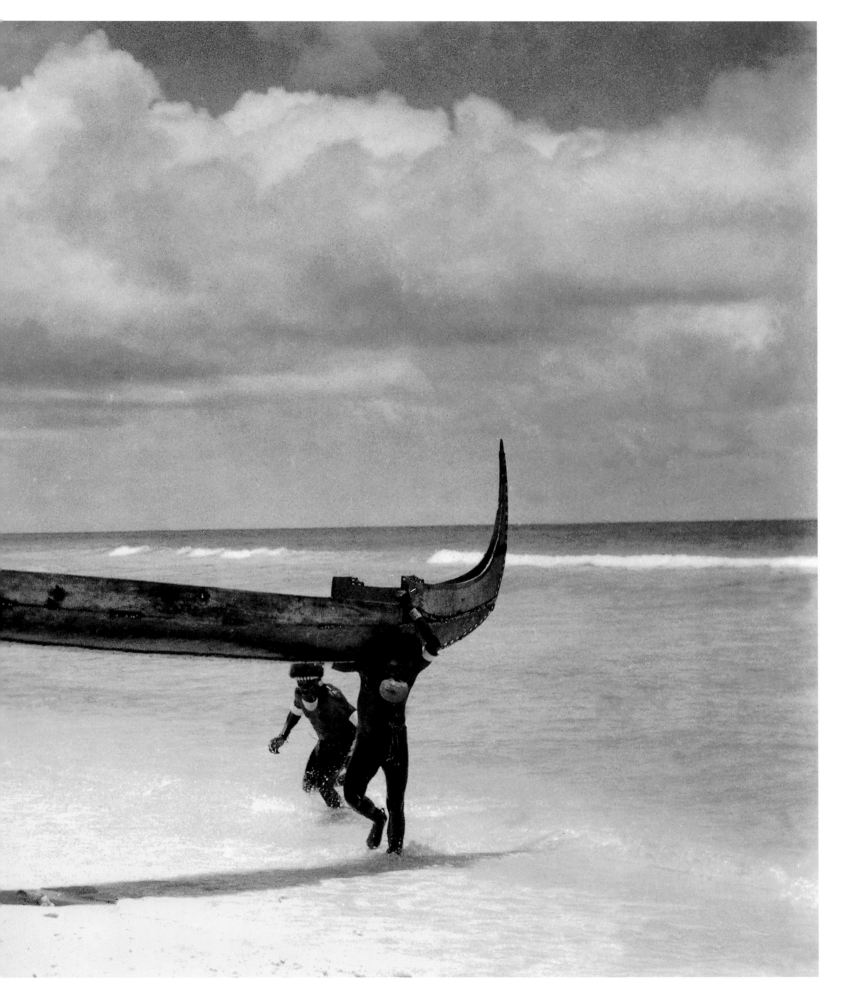

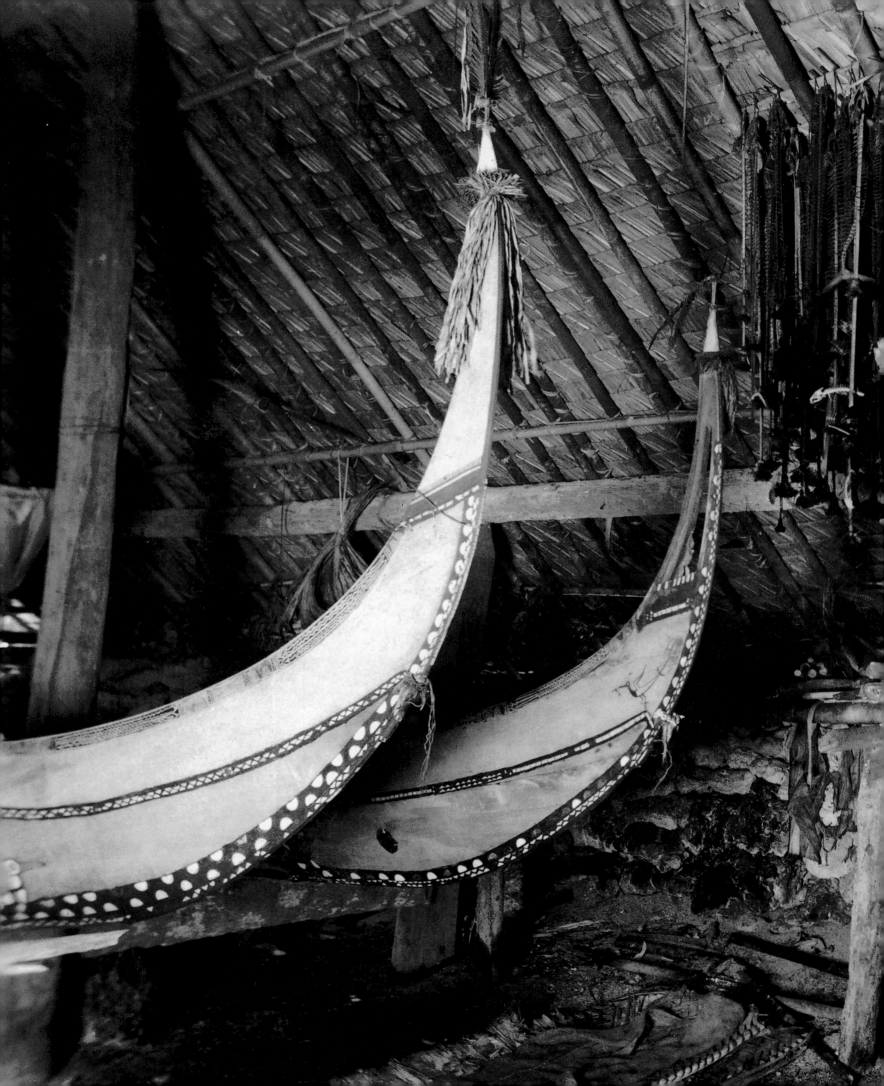

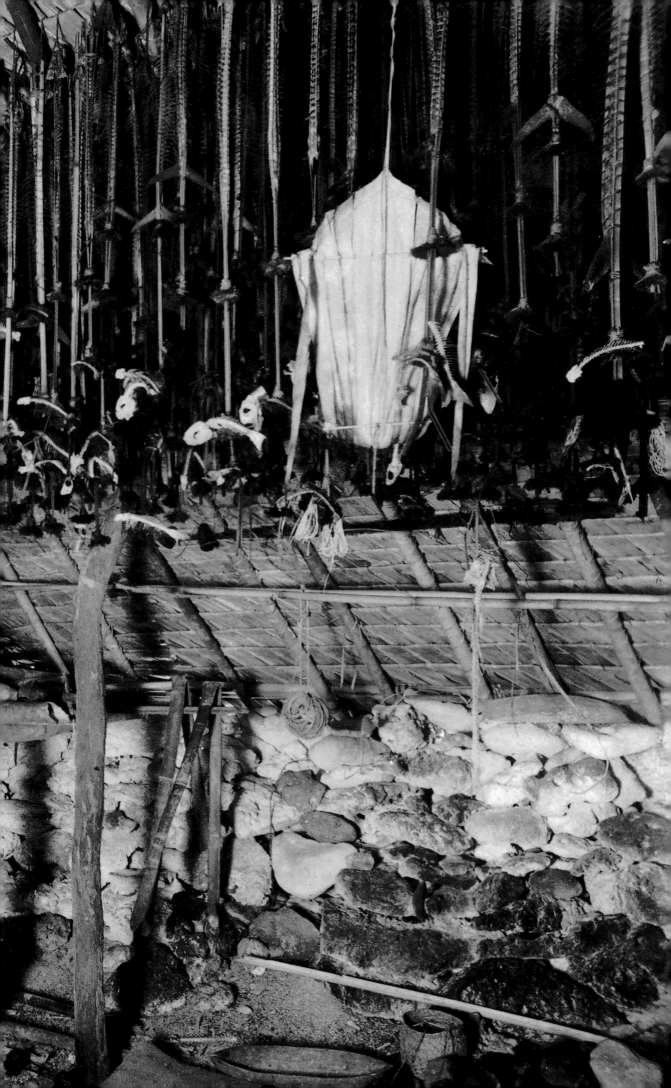

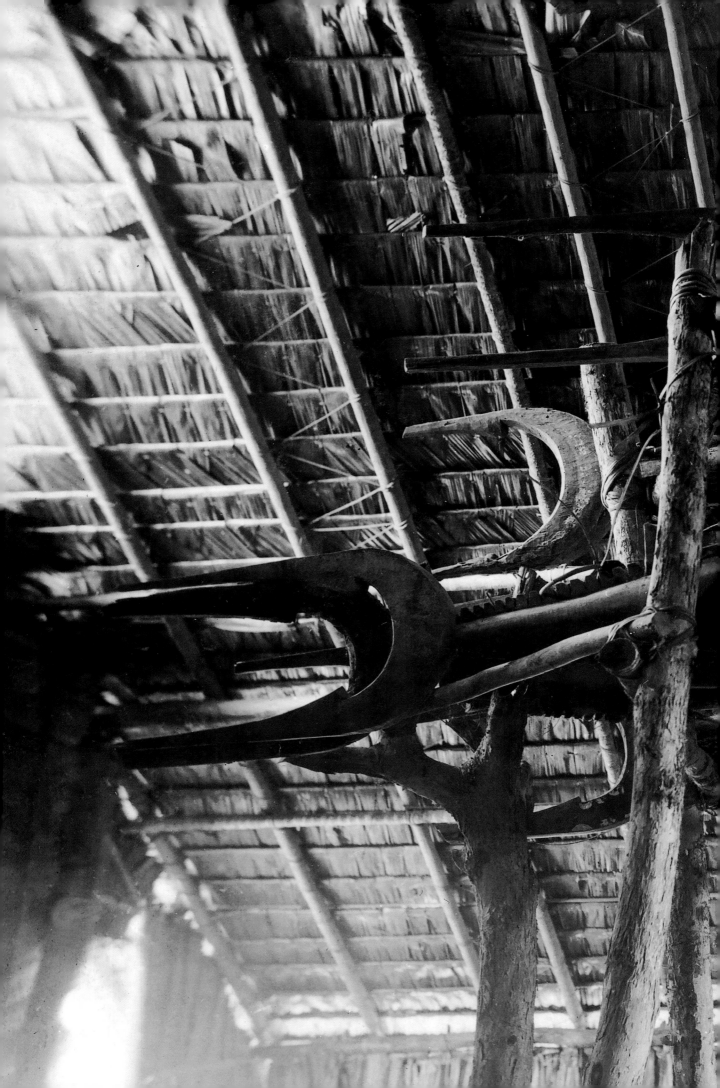

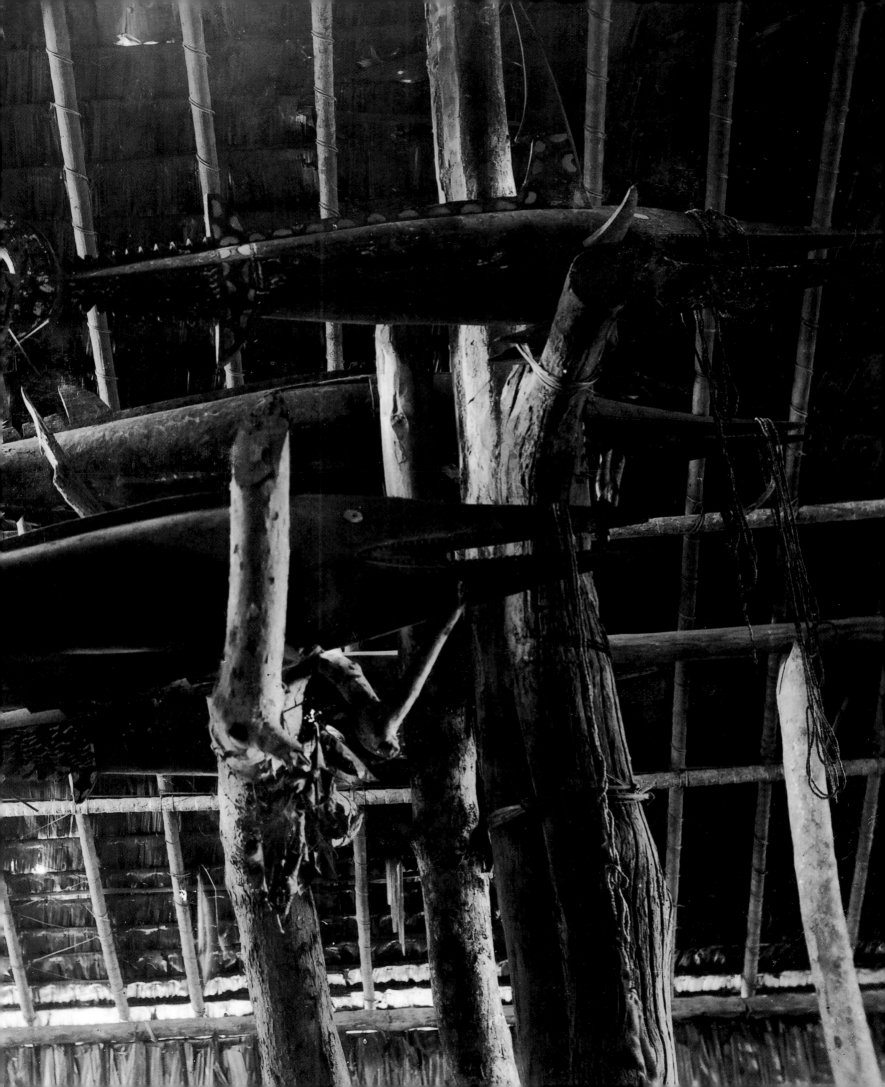

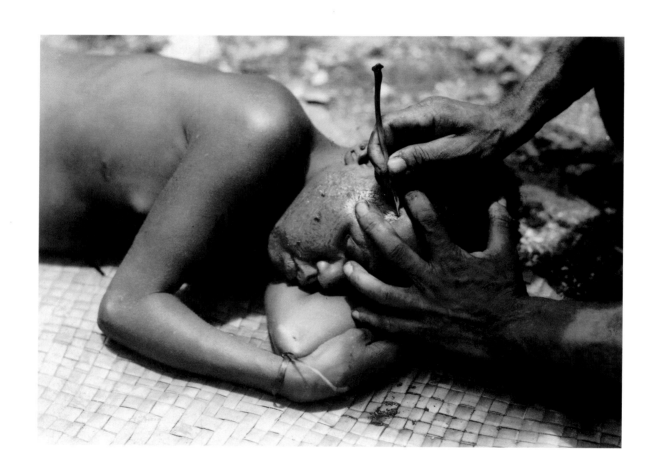

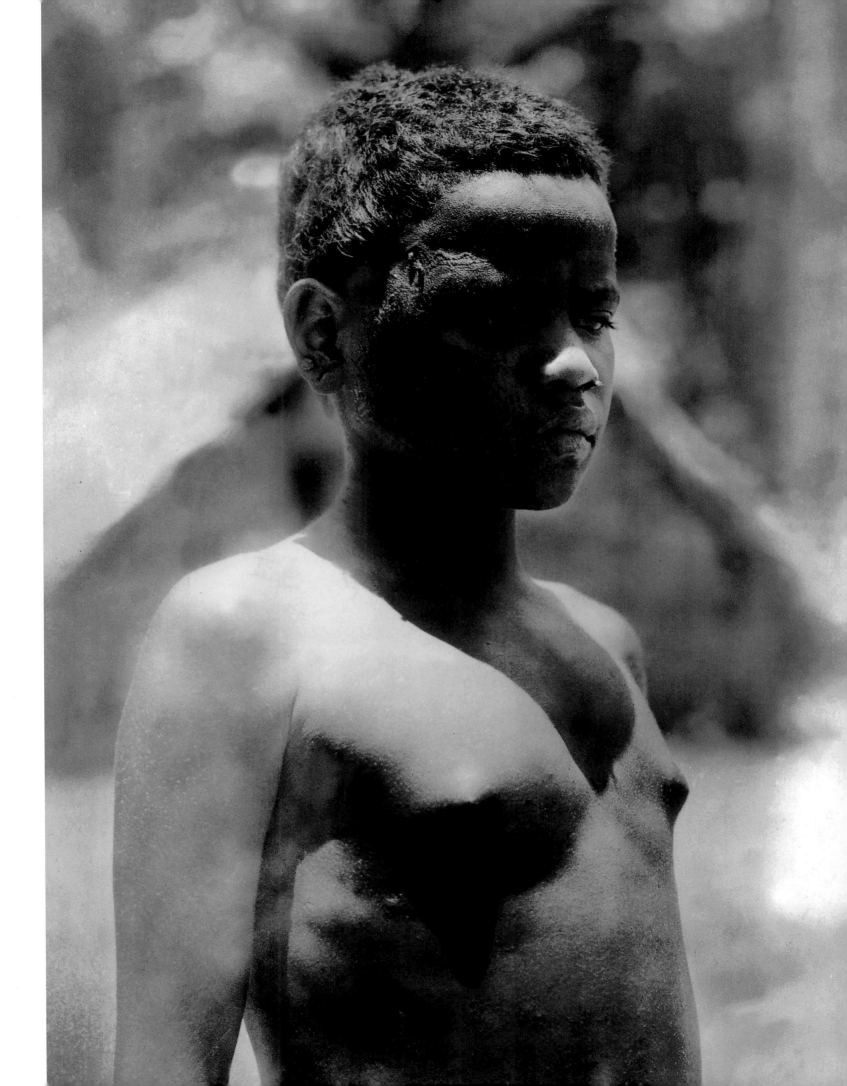

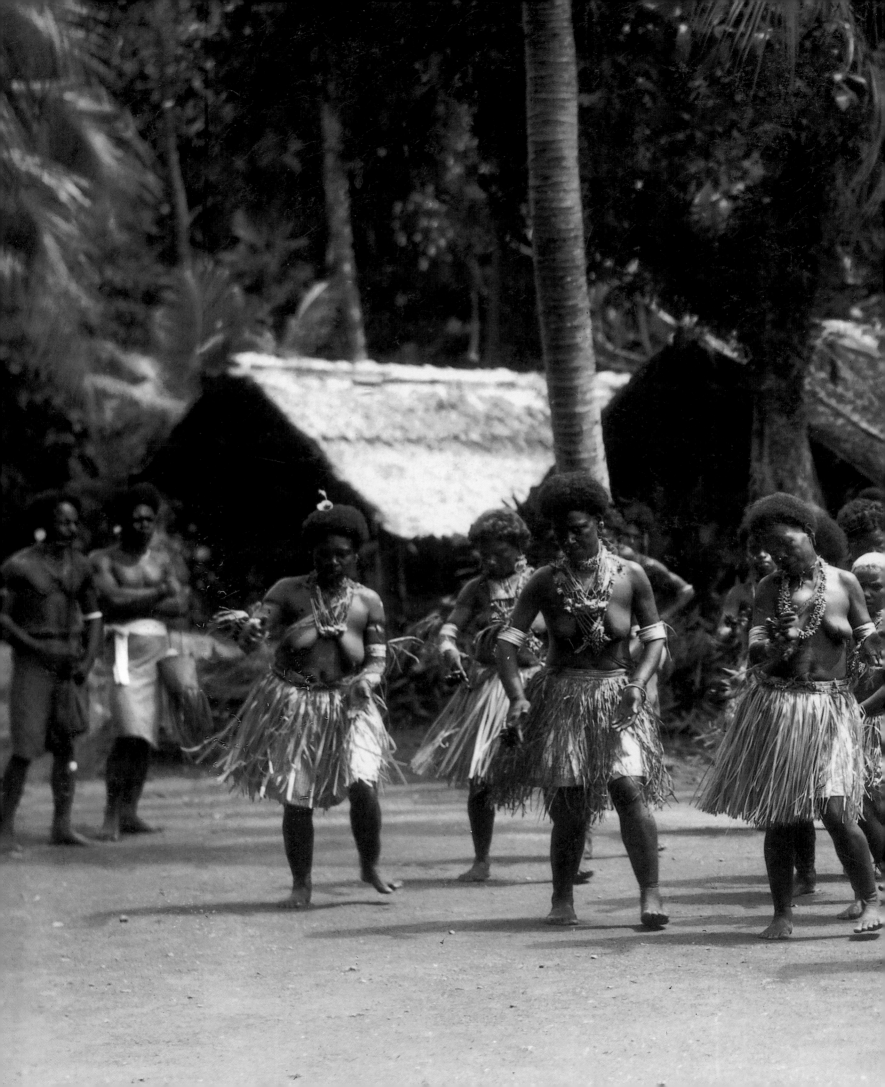

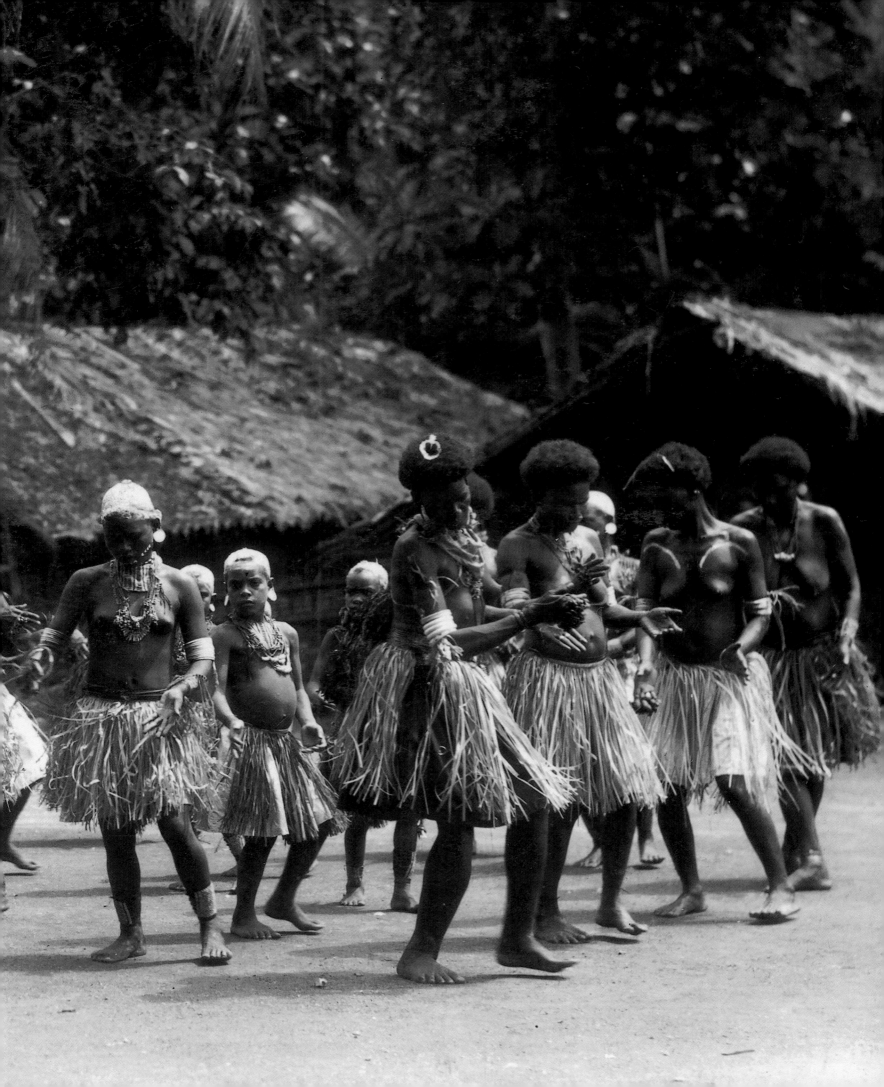

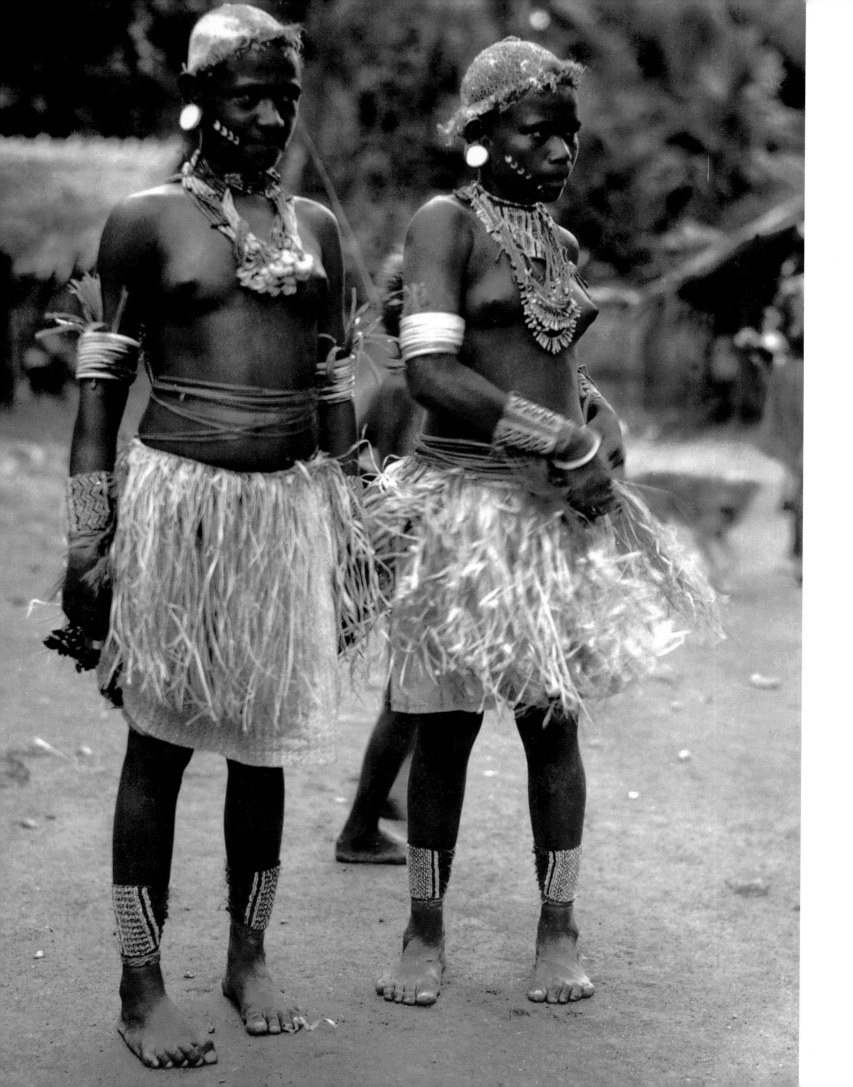

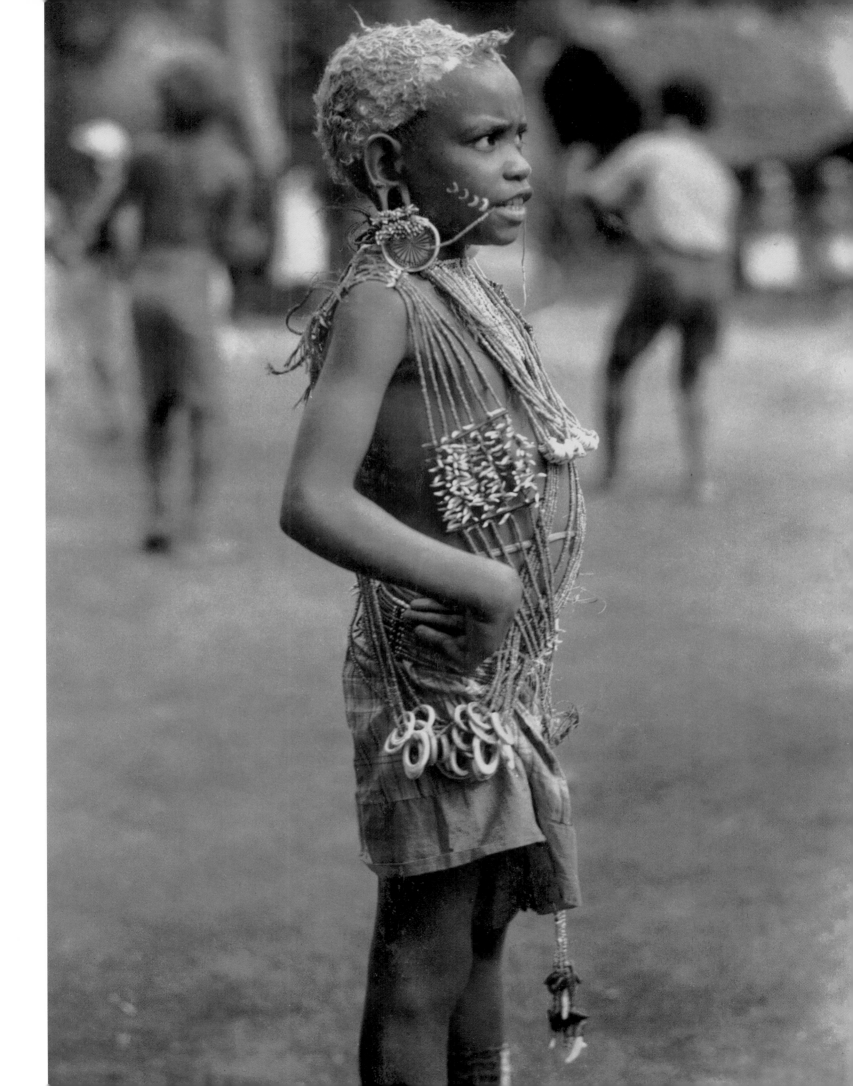

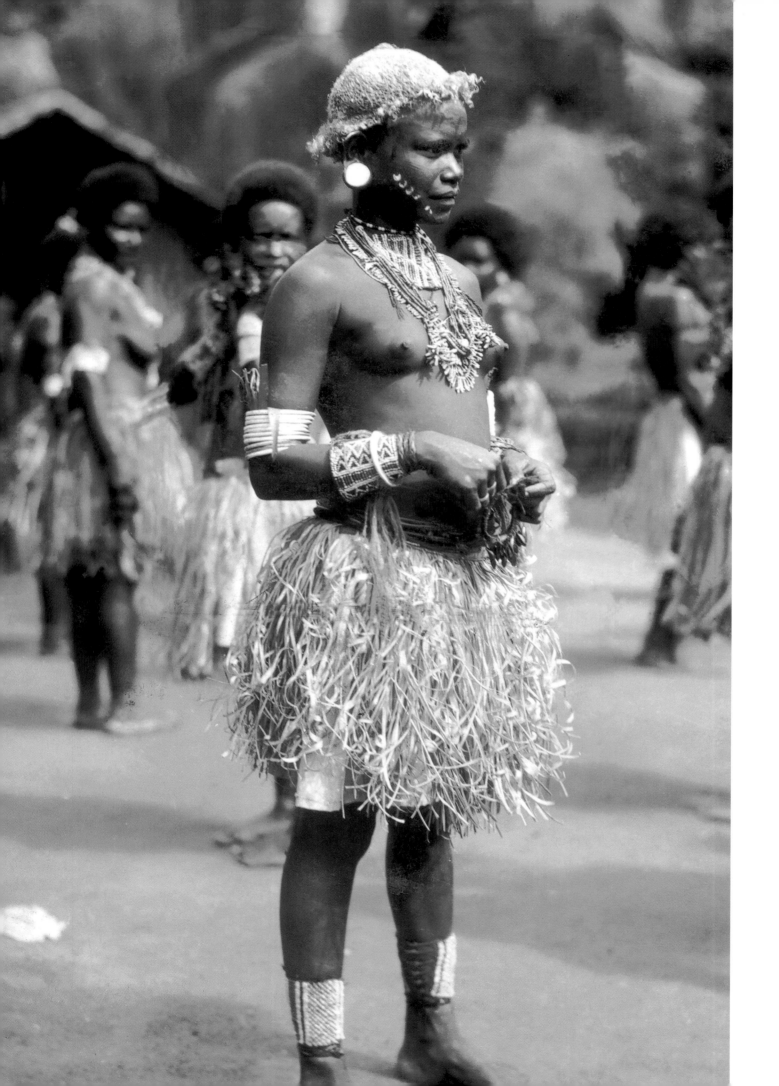

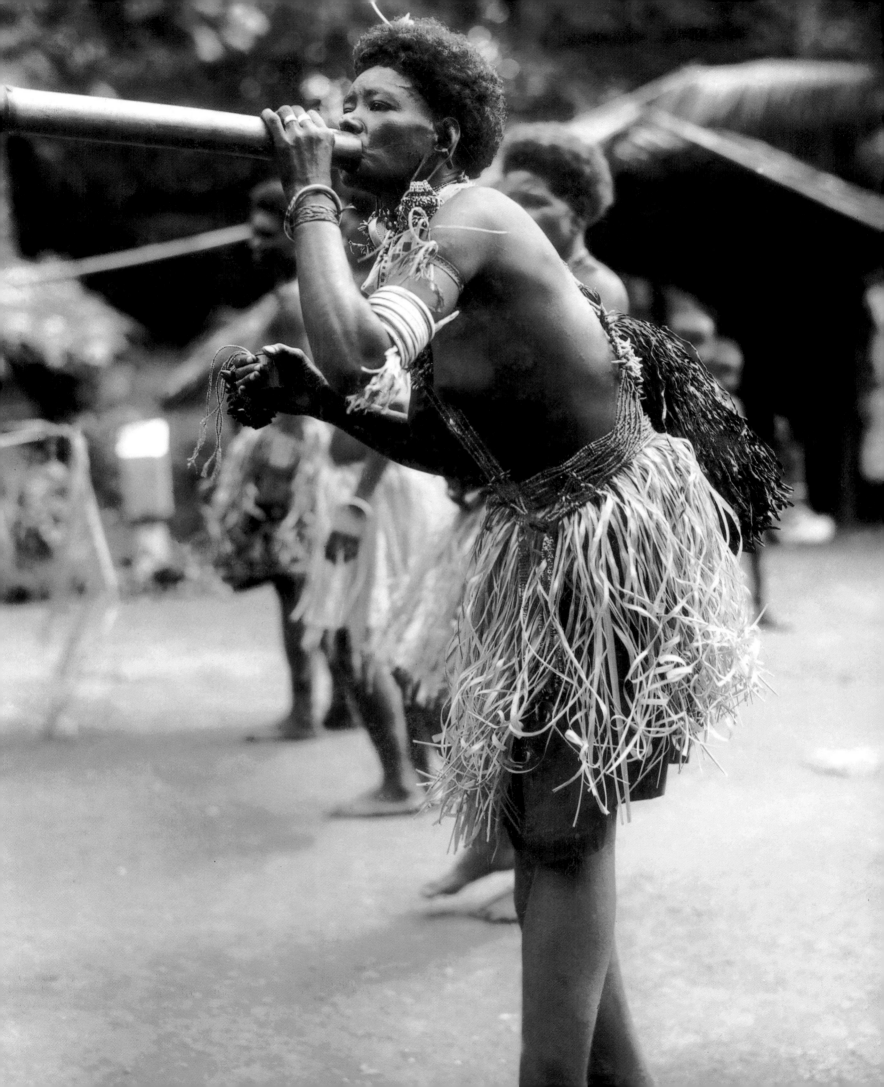

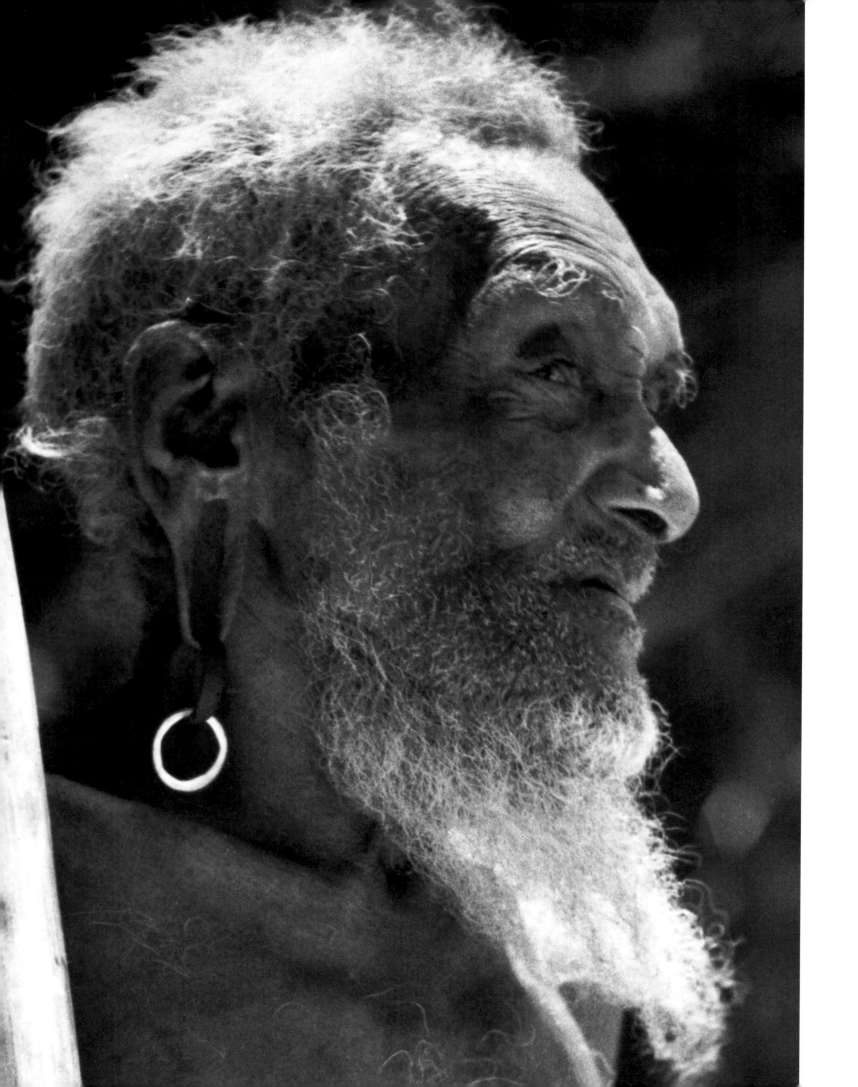

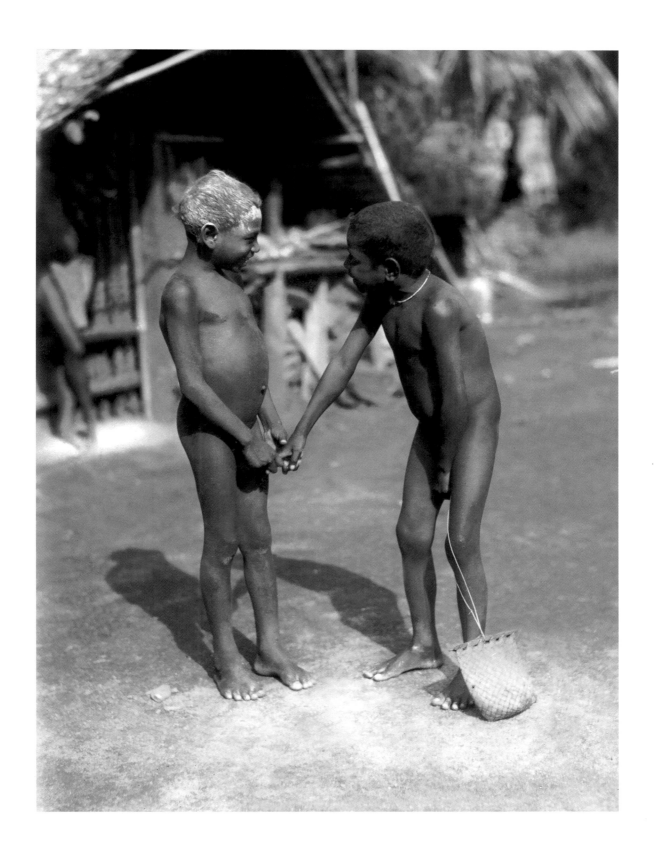

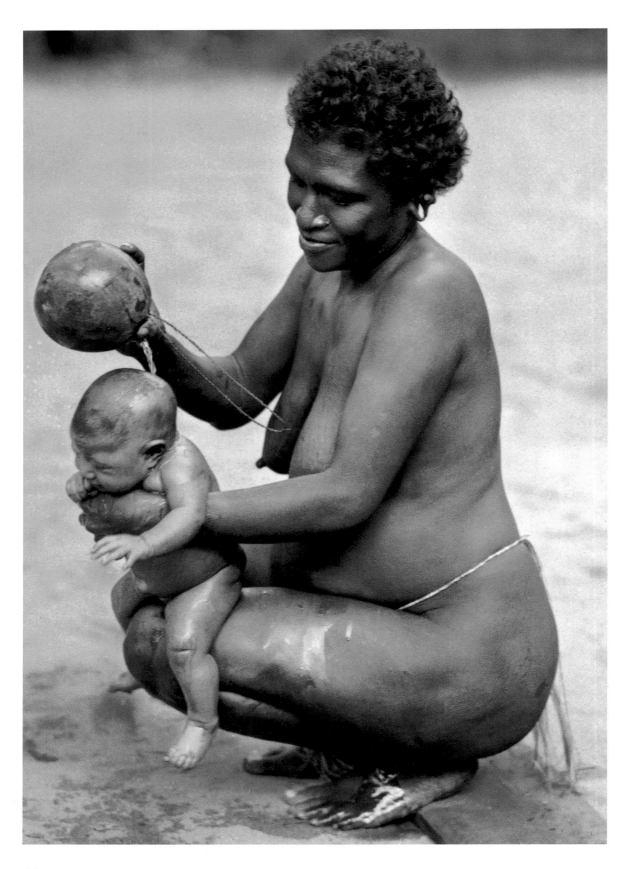

102

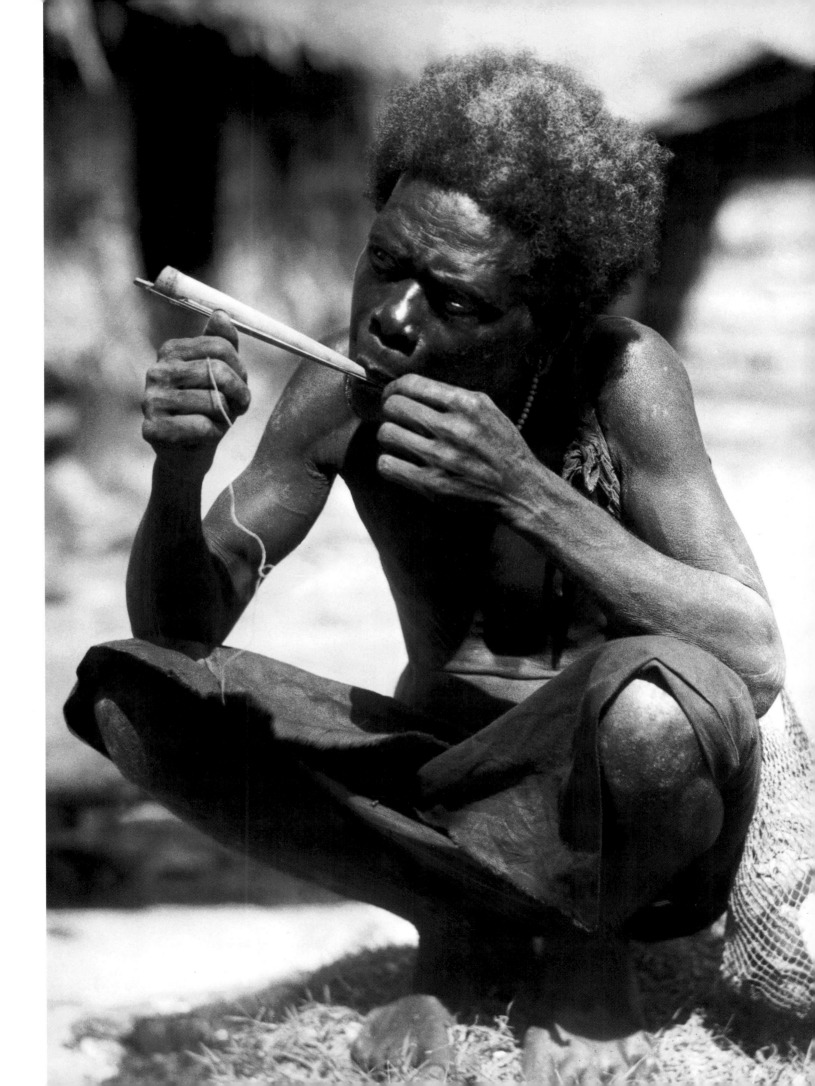

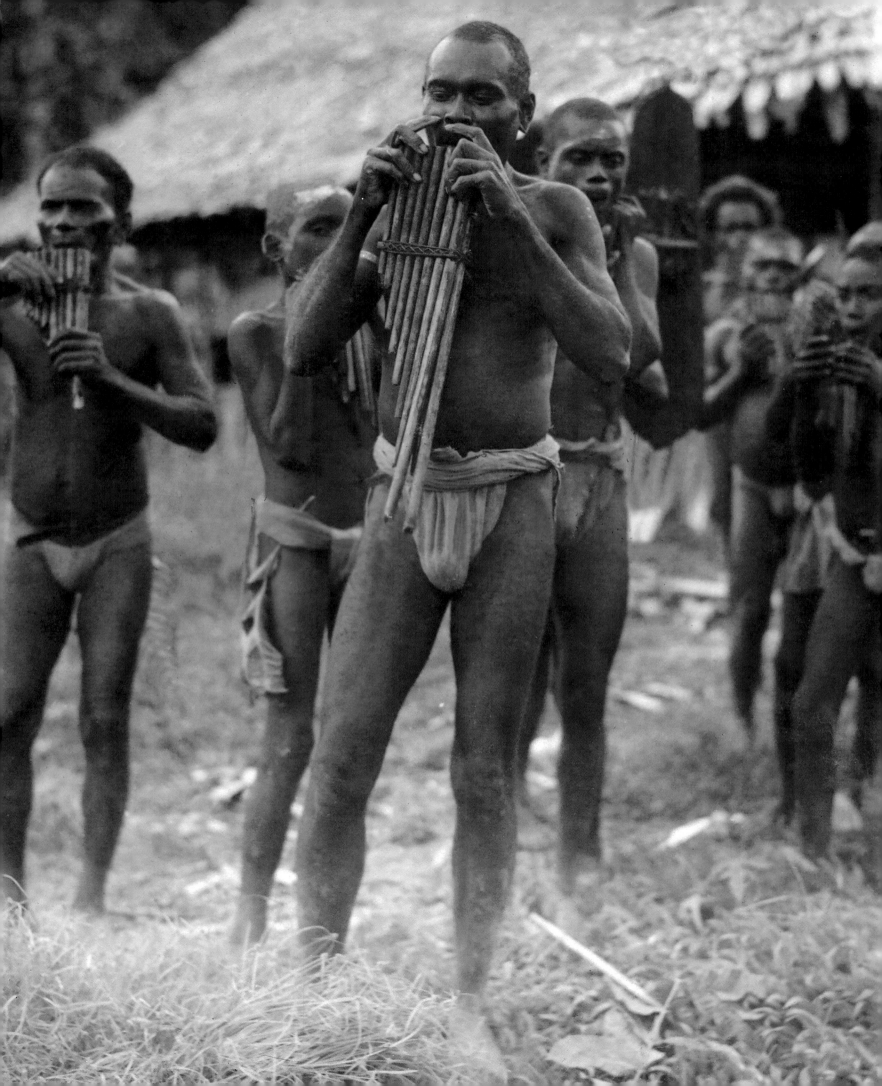

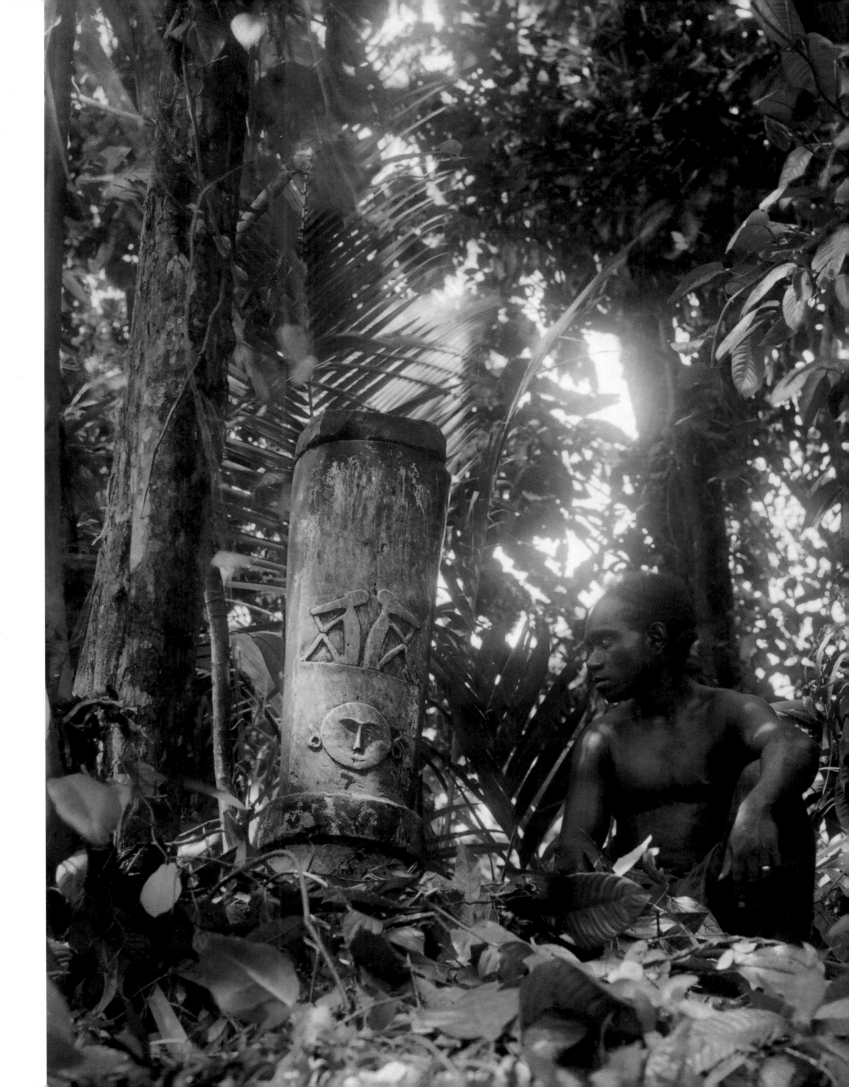

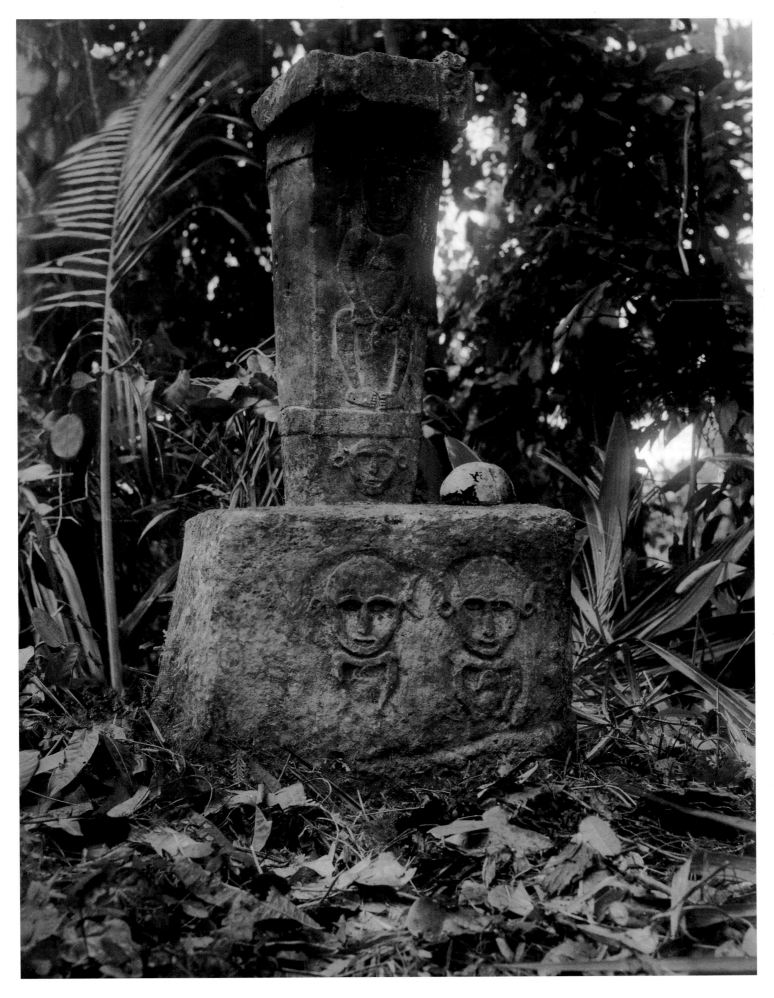

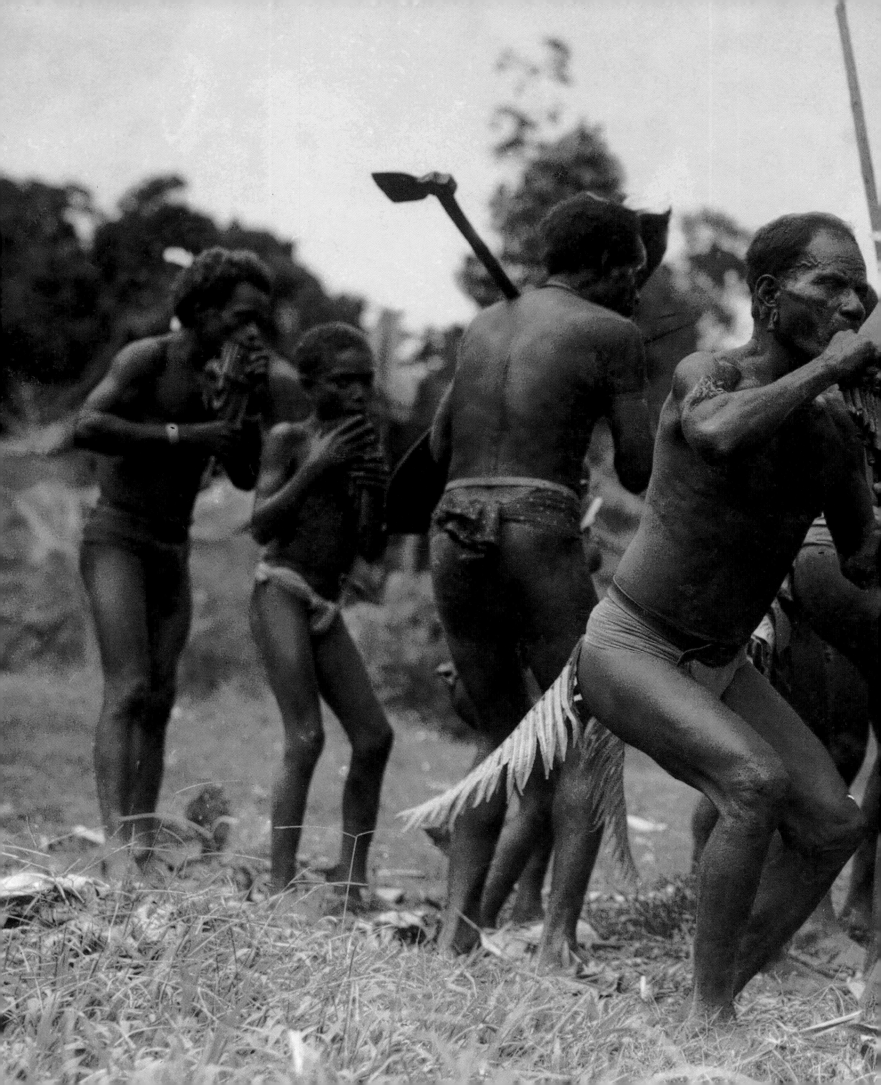

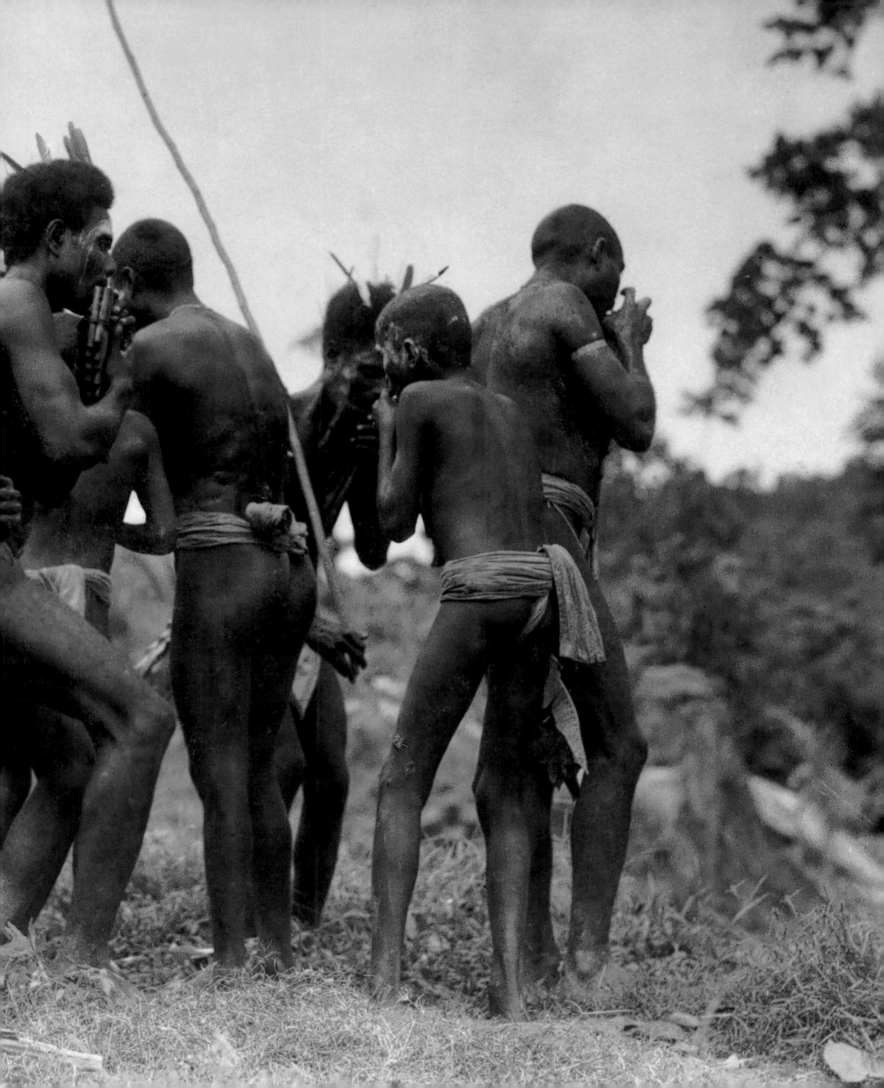

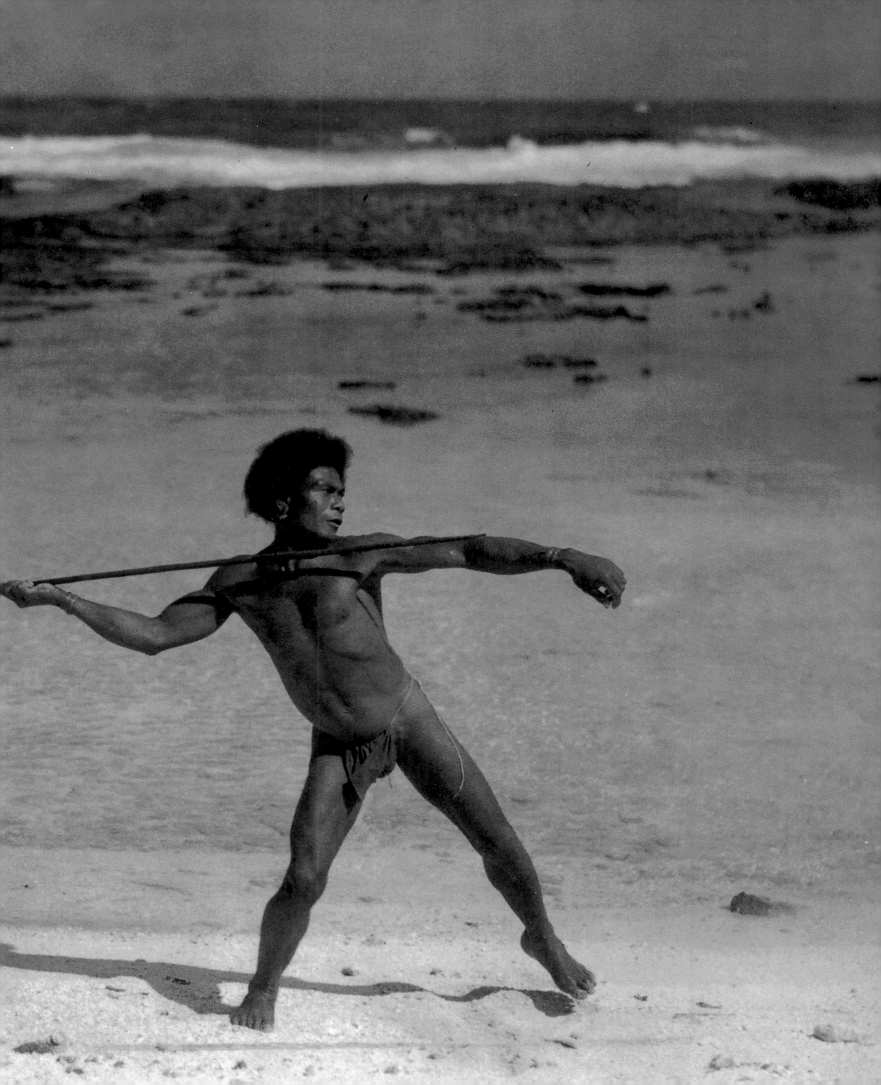

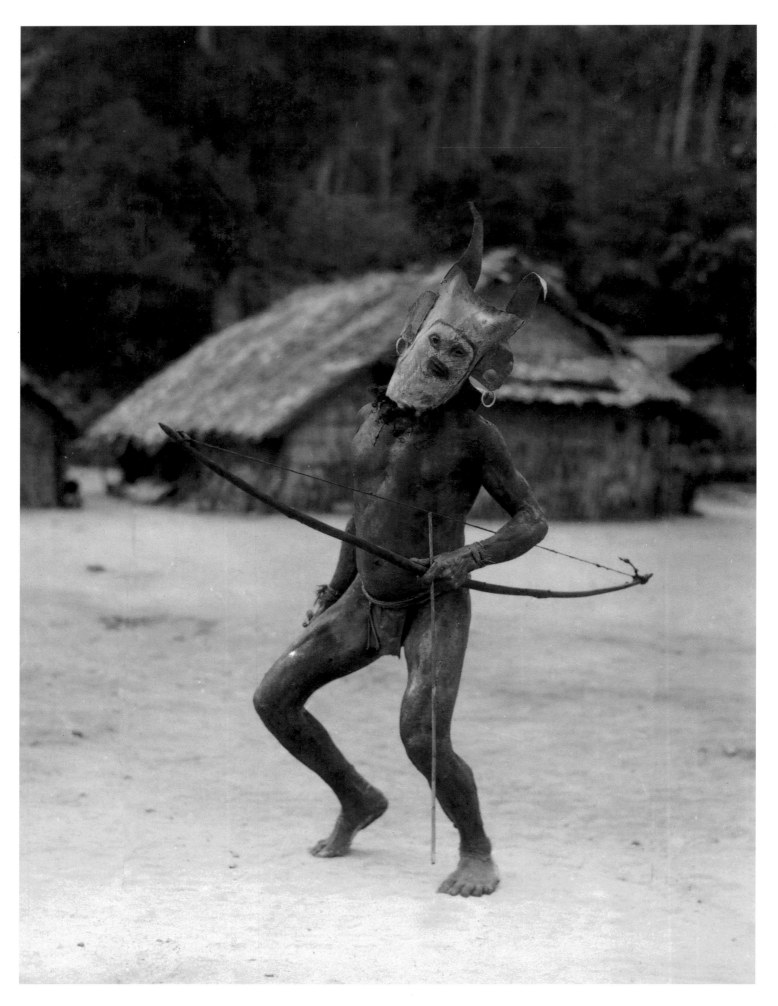

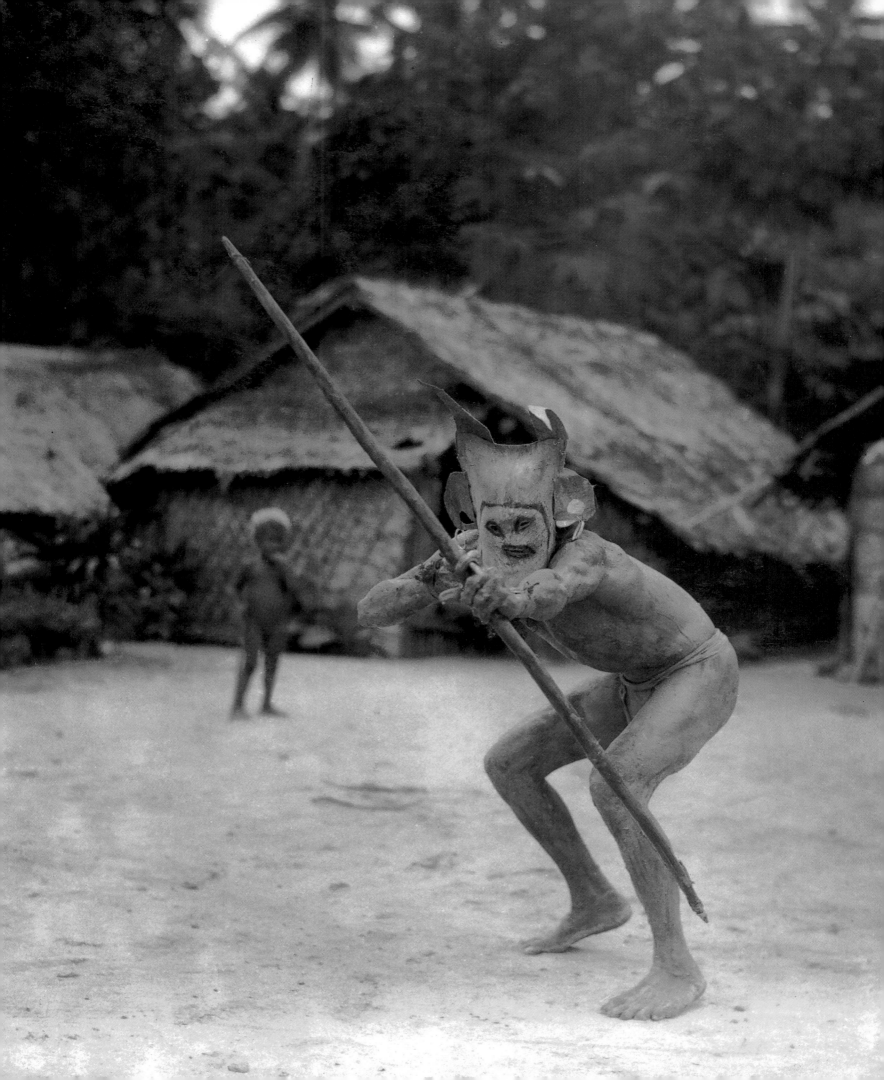

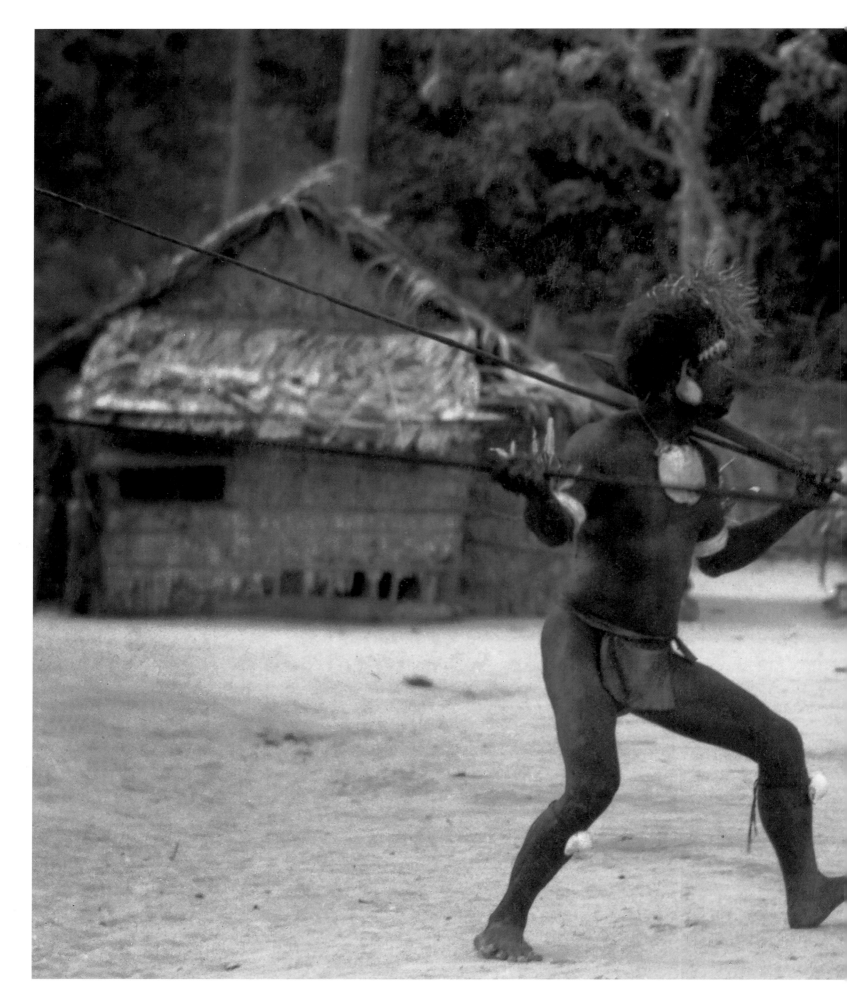

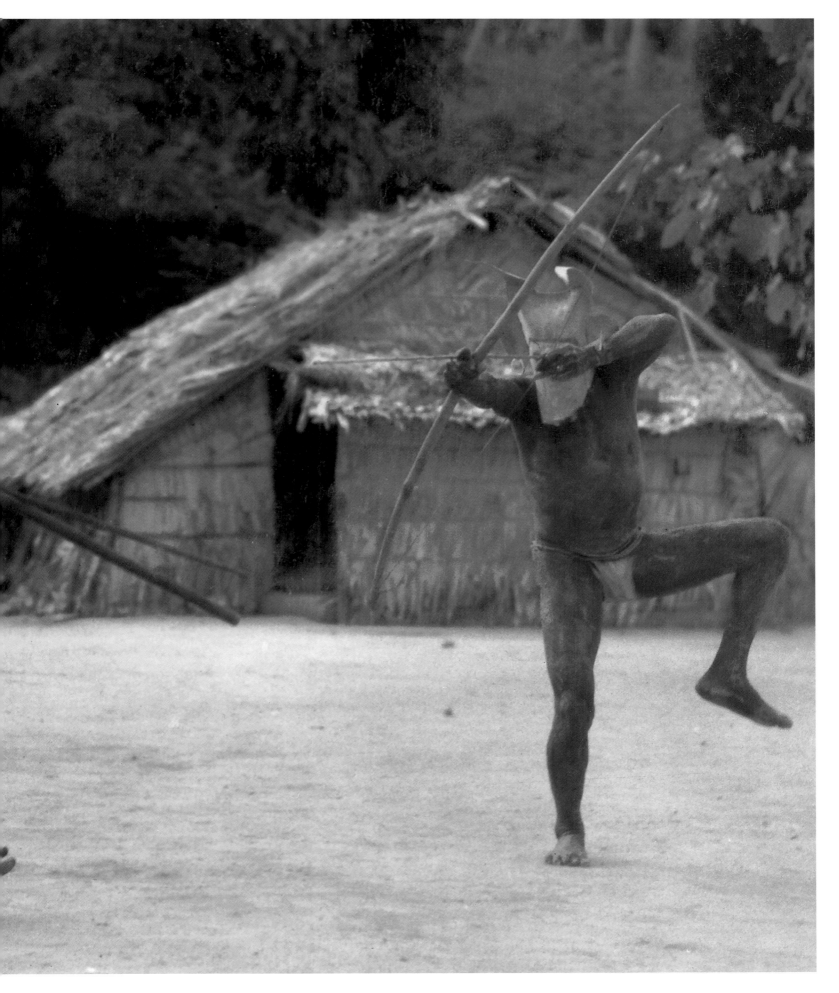

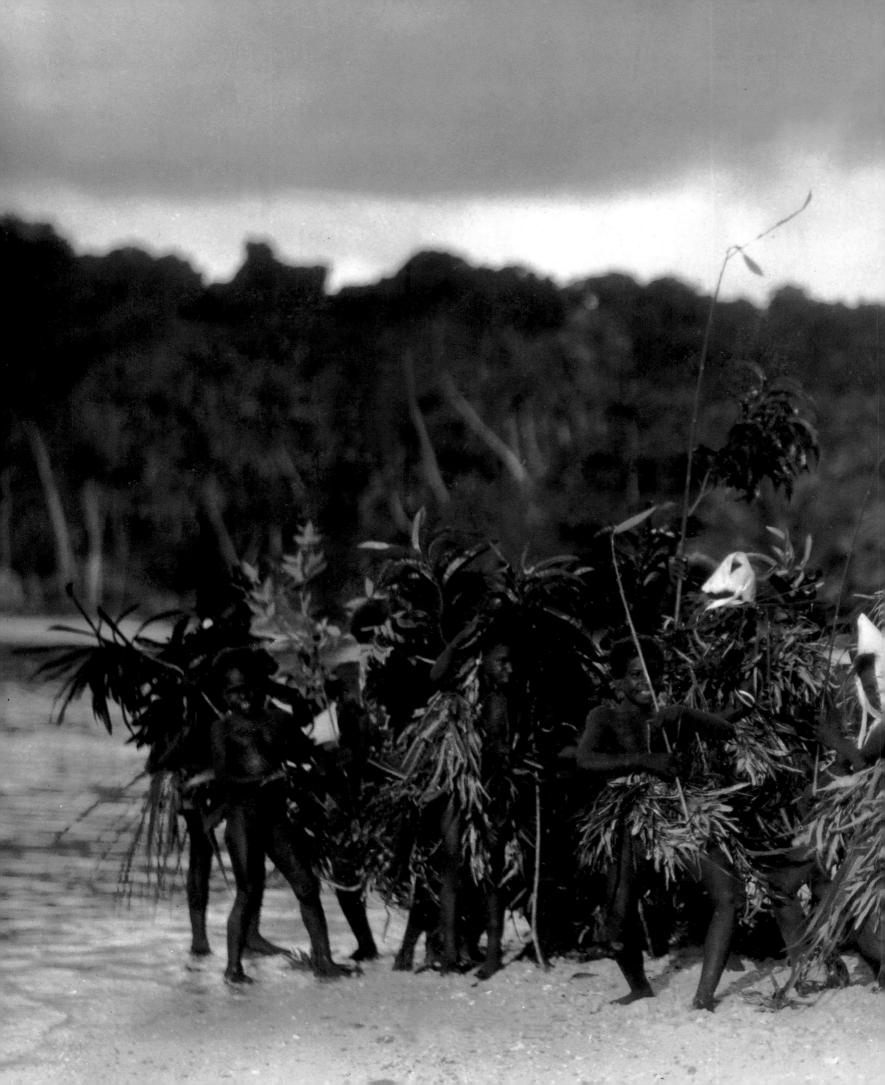

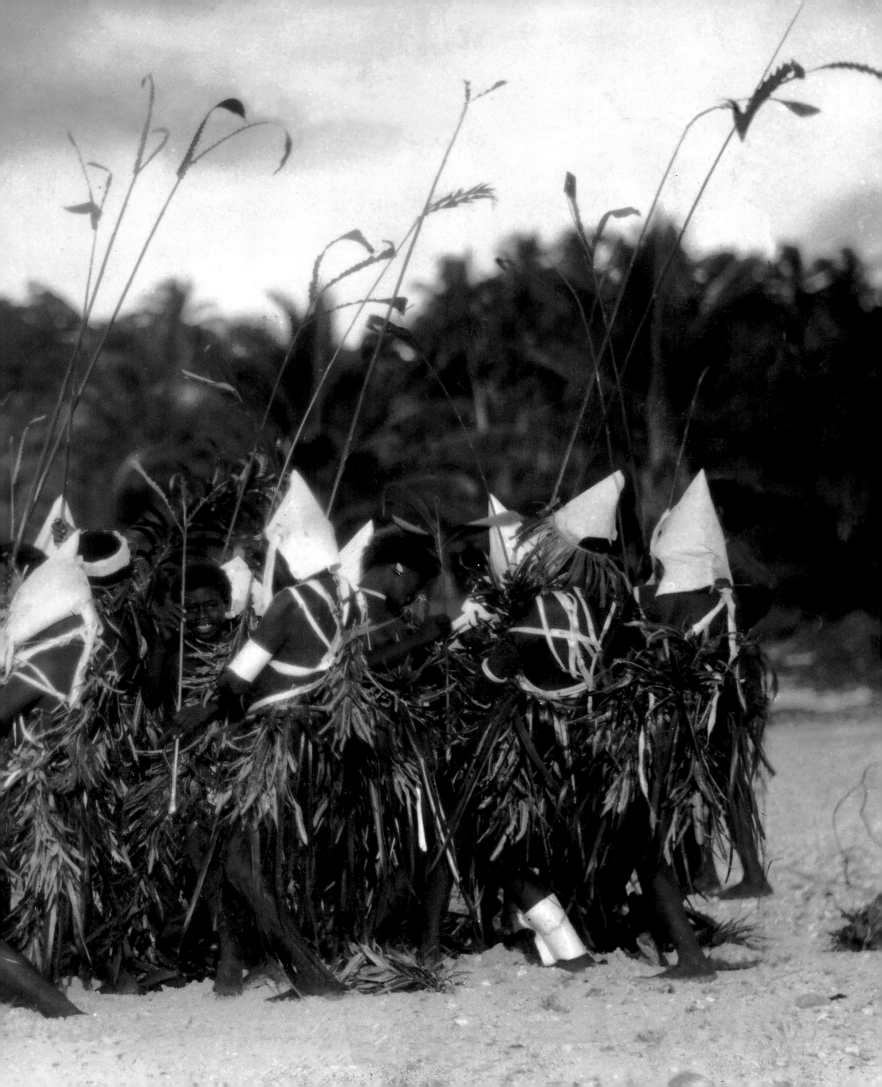

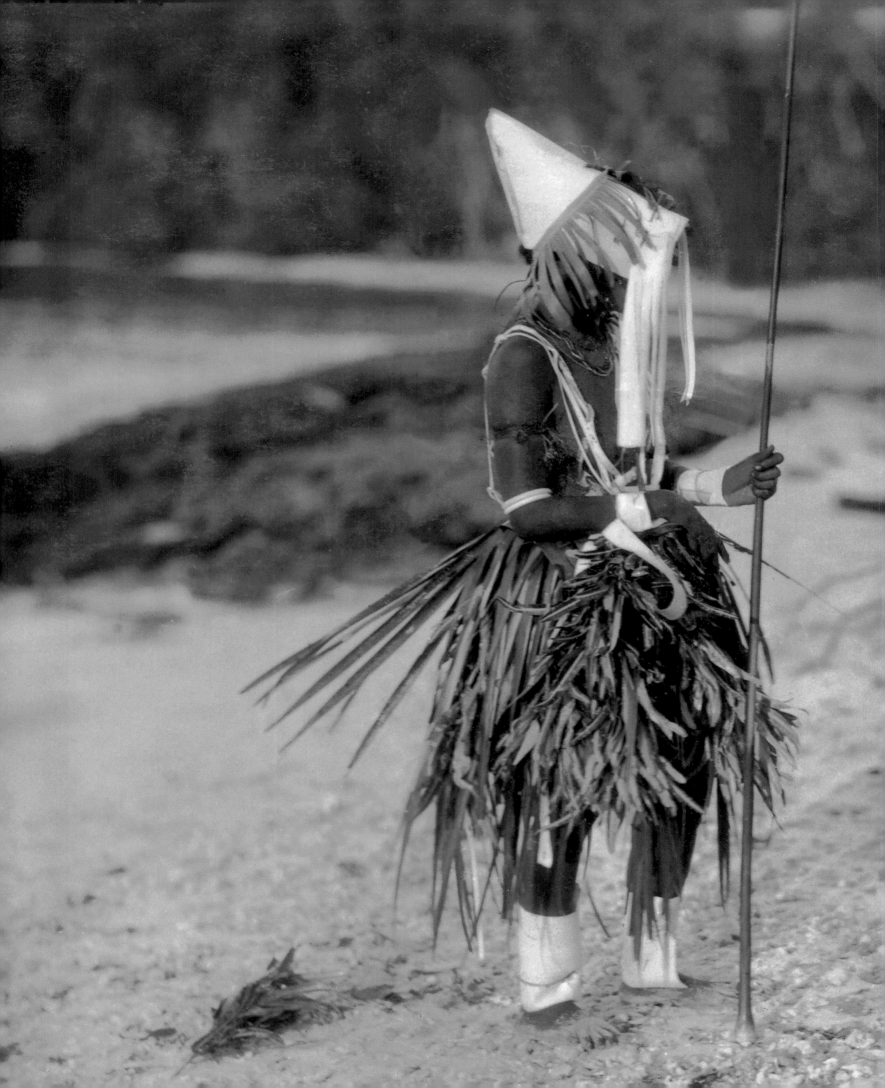

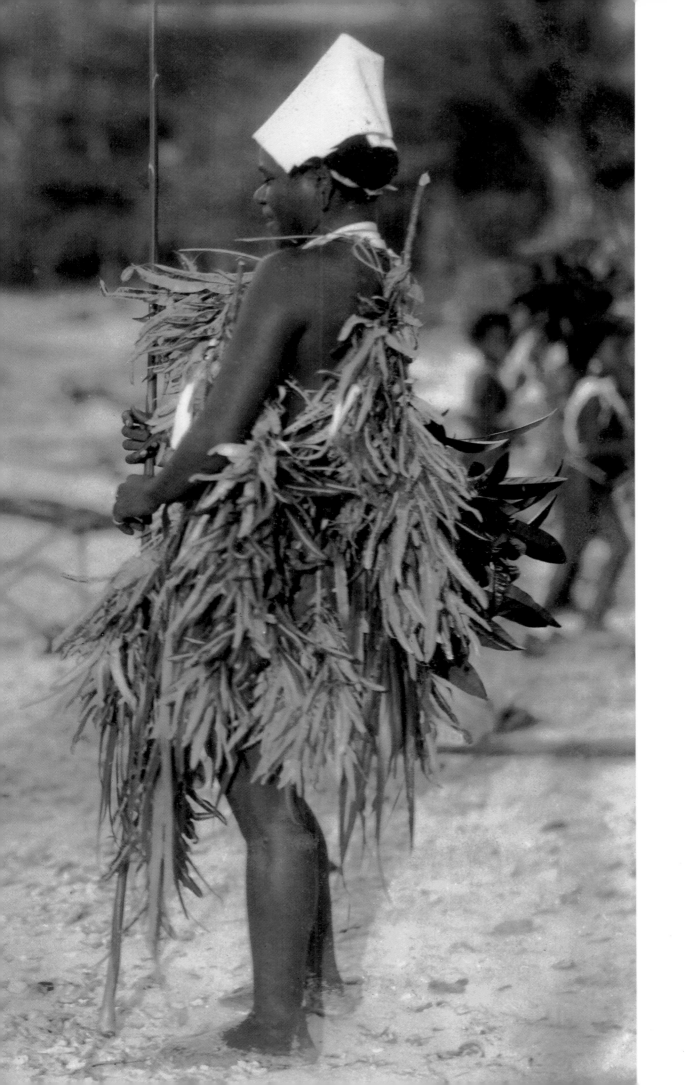

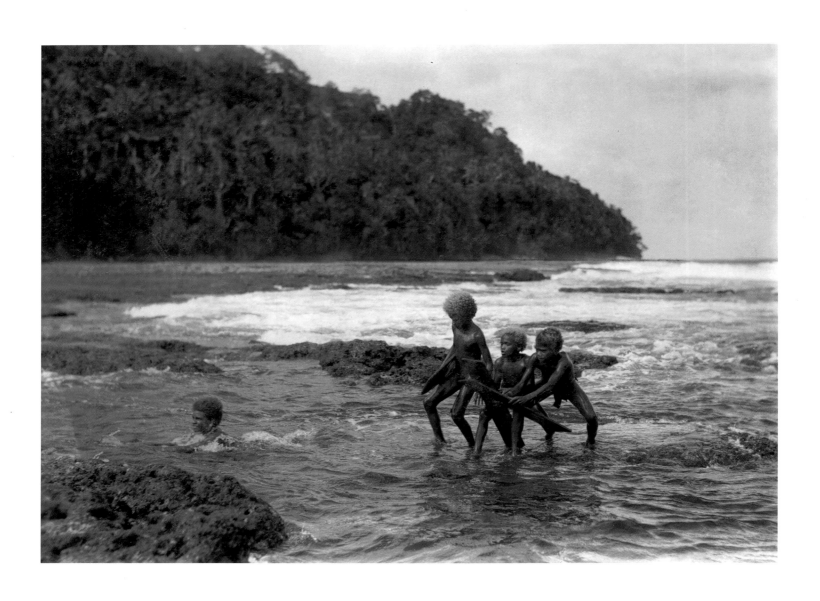

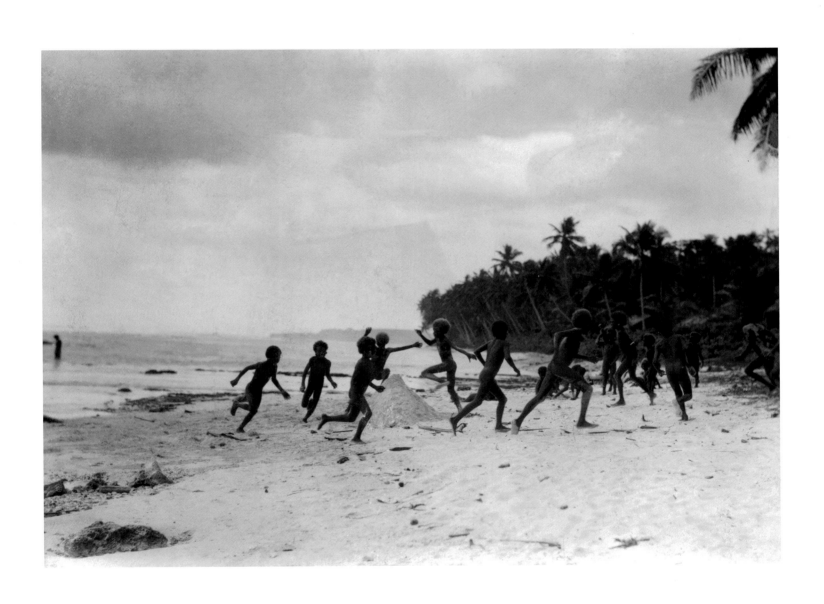

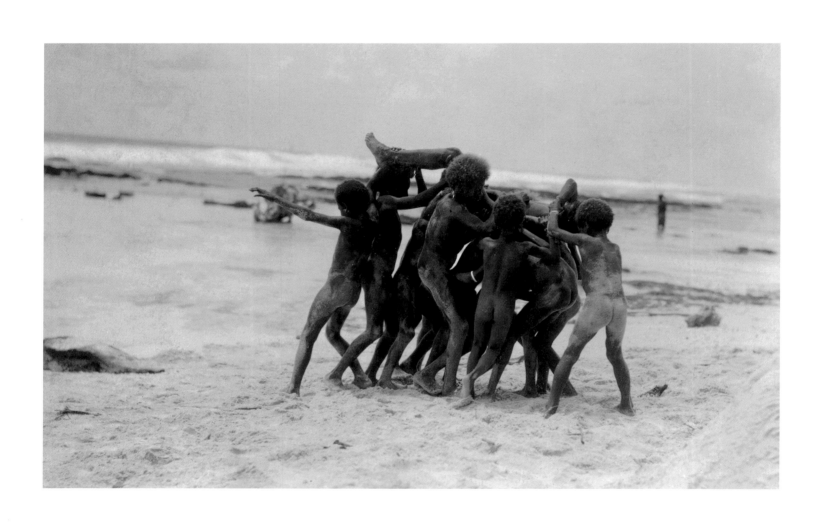

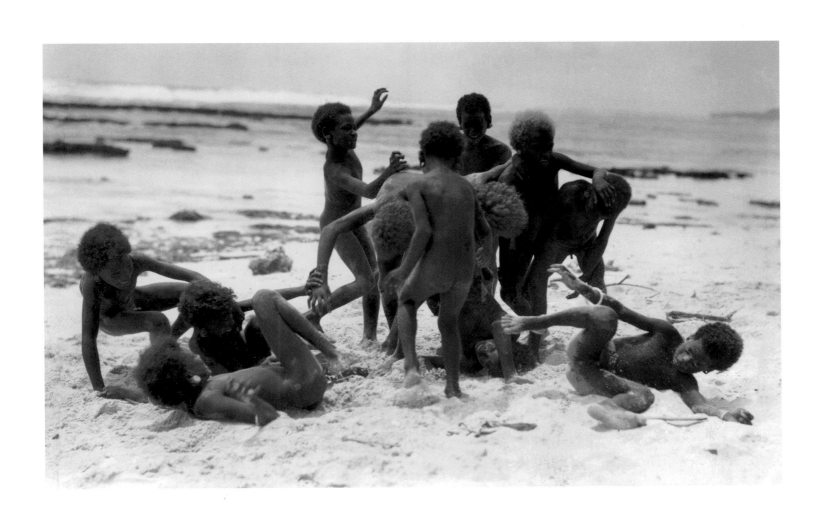

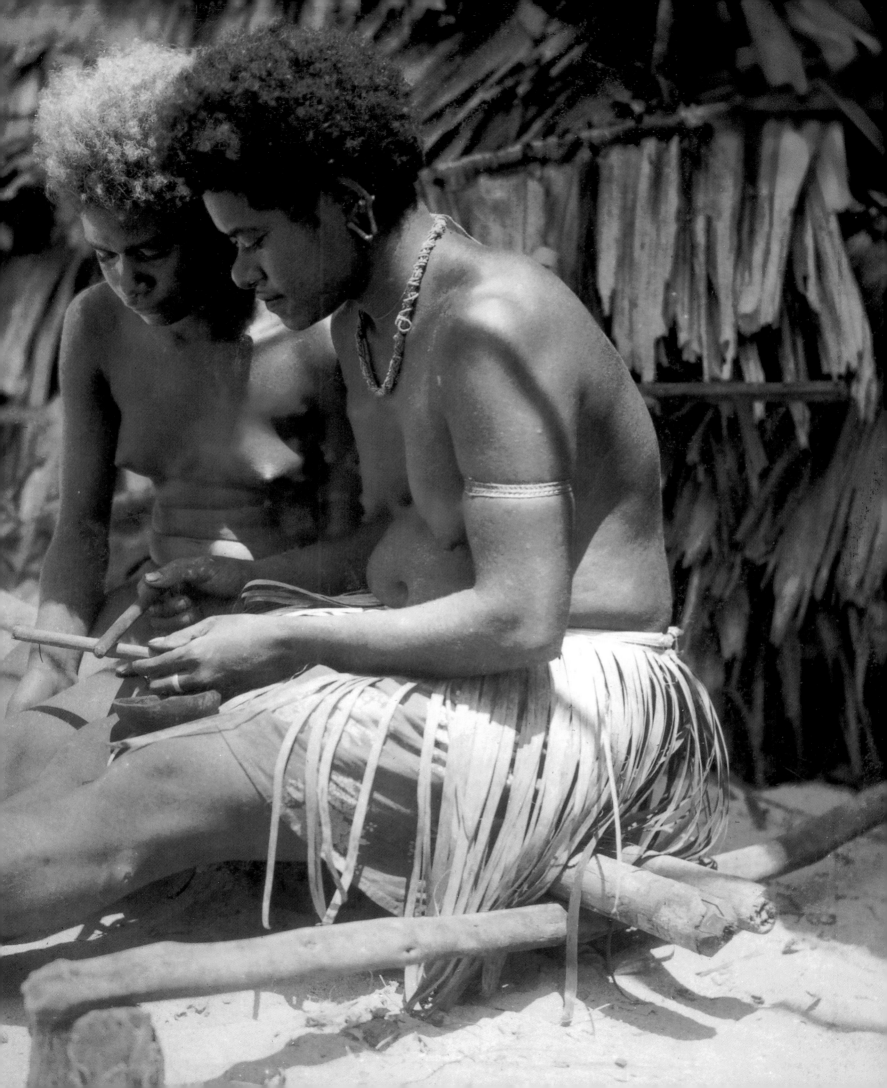

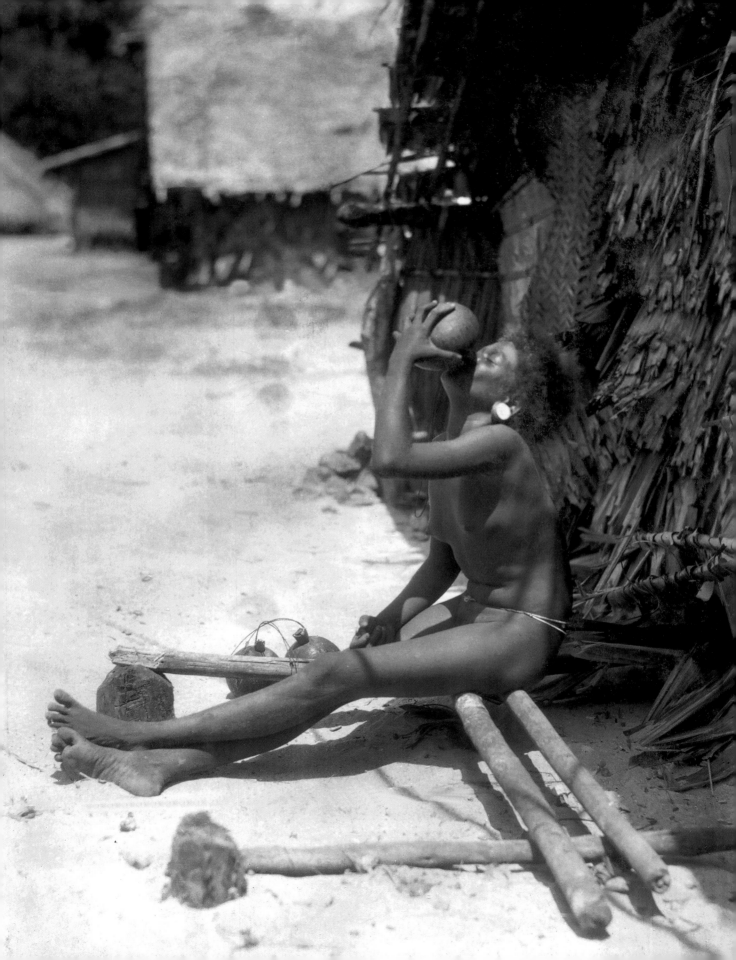

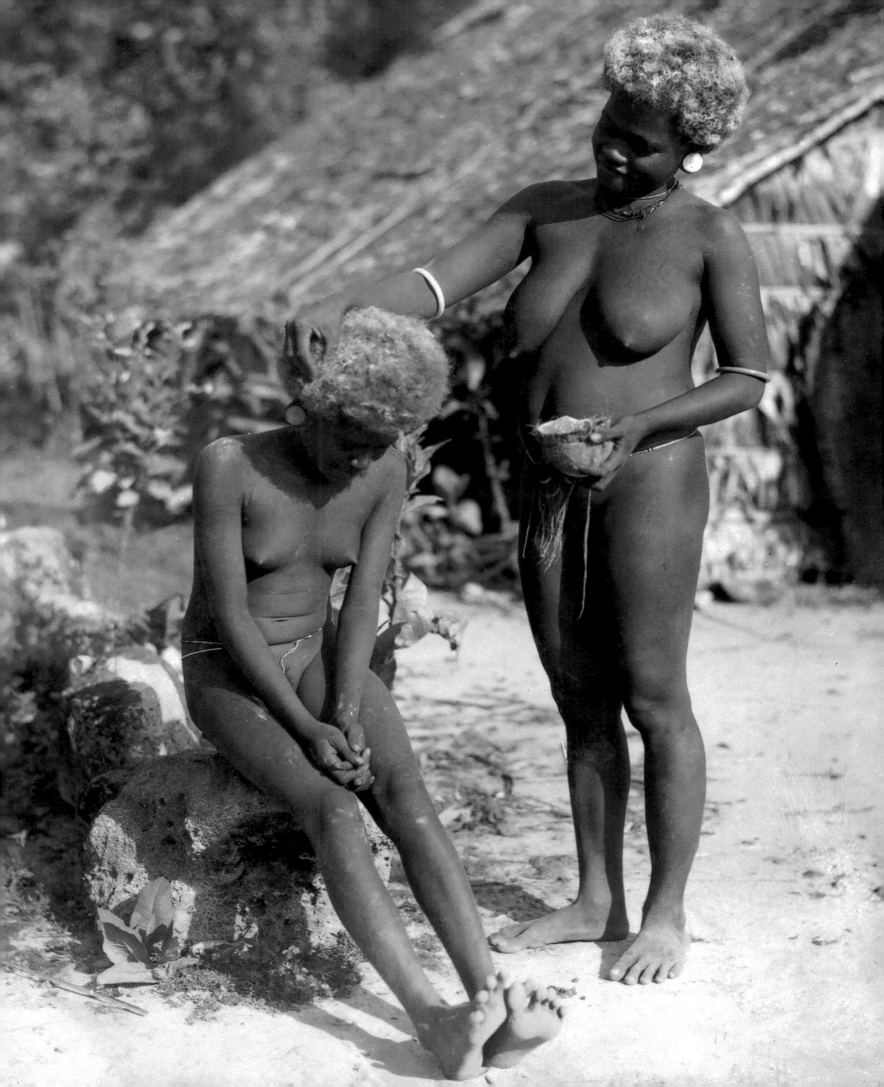

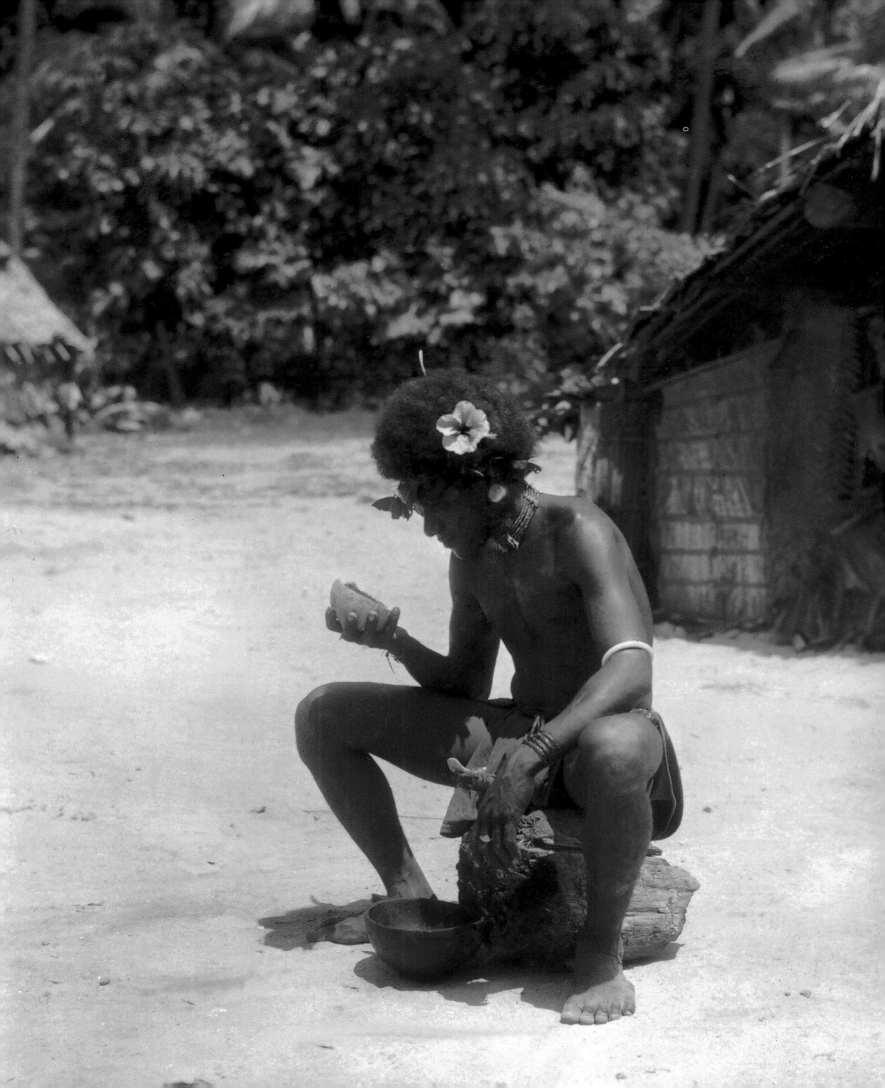

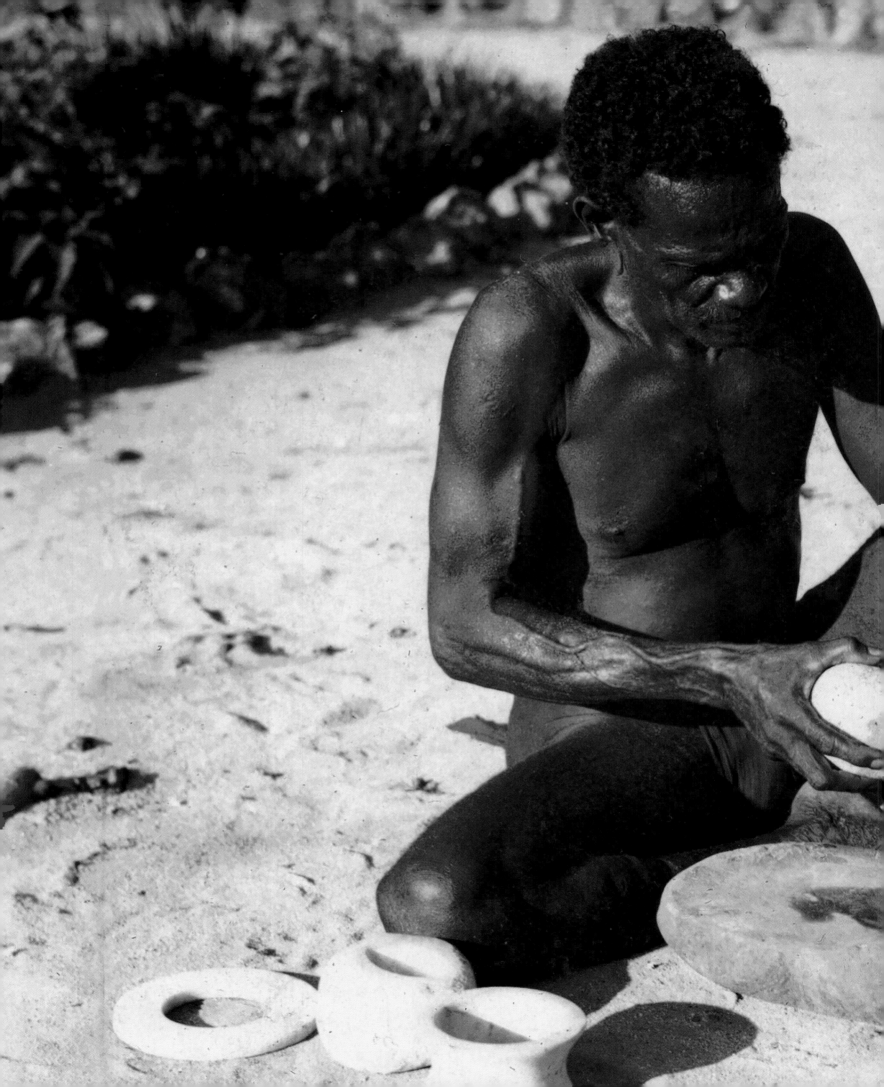

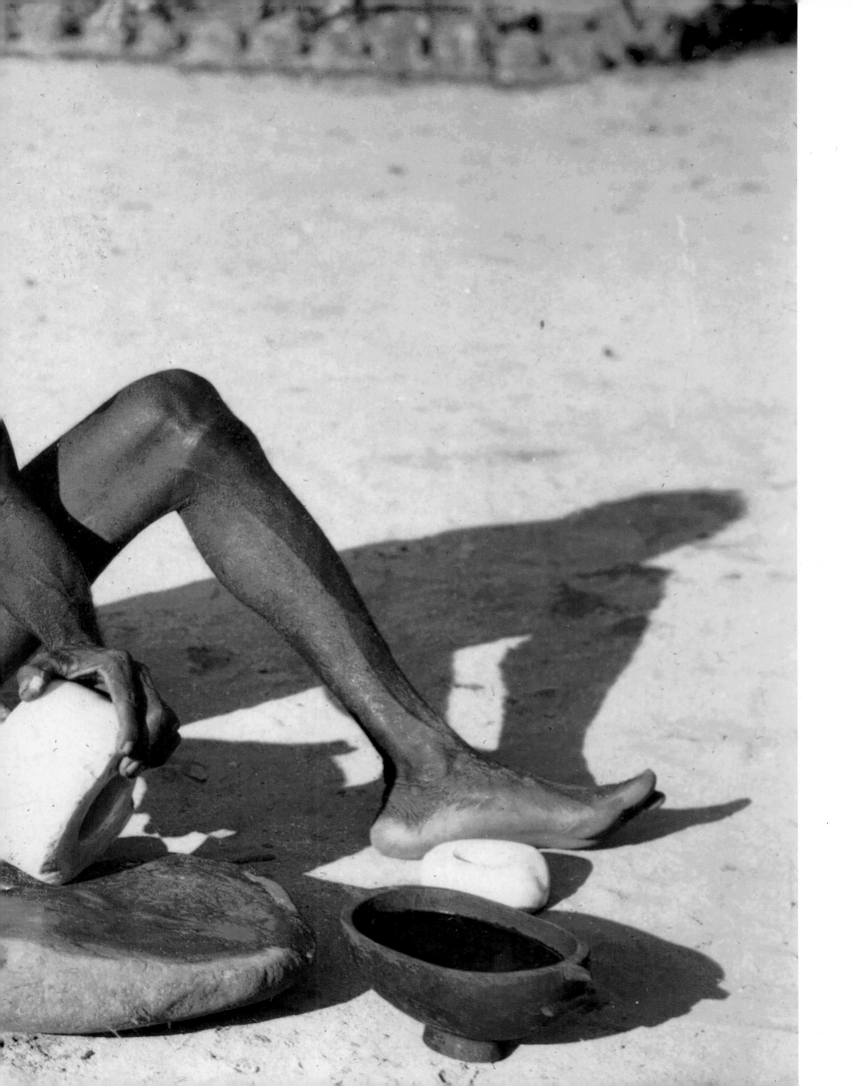

NEW GUINEA

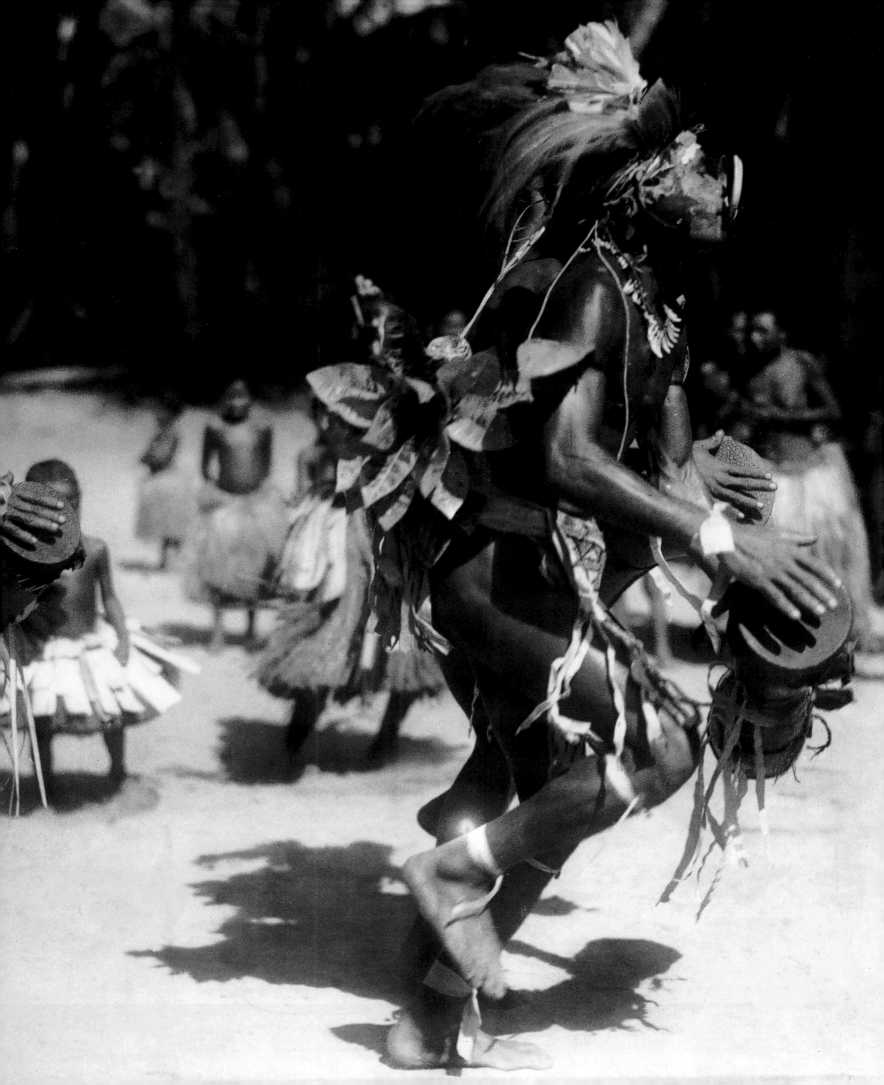

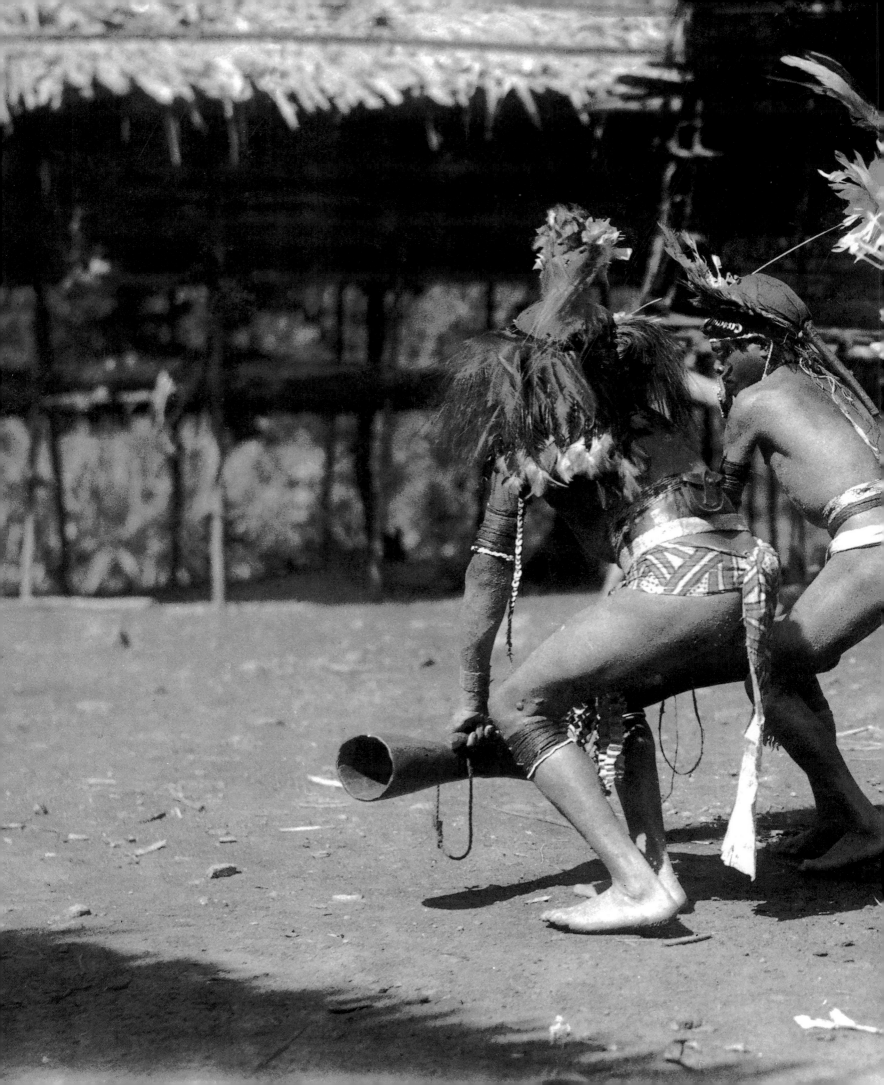

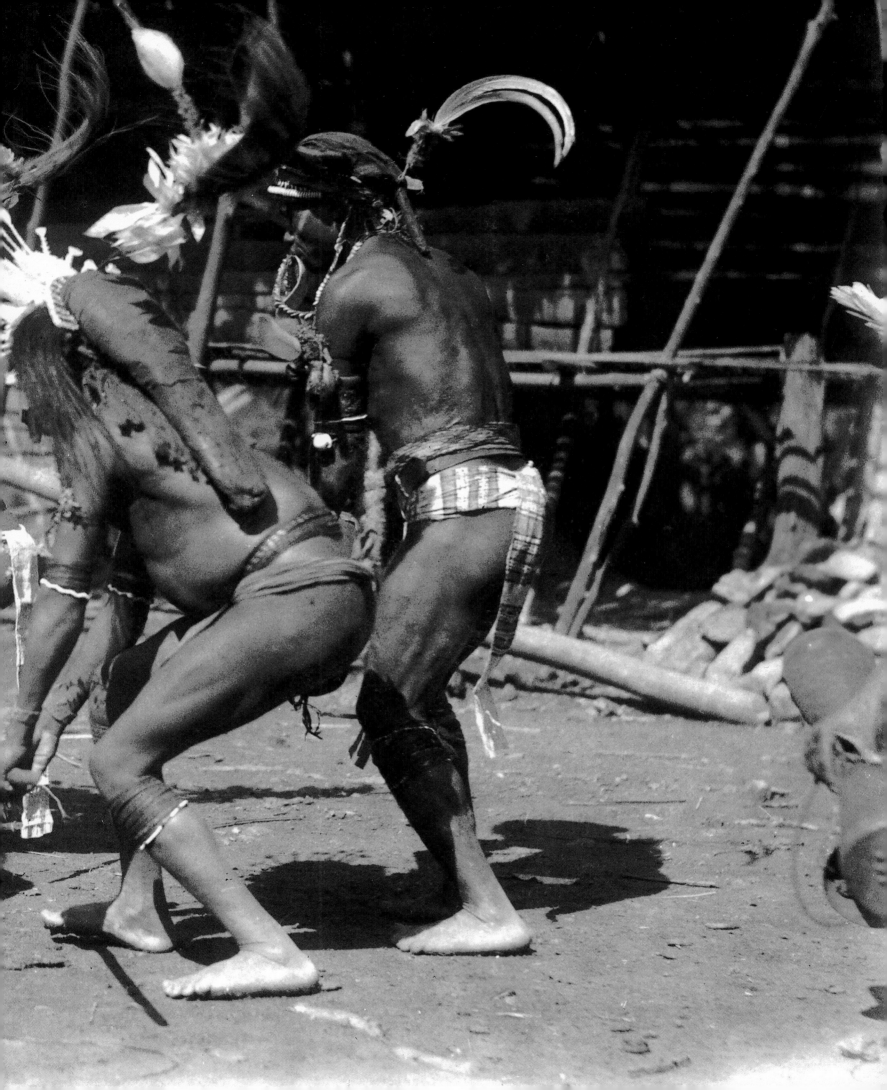

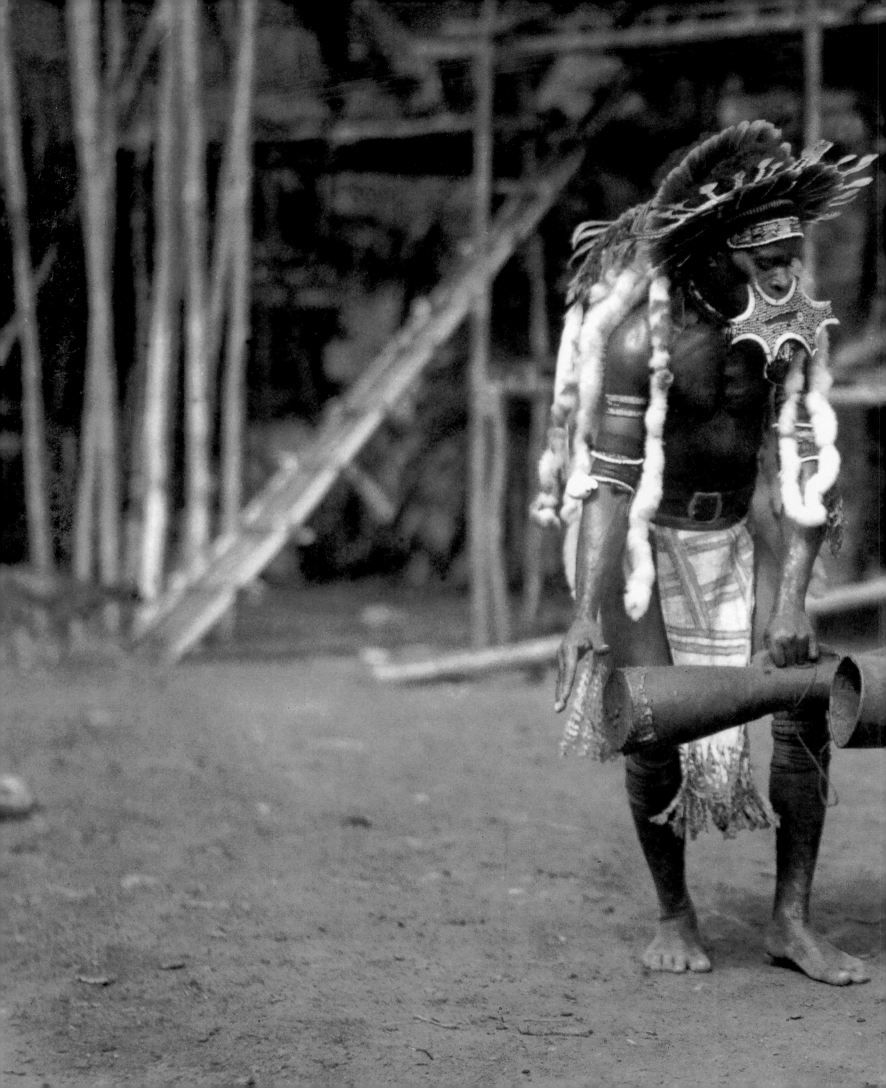

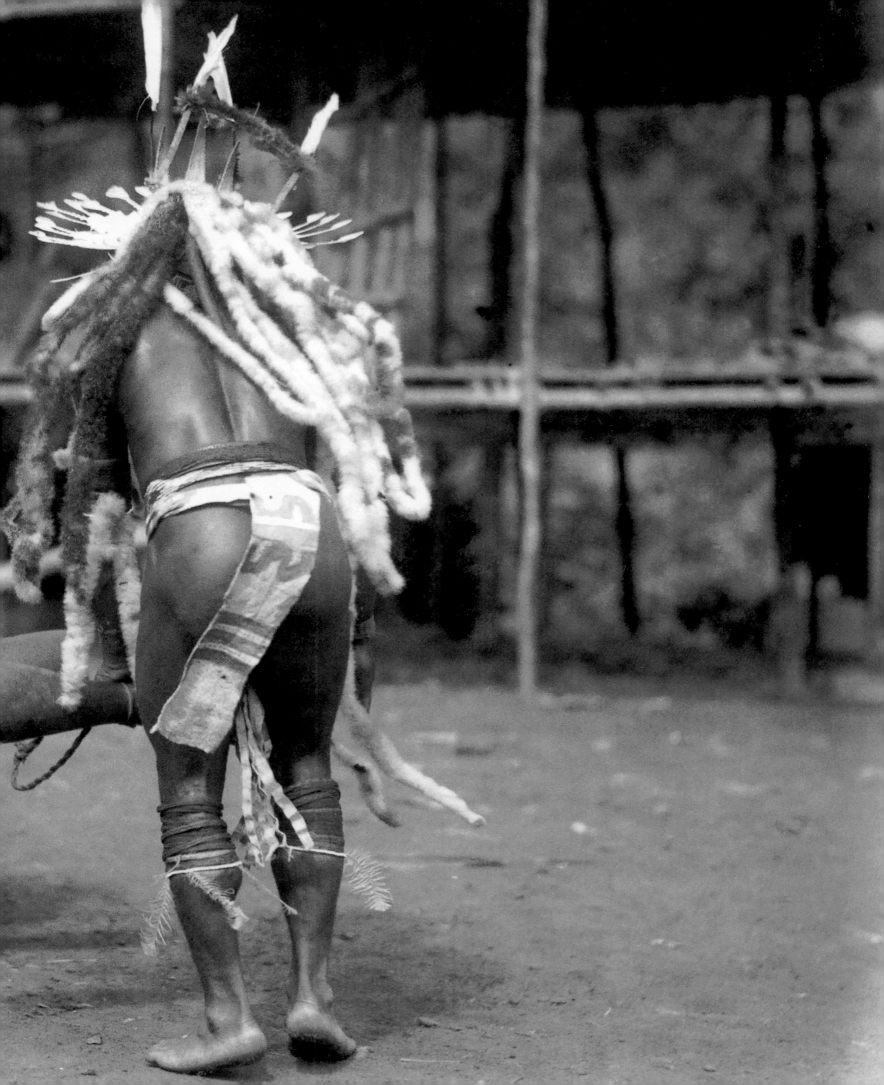

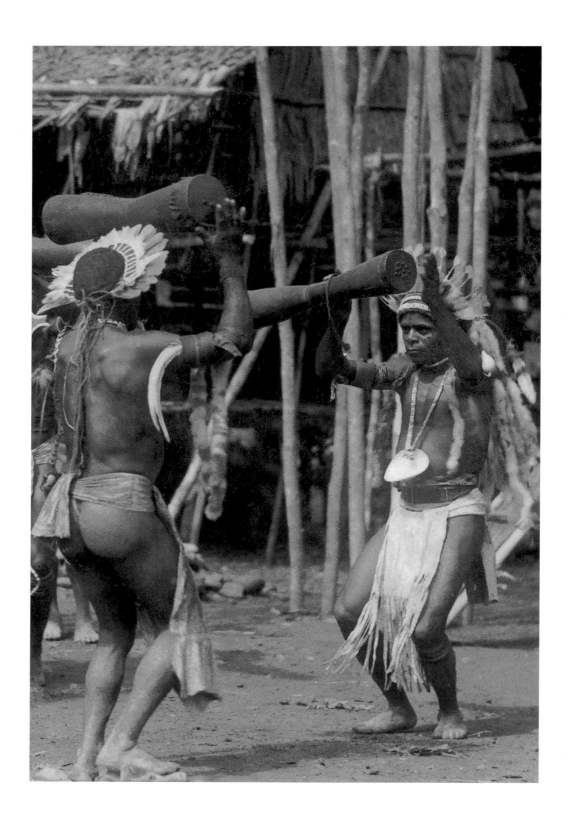

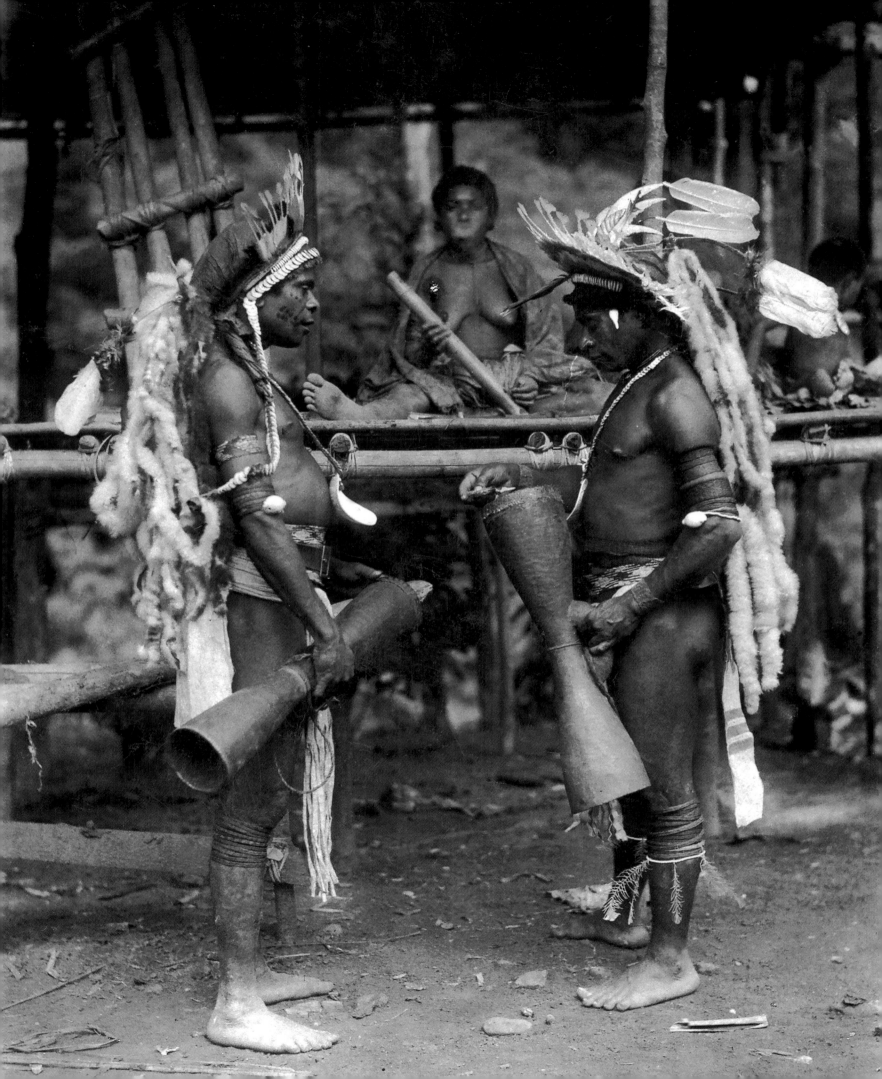

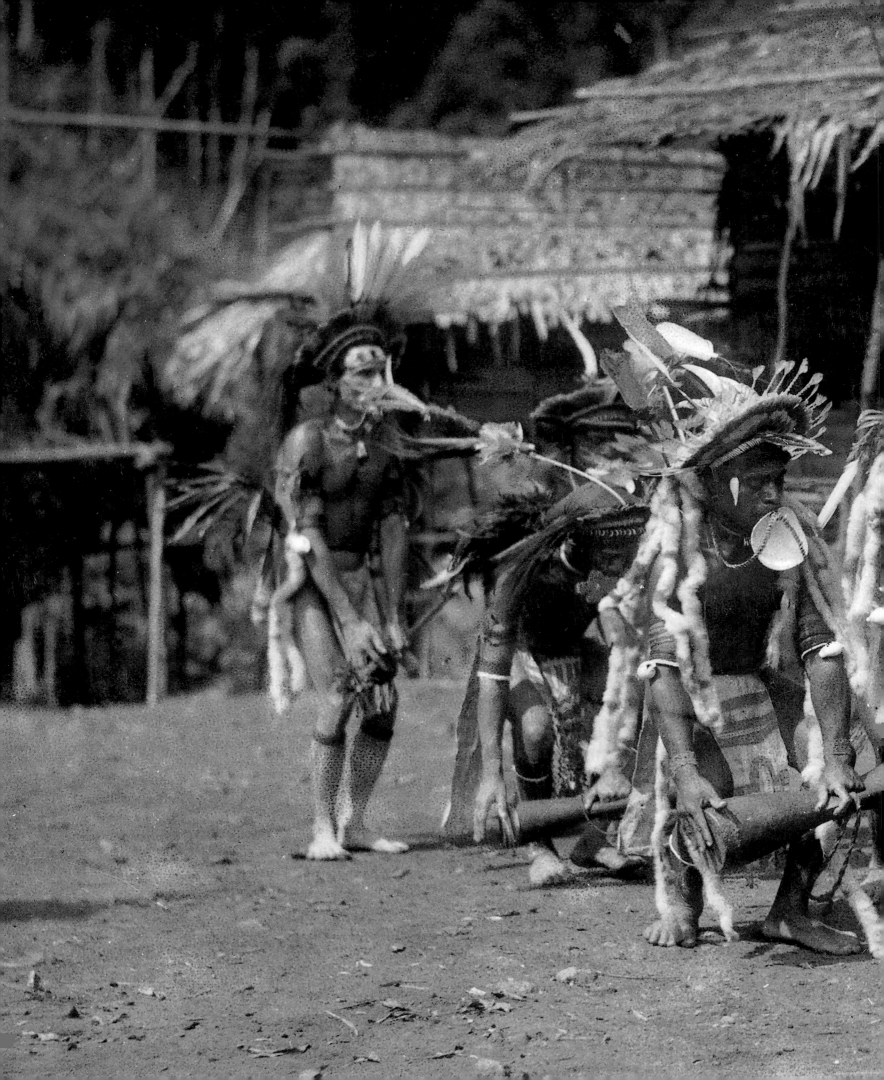

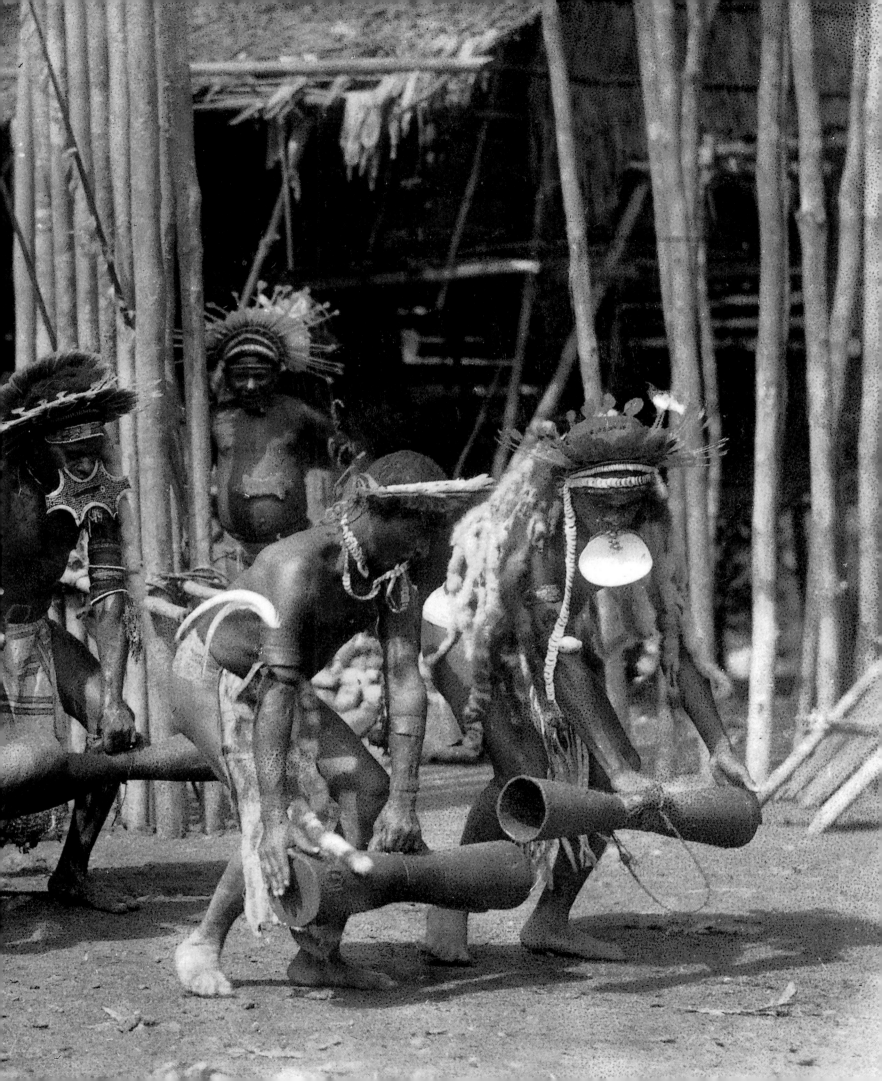

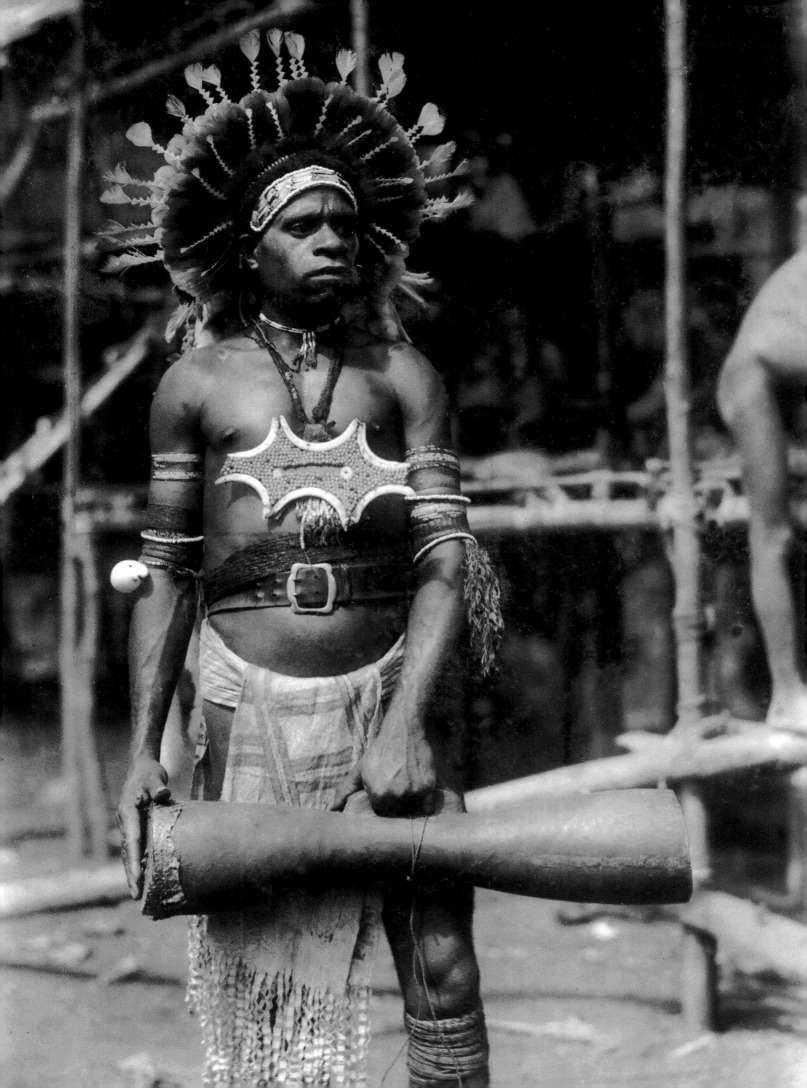

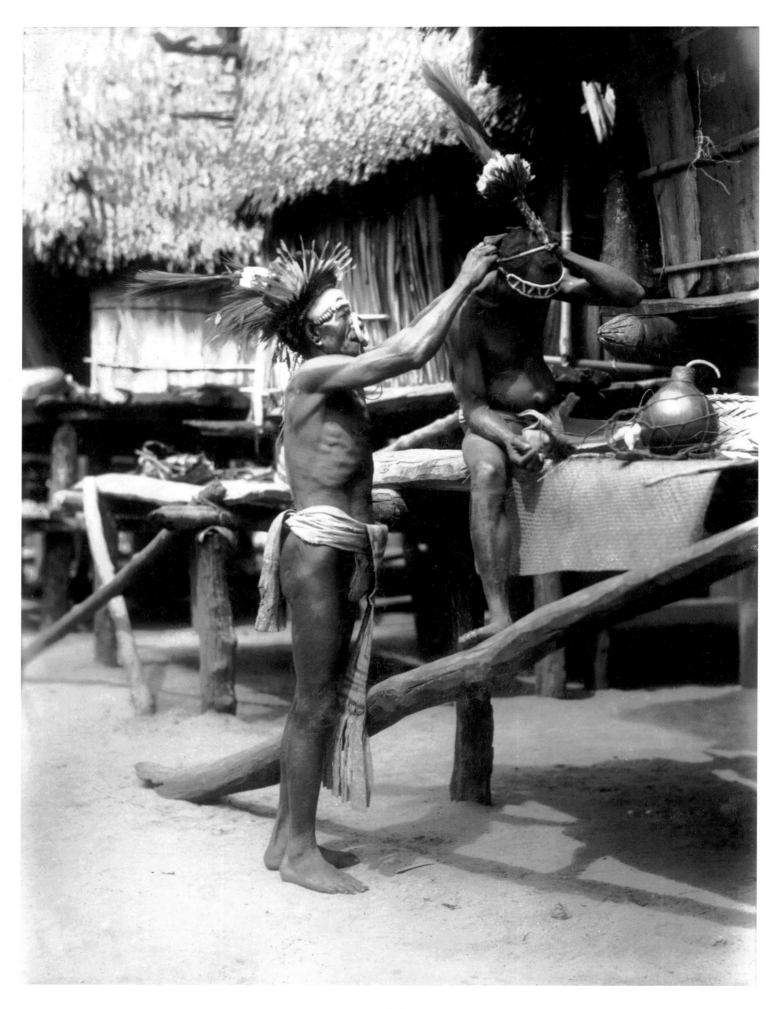

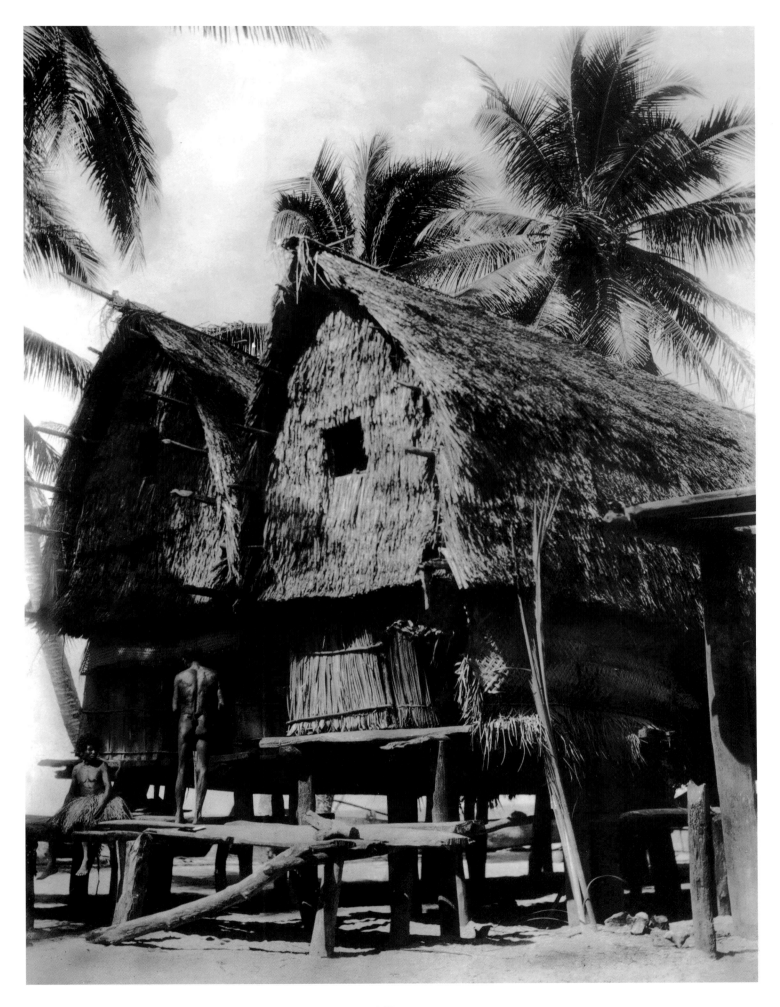

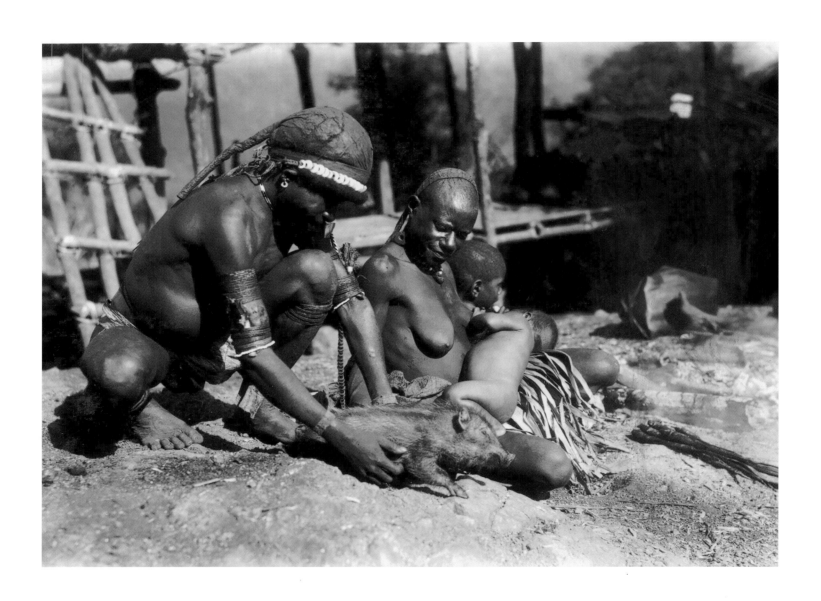

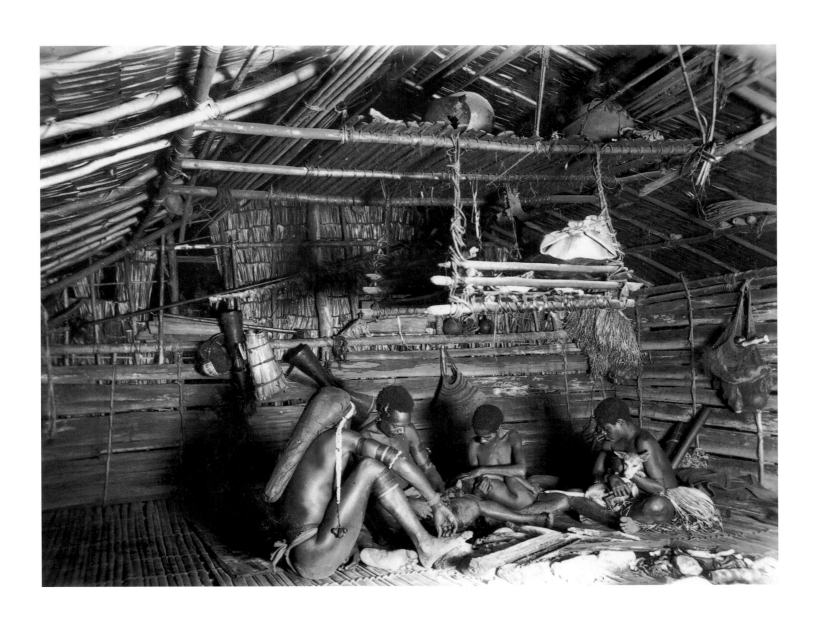

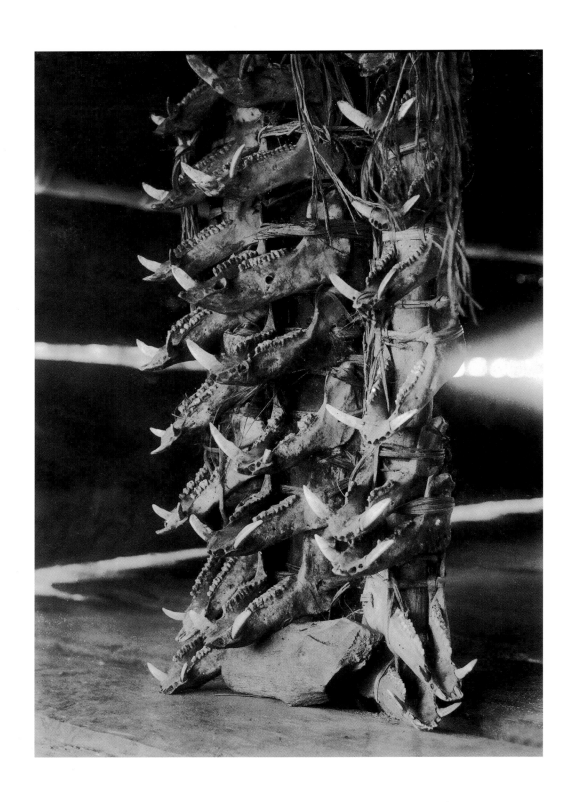

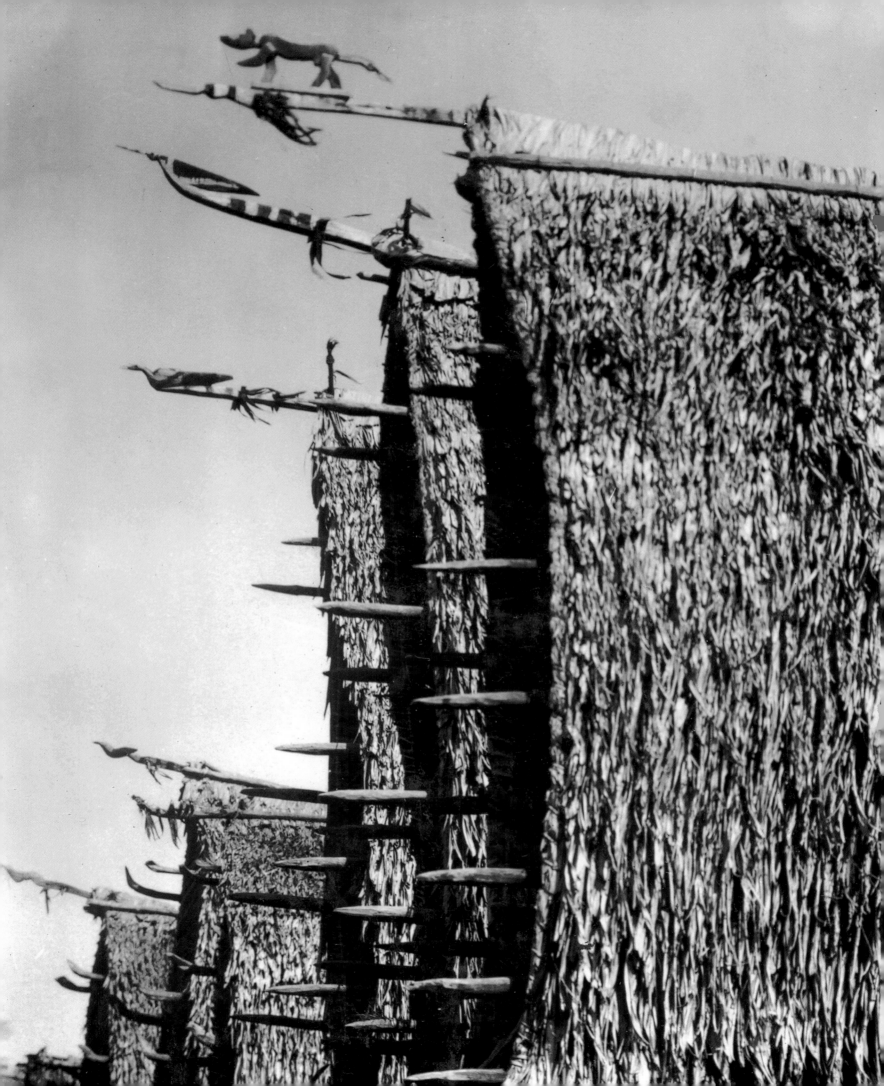

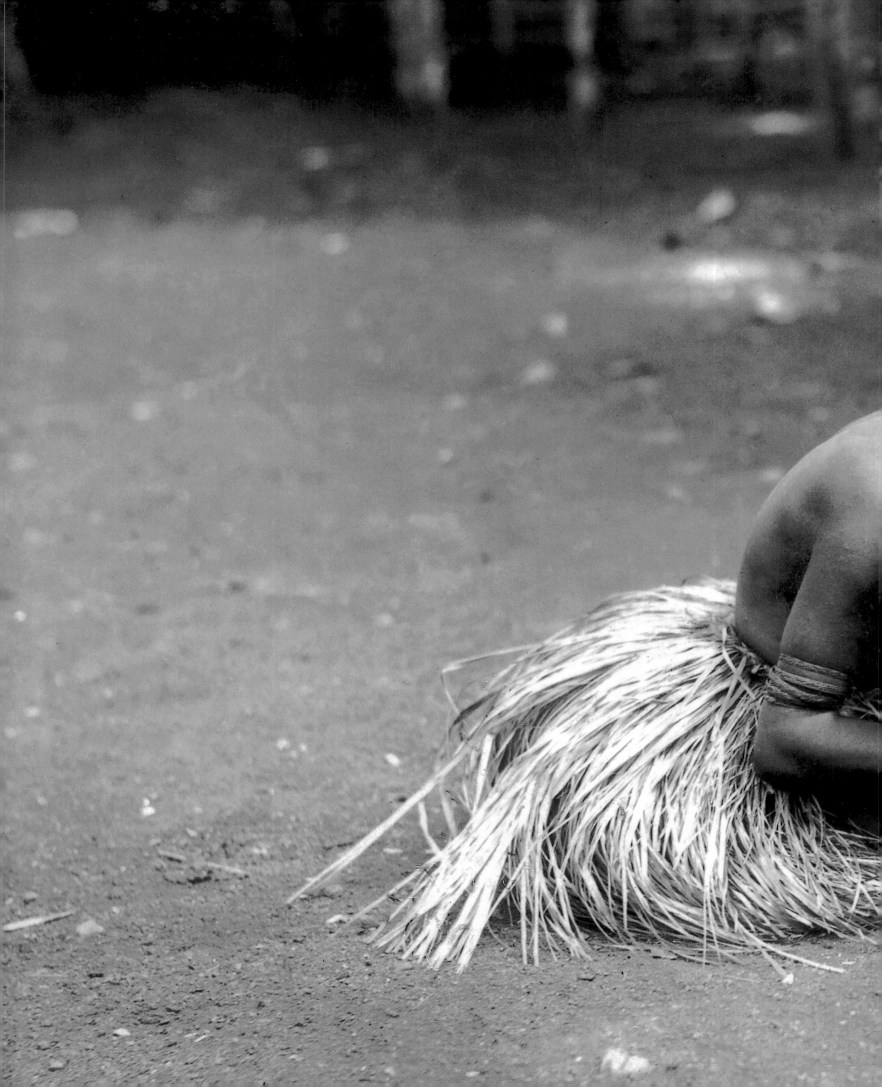

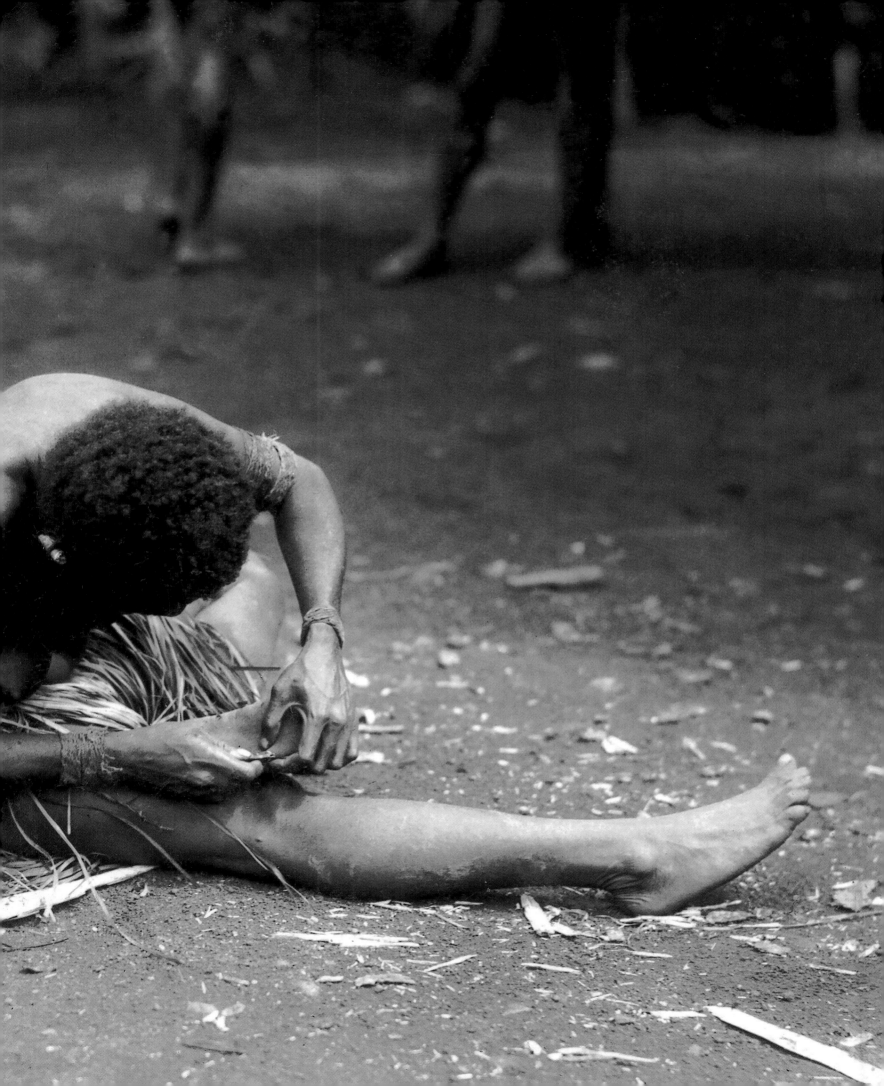

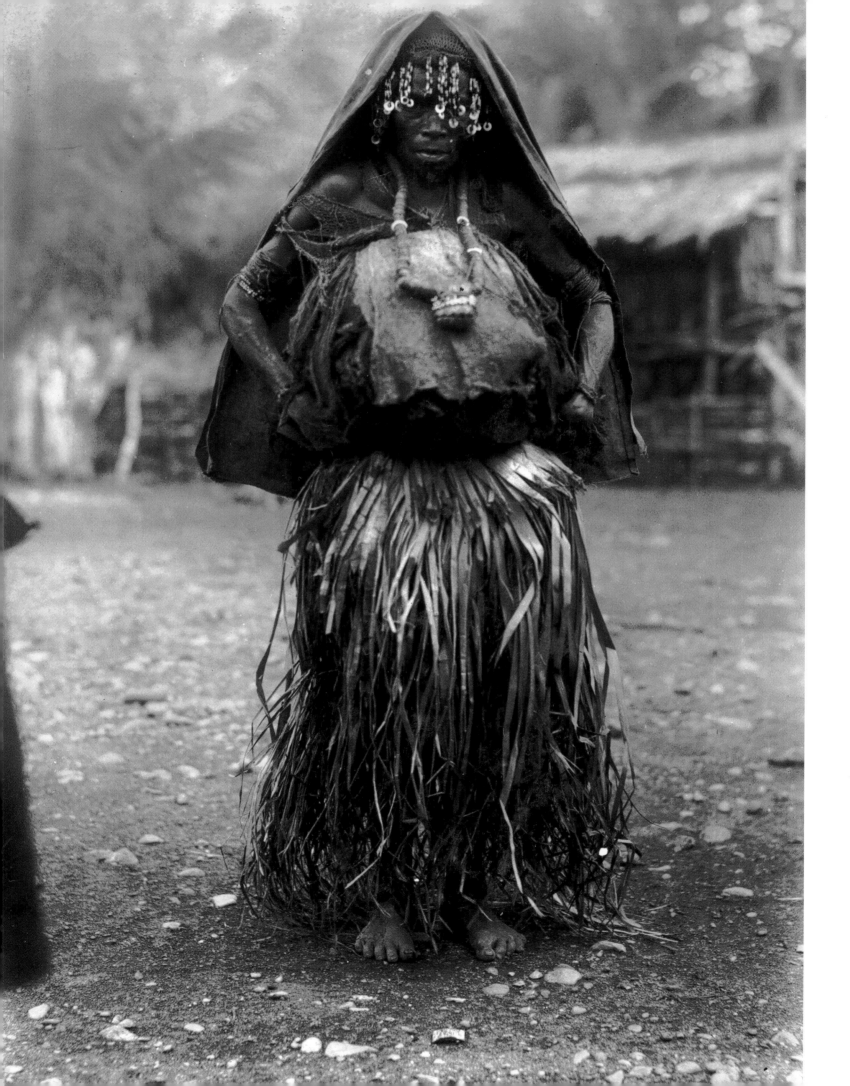

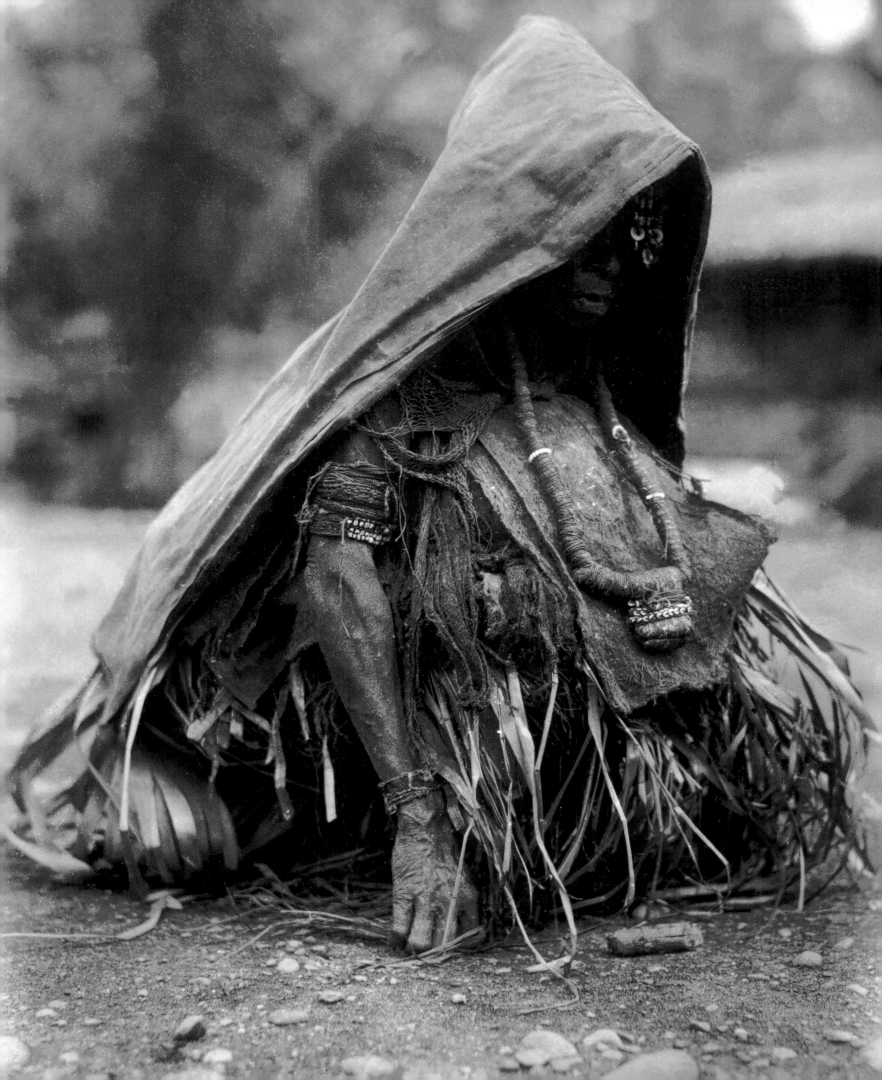

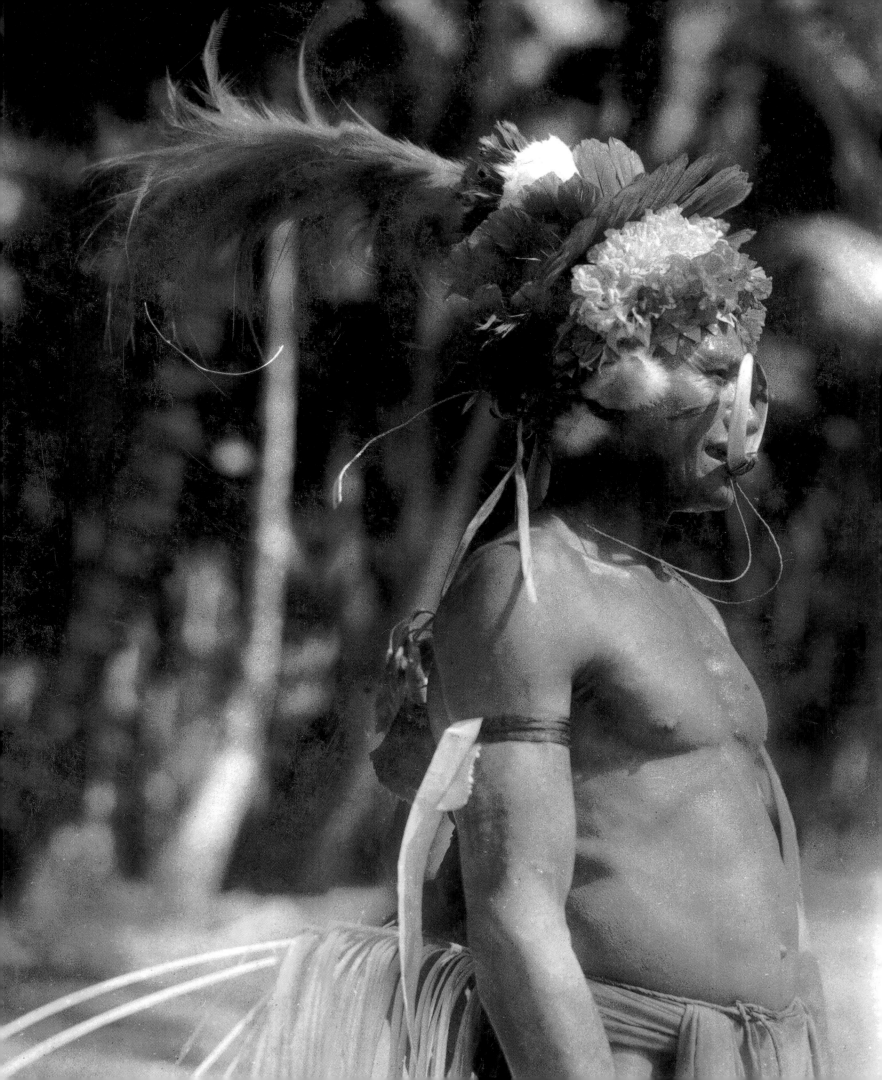

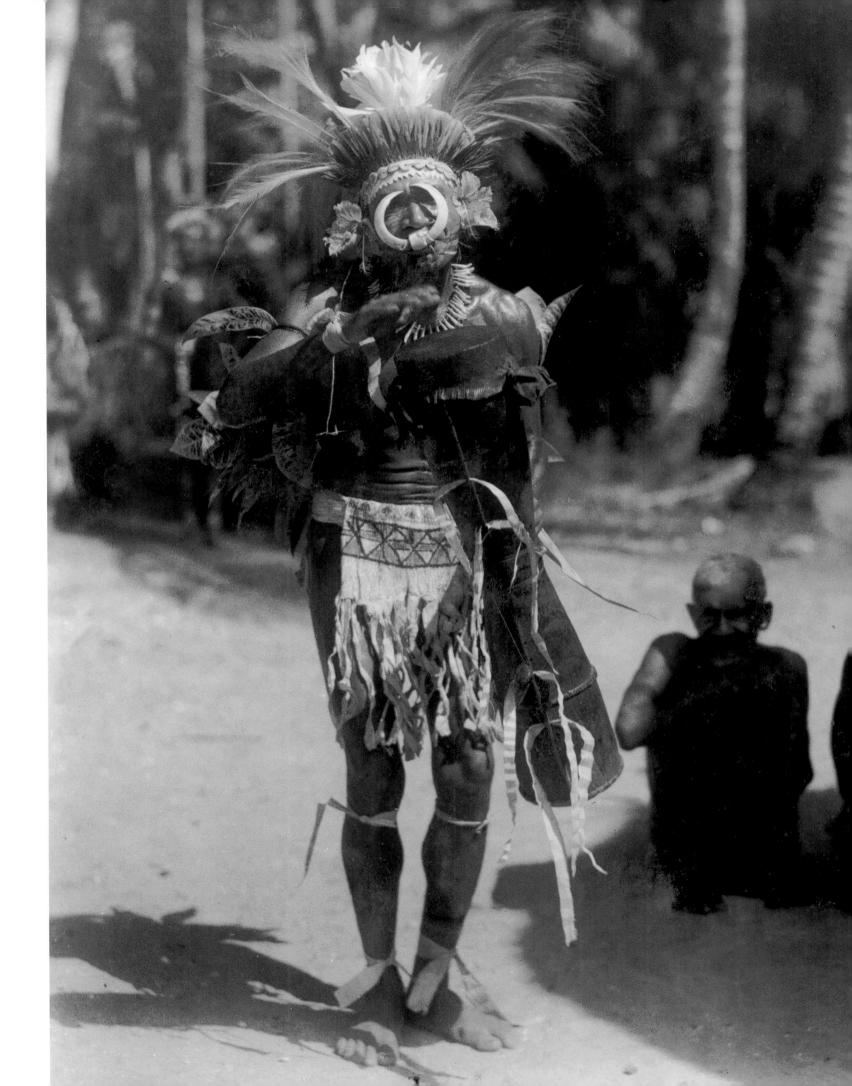

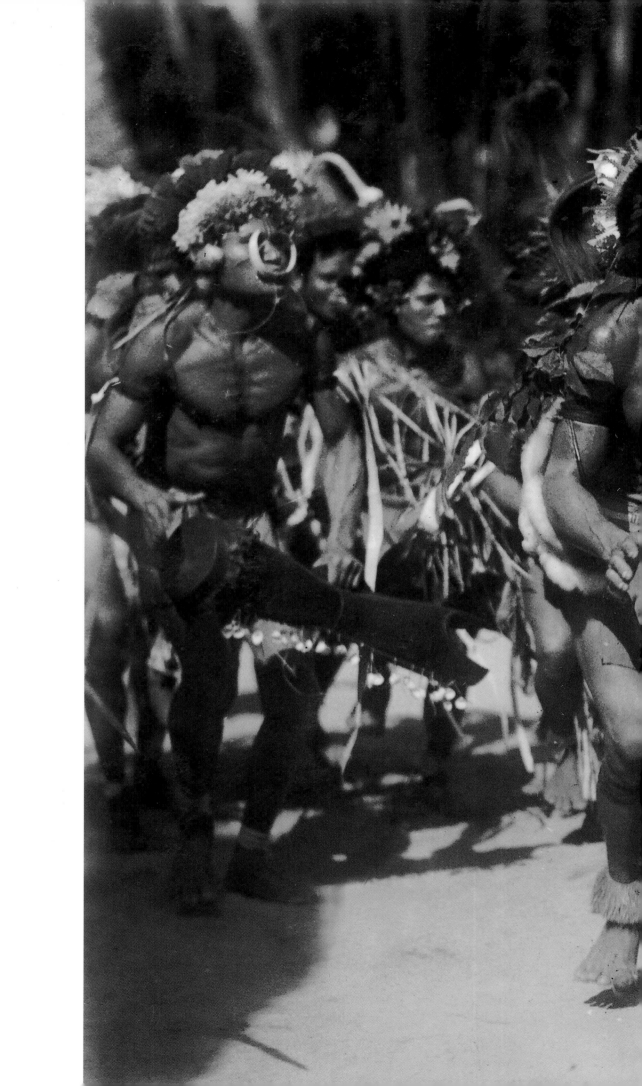

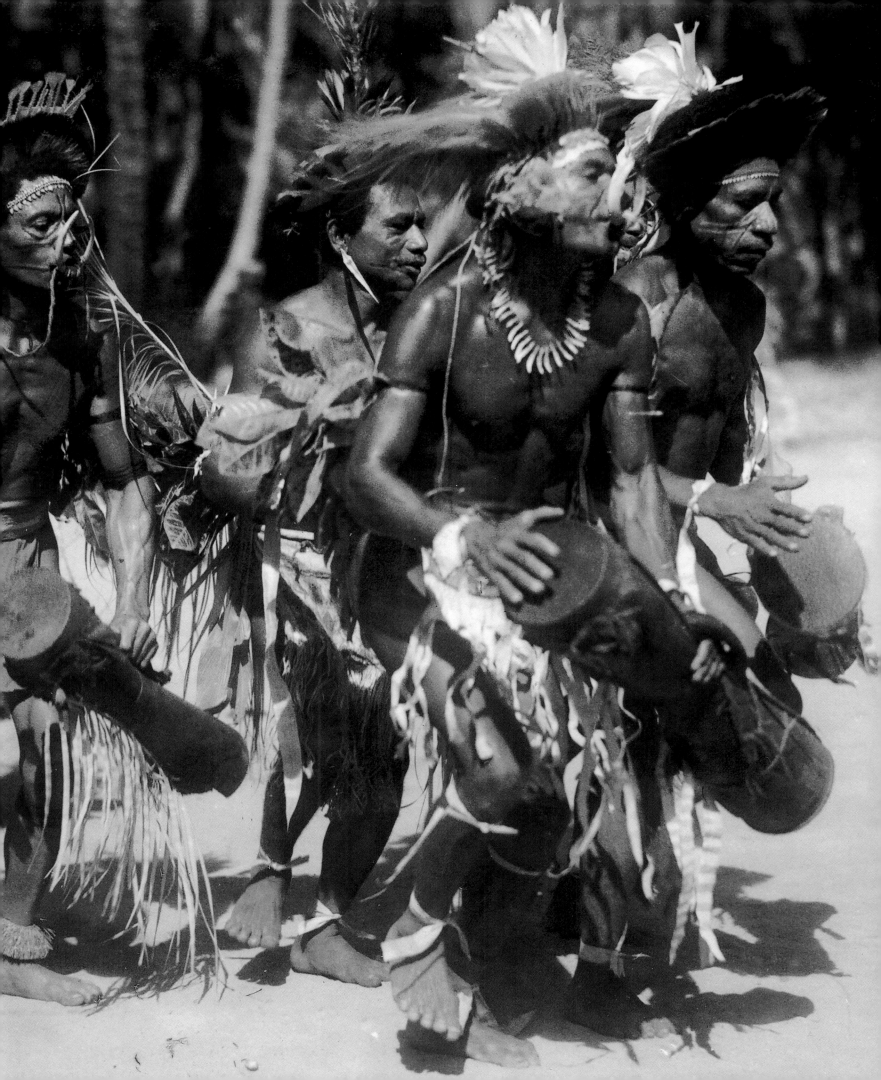

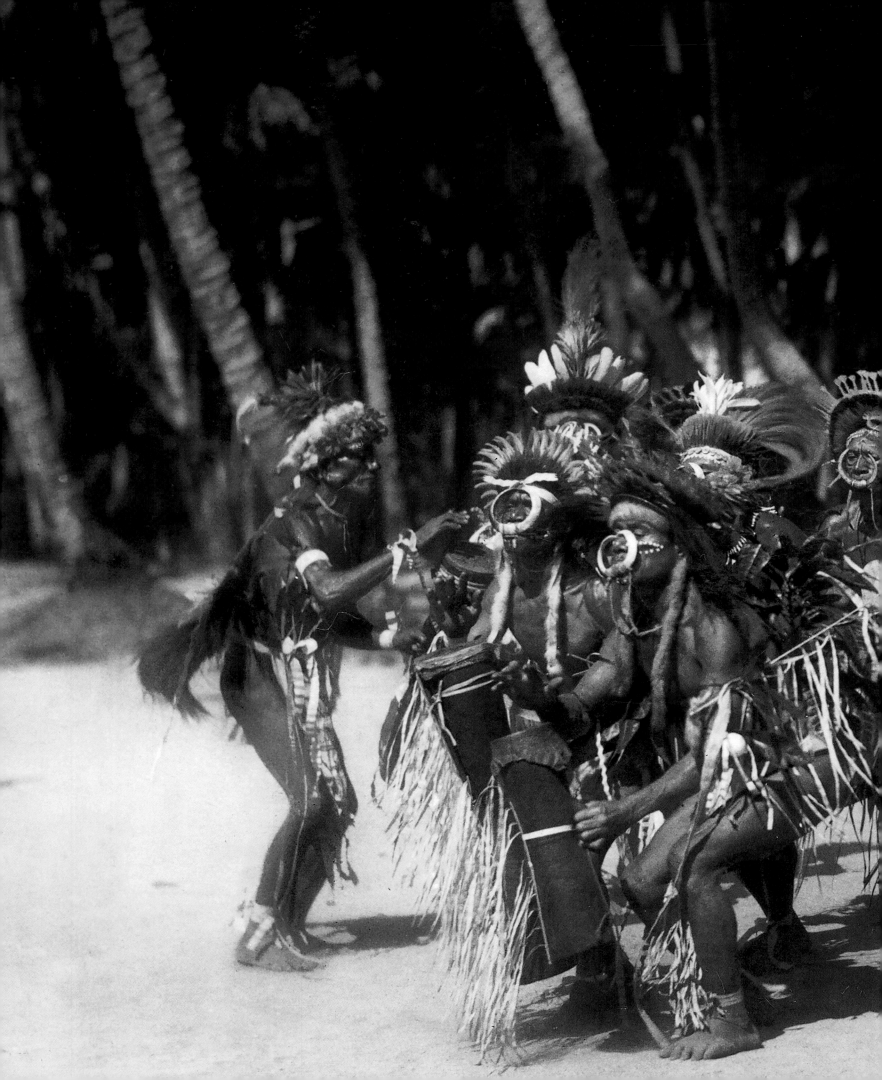

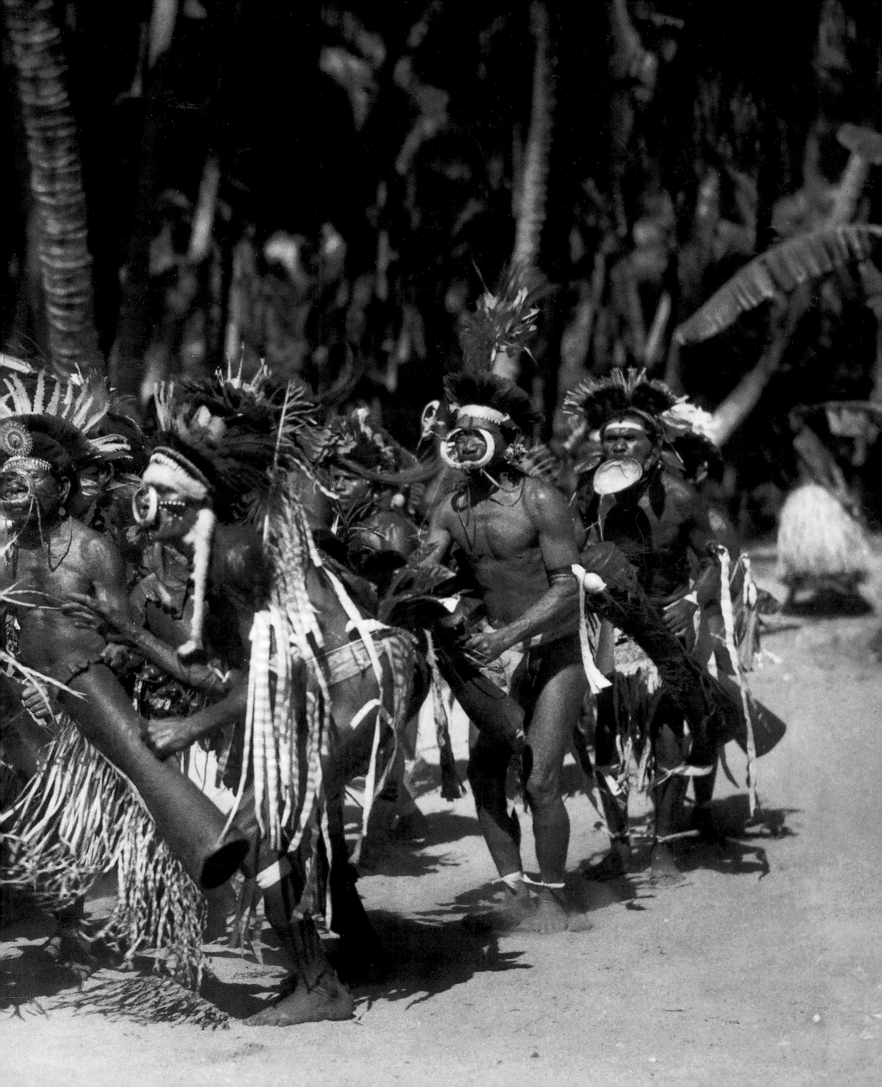

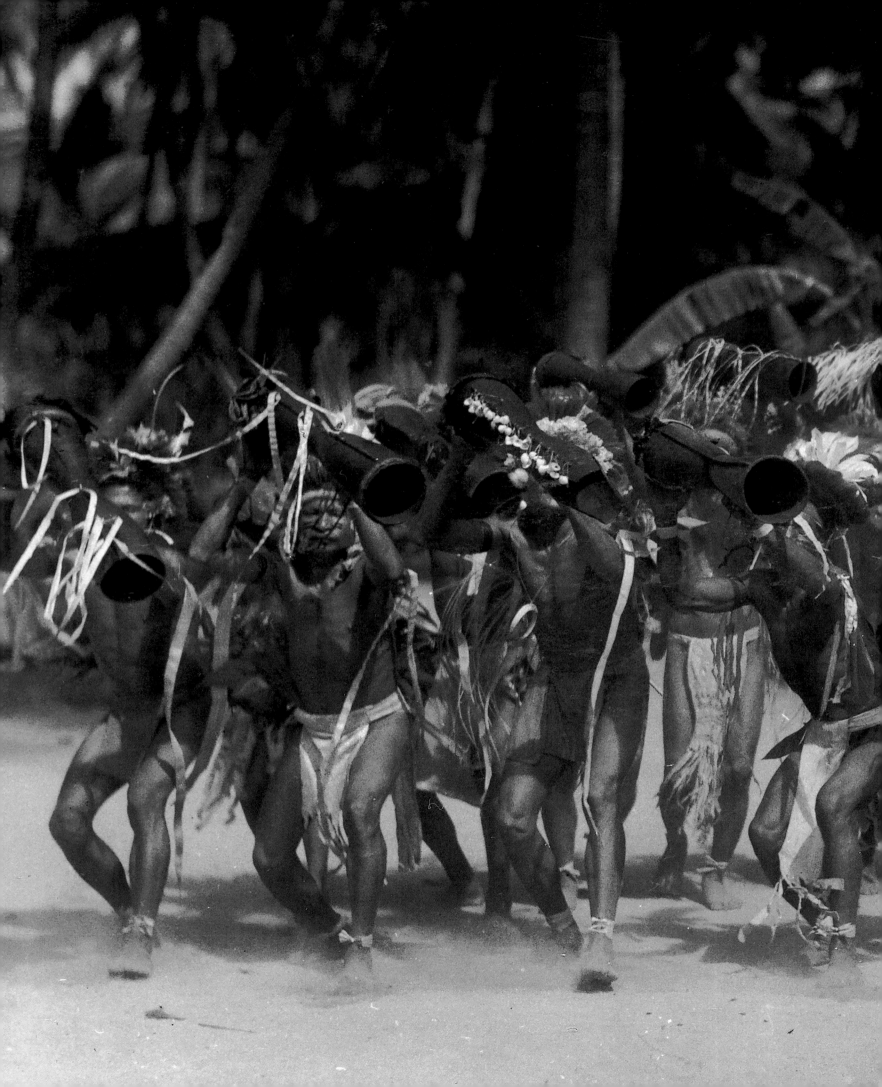

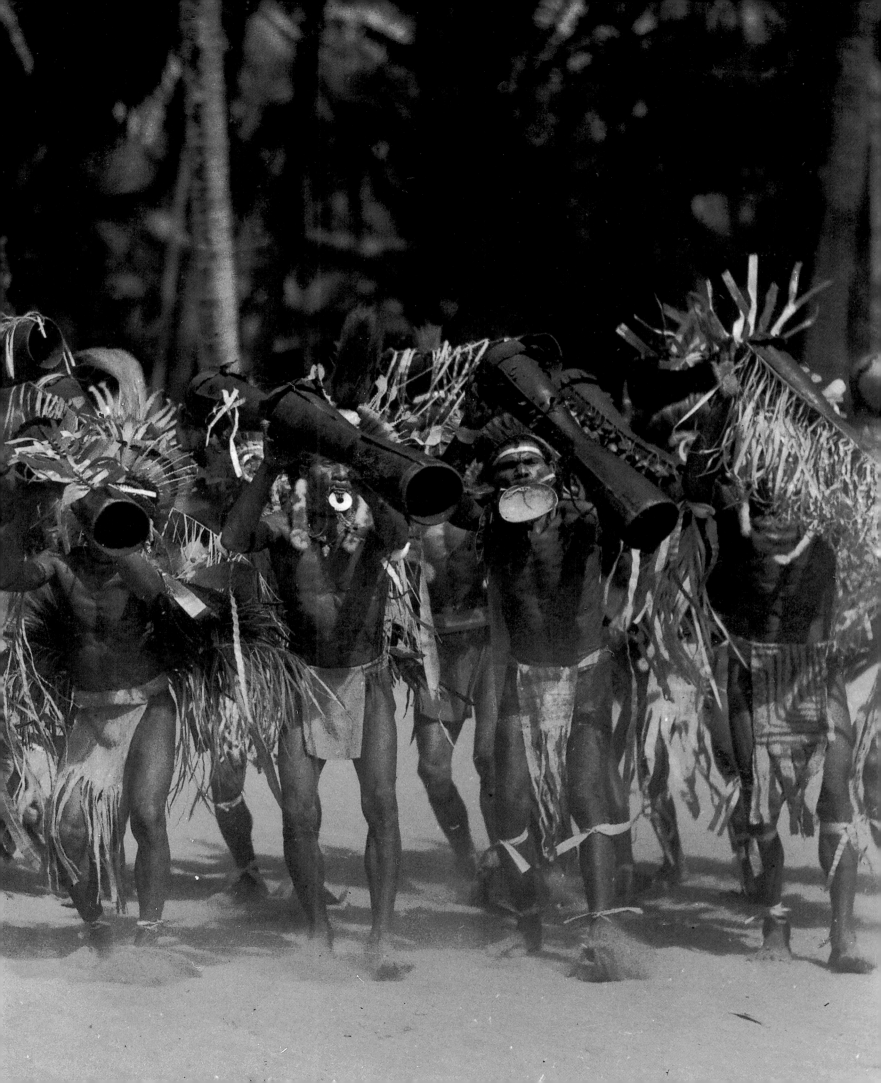

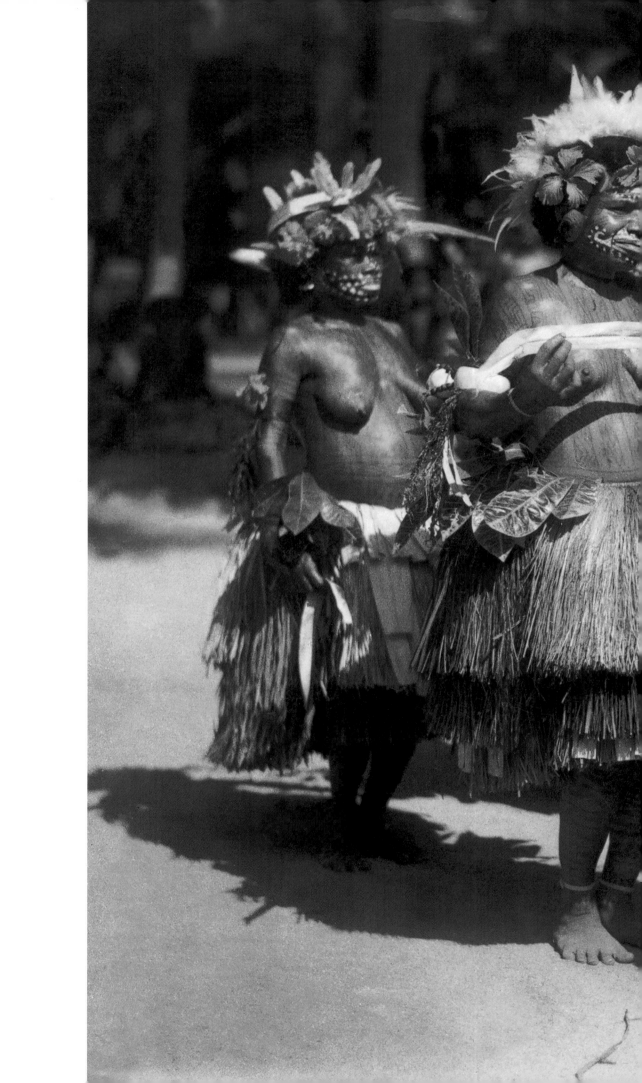

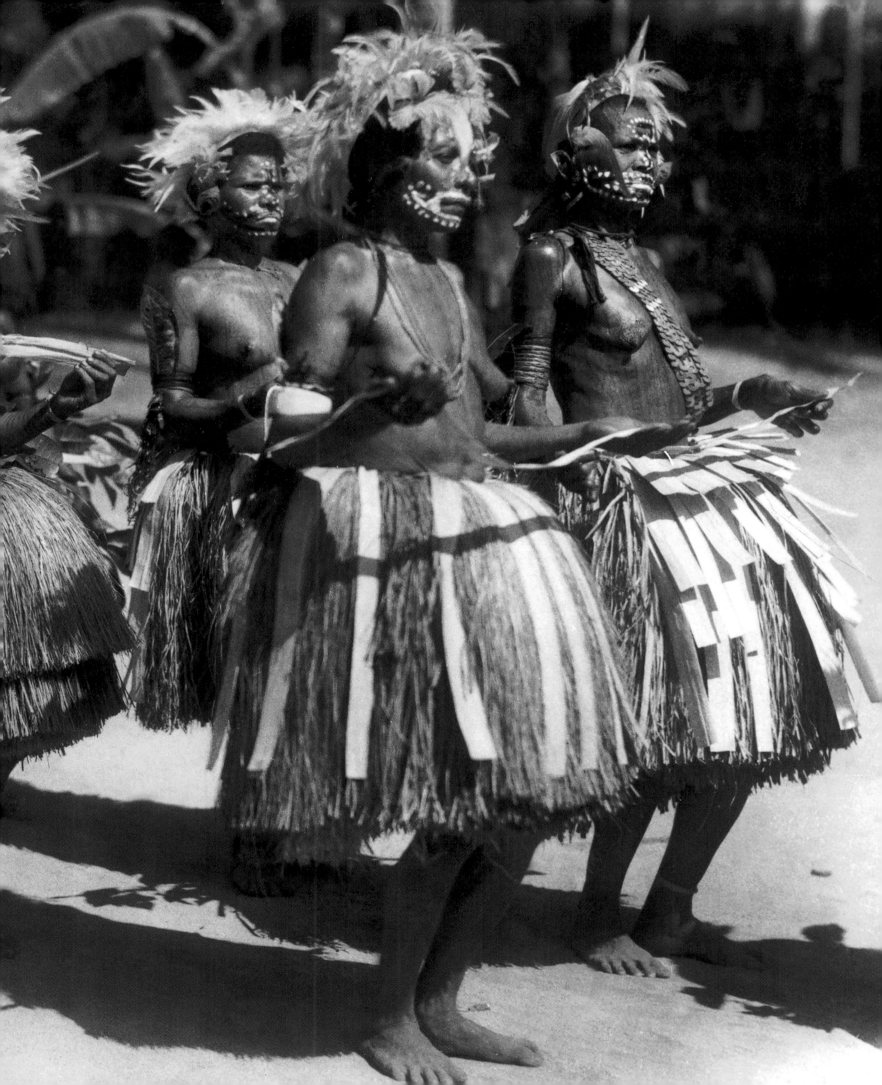

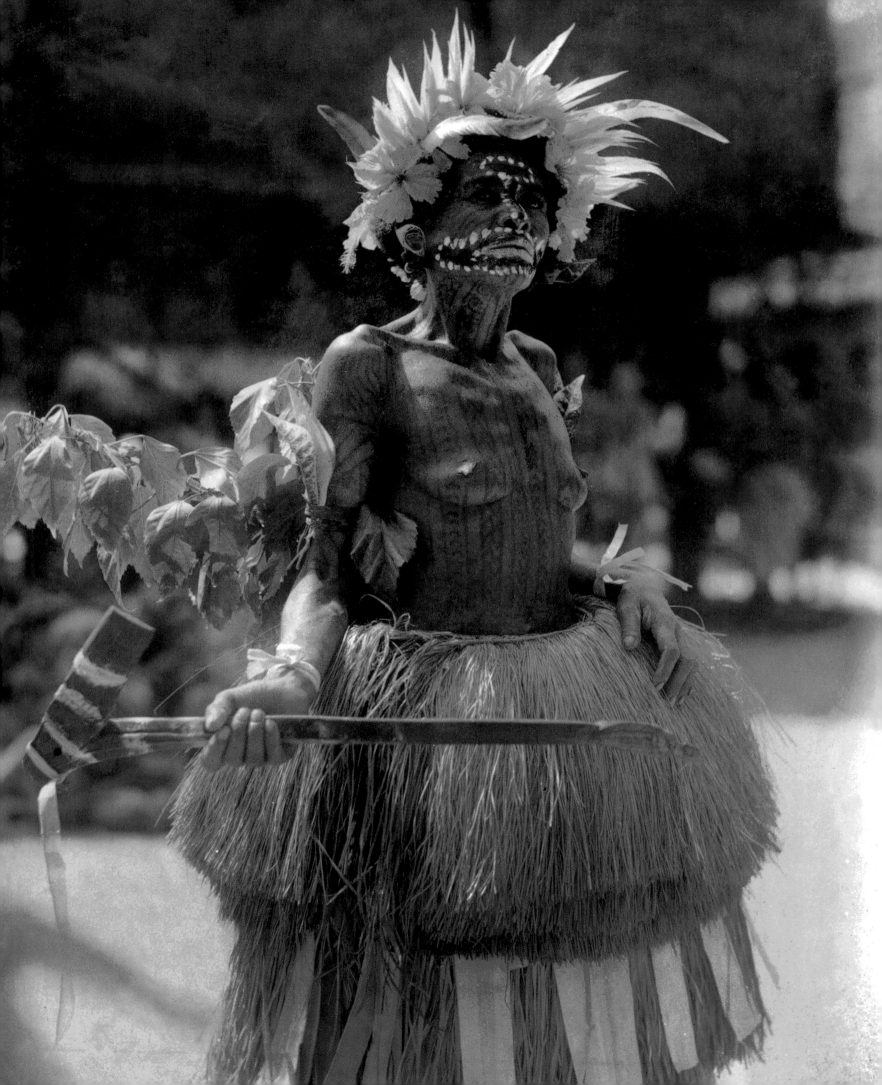

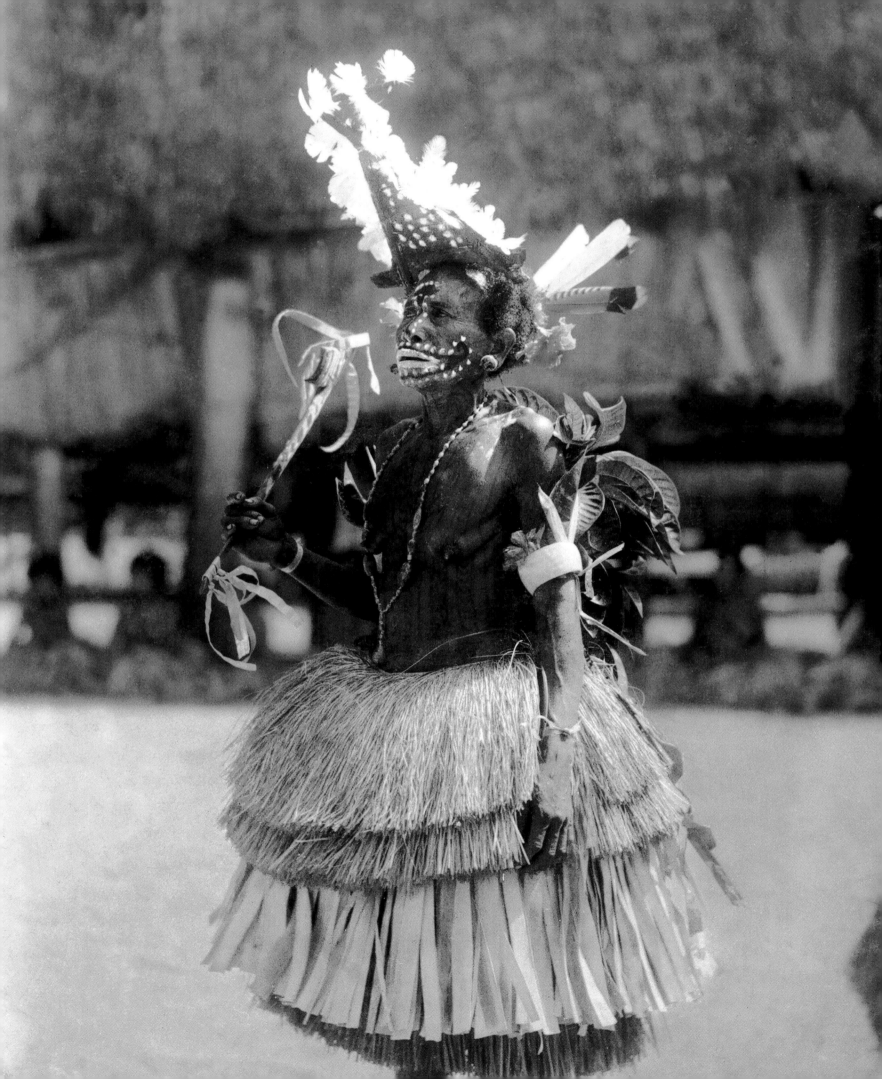

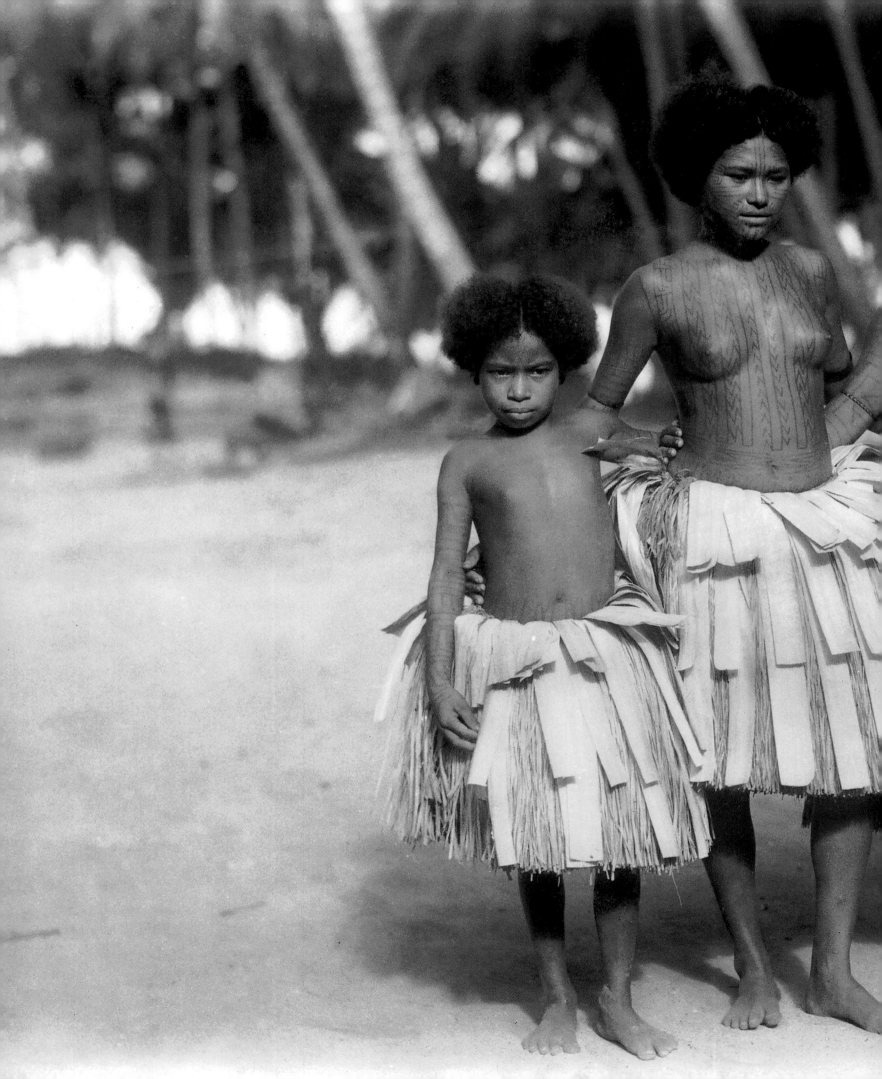

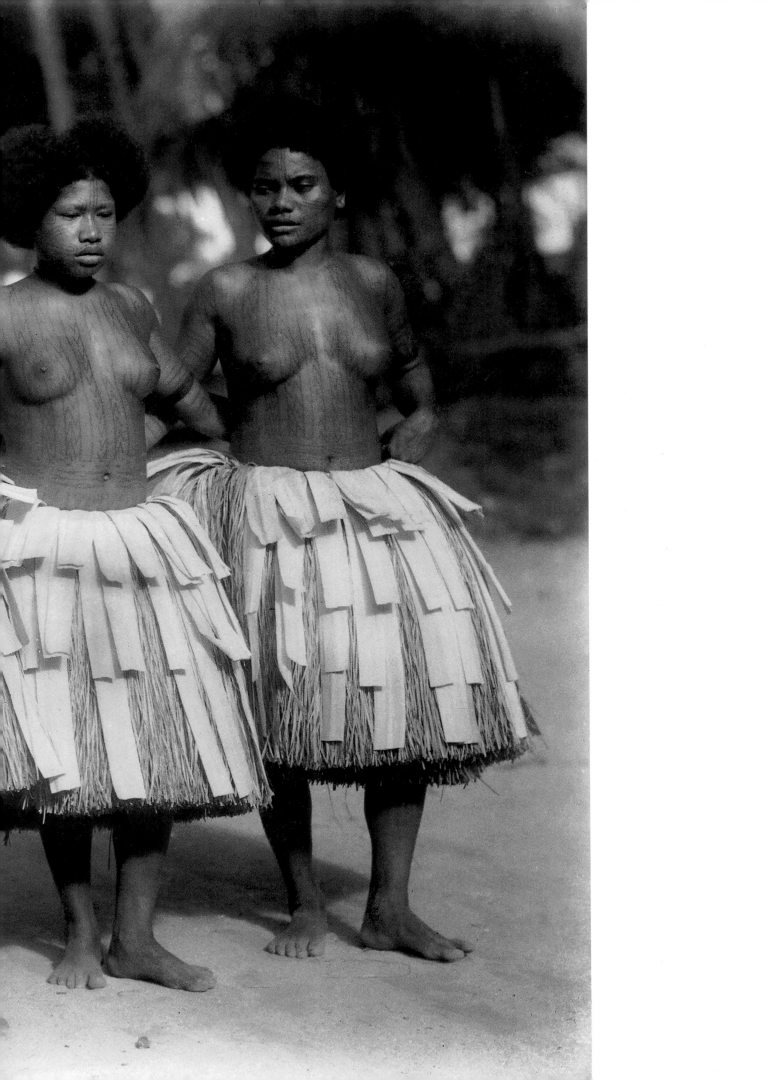

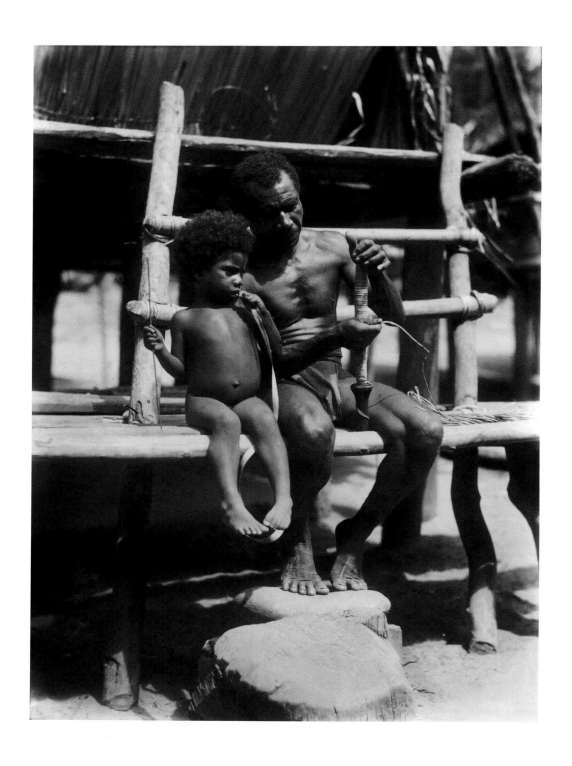

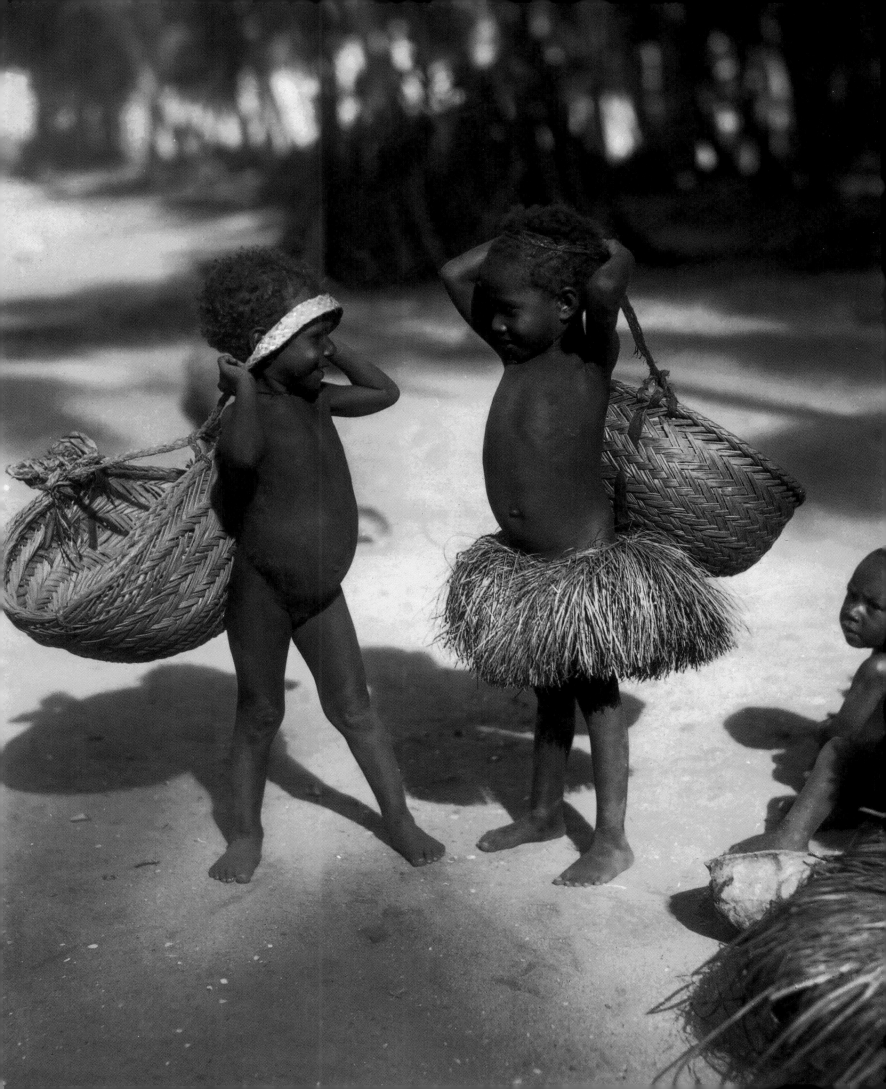

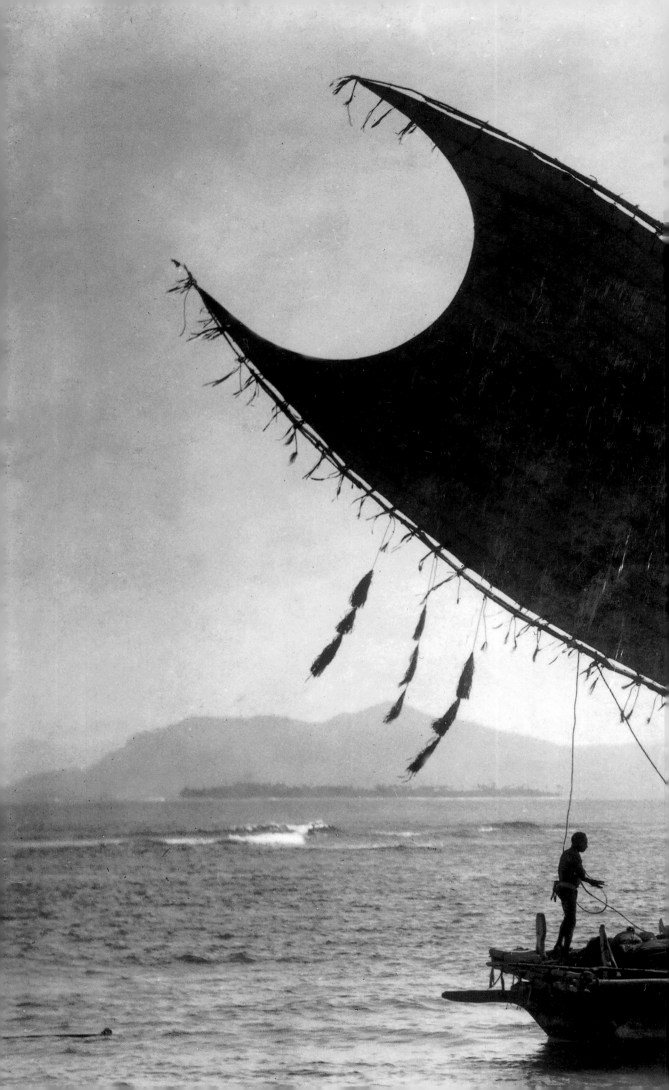

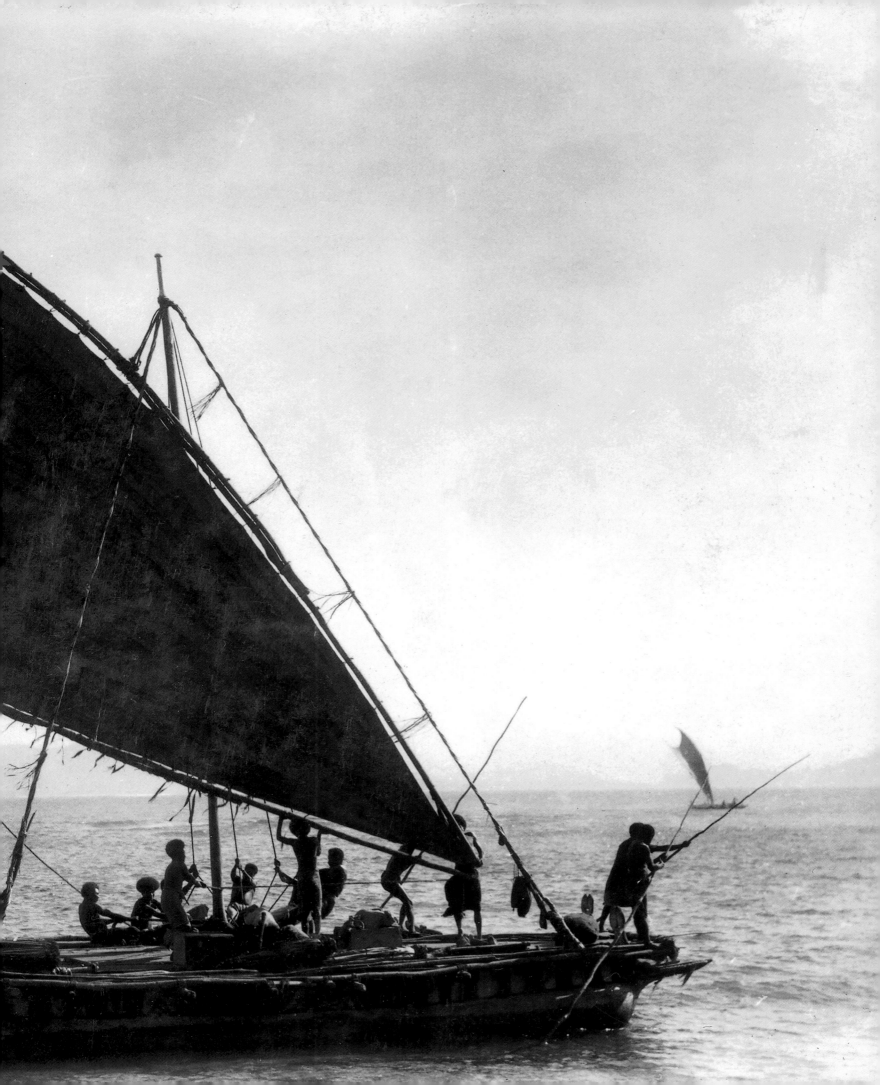

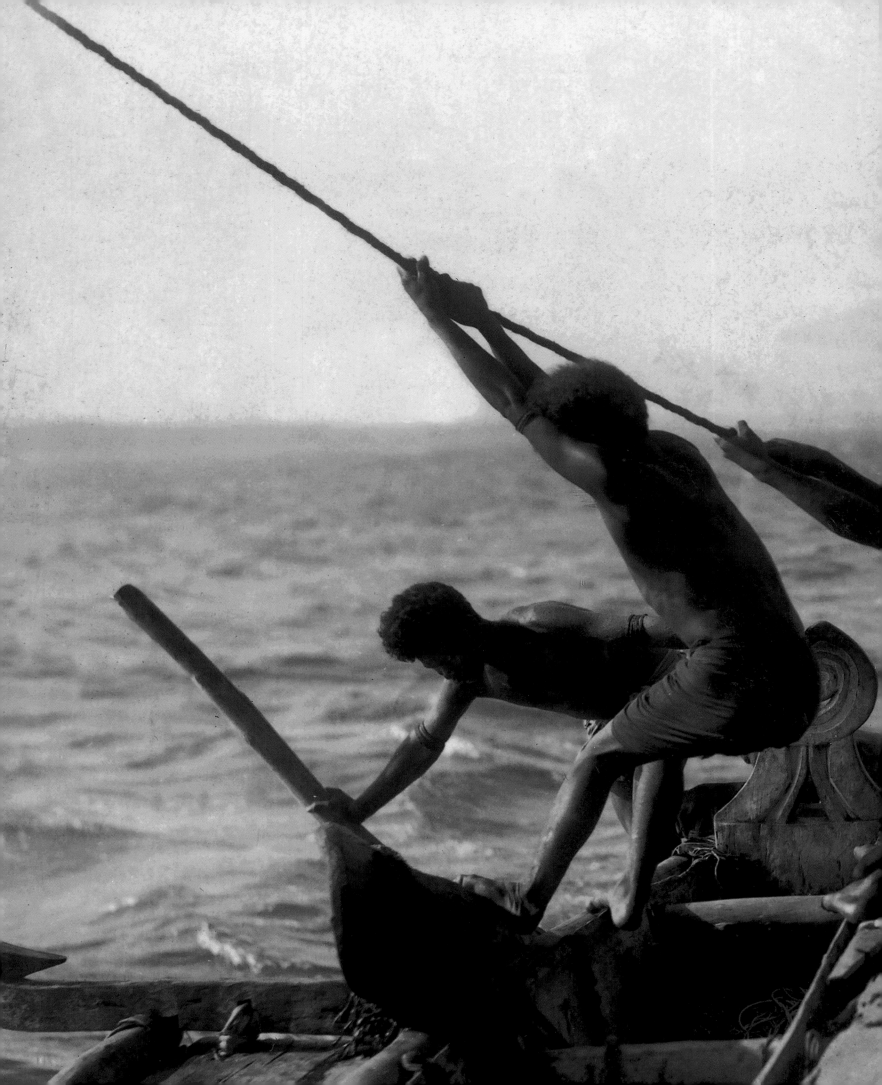

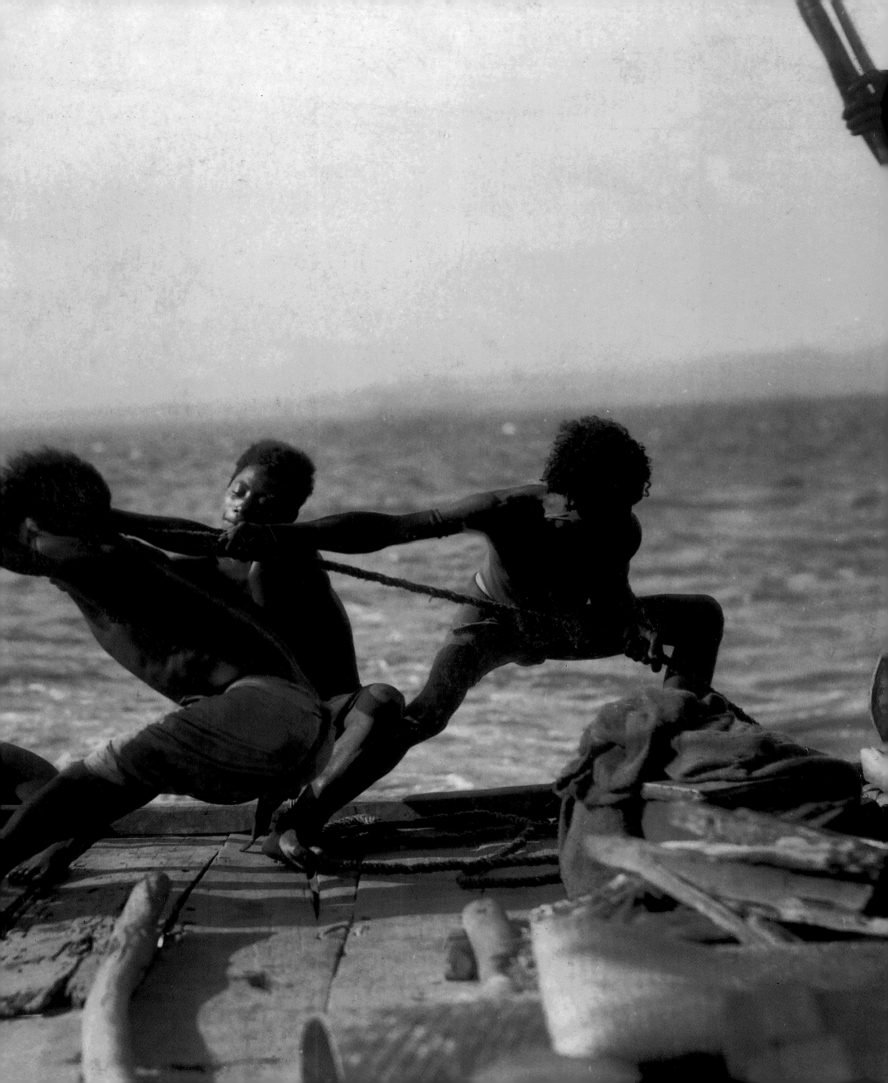

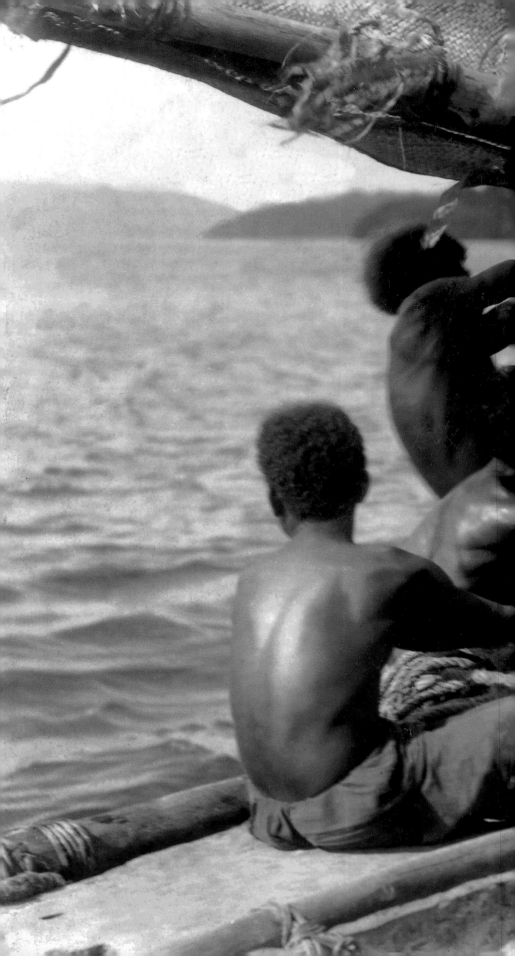

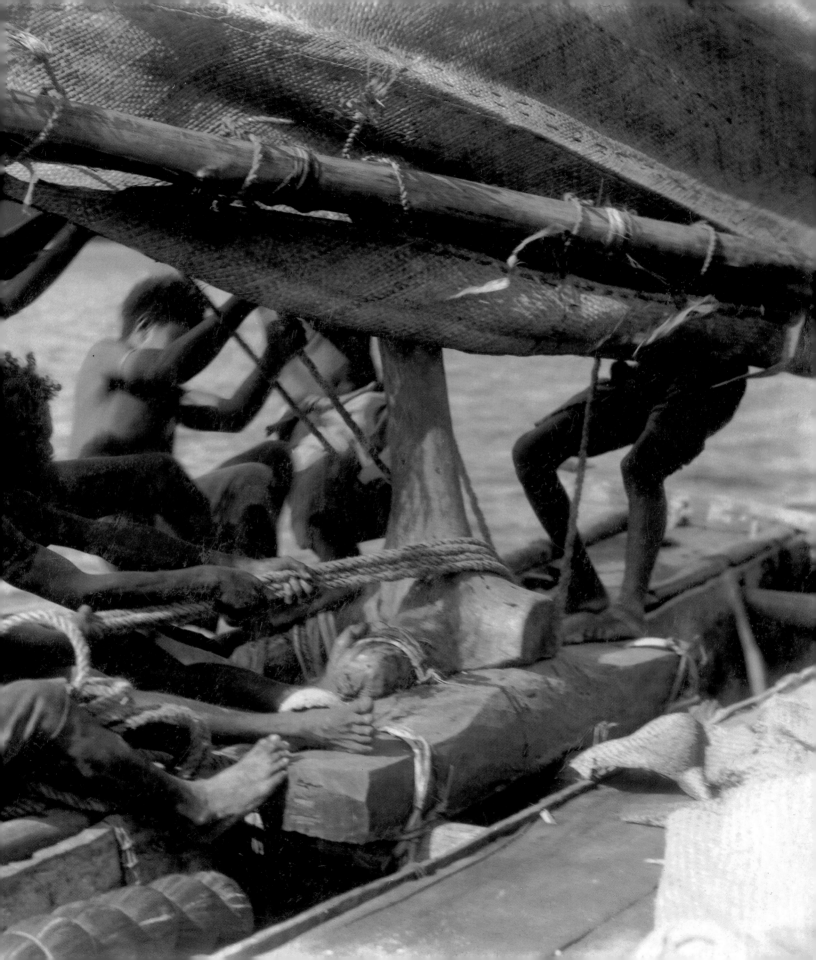

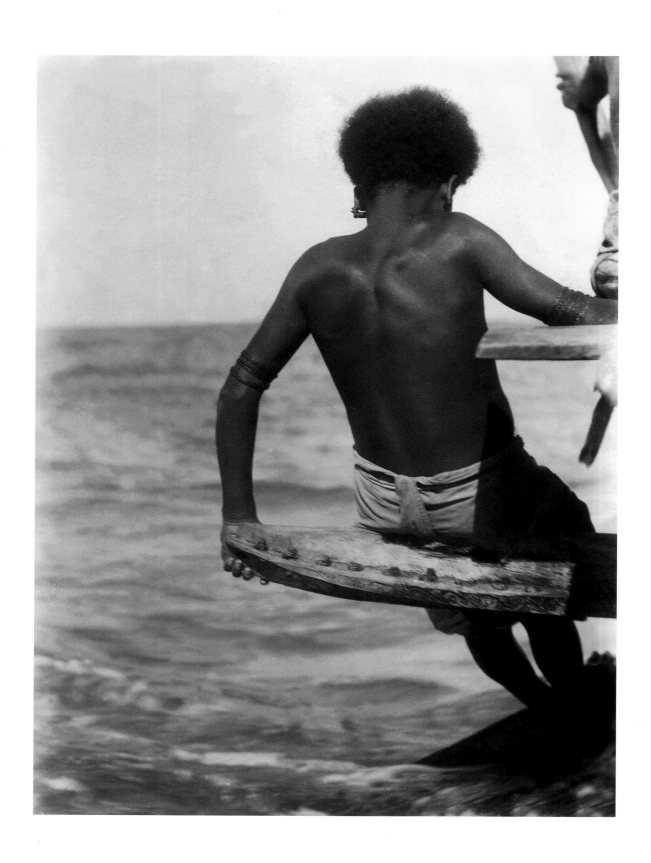

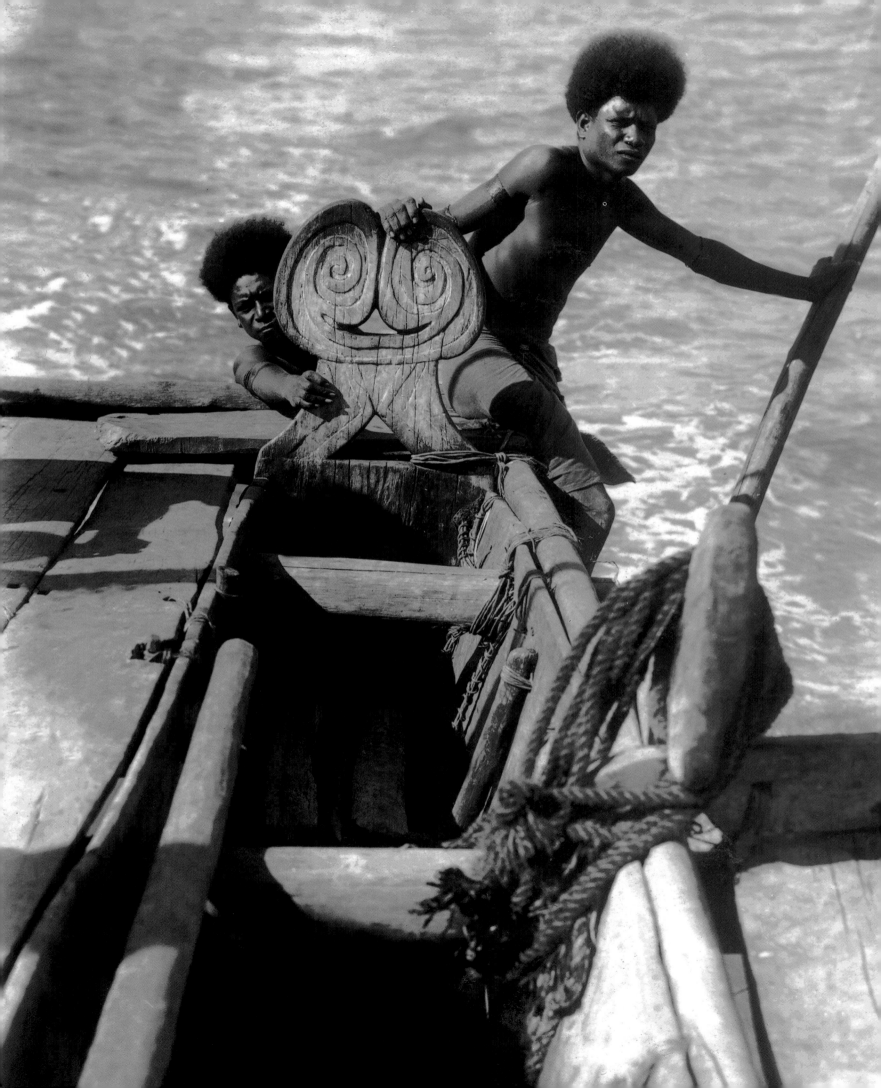

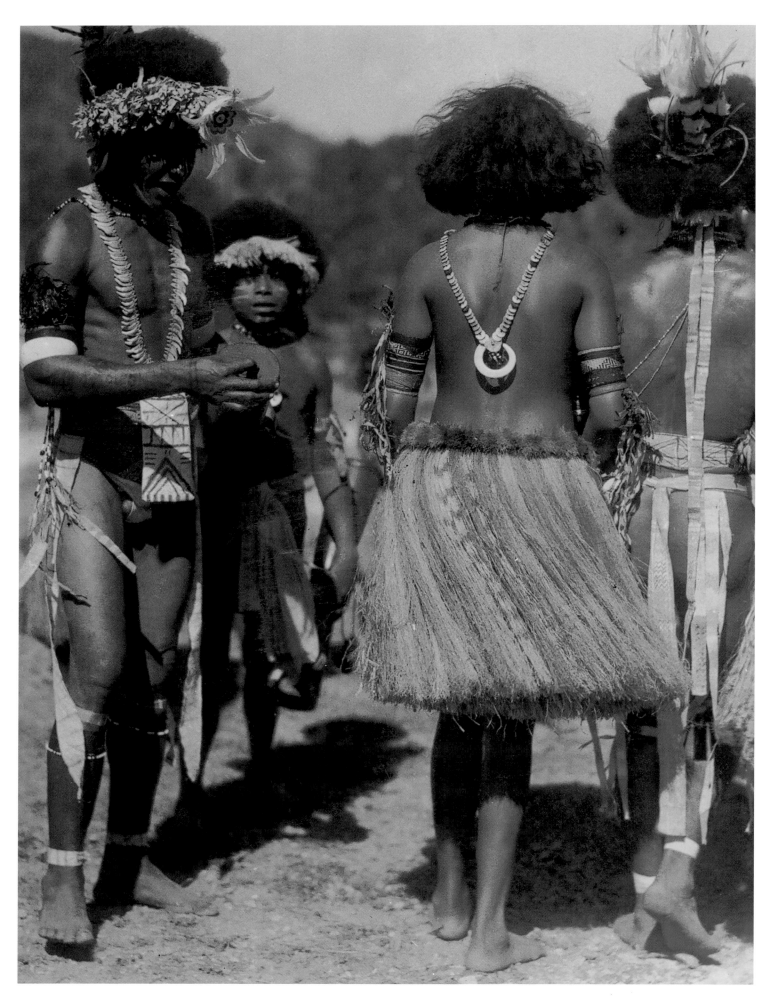

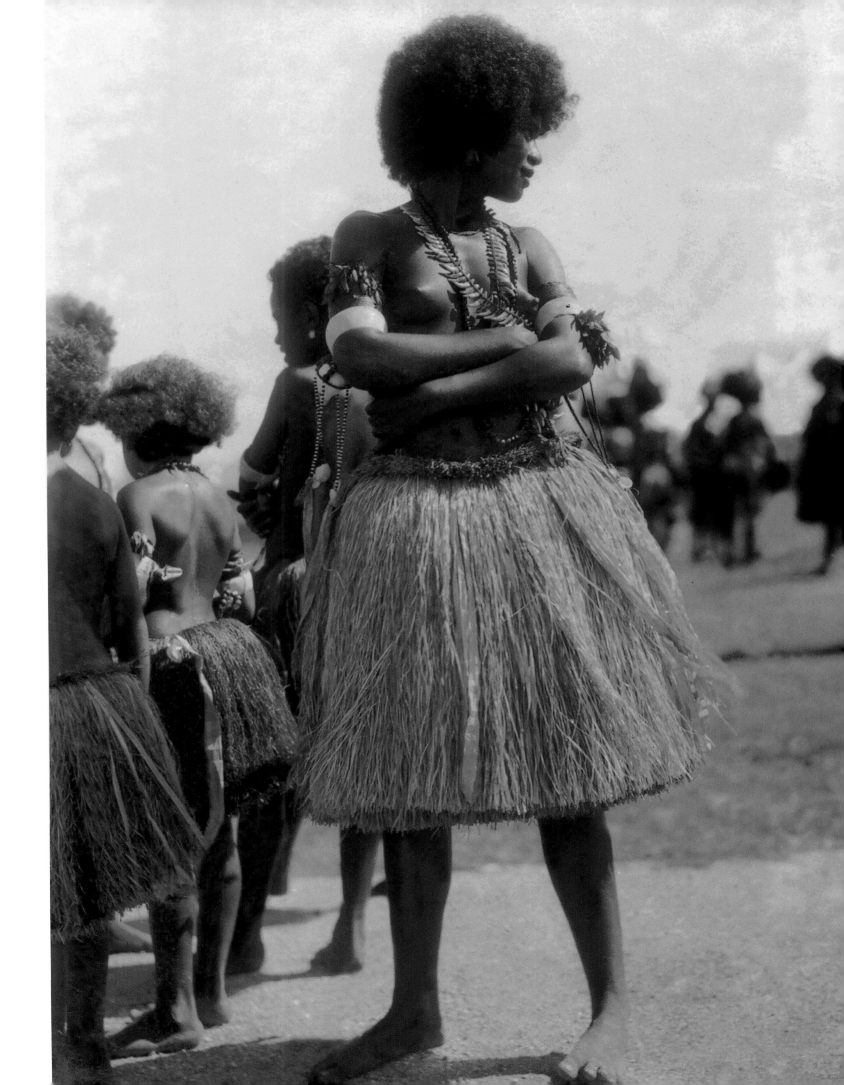

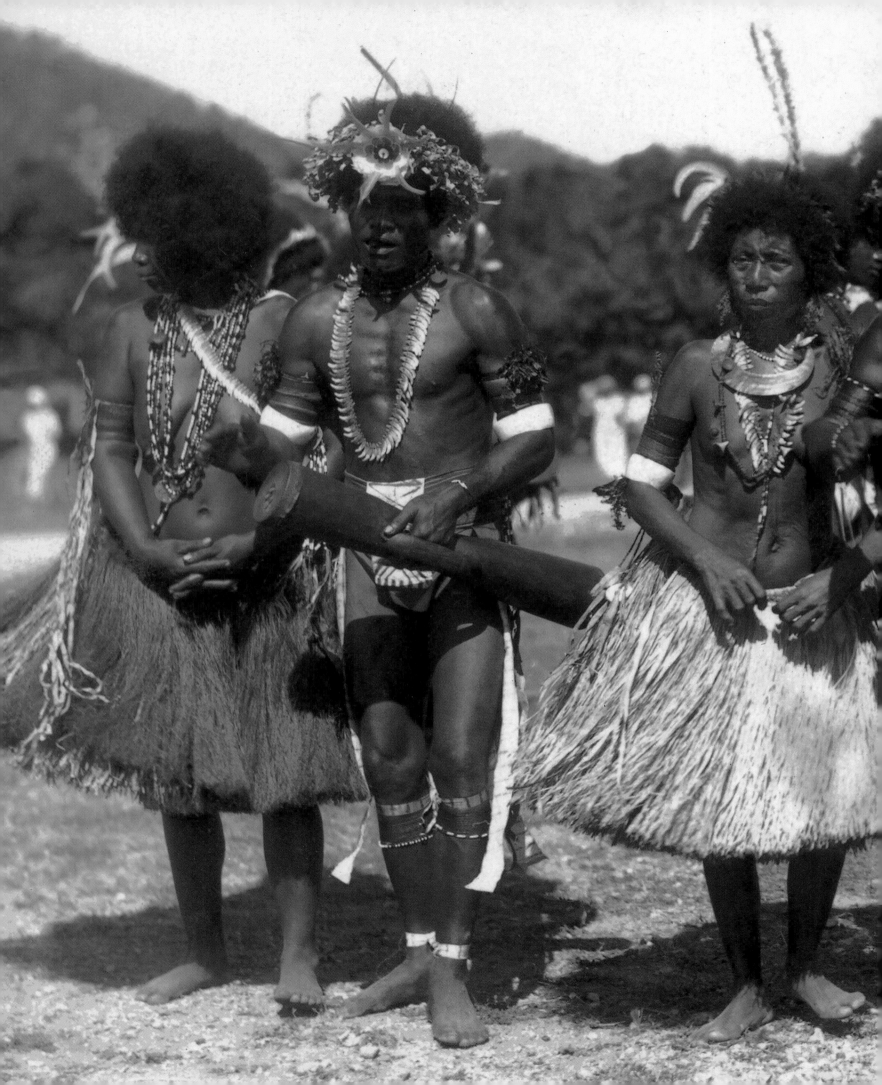

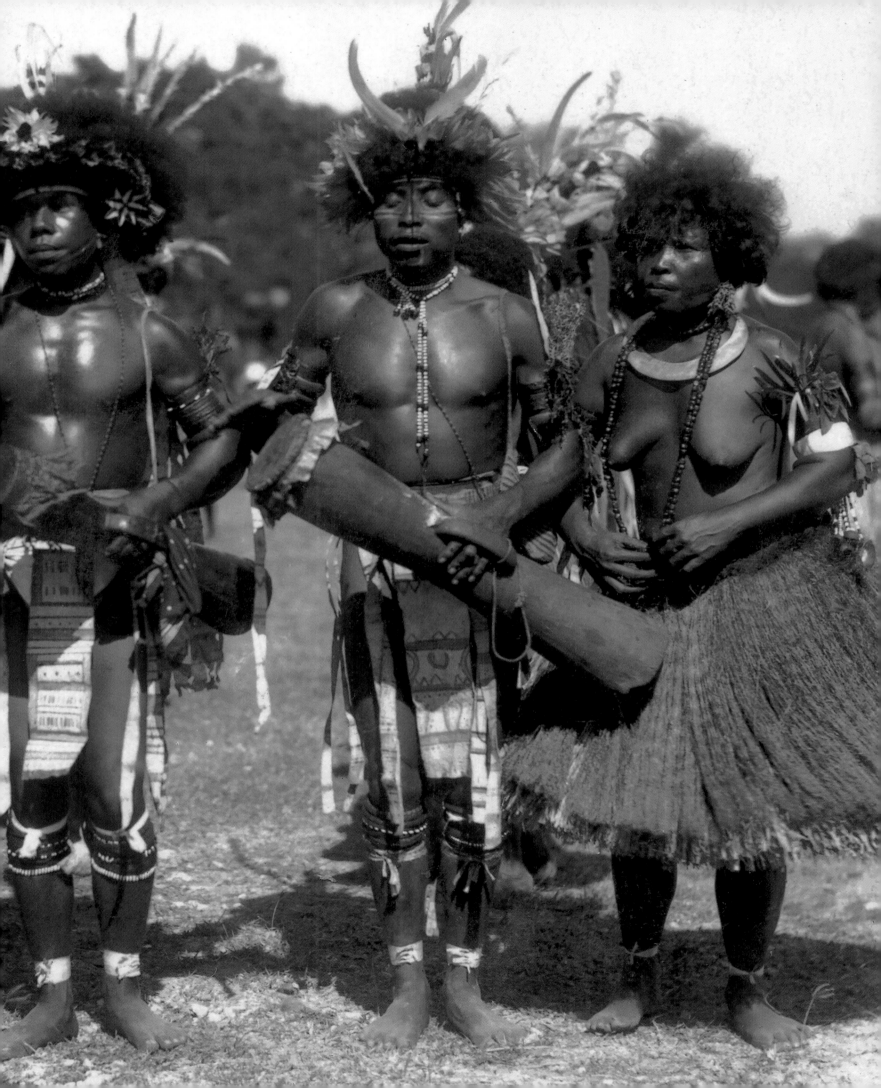

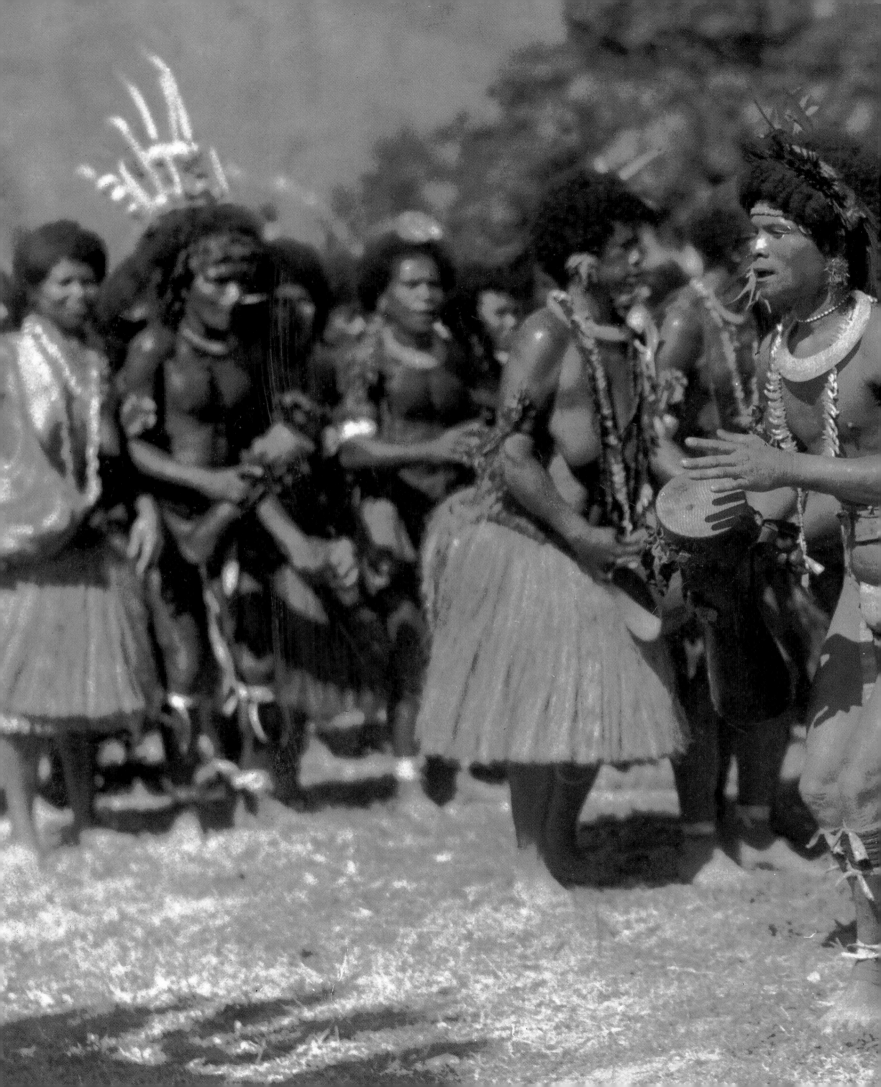

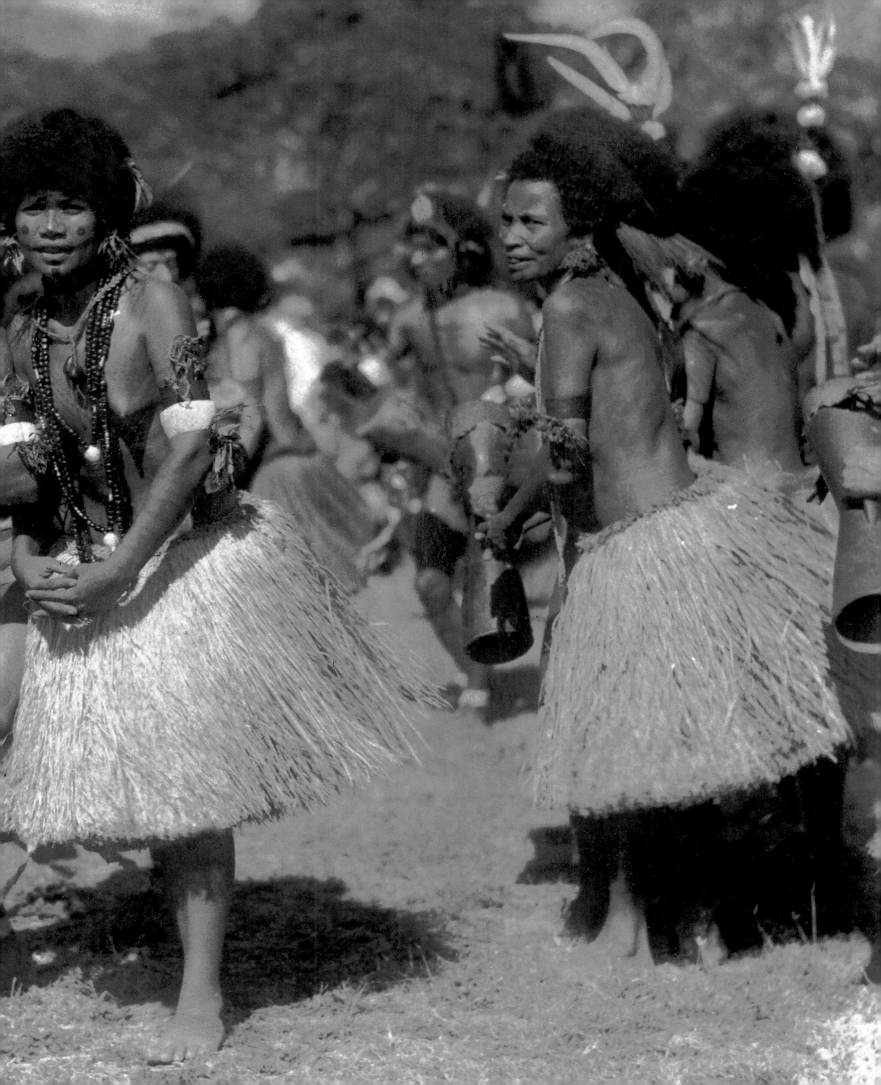

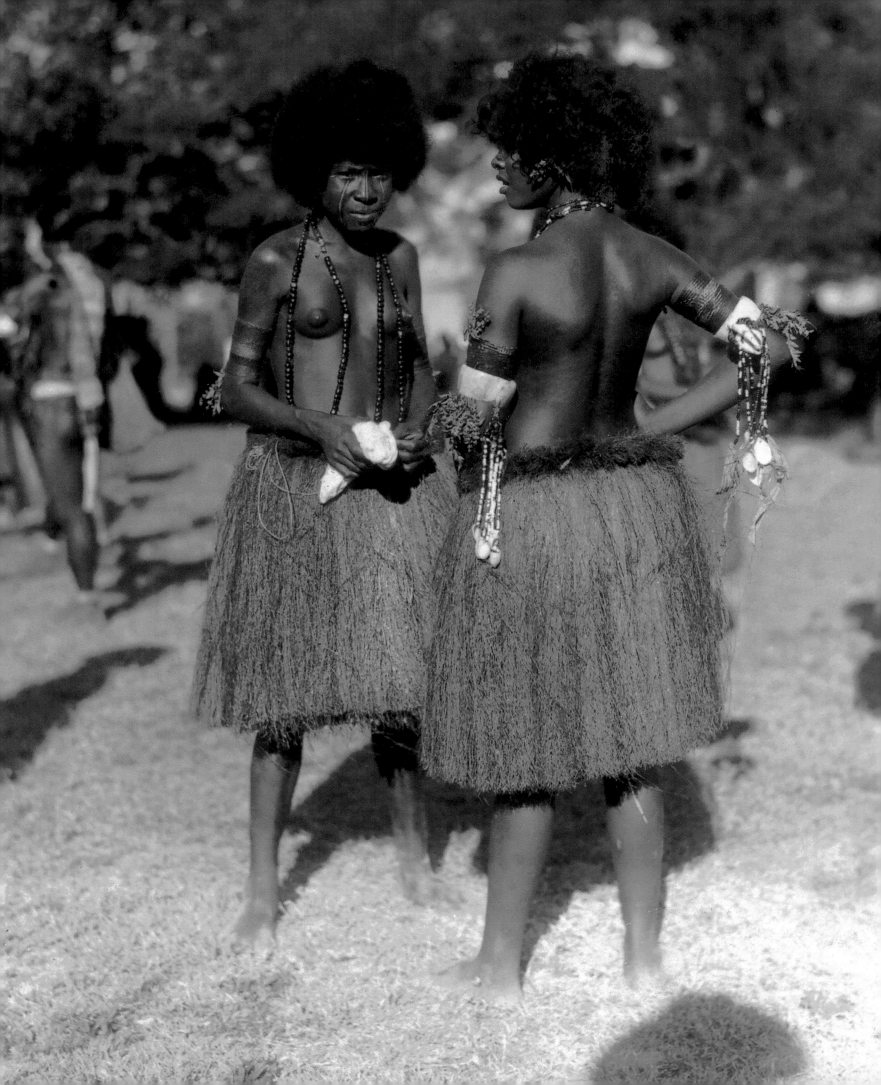

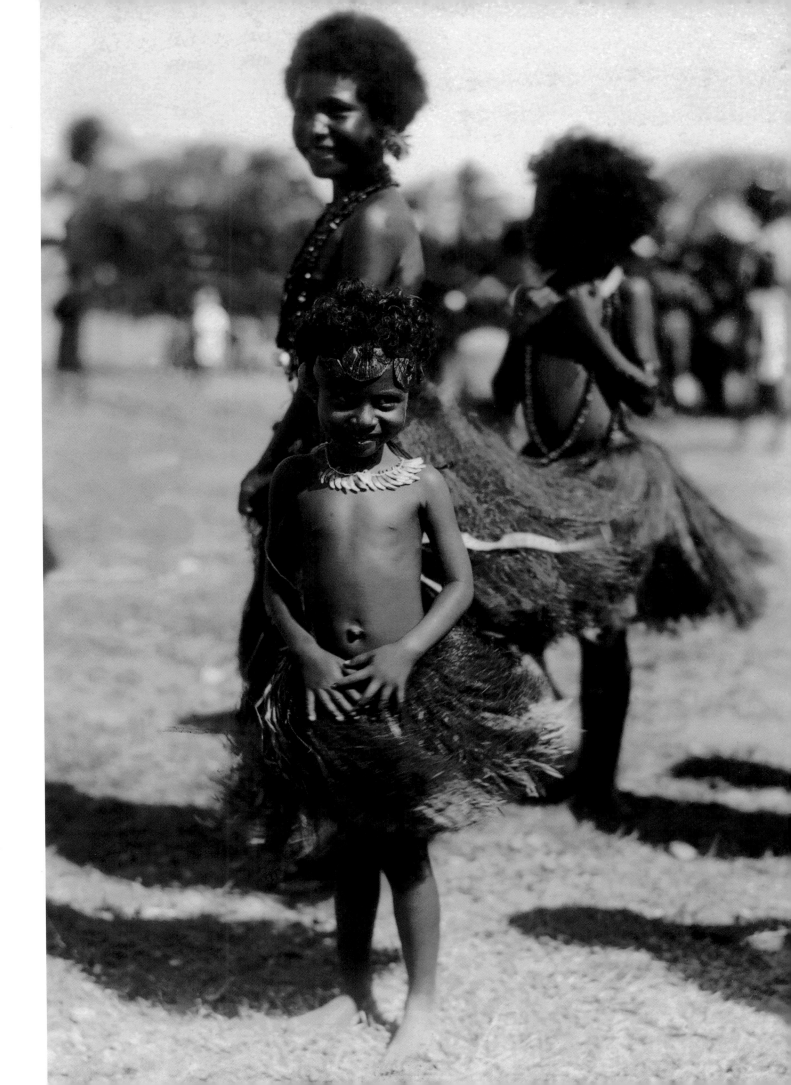

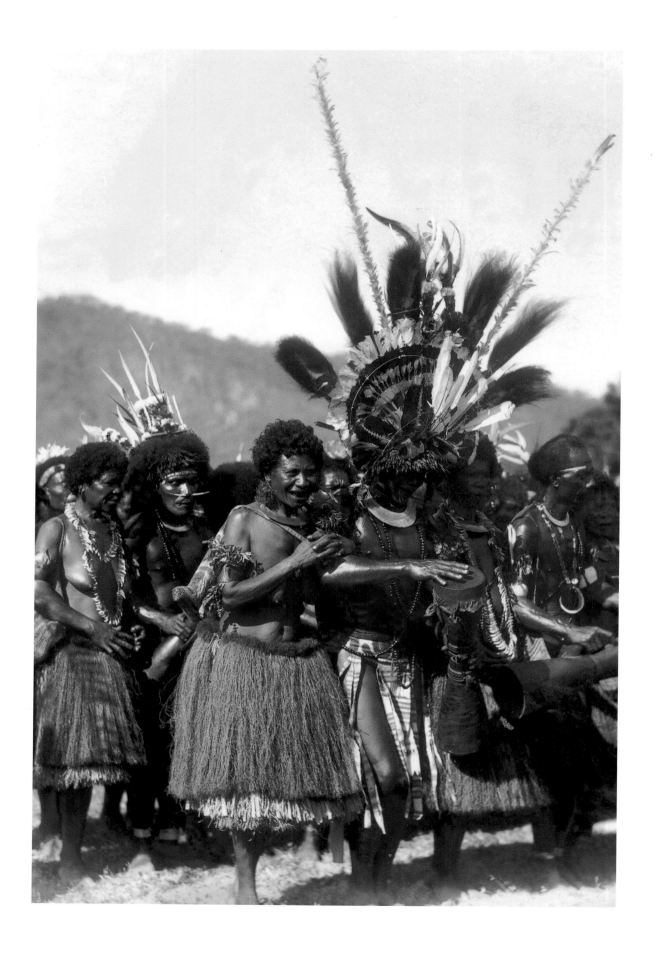

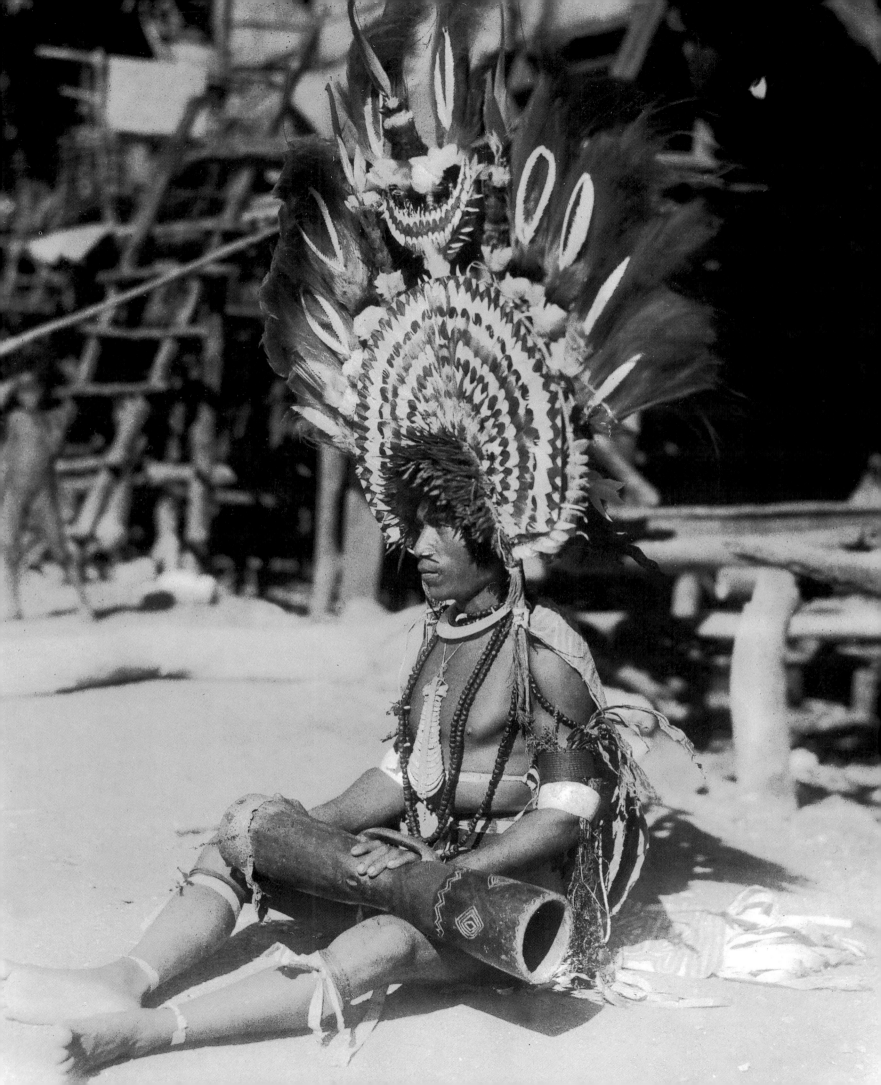

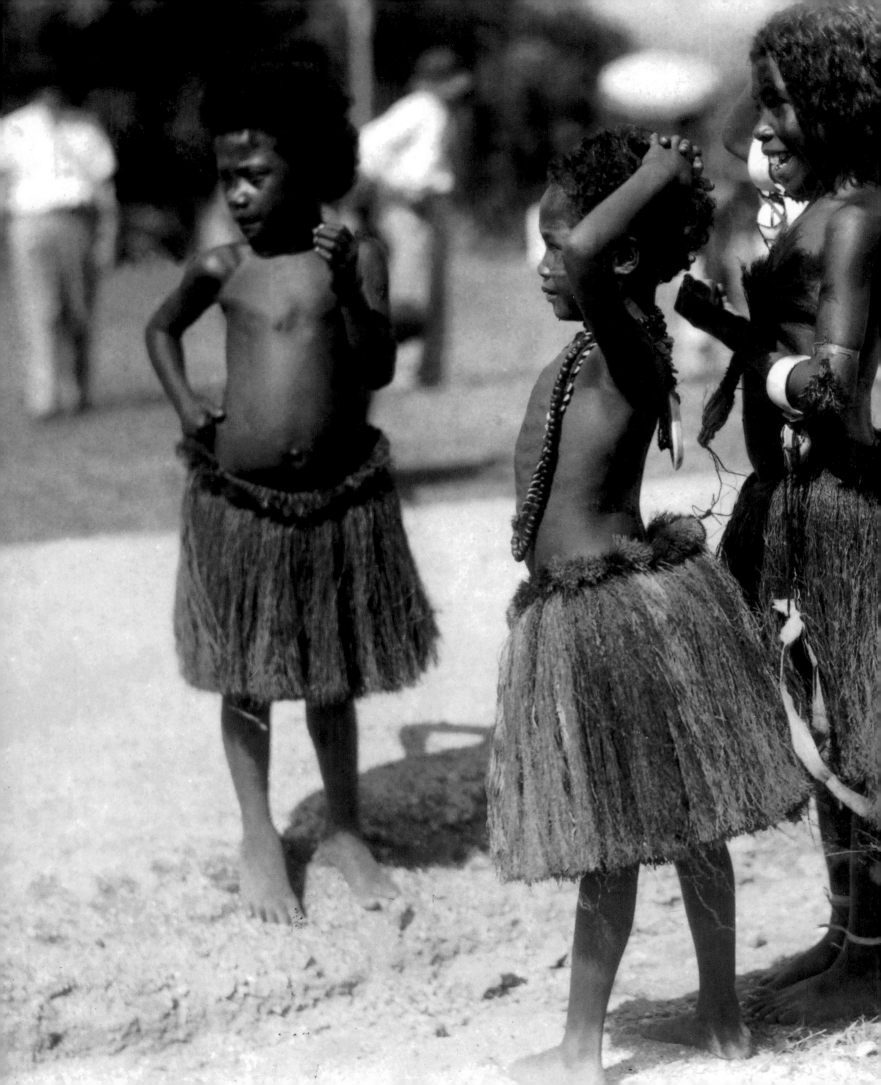

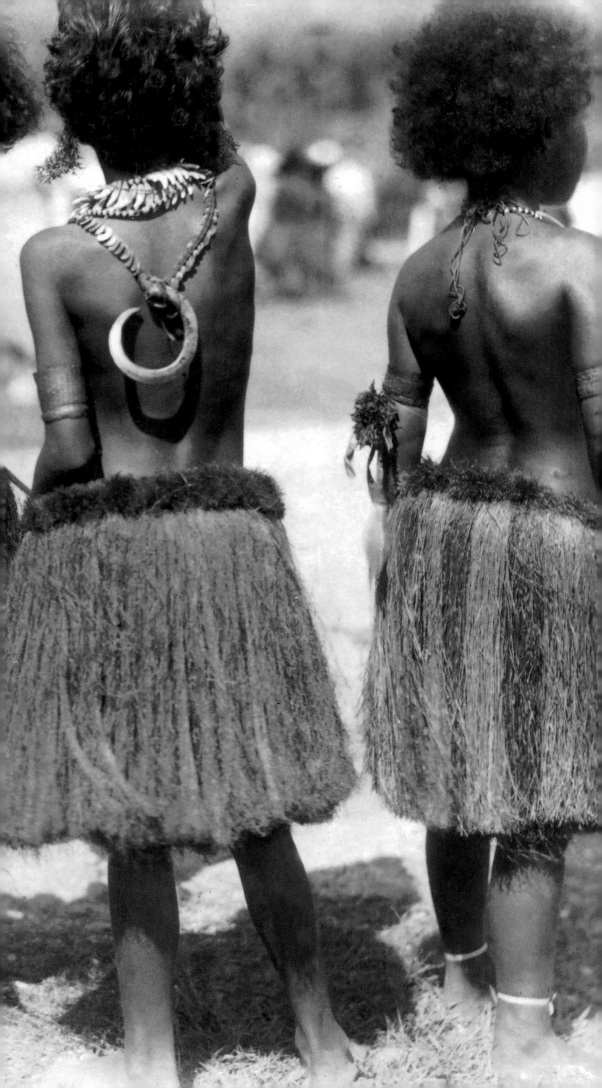

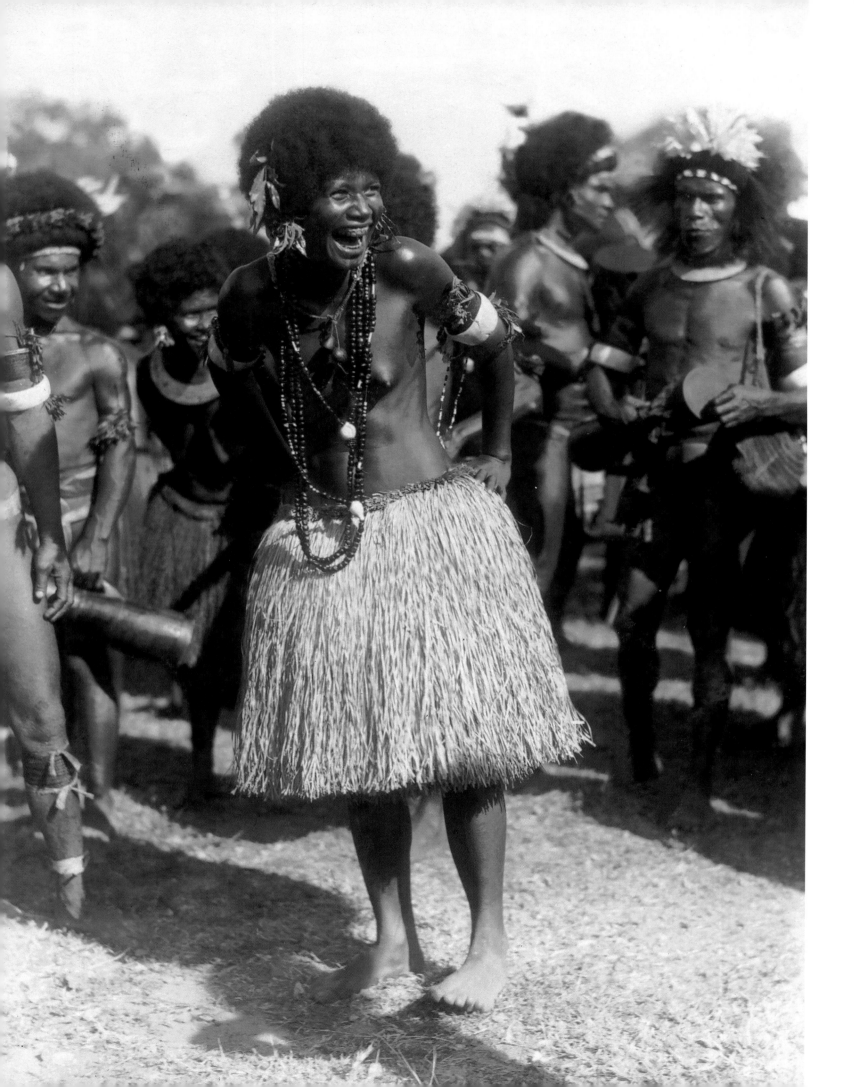

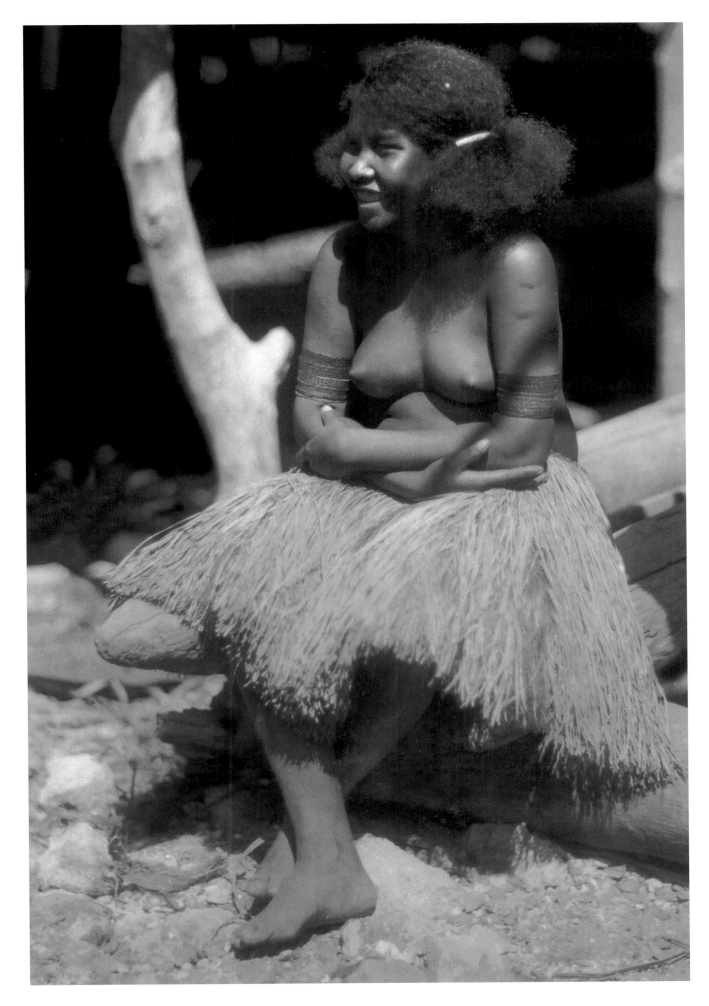

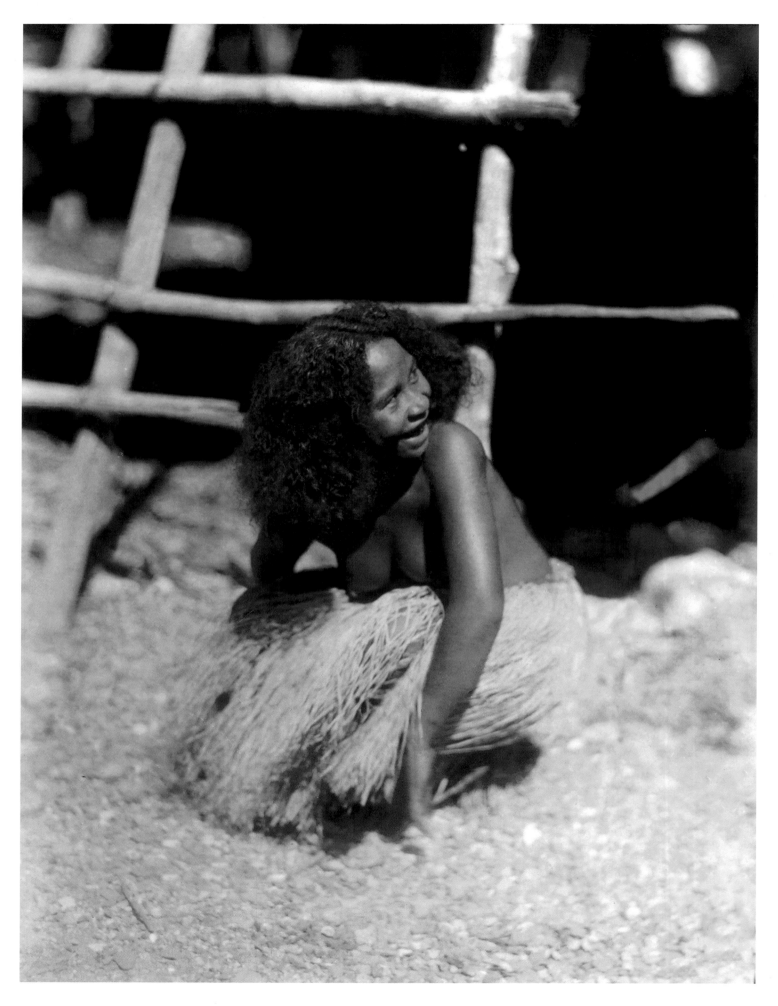

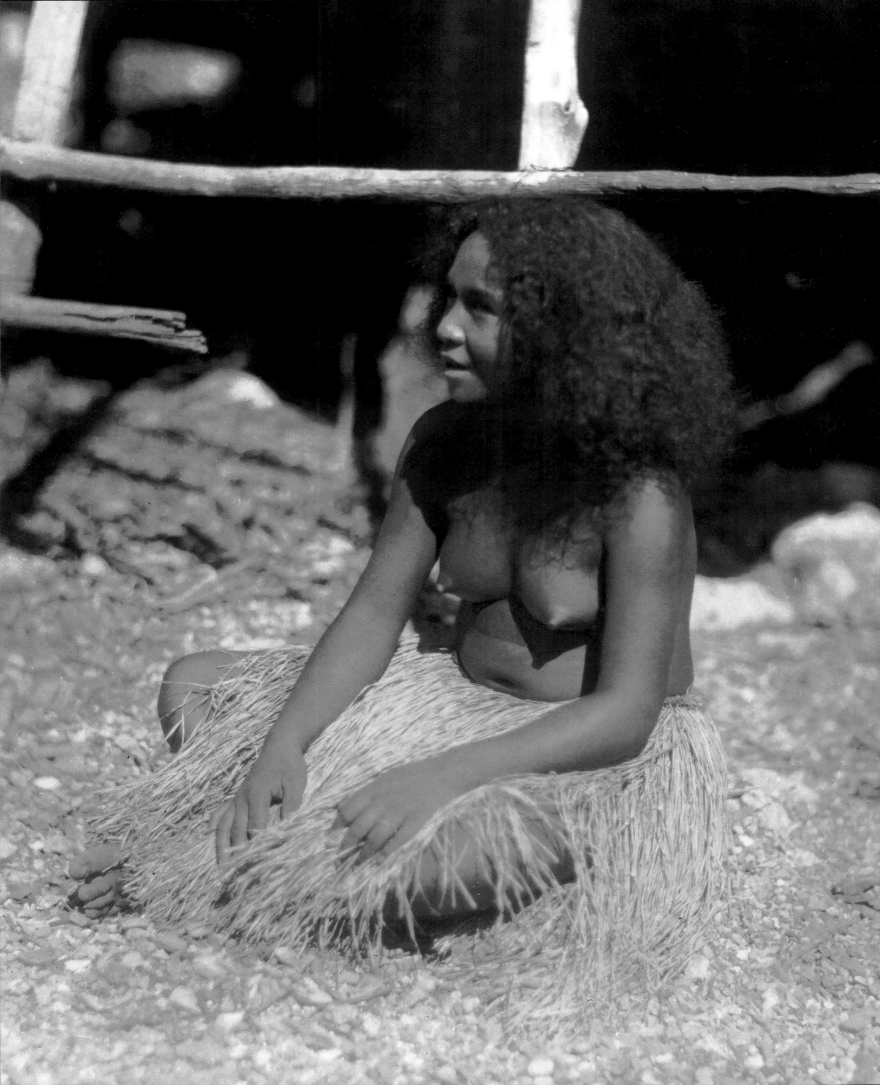

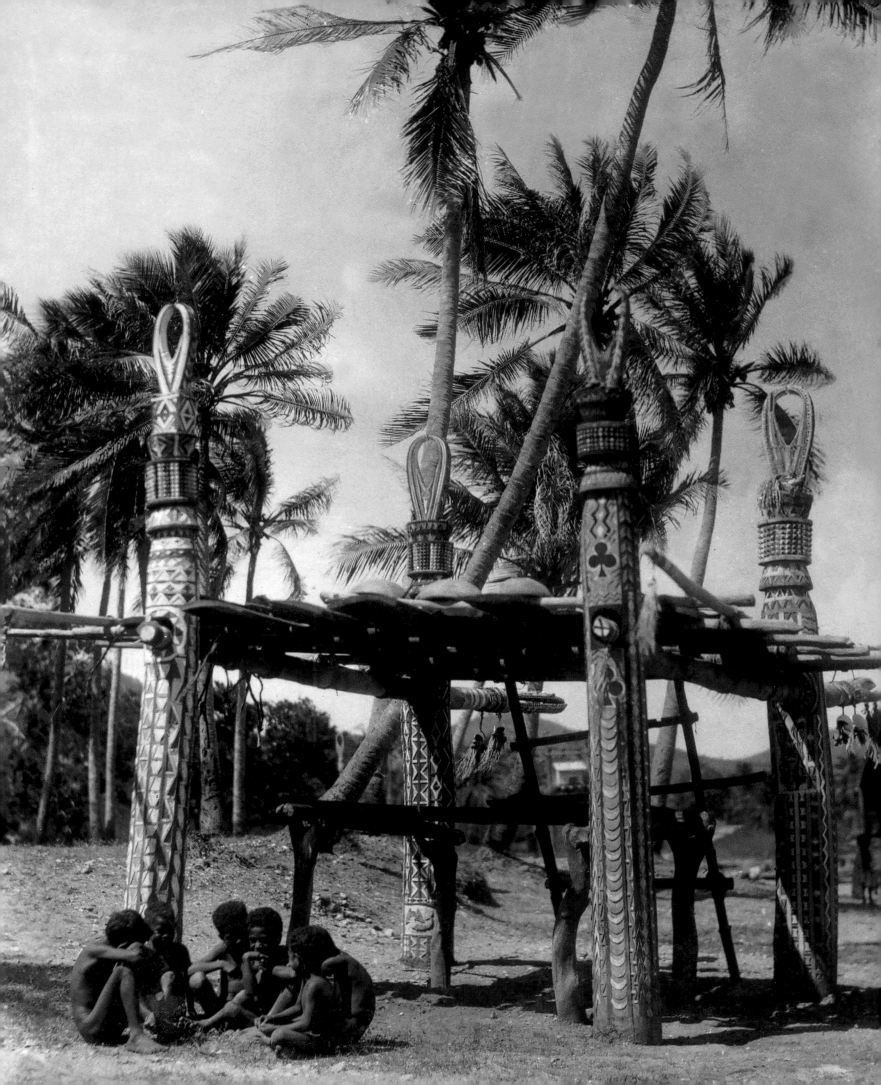

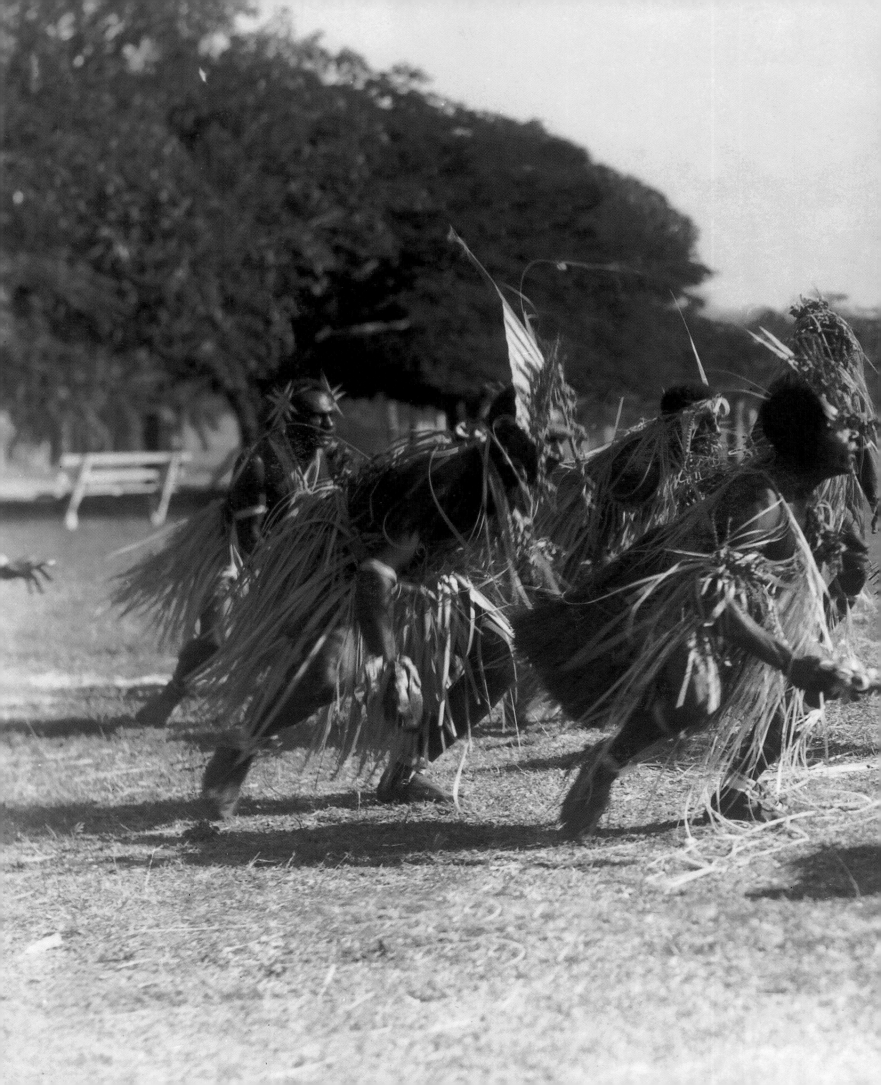

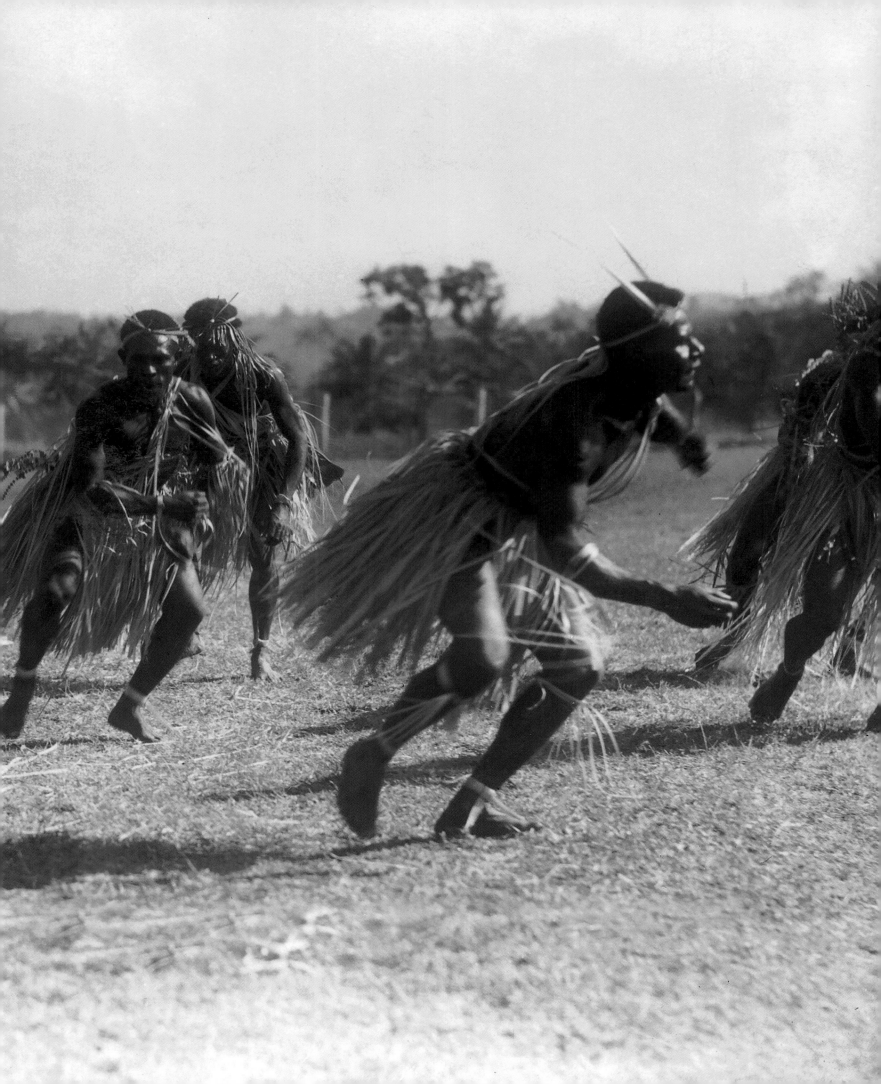

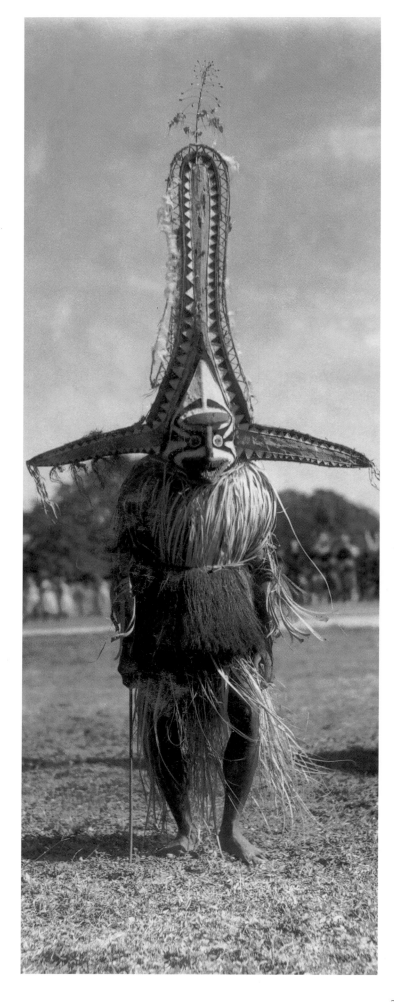
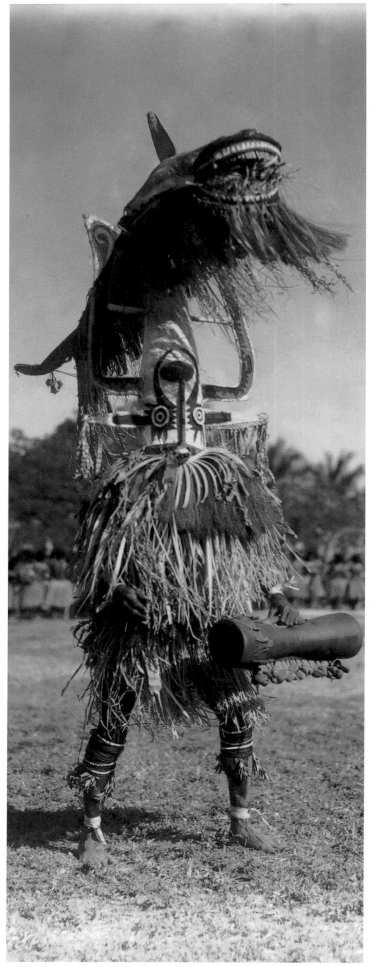

200

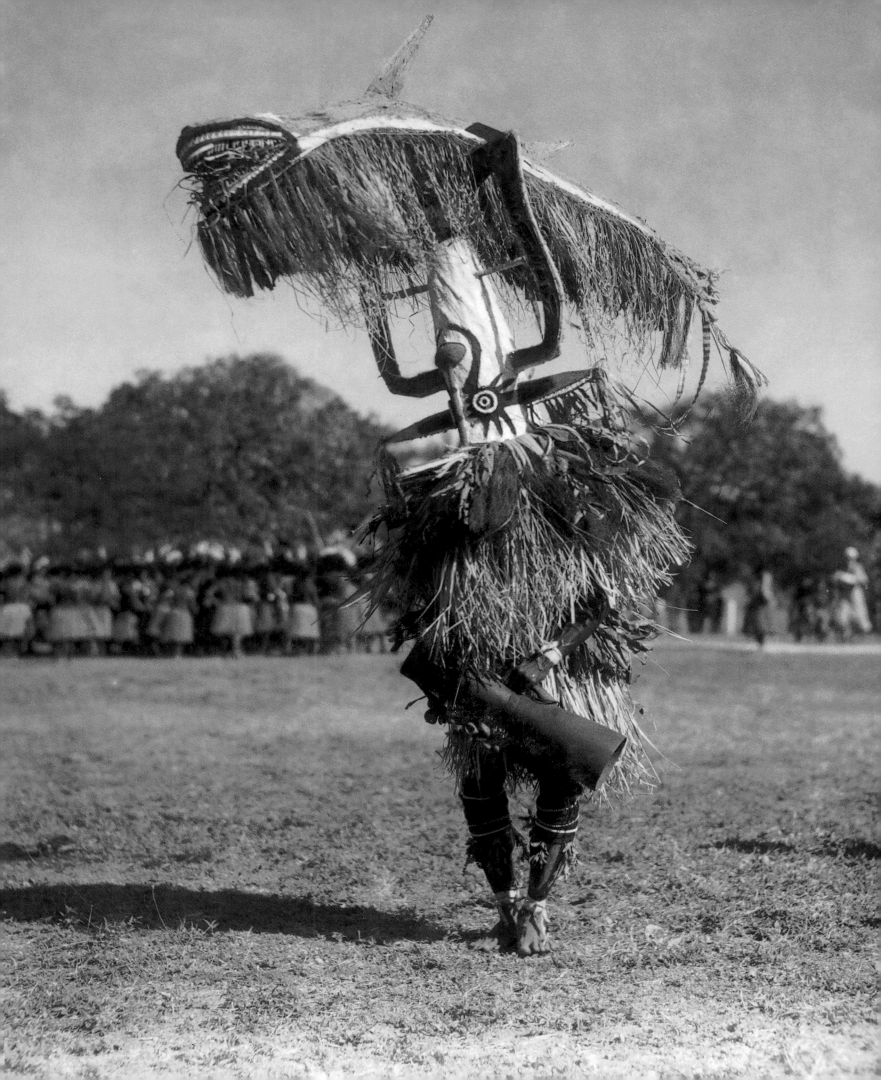

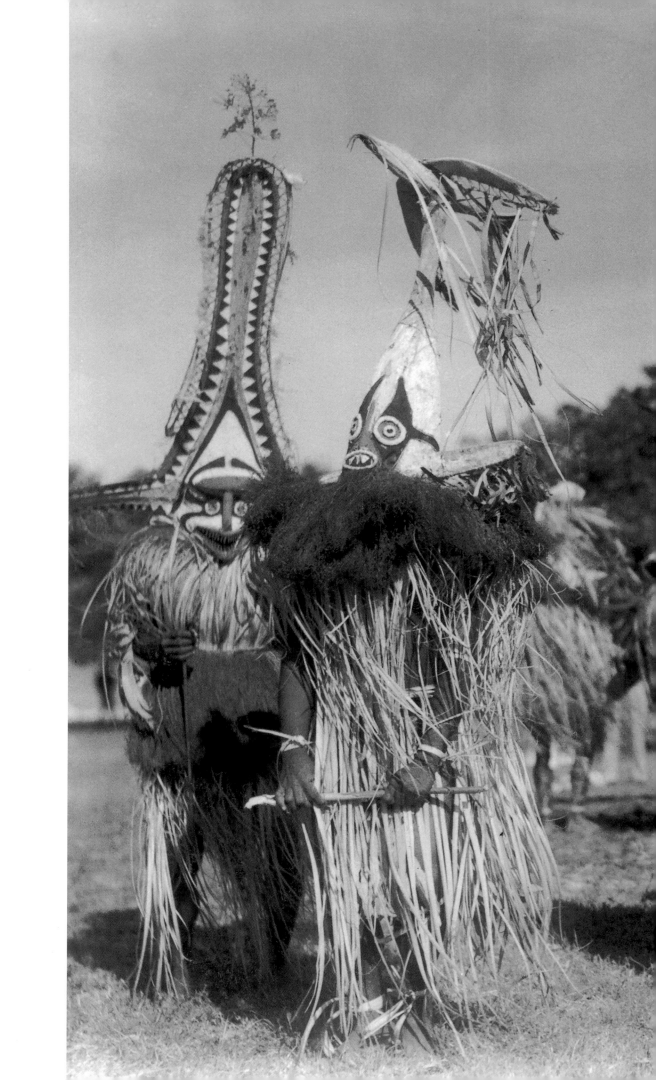

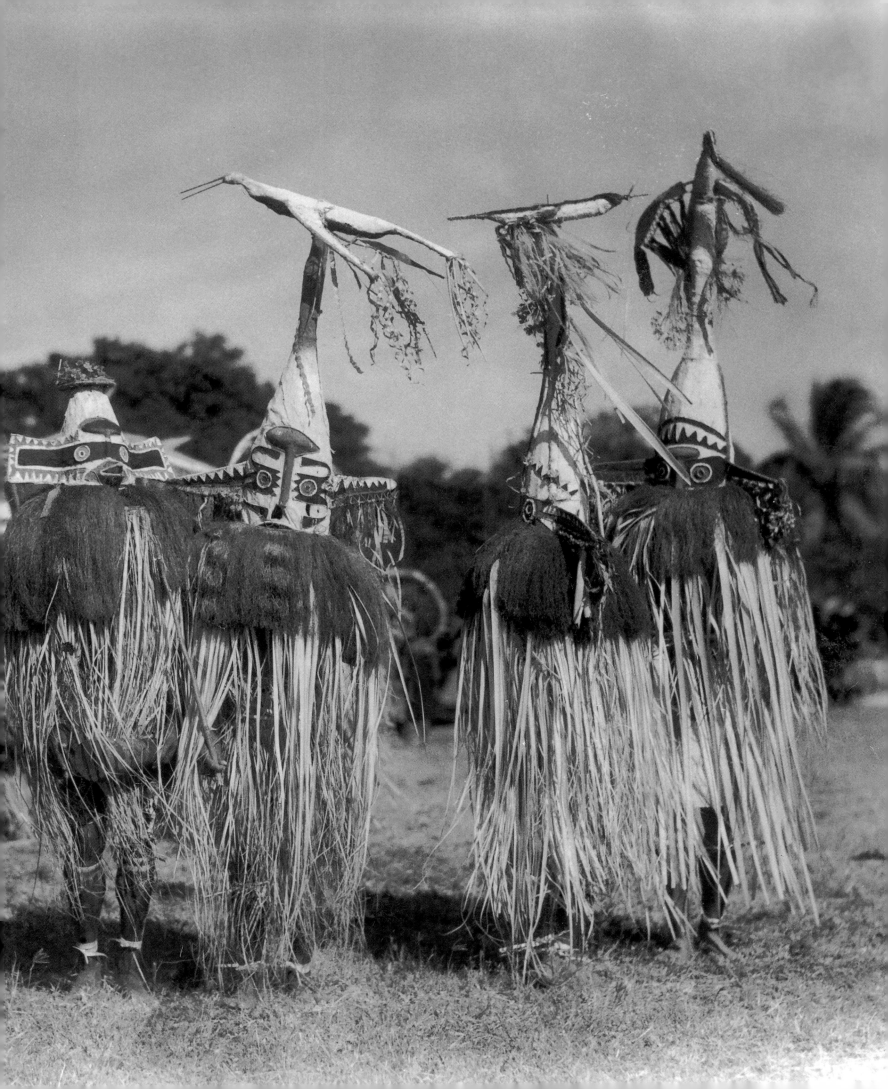

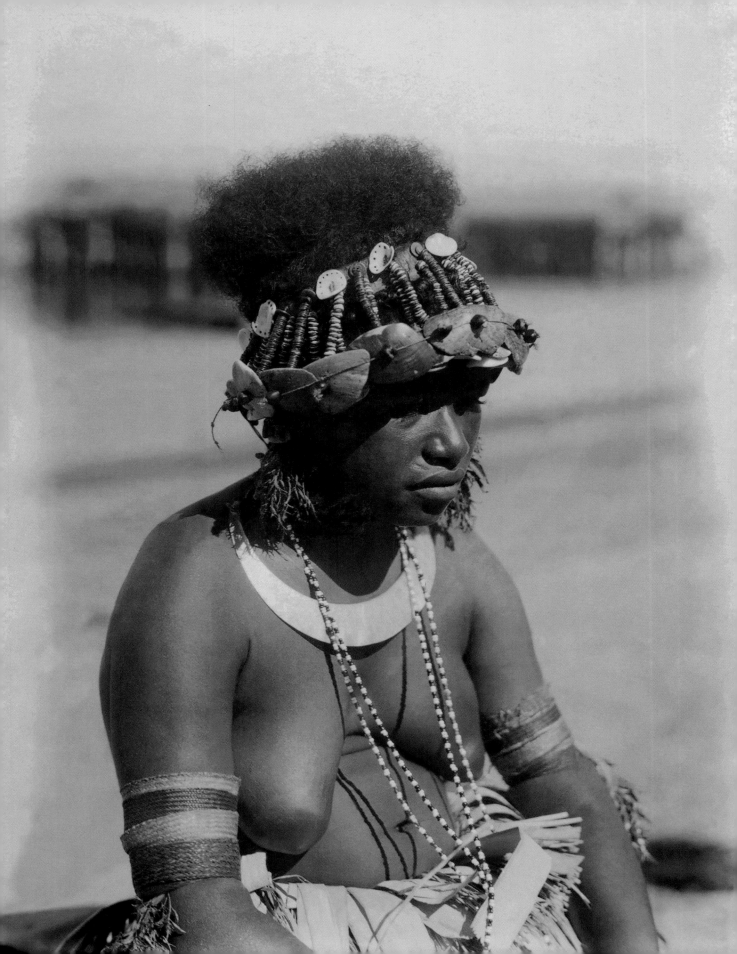

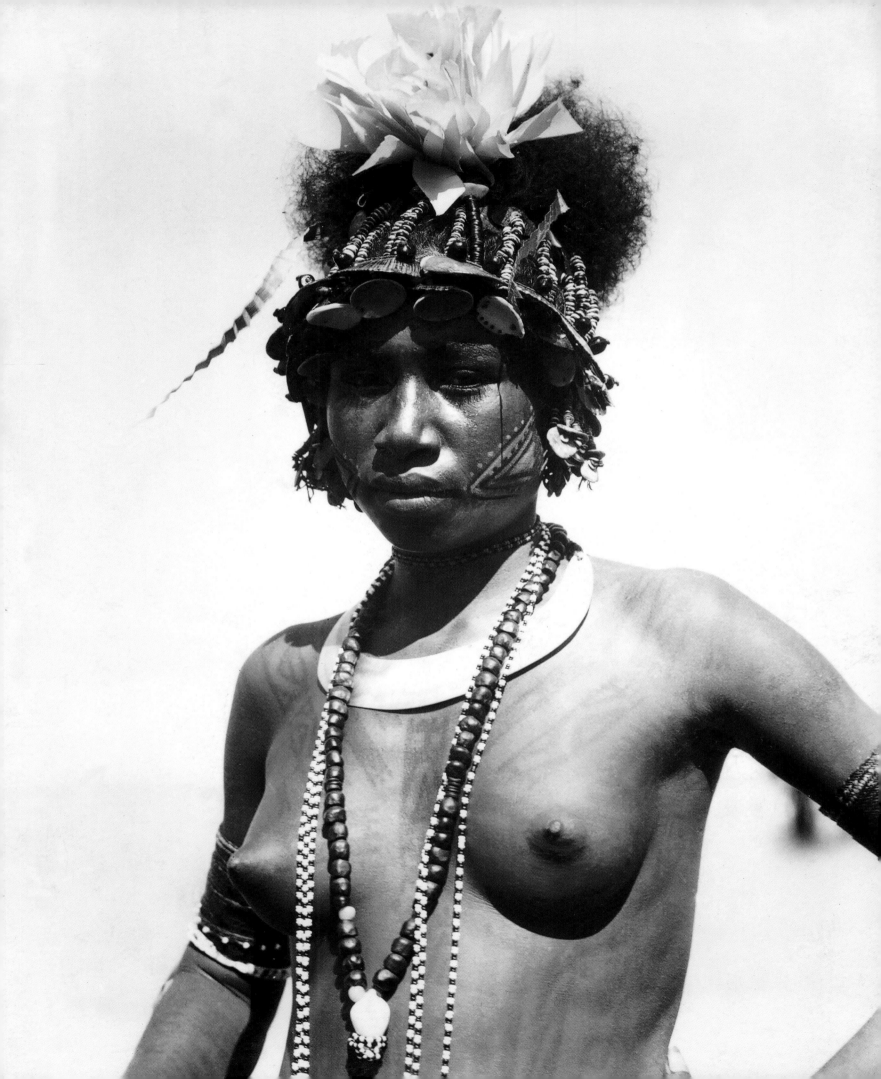

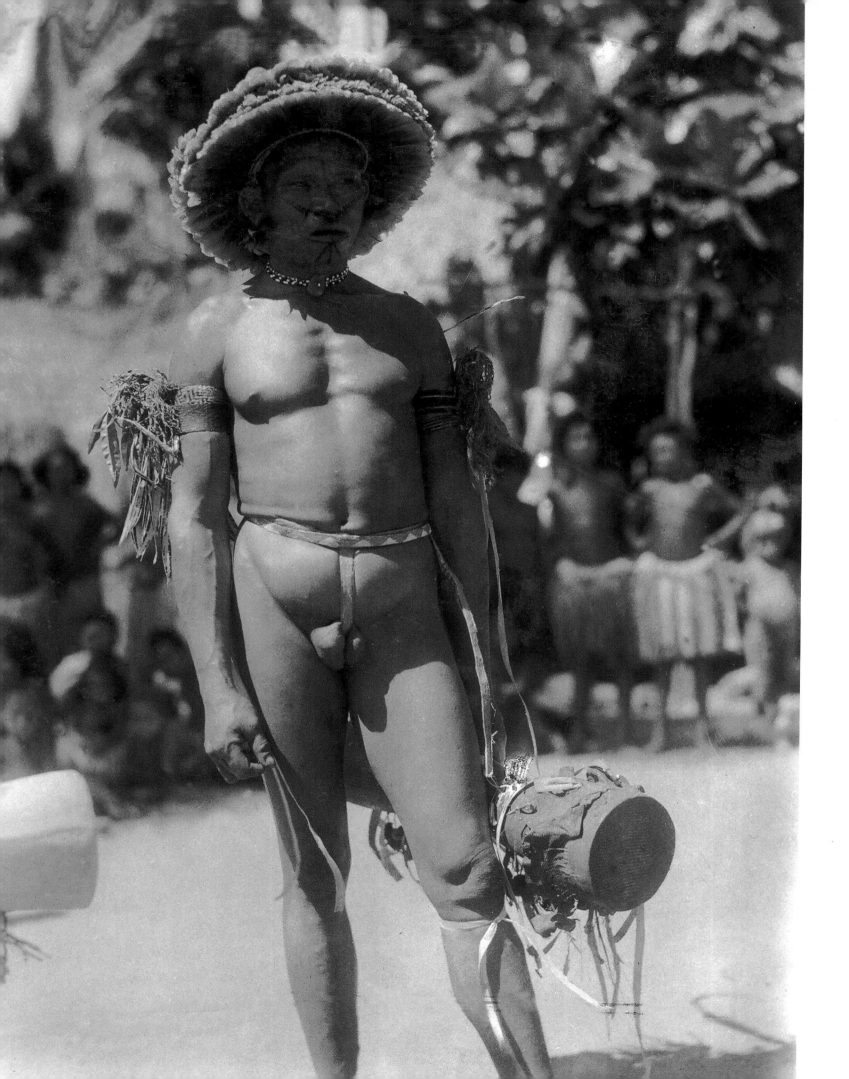

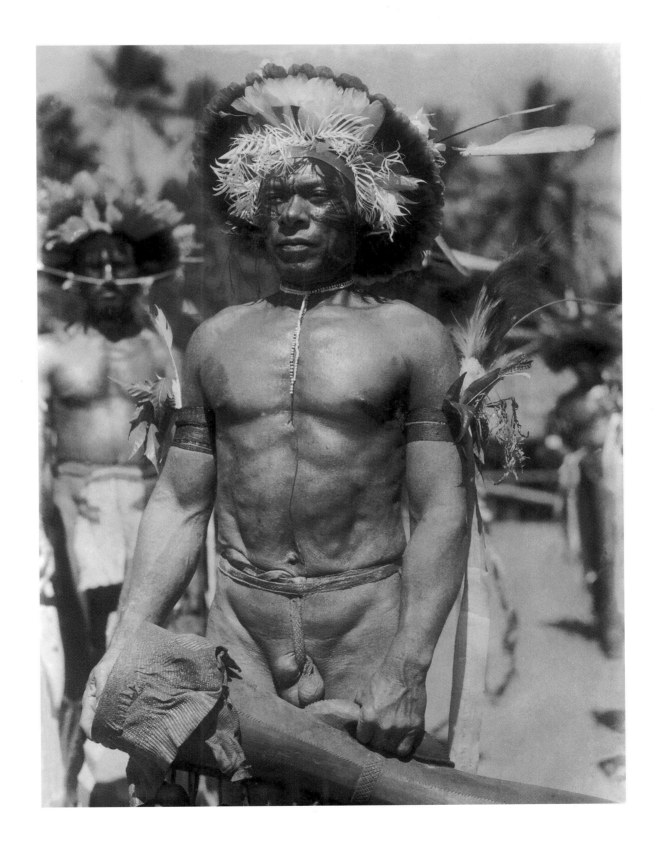

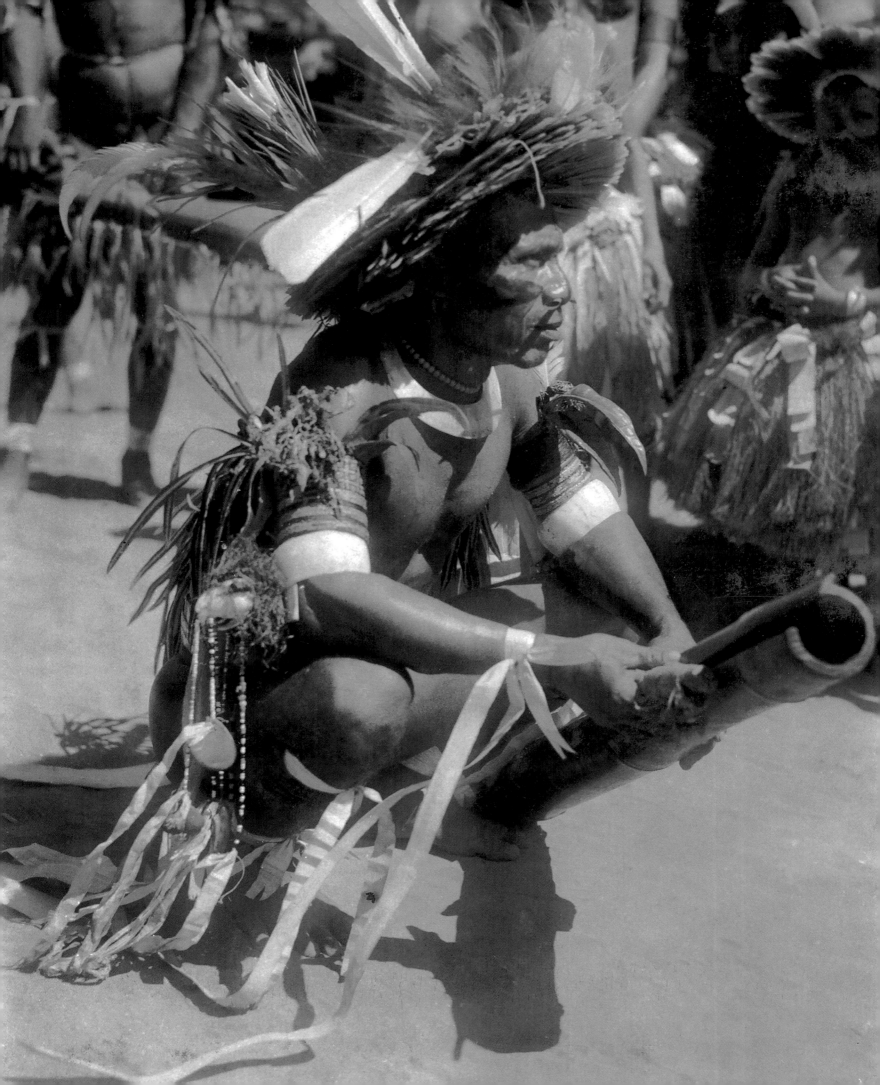

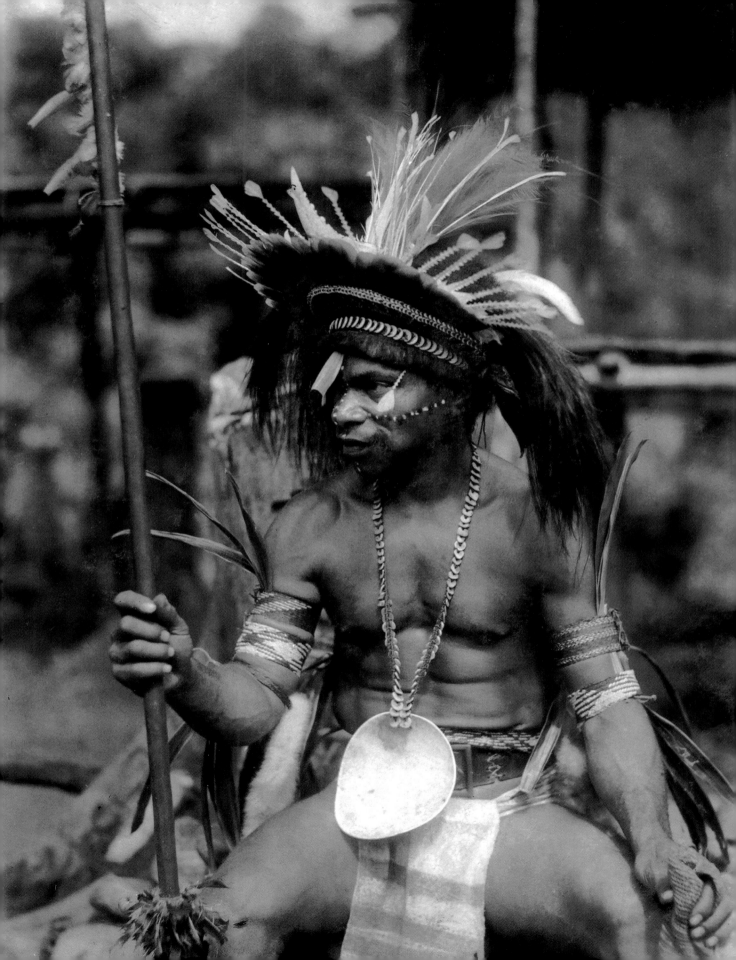

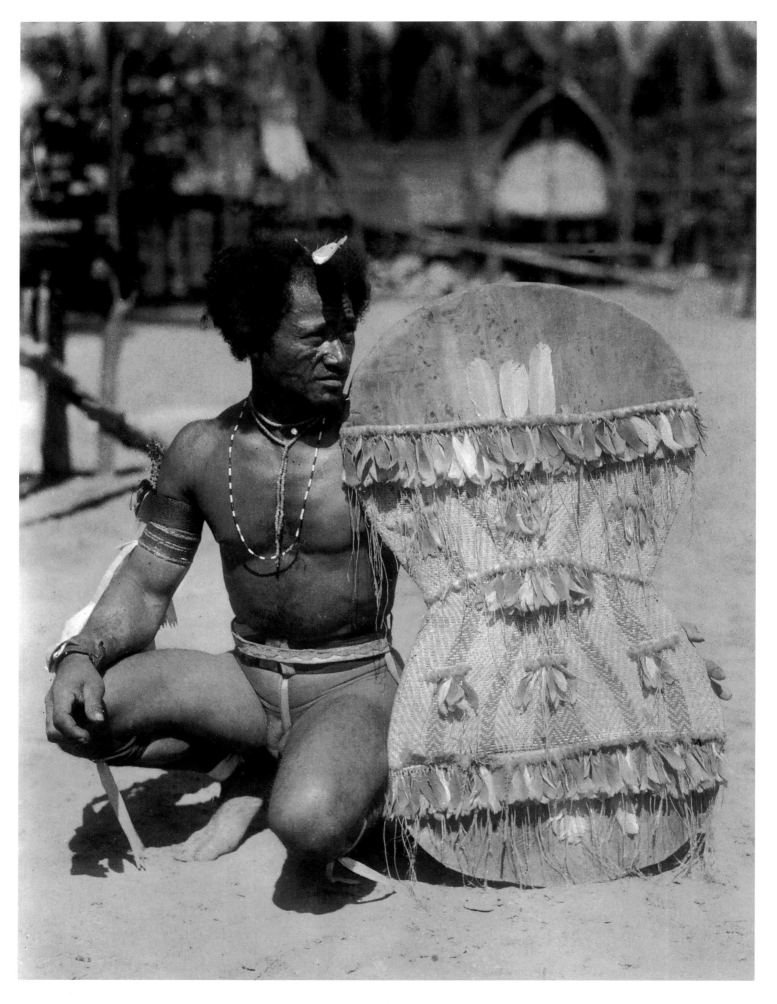

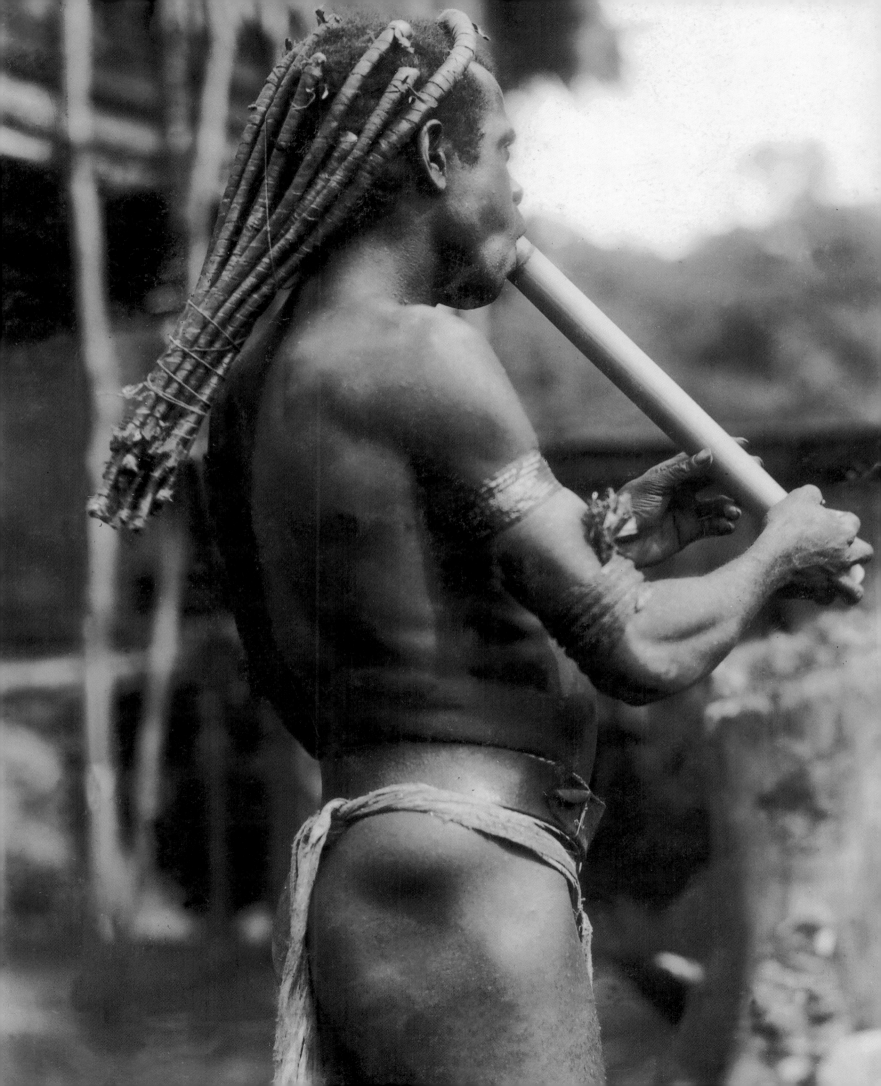

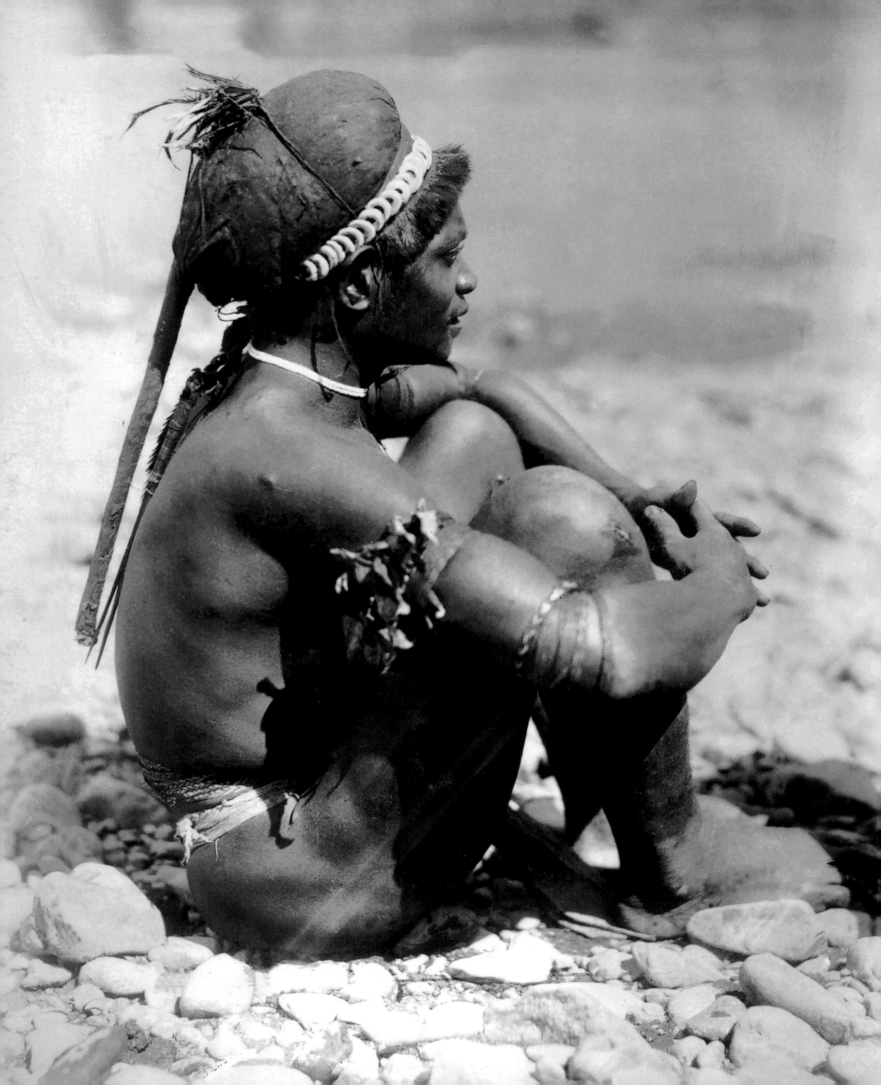

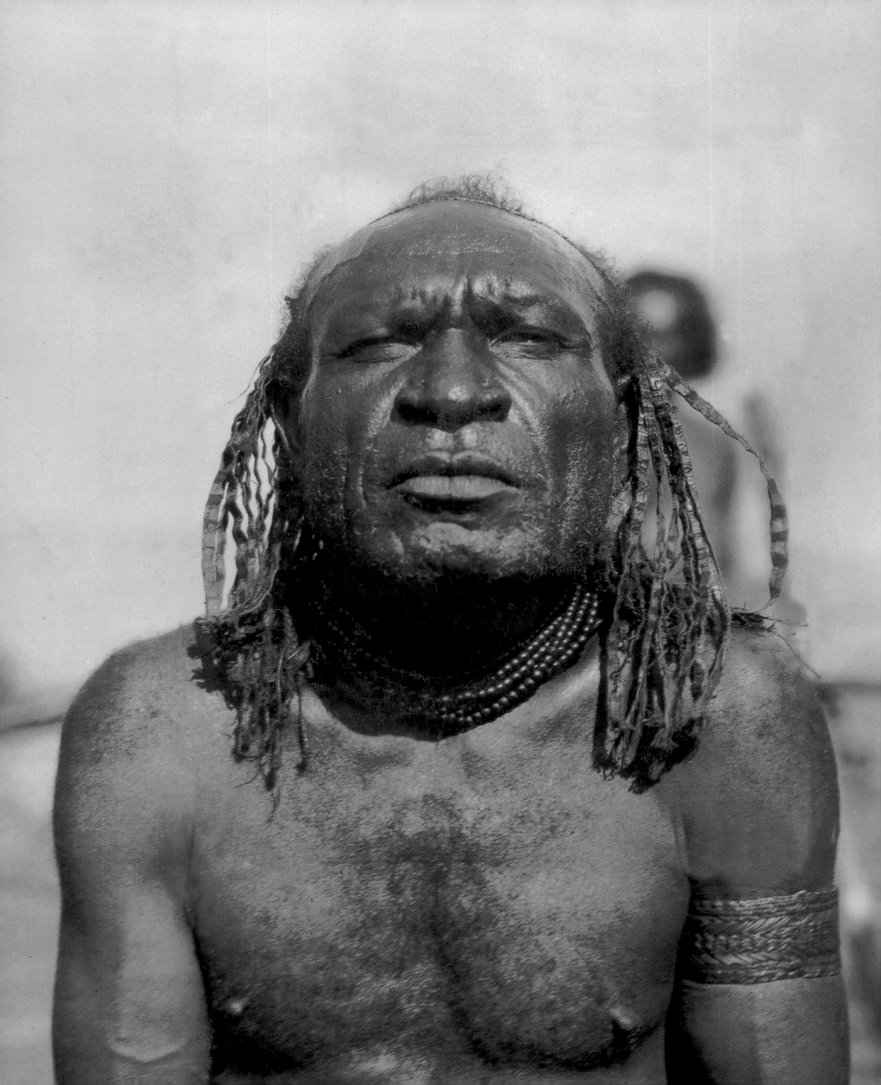

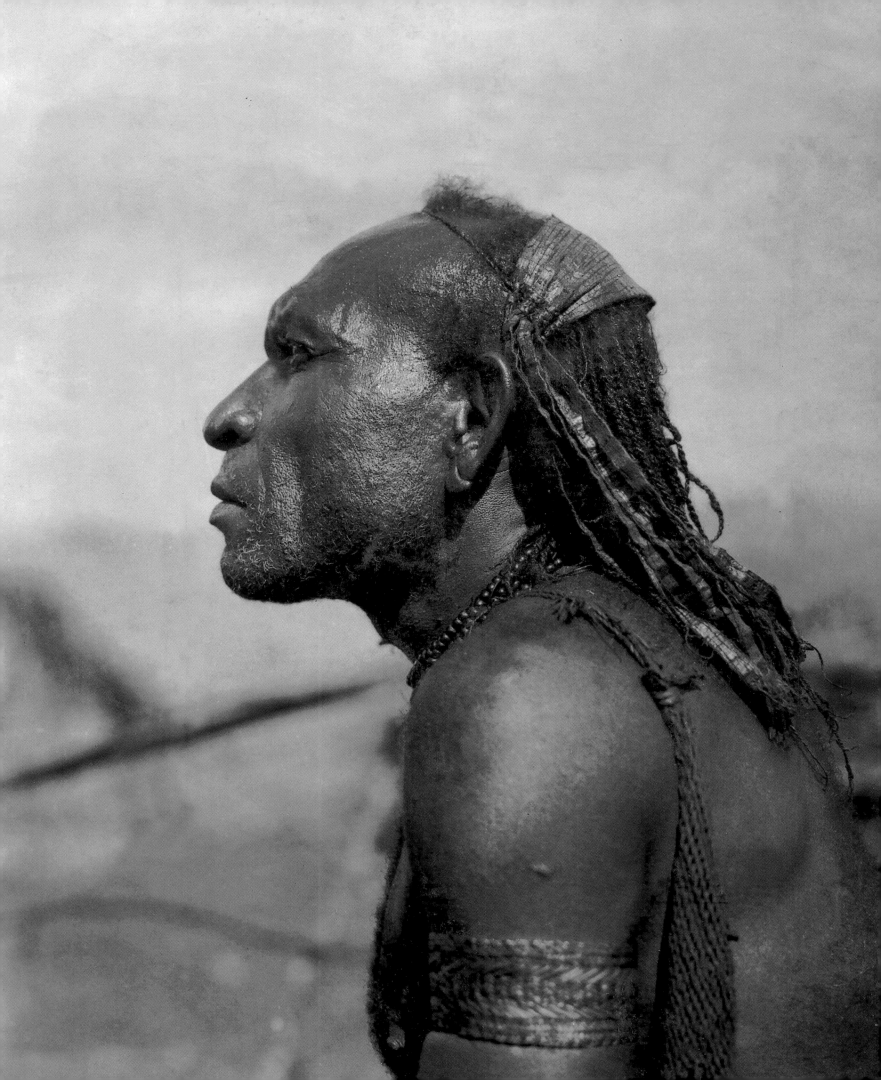

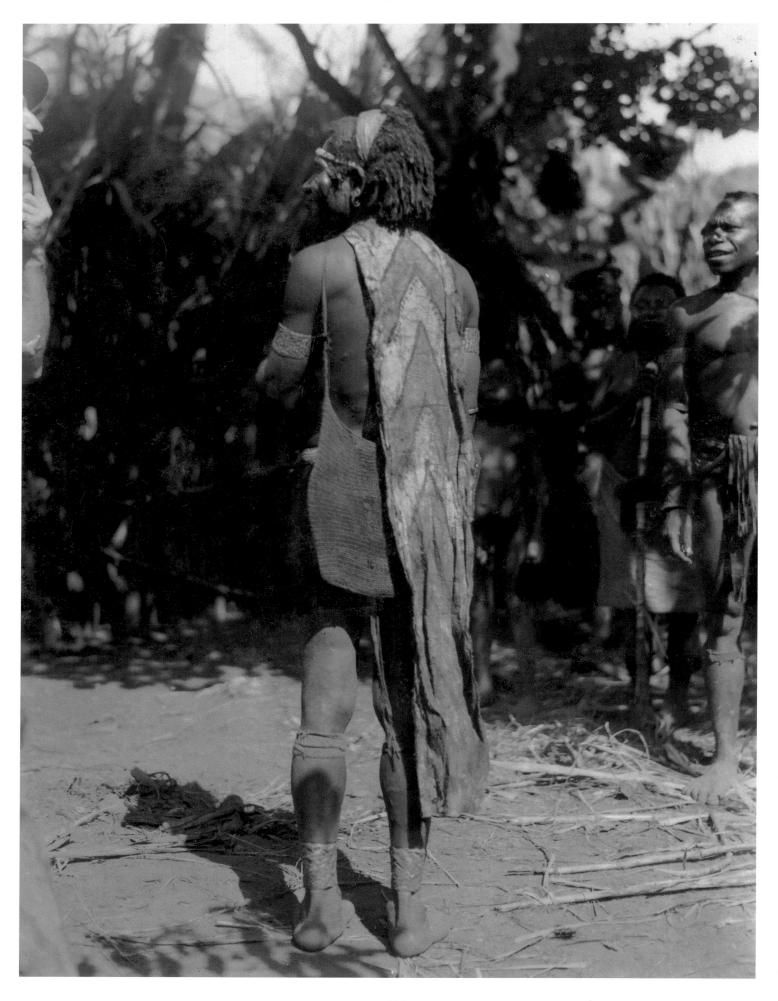

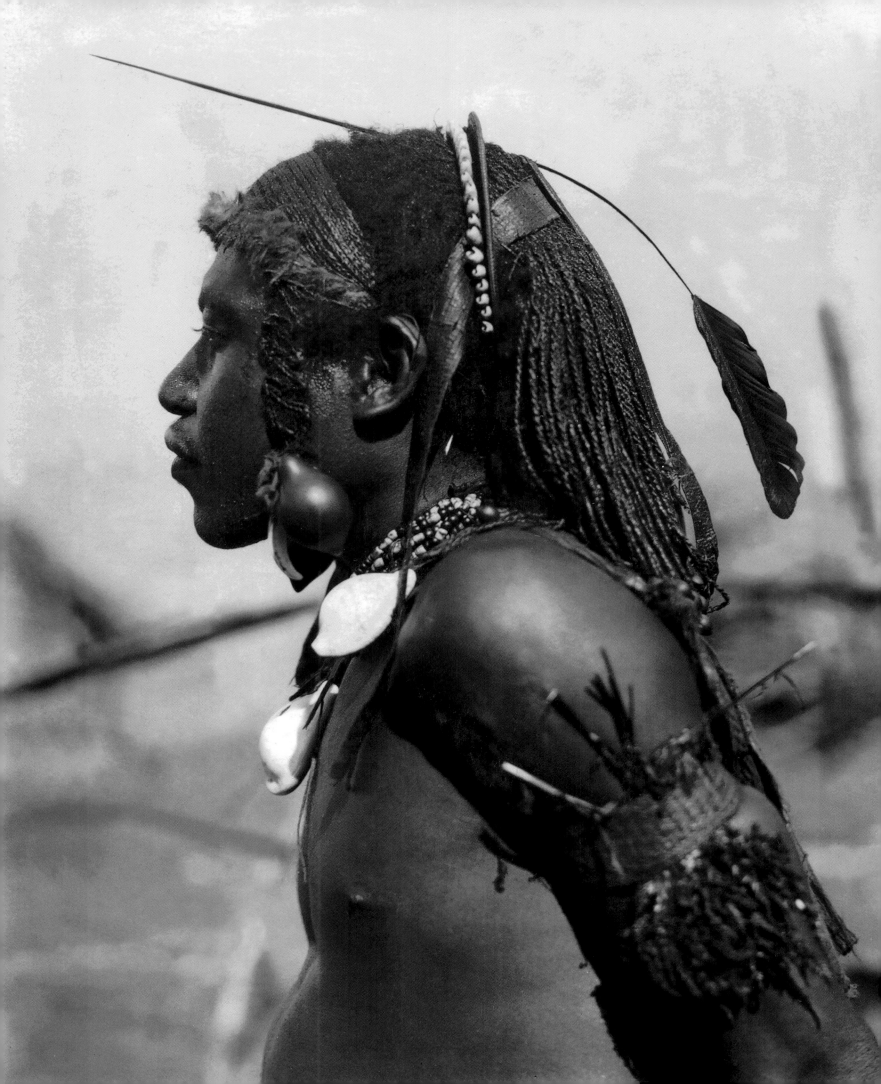

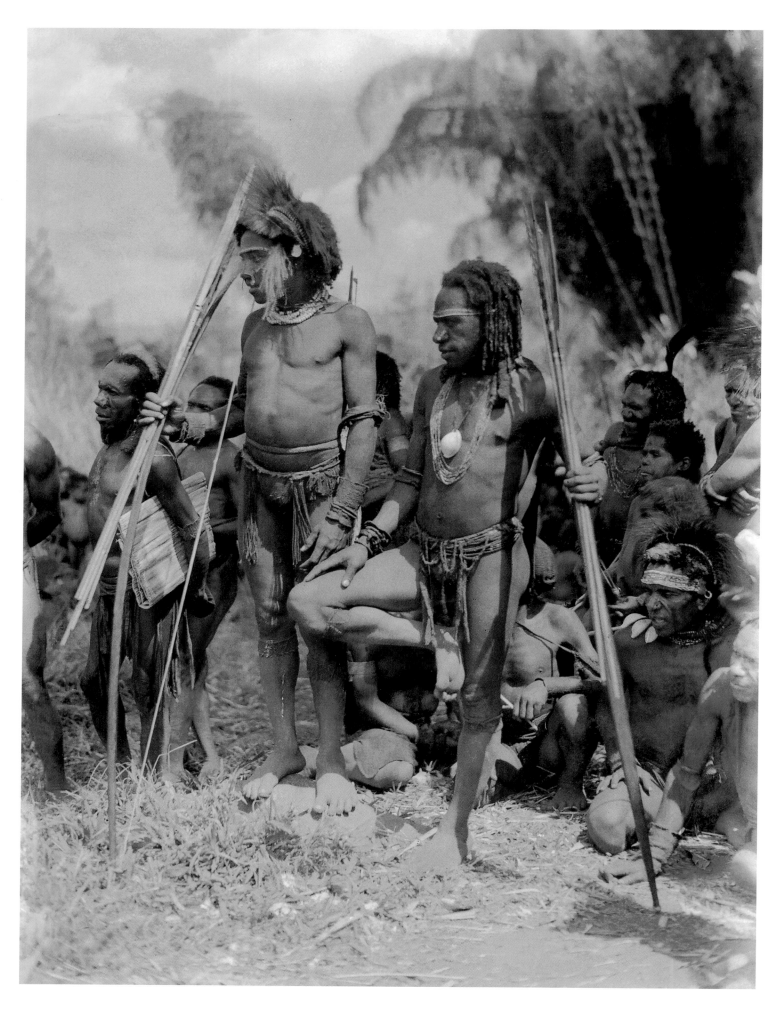

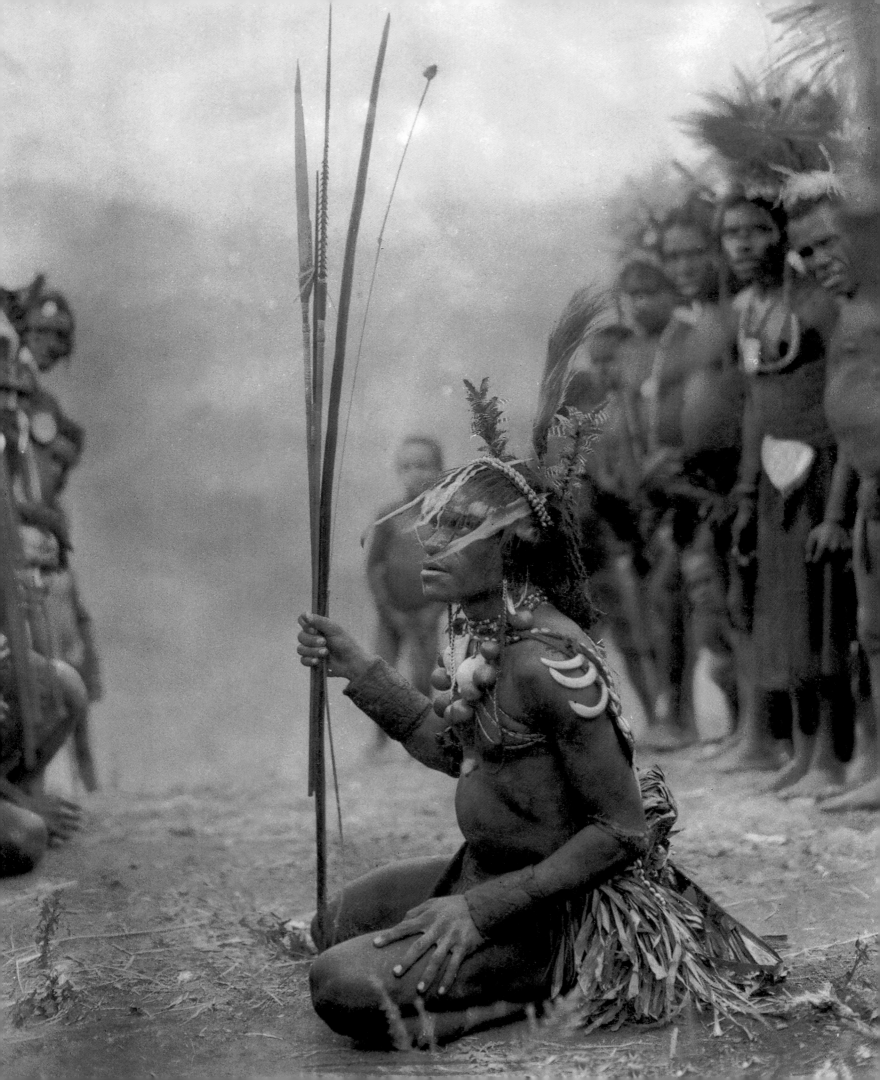

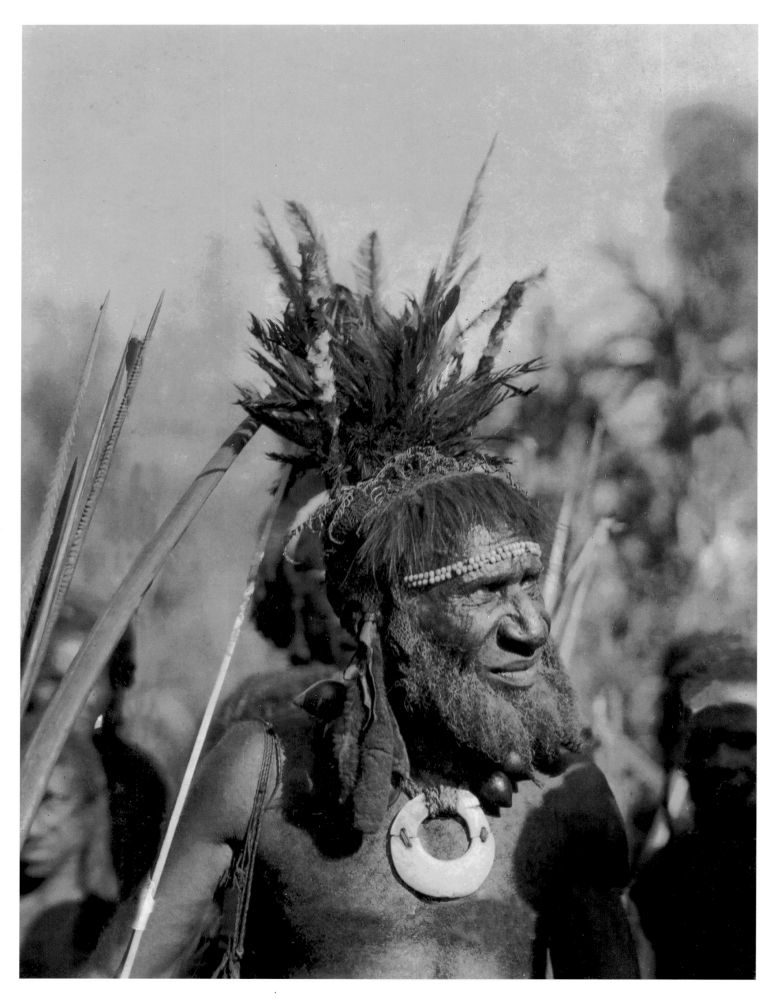

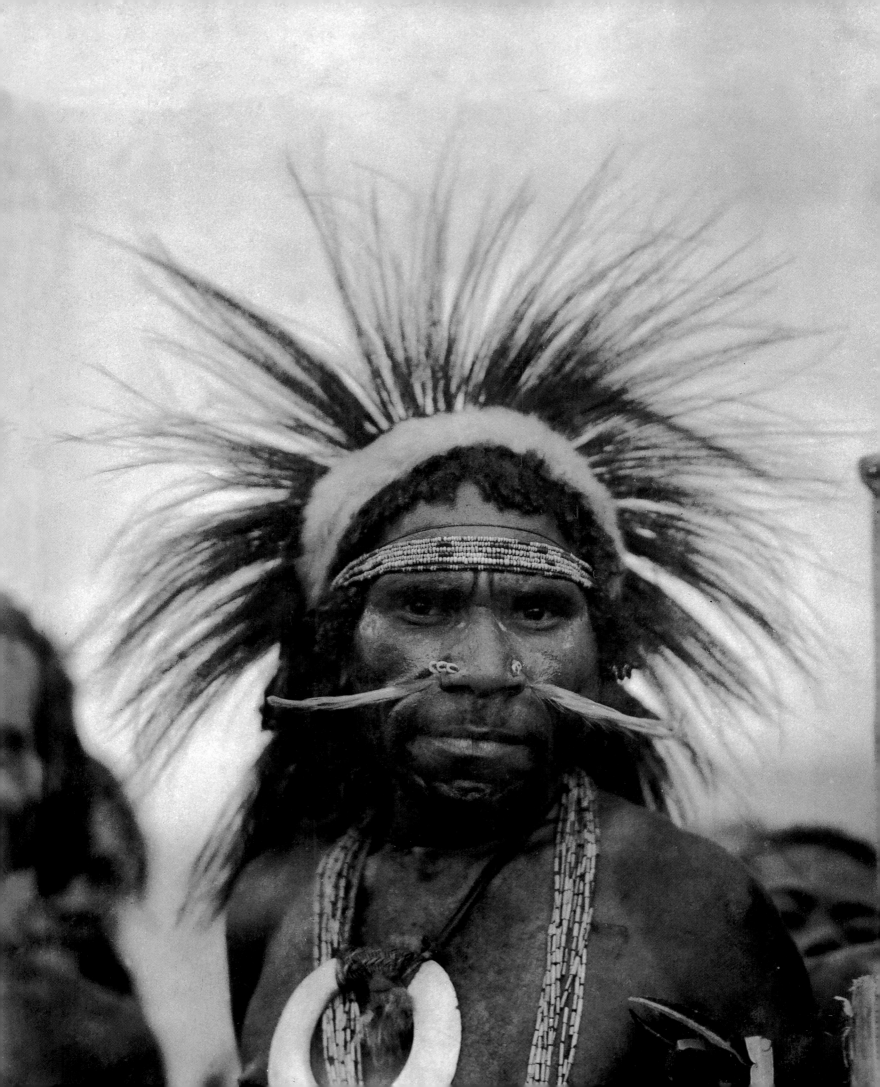

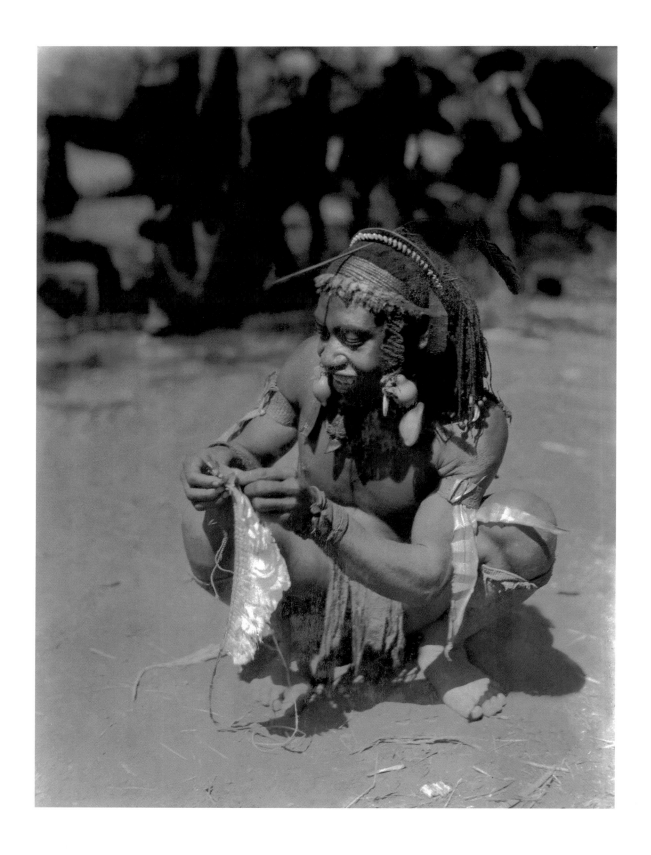

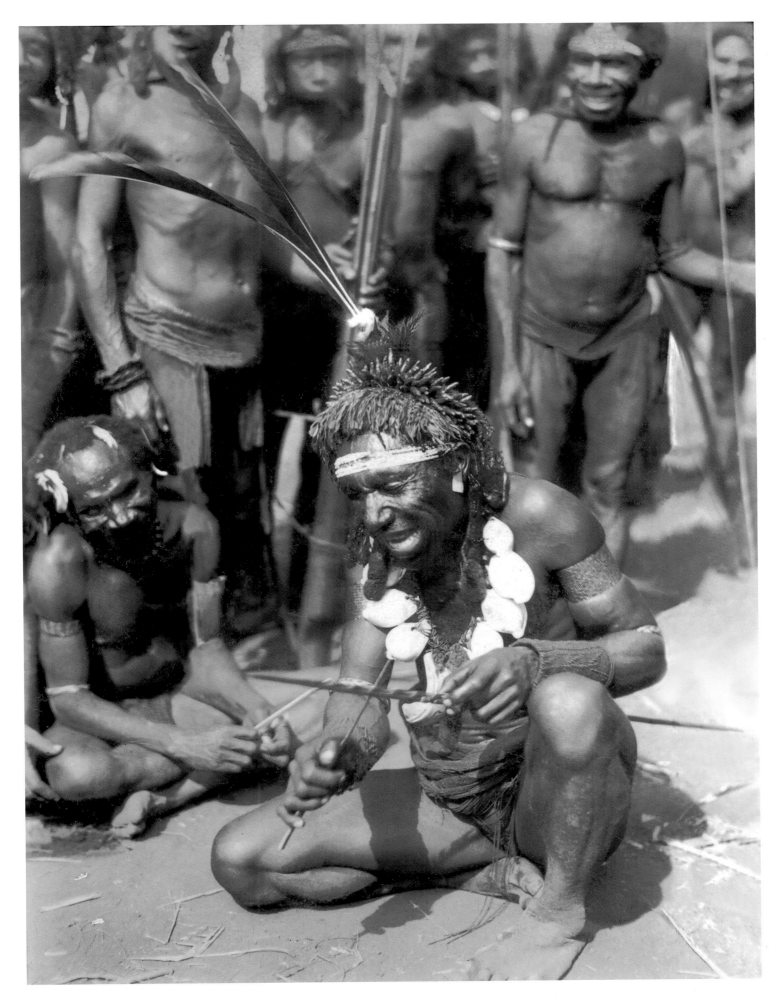

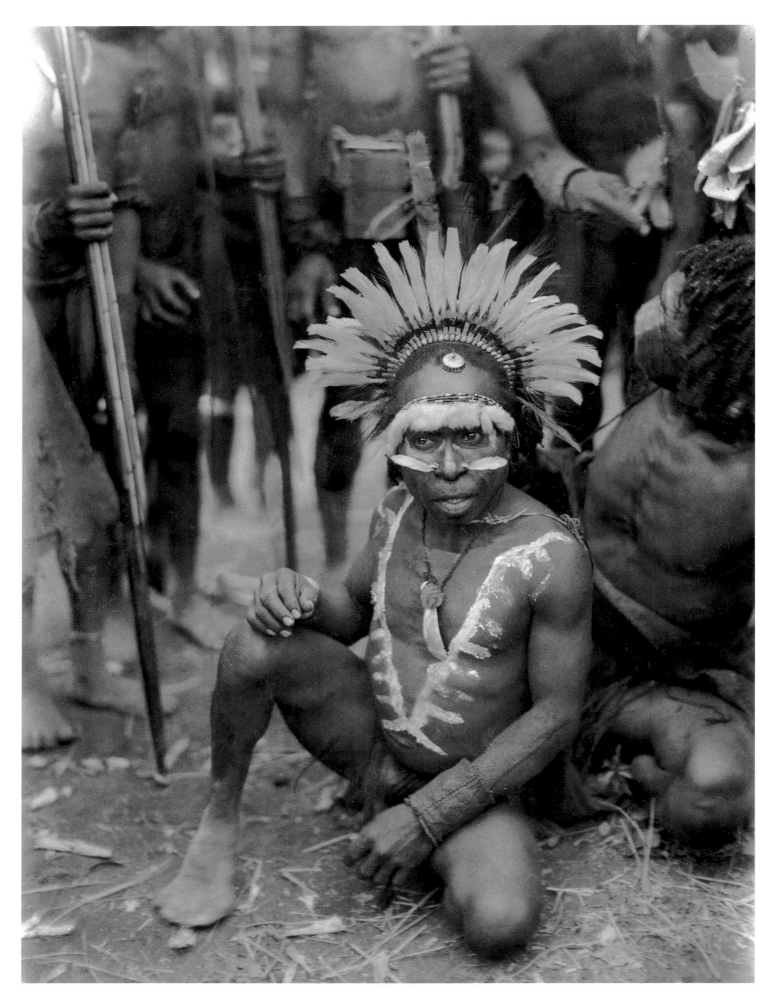

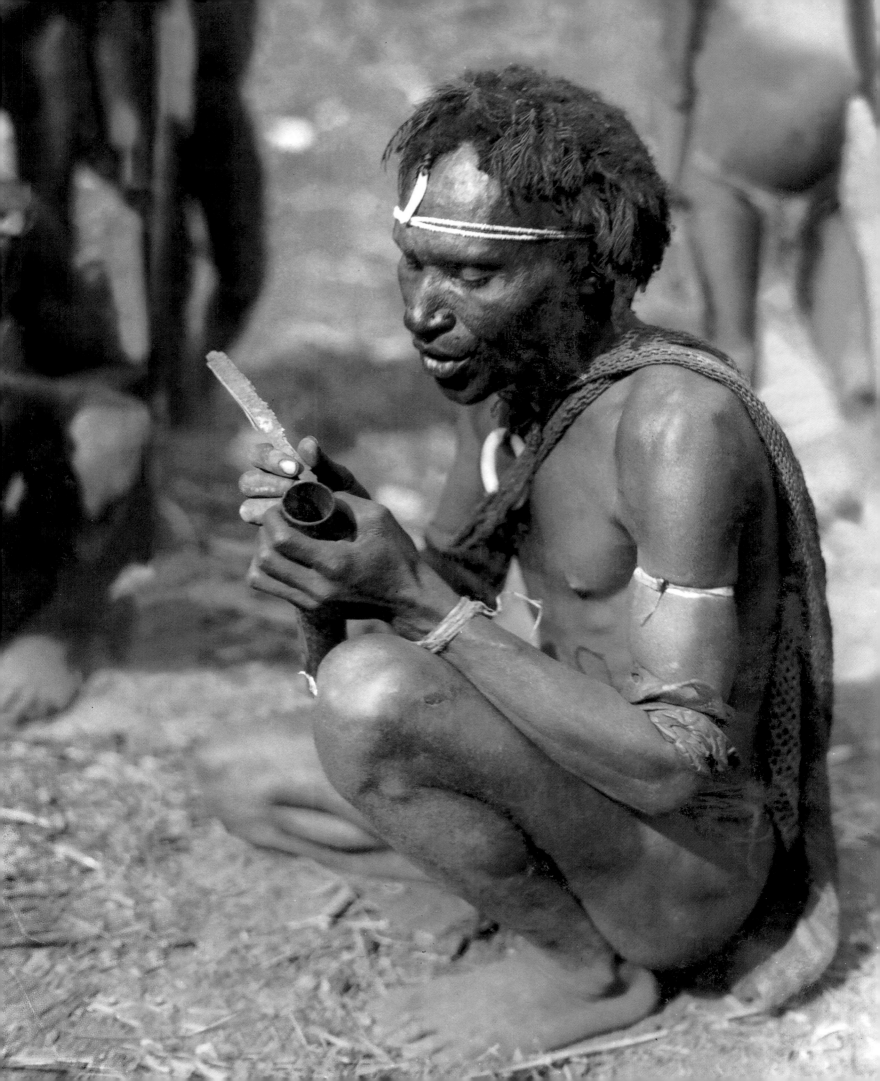

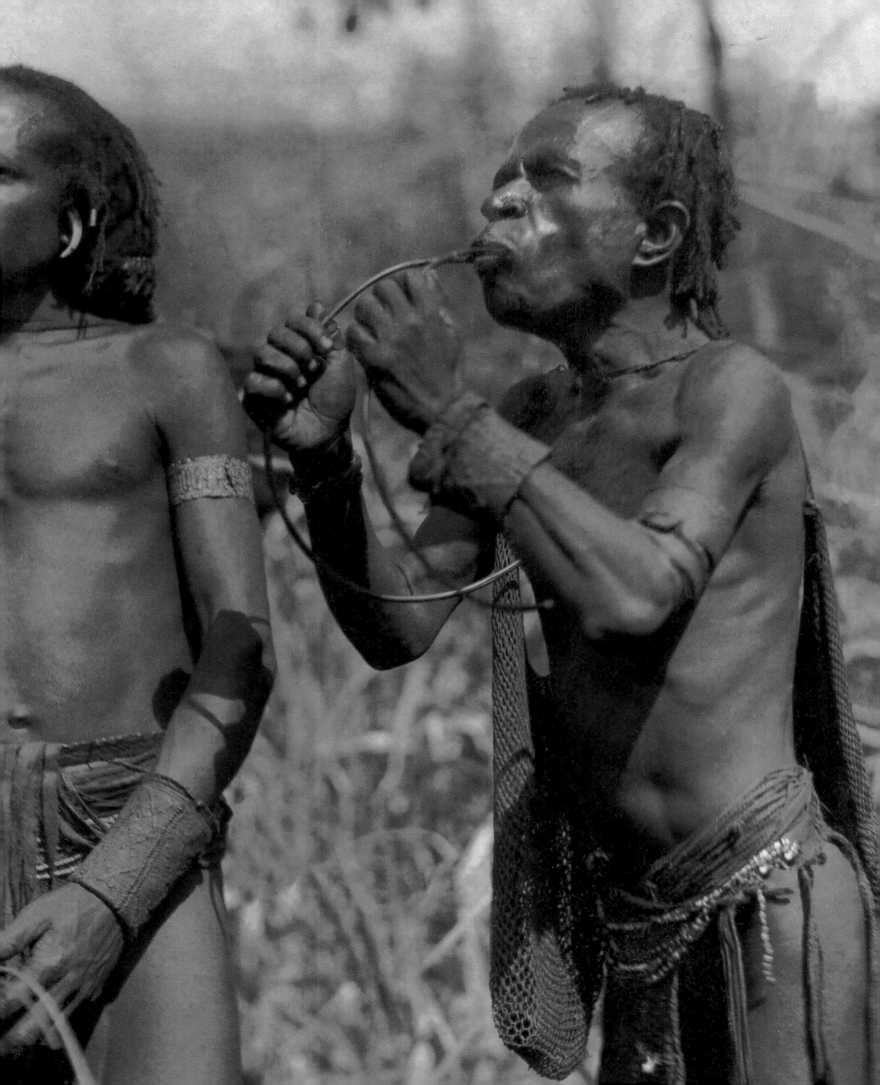

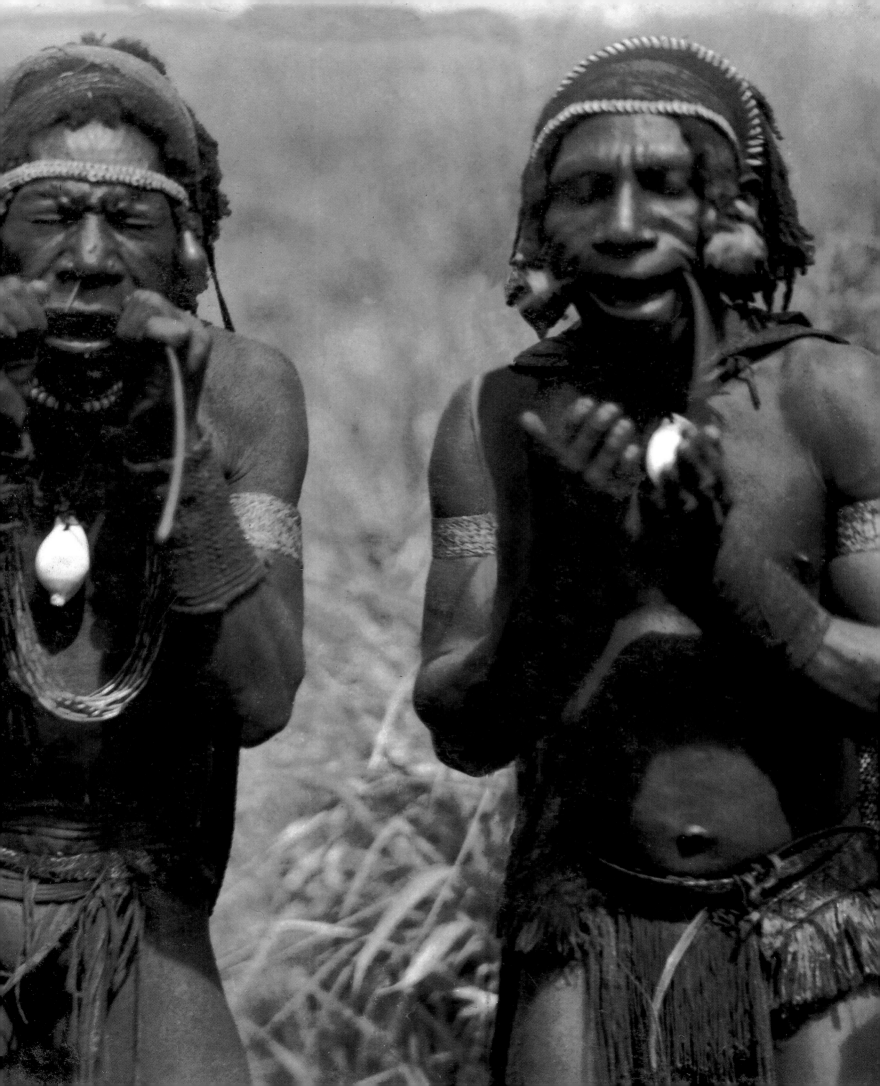

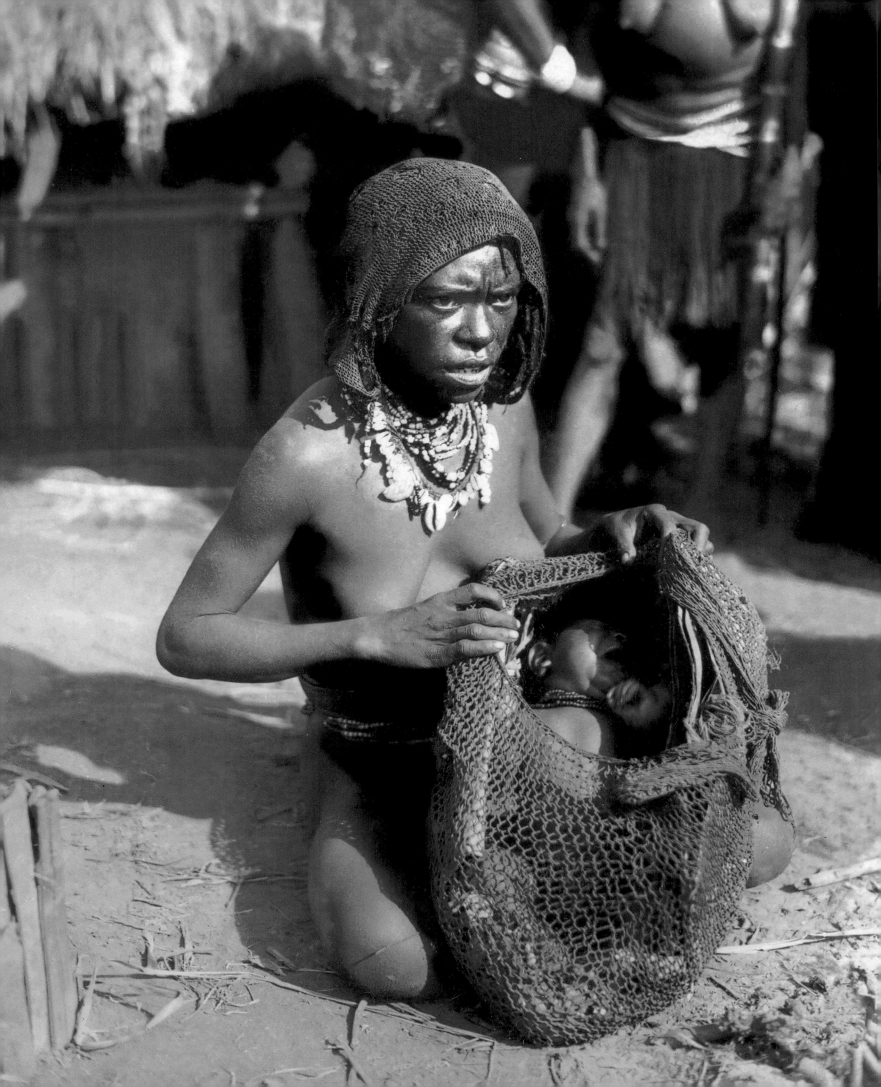

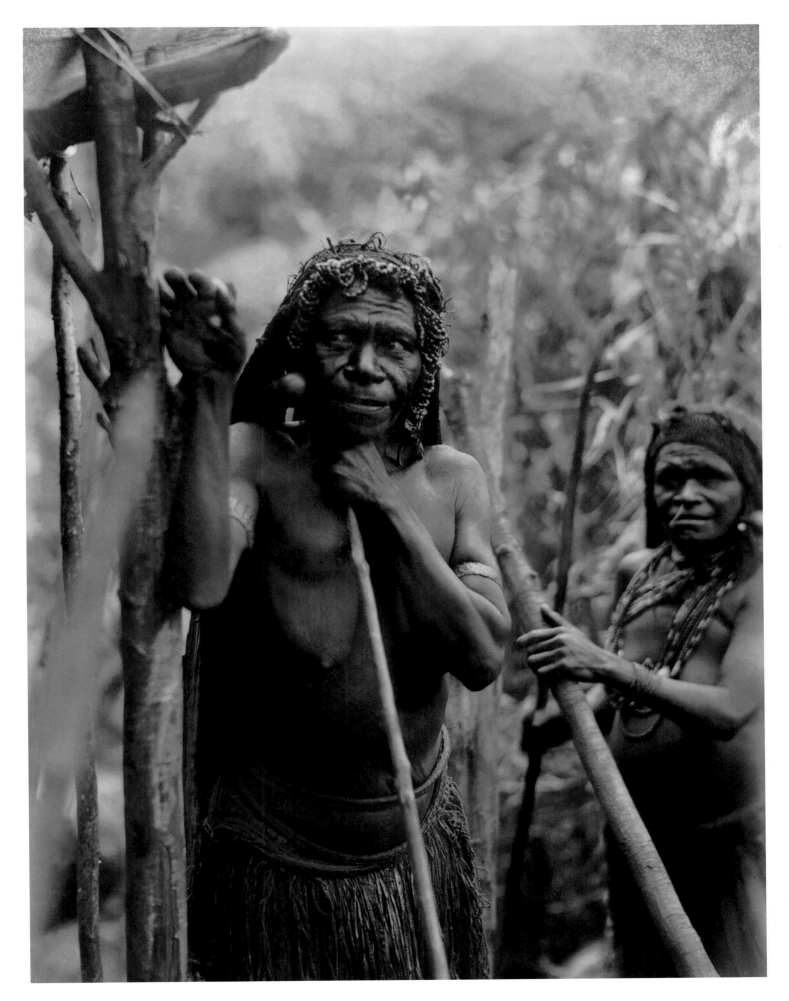

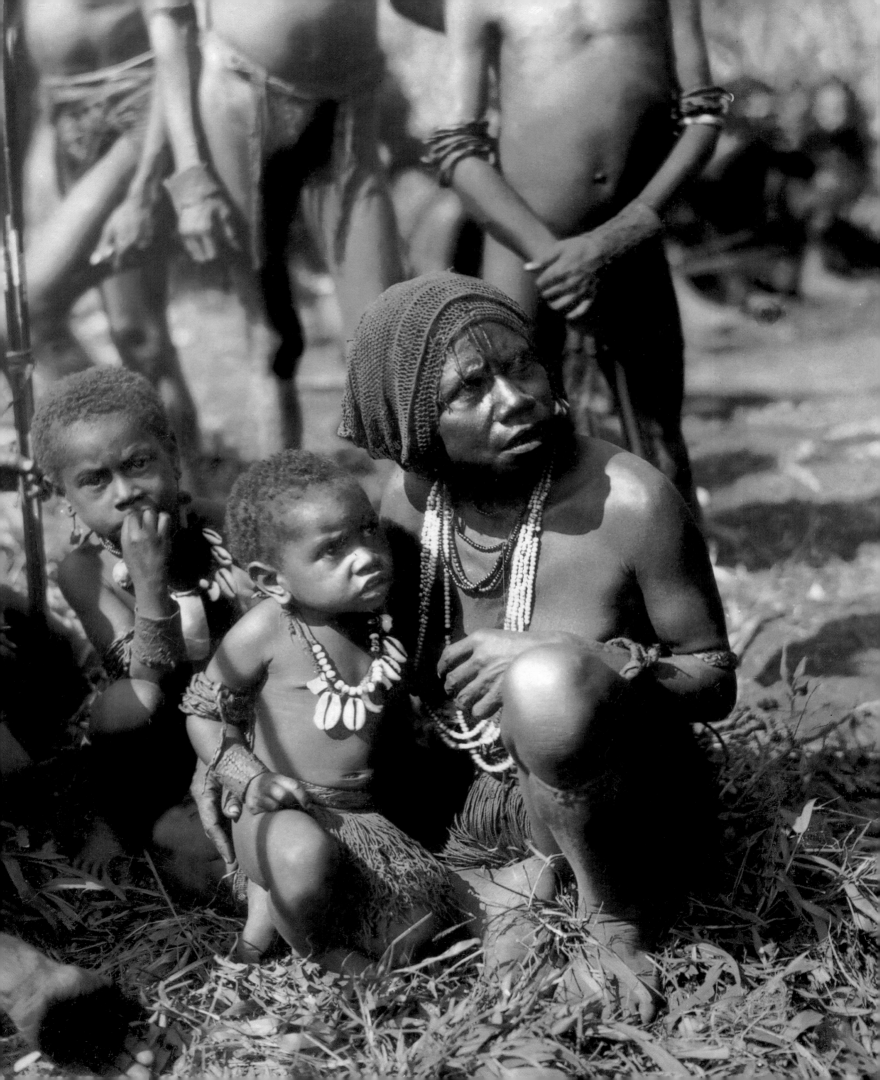

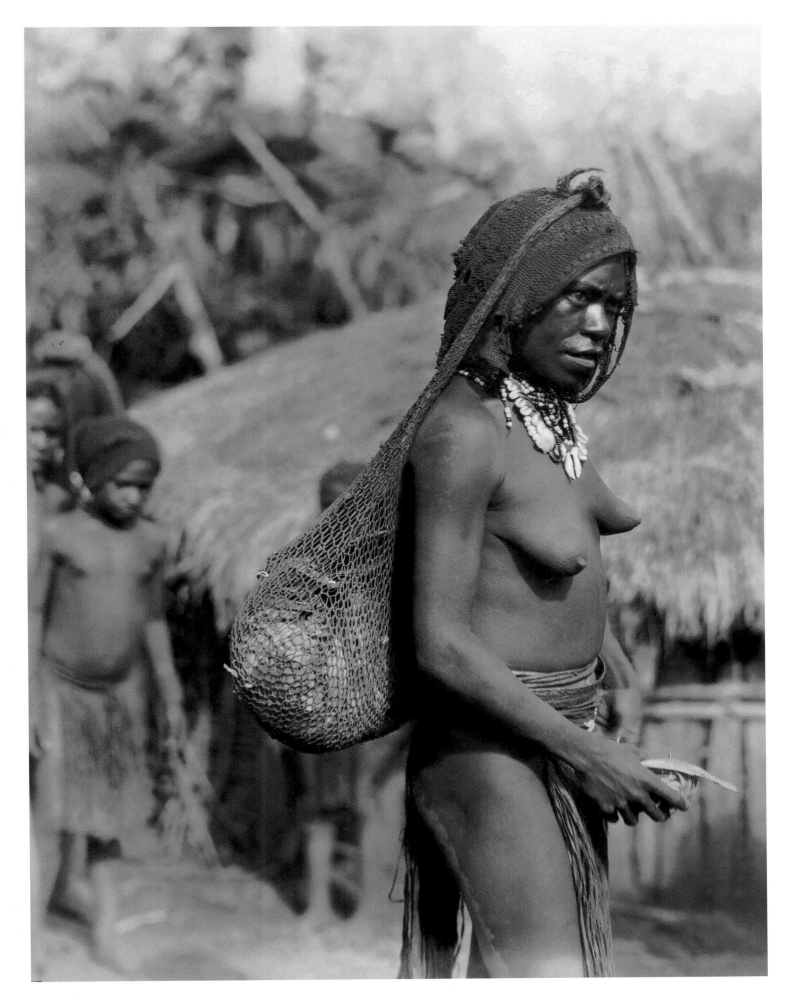

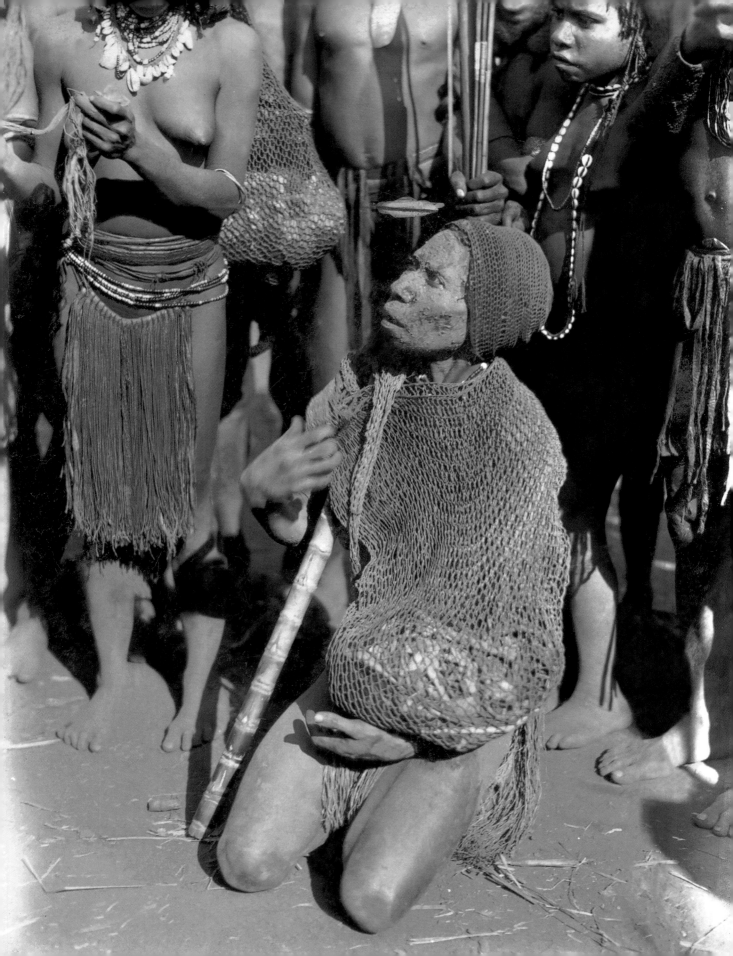

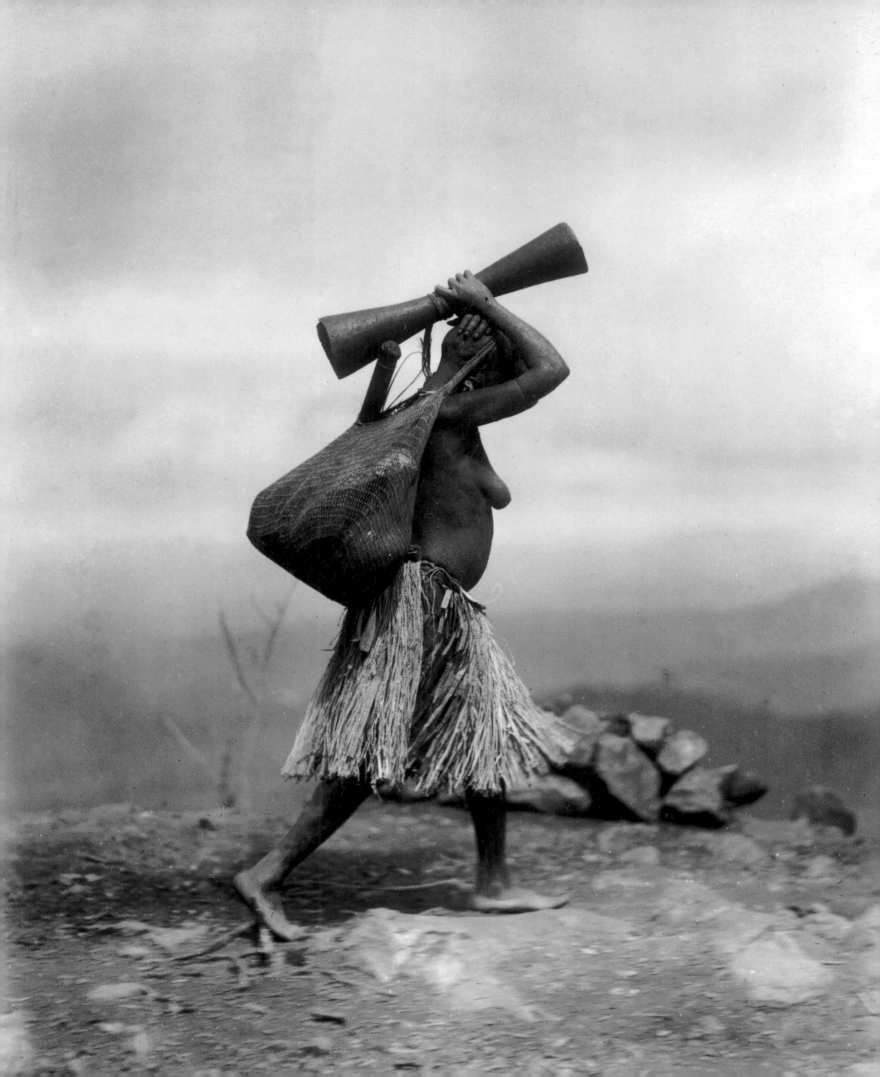

Notes to the Reader
Publishing information for each
photograph is provided in parentheses.
This information is not meant to be
definitive, that is, these photographs
may (and likely do) appear in
publications beyond those cited
here. When the photograph is not
known to have been published, the
abbreviation "n.p." (no publisher) is
used.

LIST OF ILLUSTRATIONS

X507

Warriors carrying spears and parrying shields, and wearing large discs of mother-of-pearl around their necks. Owa Raha Island. (H. Bernatzik, *Südsee*, 1934, pl. 29; 1944, 1960, pl. 30)

X808

Warriors squatting with parrying shields and spears. Gupuna Village, Owa Raha Island. (H. Bernatzik, *Owa Raha*, 1936, pl. 133)

X509

Three decorated warriors simulating a spear attack, performing at Albert Küper's initiation. Gupuna Village, Owa Raha Island. (n.p.)

X832

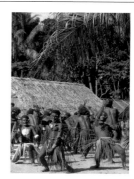

A group of men performing the shark and frigate bird dance. The men imitate the graceful swooping movements of the frigate bird. Owa Riki Island. (n.p.)

X840

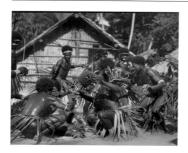

Shark and frigate bird dancers. Owa Riki Island. (n.p.)

X839

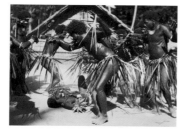

A man on the ground representing the prey of the encircling frigate birds. Owa Riki Island. (H. Bernatzik, *Südsee*, 1944, 1949, 1960, pl. 32; T. Theye, *Der geraubte Schatten*, p. 153)

X1042

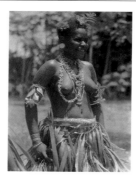

A dancing girl wearing foliate ornaments. Solomon Islands. (n.p.)

X445

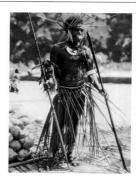

A chiefly warrior in festival costume, carrying weapons and wearing a crescent-shaped shell gorget (*tafi boni*). Gupuna Village, Owa Raha Island. (H. Bernatzik, *Owa Raha*, 1936, pl. 125)

X465

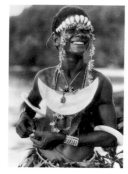

Portrait of Charlie Küper. Gupuna Village, Owa Raha Island. (n.p.)

X466

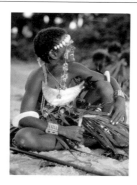

Portrait of Charlie Küper. Gupuna Village, Owa Raha Island. (H. Bernatzik, *Südsee*, 1935, pl.1; 1944, 1949, 1960, pl. 12; D. Byer, *Die Große Insel*, 1996, p. 216; T. Theye, *Der geraubte Schatten*, 1989, p. 144)

X375

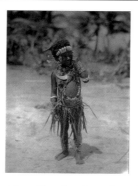

Albert Taro, brother of Jacob Siapu, wearing a comb and body decoration for the boy's initiation ceremony. Gupuna village, Owa Raha Island. (D. Byer, *Die Große Insel*, 1996, p. 289; T. Theye, *Der geraubte Schatten*, 1989, p. 145)

X394

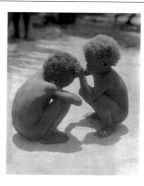

Two young boys cleaning each other's hair. Owa Raha Island. (H. Bernatzik, *Südsee*, 1944, 1960 pl. 9)

X144

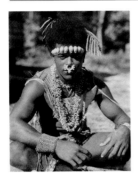

A seated youth wearing a full set of shell body ornaments. His *tridacna-*shell nose ornament denotes high rank. Gupuna Village, Owa Raha Island. (H. Bernatzik *Owa Raha*, 1936, pl. 13)

X300

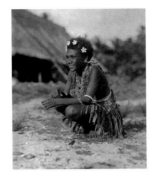

Young woman in festive attire, wearing shell-bead girdles, a nose ornament and hibiscus flowers in her hair. Nafinuatogo Village, Owa Raha Island. (D. Byer, *Die Große Insel*, p. 325)

X161

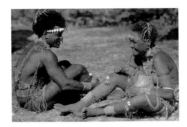

A seated betrothed couple wearing their festive costumes. Gupuna Village, Owa Raha Island. (H. Bernatzik, *Südsee*, 1934, pl. 3)

X180

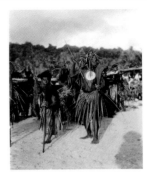

A group of warriors in dance costume carrying parrying shields. One chiefly individual wearing a circular shell ornament (*tema*). Solomon Islands. (n.p.)

X494

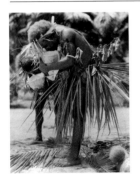

A youth in regalia blowing a conch shell trumpet at the beginning of the frigate bird dance. Owa Raha Island. (H. Bernatzik, *Südsee*, 1935, pl. 25; 1944, 1960, pl. 26)

X192

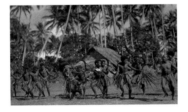

A dance for the bonito canoe initiation. Nafinuatogo Village, Owa Raha Island. (H. Bernatzik, *Owa Raha*, 1936, pl. 52)

X530

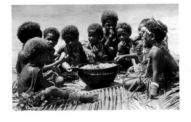

Children eating *susugu* (coconut milk with roasted taro) from a shell-inlaid ceremonial dish at Albert Küper's initiation. Gupuna Village, Owa Raha Island. (H. Bernatzik, *Südsee*, 1934, pl. 1)

X653

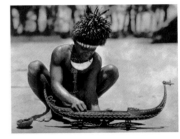

A replica of a sacred bonito canoe used as a personal feast bowl. Rich in mother-of-pearl inlay, it is supported by two stylised fish. Owa Riki Island. (H. Bernatzik, *Owa Raha*, 1936, pl. 26)

X855

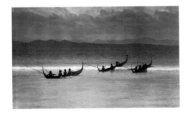

Five sacred bonito canoes breaking through the surf, departing to hunt the sacred bonito fish at the priest' surging. Natagera Village, Owa Raha Island. (H. Bernatzik, *Südsee*, 1935, pl. 30; 1944, 1960, pl. 3i)

X545

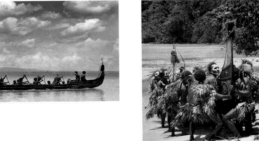

A large seagoing war canoe with festive decoration, carrying fourteen sailors. Natagera Village, Owa Raha Island. (D. Byer, *Die Große Insel*, 1996, p. 75)

X563

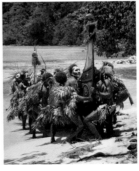

The guests of the initiation festival bringing the sacred bonito canoe to the ocean. Gupuna village, Owa Raha Island. (H. Bernatzik, *Südsee*, 1934, pl. 12)

X534

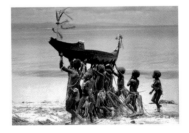

Young boys carrying a bonito initiation canoe. Gupuna Village, Owa Raha Island. (H. Bernatzik, *Südsee*, 1934, pl. 2)

X695

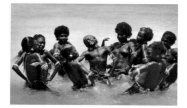

Girls playing in the ocean. Owa Riki Island. (H. Bernatzik, *Südsee*, 1934, pl. 22; D. Byer, *Fremde Frauen*, 1985, pp. 146, 147)

X768

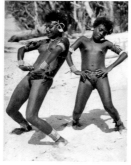

Two girls performing an erotic dance. Owa Riki Island. (H. Bernatzik, *Südsee*, 1944, 1949, 1960, pl. 11; D. Byer, *Fremde Frauen*, 1985, p. 158; *Die Große Insel*, 1996, p. 320)

X771

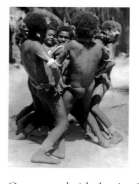

Ornamented girls dancing in a circle. Mamako Village, Owa Riki Island. (H. Bernatzik, *Owa Raha*, 1936, pl. 151; *Südsee*, 1935, frontispiece, 1944, 1960, pl. 1; D. Byer, *Fremde Frauen*, 1985, p. 158)

X918

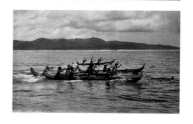

Four canoes in pursuit of the sea turtle. Makira Island. (H. Bernatzik, *Südsee*, 1935, 1944, 1949, 1960, pl. 36; D. Byer, *Die Große Insel*, p. 81)

X937

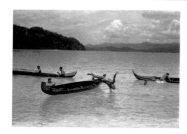

A man, Mattes Mafuara, diving into the sea after the turtle. Makira Island. (H. Bernatzik, *Owa Raha*, 1936, pl. 129)

X935

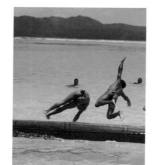

Four men jump overboard after the turtle. Makira Island. (H. Bernatzik, *Südsee*, 1935, pl. 36; 1944, pl. 37; 1949, 1960, pl. 37; D. Byer, *Die Große Insel*, p. 81)

X944

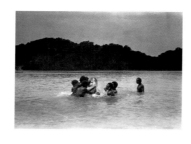

Men capturing a sea turtle. Makira Island. (n.p.)

X978

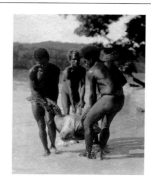

Four men carrying the turtle to land. Makira Island. (H. Bernatzik, *Südsee*, 1935, pl. 38; 1944, pl. 40; 1960, pl. 39)

X985

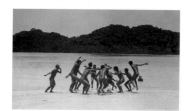

The triumphant hunters perform a celebratory dance around the captured turtle. Makira Island. (H. Bernatzik, *Südsee*, 1935, pl. 39; 1944, 1960, pl. 40)

X995

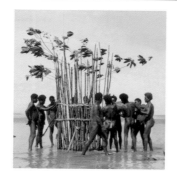

The turtle is placed in the enclosure. Makira Island. (H. Bernatzik, *Owa Raha*, 1936, pl. 122)

X997

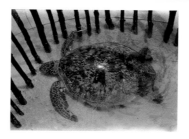

The captured turtle in a mangrove pole enclosure. Makira Island. (n.p.)

X846

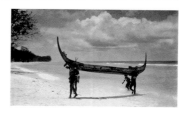

Four men carrying a decorated bonito canoe. Mamako Village. (H. Bernatzik, *Owa Raha*, 1936, pl. 21)

X1195

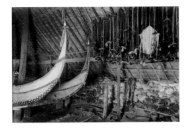

Canoe house, *aofa*, with bonito canoes decorated with mother-of-pearl inlay. The skeletons of the sacred bonito hang nearby. Ngora-Ngora Village, Ulawa Island. (H. Bernatzik, *Südsee*, 1935, pl. 23; 1944, 1960, pl. 24)

X1083

Sacred bonito fish reliquaries in a canoe house. Tavearoga Village, southeast Makira Island. (n.p.)

X1063

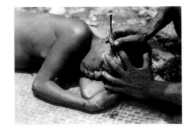

A young boy being *sege-sege* tattooed. Funukuma Village, Makira Island. (H. Bernatzik, *Südsee*, 1935, 1944, 1949, 1960, pl. 8)

X1069

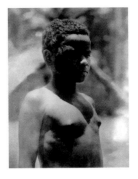

Portrait of a young boy with fresh *sege-sege* tattooing. Funukuma Village, Makira Island. (n.p.)

X1176

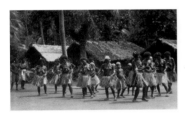

Female dancers at an ancestor commemoration ceremony marking the return of the bonito canoes. Ngora-Ngora Village, Ulawa Island. (n.p.)

X1163

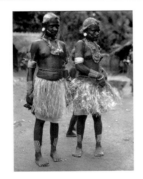

Two young girls waiting for the dancing to commence. Ulawa. (n.p.)

X1166

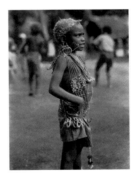

Young girl waiting for the dancing to commence. Ulawa. (H. Bernatzik, *Südsee*, 1944, 1960, pl. 7)

X1165

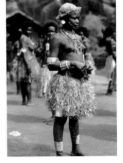

A young girl with limed hair, wearing shell body ornaments. Ulawa Island. (H. Bernatzik, *Südsee*, 1944, pl. 6; 1960, front cover and pl. 6)

X1172

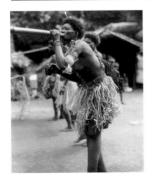

A village woman blowing a sacred trumpet. Solomon Islands. (n.p.)

X786

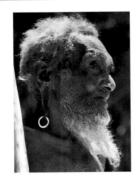

Portrait of the old shaman, *Mwane Apuna*. Wapo Village, Owa Riki Island. (H. Bernatzik, *Südsee*, 1935, pl. 16; 1944, 1949, 1960, pl. 17; T. Theye, *Der geraubte Schatten*, 1989, p. 151)

X1168

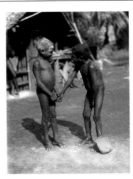

Two boys holding hands in a gesture of greeting, one carrying a net bag. Ulawa Island. (H. Bernatzik, *Südsee*, 1934, pl. 15)

X677

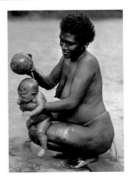

A seated woman pouring water from a coconut, washing her infant. Natagera Village, Owa Raha Island. (H. Bernatzik, *Südsee*, 1934, pl. 19)

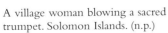

X1262

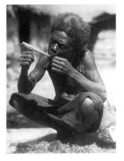

Crouching man with a net bag playing a jew's harp. Mamarana Village, Choiseul Island. (n.p.)

X1334

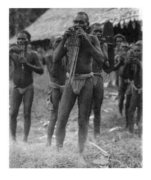

A man playing large pan pipes (*au paina*). Kokoria Village. (n.p.)

X1280

A man seated next to a stone urn. Choiseul Island. (H. Bernatzik, *Südsee*, 1934, pl. 28)

X1275

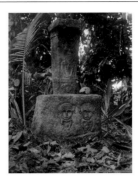

A Choiseul Island stone monolith, with carved ancestor figures and an anthropomorphic finial. Mamarana Village. (H. Bernatzik, *Südsee*, 1935, pl. 43; 1944, 1949, 1960, pl. 44)

X1346

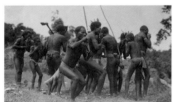

A group of dancers, some playing the sacred flutes, others with dance axes. Kokoria Village. (n.p.)

X73

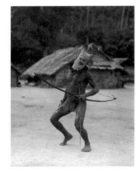

A man at the beach in classic spear-throwing position. Natagera Village, Owa Raha Island. (n.p.)

X105

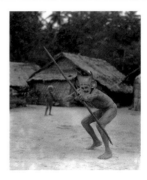

Dancing masquerader from the *mako-mako* dance. Natagera Village, Owa Raha Island. (H. Bernatzik, *Südsee*, 1935, pl. 11; 1944, 1960, pl. 16)

X108

A scene from the *mako-mako* dance. Natagera Village, Owa Raha Island. (n.p.)

X96

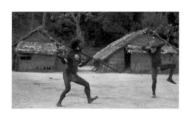

A scene from the *mako-mako* historical dance drama, in which a stranger challenges a village resident. Natagera Village, Owa Raha Island. (H. Bernatzik, *Owa Raha*, 1936, pl. 5)

X171

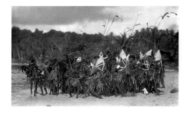

Women and girls' sacred dance. Gupuna Village, Owa Raha Island. (H. Bernatzik, *Südsee*, 1934, pl. 23)

X168

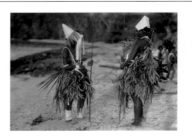

Clothed in leaves and vegetable fibre hoods, the women dance with long staffs between their legs. Owa Raha Island. (H. Bernatzik, *Südsee*, 1934, pl. 23; D. Byer, *Die Große Insel*, 1996, p. 121)

X356

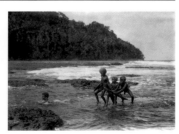

Three young boys surfing in the coastal waters off Owa Raha Island. Natagera Village. (H. Bernatzik, *Südsee*, 1934, pl. 26)

X419

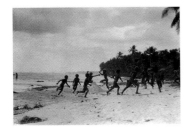

X410

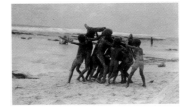

X413

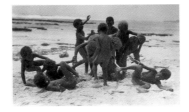

X261

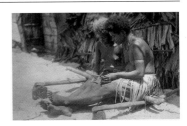

Girls running around a sand heap at Natagera Village. Owa Raha Island. (H. Bernatzik, *Owa Raha*, 1936, pl. 166)

A group of young boys playing on the beach, carrying one of their companions on their shoulders. Owa Raha Island. (n.p.)

Children playing on the beach. Natagera Village, Owa Raha Island. (n.p.)

Two women preparing tatoo pigments. Natagera Village, Owa Raha (H. Bernatzik, *Owa Raha*, 1936, pl. 147; D. Byer, *Die Große Insel*, 1996, pp. 461–462; T. Theye, *Der geraubte Schatten*, 1989, p. 149)

X282

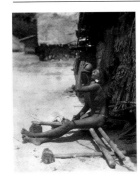

X265

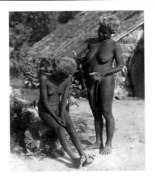

X256

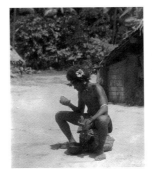

X247

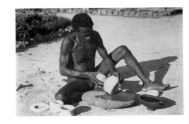

A young girl drinking from a coconut. Natagera Village, Owa Raha Island. (H. Bernatzik, *Südsee*, 1935, 1944, 1949, 1960, pl. 5)

Two women applying crushed shell lime decoration to their hair. Natagera Village, Owa Raha Island. (H. Bernatzik, *Owa Raha*, 1936, pl. 150)

A young man wearing hibiscus flowers and shell body ornaments, preparing a coconut. Gupuna Village, Owa Raha Island. (H. Bernatzik, *Owa Raha*, 1936, pl. 137)

A man making *tridacna* shell armbands. Owa Raha Island. (H. Bernatzik, *Südsee*, 1934, pl. 25)

X3161

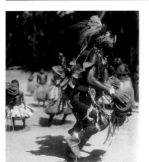

An animated solo dancer with a bird-of-paradise feather headdress, a boar's tooth bite piece and a *kundu* drum. Mailu Island. (n.p.)

X2927

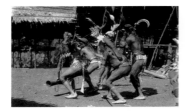

Two pairs of male dancers imitating the bird-of-paradise. Koraudi Village. (n.p.)

X2977

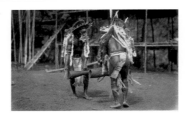

Two dancers facing each other with hourglass-shaped *kundu* drums. Koraudi Village. (n.p.)

X2996

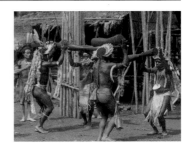

Couples of dancers facing each other and dancing. Koraudi Village. (n.p.)

X2968

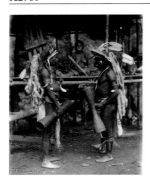

Two dancers facing each other and talking. Koraudi Village. (n.p.)

X2994

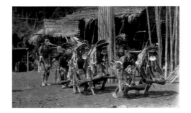

Pairs of decorated dancers beating their *kundu* drums, while bending at their waists in an up-and-down motion. Koraudi Village.
(H. Bernatzik, *Die Große Völkerkunde*, 1953, vol. II, pl. 139)

X2942

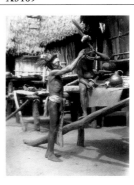

A Papuan dancer holding his *kundu* drum. Koraudi Village. (n.p.)

X3169

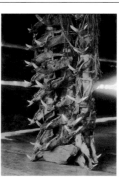

Two dancers preparing their body decorations on the veranda of a house. Mailu Island. (n.p.)

X3093

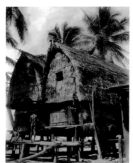

Houses in the village of Kurere on the mainland, across from Mailu Island (n.p.)

X3050

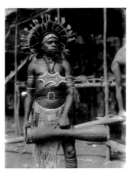

A family scene with a man holding a small pig. He crouches next to his wife who is breast-feeding an infant. Buyay Village. (n.p.)

X3004

An interior shot of a tree-house. The occupants turn their faces to avoid the brilliance of the camera flash. Koraudi Village.
(H. Bernatzik, *Südsee*, 1944, 1949, 1960, pl. 90)

X2857

A totem made of pigs' lower jaw bones, kept in the men's house. Domara Village. (n.p.)

X2889

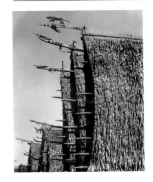

A row of house fronts in Domara Village. (H. Bernatzik, *Südsee*, 1935, pl. 57; 1944, 1960, pl. 63)

X3018

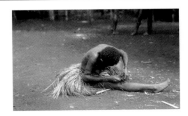

A young girl removing a splinter from her foot. Papua New Guinea. (n.p.)

X3020

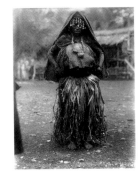

A mourning widow wearing a bast–fibre hood and a necklace. Domara Village. (H. Bernatzik, *Südsee*, 1934, pl. 49; D. Byer, *Fremde Frauen*, 1985, p.166; *Die neue Große Völkerkunde*, 1953, vol. II, pl. 145)

X3024

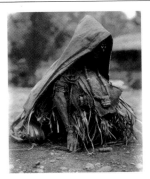

A widow in mourning wearing a bast–fibre hood and a shell ring necklace. Domara Village. (n.p.)

X3147

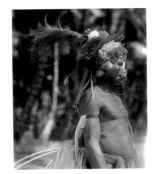

A male dancer wearing a large, feather–overlaid bonnet, and holding a boar's tooth ornament in his mouth. Mailu Island. (n.p.)

X3153

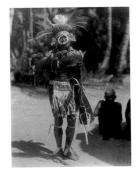

A *kundu* drum dancer with a very large and elaborate feather headdress. Mailu Island. (H. Bernatzik, *Südsee*, 1934, pl. 52)

X3188

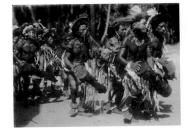

Male Motu dancers with *kundu* drums, wearing full dress regalia. The dancers troop for many hours, up and down the parade ground. Mailu Island. (n.p.)

X3191

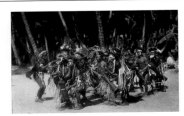

Male Motu dancers with *kundu* drums, wearing full dress regalia. Mailu Island. (n.p.)

X3178

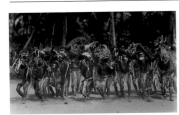

Male Motu dancers with *kundu* drums, wearing full dress regalia. Mailu Island. (n.p.)

X3196

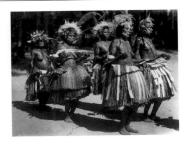

Married women dance with rows of paired dancers, carrying ceremonial *tapa*. Mailu Island. (H. Bernatzik, *Südsee*, 1944, 1949; 1960, pl. 73)

X3206

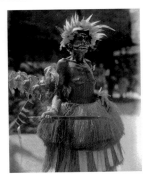

Married woman dancing. Mailu Island. (D. Byer, *Fremde Frauen*, 1985, p. 52)

X3201

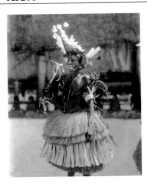

Older woman dancer with tattoos and feather headdress. Mailu Island. (H. Bernatzik, *Südsee*, 1934, pl. 53; D. Byer, *Fremde Frauen*, 1985, p. 175)

X3266

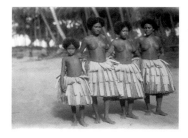

Four girls standing loosely in a row, their arms intertwined. Mailu Island. (n.p.)

X3217

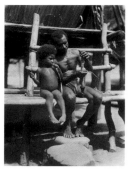

A young boy seated with his father, coiling a line around a spindle. Mailu Island. (H. Bernatzik, *Südsee*, 1935, pl. 61; 1944, 1949, 1960, pl. 71)

X3226

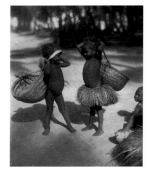

Two young girls chatting, carrying large baskets through straps attached to their foreheads. This practice is learned early. Mailu Island. (H. Bernatzik, *Südsee*, 1935, pl. 64; 1944, 1949, 1960, pl. 76)

X3363

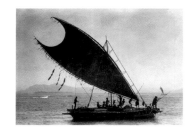

A large *lakatoi* (or *ouru*) intercostal trading canoe, based at the island of Mailu. (n.p.)

X3367

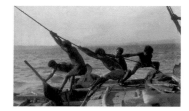

Deck hands at the stern of a *lakatoi* canoe, hauling in the mainsail. Mailu Island. (H. Bernatzik, *Südsee*, 1935, pl. 67; 1944, 1949, 1960, pl. 78)

X3369

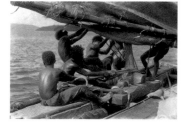

Sailors hauling in the mainsail—a job requiring all hands. Mailu Island. (H. Bernatzik, *Südsee*, 1935, pl. 67; 1944, 1960, pl. 79)

X3382

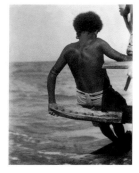

A helmsman on a *lakatoi* canoe. Mailu Island. (n.p.)

X3388

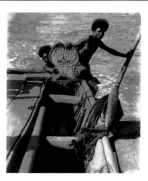

A helmsman on a *lakatoi* canoe. Mailu Island. (n.p.)

X2546

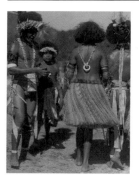

A Motu man and a youth standing next to a row of dancers. Hanuabada Village. (H. Bernatzik, *Südsee*, 1934, pl. 57)

X2607

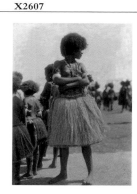

A Motu woman. Hanuabada Village. (H. Bernatzik, *Südsee*, 1934, pl. 56)

X2560

Three Motu couples dancing in a row. Hanuabada Village. (n.p.)

X2553

A young couple dancing amidst a throng. Hanuabada Village. (H. Bernatzik, *Südsee*, 1935, pl. 94; 1944, 1949, 1960, pl. 106)

X2604

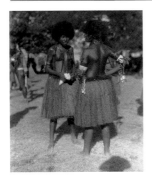

Two Motu girls chatting. South coastal Papua New Guinea. (n.p.)

X2587

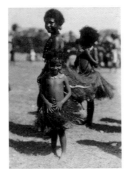

A young Motu girl preparing to dance. South coastal Papua New Guinea. (n.p.)

X2584

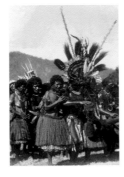

A group of dancers, with large feather coiffures, swaying over the assembly. Hanuabada Village. (n.p.)

X2532

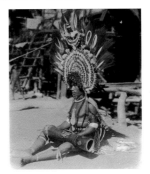

A Motu youth with an elaborate feather headdress. Hanuabada Village. (n.p.)

X2589

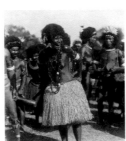

Five young Motu girls awaiting the dance. Hanuabada Village. (n.p.)

X2613

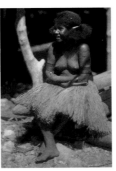

A laughing Motu girl dressed in a grass skirt and wearing long necklaces of glass trade beads. Hanuabada Village. (H. Bernatzik, *Südsee*, 1935, pl. 91; 1944, 1960, pl. 102)

X2621

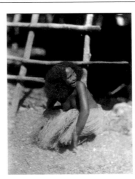

A young Motu girl seated in front of a house. Hanuabada Village. (n.p.)

X2624

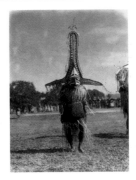

A young Motu girl seated in front of a house. Hanuabada village. (n.p.)

X2620

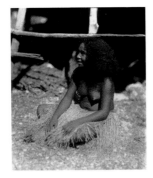

A young Motu girl seated in front of a house. Hanuabada Village. (n.p.)

X2658

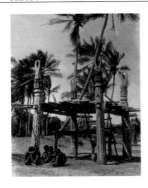

A Motu platform made for a funeral ceremony. The four, large, carved posts support the platform on which the offerings will be placed. Hanuabada Village. (H. Bernatzik, *Südsee*, 1935, pl. 90; 1944, 1949, 1960, pl. 104)

X2674

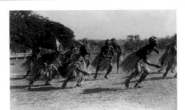

A group of male dancers wearing foliate costumes from Kiwai Island, performing in Port Moresby. (n.p.)

X2679

An *eharo* ceremony masked dancer from the Orokolo region. Papua New Guinea. (n.p.)

X2683

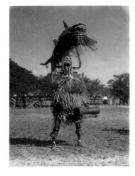

An *eharo* ceremony masked dancer from Orokolo. Papua New Guinea. (n.p.)

X2684

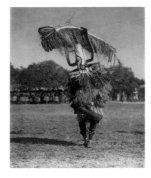

An *eharo* ceremony masked dancer from Orokolo. Papua New Guinea. (n.p.)

X2690

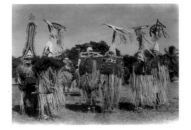

A large cast of *eharo* masked dancers from Orokolo. Papua New Guinea. (n.p.)

X2699

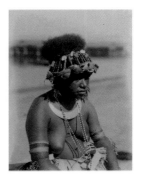

Portrait of a female dancer wearing a headdress with many additions. Gaili Village, Port Moresby. (n.p.)

X2700

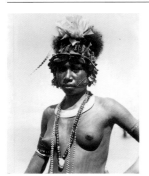

A woman with facial and breast tattoos, wearing an elaborate costume headdress. Gaili Village, Port Moresby. (H. Bernatzik, *Südsee*, 1935, pl. 92; D. Byer, *Fremde Frauen*, 1985, p. 172)

X2792

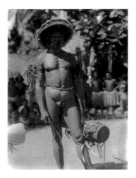

A standing male drummer waiting in repose for the dying woman's dance. Kerepuna Village. A related photograph is published in *Südsee* (Bernatzik, 1944, 1960, pl. 101)

X2796

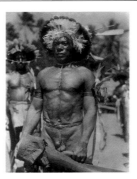

A Motu *kundu* drummer preparing to enter the line of dancers. South coastal Papua New Guinea. (n.p.)

X2797

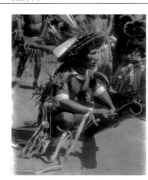

A pausing Motu dancer. South coastal Papua New Guinea. (n.p.)

X2940

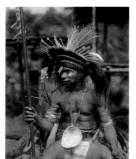

A seated warrior with a cassowary feather headdress and bailer shell gorget. When dancing, he holds the bailer shell in his mouth. Koraudi Village. (n.p.)

X2824

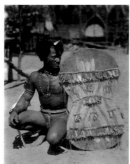

A Motu man holding his dance shield with feather tassels and ornaments attached to its wickerwork binding. Kerepuna Village. (n.p.)

X2923

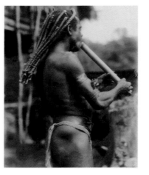

A side view of a man smoking a large bamboo pipe. Buyay Village. (n.p.)

X2914

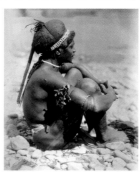

A profile of a man seated on rocky ground, wearing a bast-fibre cap that helps prevent parasites. Koraudi Village. (H. Bernatzik, *Südsee*, 1934, pl. 48)

X2182

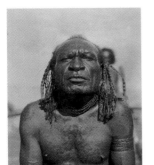

Bena-Bena warrior. The front portion of his scalp is shaved. Northeast Papua New Guinea. (n.p.)

X2184

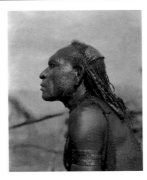

Profile of a Bena-Bena warrior. Northeast Papua New Guinea. (H. Bernatzik, *Südsee*, 1934, pl. 41)

X2210

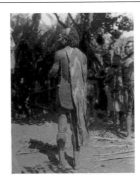

Rear view of a Bena-Bena warrior. Northeast Papua New Guinea. (n.p.)

X2187

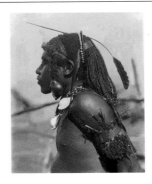

Profile of a Bena-Bena warrior. Northeast Papua New Guinea. (n.p.)

X2205

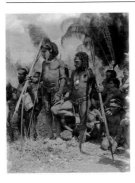

Two Bena-Bena warriors, one standing and supporting himself with his spears. Sigoyabu Village. (n.p.)

X2207

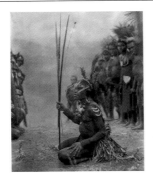

A young, seated Bena-Bena warrior, wearing an unusual bird-of-paradise feather headdress. Sigoyabu Village. (n.p.)

X2214

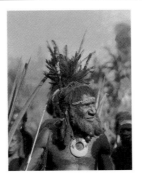

Portrait of a Bena-Bena man wearing a feather headdress, with a large ring around his neck. Sigoyabu Village. (H. Bernatzik, *Südsee*, 1934, pl. 40)

X2250

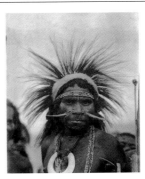

Portrait of a Bena-Bena man wearing a bird-of-paradise feather headdress, and a shell and bead necklace. Sigoyabu Village. (H. Bernatzik, *Südsee*, 1944, 1960, pl. 58)

X2339

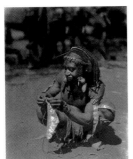

A crouching youth fixing his feather headband. Northeast Papua New Guinea. (n.p.)

X2352

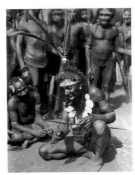

A high-ranking Bena-Bena man carving an arrow. He is wearing a cowrie shell necklace. Sigoyabu Village. (n.p.)

X2251

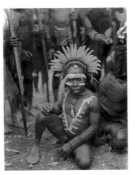

A young, crouching Bena-Bena warrior wearing war paint, and an elaborate feather headdress. Sigoyabu Village. (n.p.)

X2319

A Bena-Bena youth engraving a betel nut container. Sigoyabu Village. (n.p.)

X2374

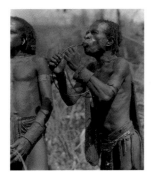

A Bena–Bena man with a curve stick inserted into his stomach. Sigoyabu Village. (H. Bernatzik, *Südsee*, 1935, pl. 53; 1944, 1949, 1960, pl. 51)

X2371

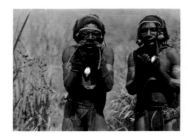

Two Bena–Bena men with curved sticks inserted in their mouths to suppress the automatic gag reflex. Sigoyabu Village. (H. Bernatzik, *Südsee*, 1935, 1944, 1949, 1960, pl. 52)

X2425

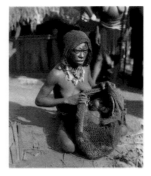

A young Bena–Bena mother with her child in her woven net bag (*bilum*). Kufagogo Village. (H. Bernatzik, *Südsee*, 1935, pl.46; 1944, 1949, 1960, pl. 54; D. Byer, *Fremde Frauen* 1985, p. 164)

X2423

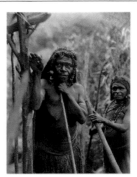

A Bena–Bena Village matriarch standing by her house. Northeast Papua New Guinea. (n.p.)

X2434

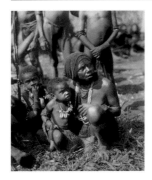

A Bena–Bena woman with her children. Northeast Papua New Guinea. (n.p.)

X2436

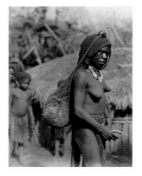

A young Bena–Bena mother carrying her child in a *bilum* bag. Kufagogo Village. (n.p.)

X2458

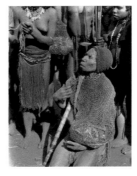

A Bena–Bena widow carrying the bones of her deceased husband in a *bilum* bag. Kufagogo Village. (H. Bernatzik, *Südsee*, 1934, pl. 42; D. Byer, *Fremde Frauen*, 1985, p. 167)

X3042

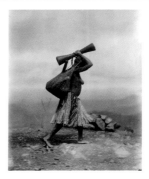

An old woman in the mountain village of Buyay, carrying her *bilum* bag and *kundu* drum. The *bilum* contains yams to be consumed at the feast. (n.p.)

Color separation
Eurofotolit, Cernusco sul Naviglio (Milano)

Printed August 2002
by Bianca & Volta, Truccazzano (Milan)
for 5 Continents Editions, Milan

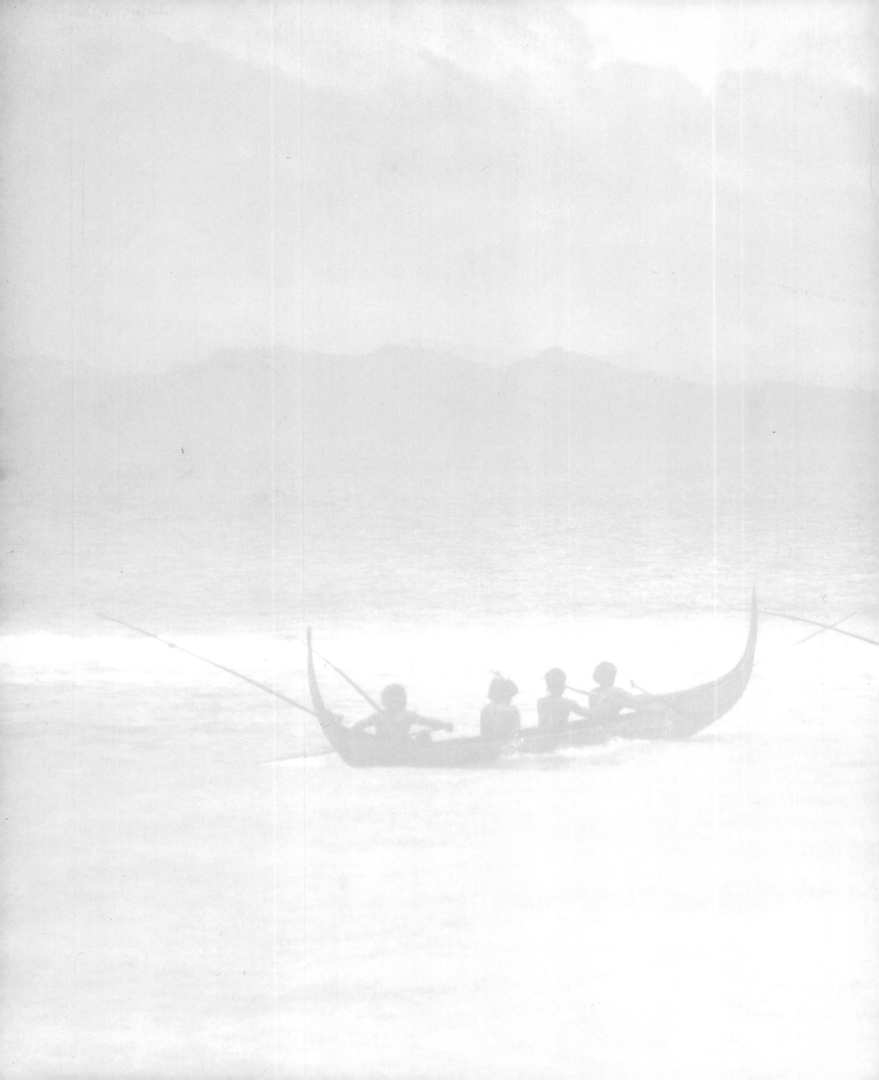